Design and Aesthetics

Design and Aesthetics is a comprehensive student reader on the relationship between design history and aesthetic theory. It includes contributions from many significant writers in this field, including classic articles by Raymond Williams and Roger Scruton, and new articles which provide an overview of current concerns and debates.

The role of design in the world today has aroused much controversy. The first half of this book deals with the main arguments which have emerged from contemporary analysis of its role in the communication process. Essays focus on the question of absolute aesthetic standards versus cultural relativism, and the role of objects in cultural and social life. The second part turns to particular areas of design history, ranging from architecture and pottery to the history of dress. These two main sections are prefaced by contextualizing introductions by Jerry Palmer and Mo Dodson.

The contributors: Barbara Bender, Tony Bennett, Adam Briggs and Paul Cobley, Jos Boys, Cheryl Buckley, David Docherty, Mo Dodson, Peter Fuller, Gordon Fyfe, Nicholas Garnham, Daniel Miller, Stella Newton, Jerry Palmer, Roger Scruton, Sebastiano Timpanaro, Raymond Williams.

The editors: Jerry Palmer is Professor of Communications Theory, and Mo Dodson is Principal Lecturer in Communications at London Guildhall University.

Design

and

Aesthetics

a Reader

Edited by Jerry Palmer
and Mo Dodson

London and New York

First published 1996
by Routledge
11 New Fetter Lane, London EC4P 4EE

Simultaneously published in the USA and Canada
by Routledge
29 West 35th Street, New York, NY 10001

© 1996 Jerry Palmer and Mo Dodson, the collection as a whole;
the individual contributors, their chapters

Phototypeset in Times by Intype, London
Printed and bound in Great Britain by
Biddles Ltd, Guildford and King's Lynn

British Library Cataloguing in Publication Data
A catalogue record for this book is available from the British Library

Library of Congress Cataloguing in Publication Data
A catalogue record for this book has been requested

ISBN 0–415–07232–8 (hbk)
ISBN 0–415–07233–6 (pbk)

Contents

Part II

Plates

Contributors

Barbara Bender Lecturer in Archaeology, University College London

Tony Bennett Associate Professor of Humanities, Griffith University, Queensland

Jos Boys Lecturer in Architecture, School of the Built Environment, De Montfort University, Milton Keynes

Adam Briggs Senior Lecturer in Communications, London Guildhall University

Cheryl Buckley Reader in Design History, University of Northumbria, Newcastle

Paul Cobley Senior Lecturer in Communications, London Guildhall University

David Docherty Head of Strategic Planning, BBC TV

Mo Dodson Principal Lecturer in Communications, London Guildhall University

Peter Fuller (deceased) was a freelance writer on art history

Gordon J. Fyfe Lecturer in Sociology, University of Keele

Nicholas Garnham Professor of Communications, University of Westminster, London

Daniel Miller Lecturer in Anthropology, University College London

Stella Newton Head of Department of the History of Dress, Courtauld Institute of Art, London

Jerry Palmer Professor of Communications, London Guildhall University

Roger Scruton Professor of Philosophy, University of Boston, MA

Sebastiano Timpanaro Teacher at Pisa University, Italy

Raymond Williams (deceased) was Professor of Drama, University of Cambridge

Acknowledgements

The editors would like to thank the following publishers for permission to reproduce essays which have appeared elsewhere:

'Judging Architecture' from Roger Scruton, *Judging Architecture* (Methuen, 1979). 'Really useless "knowledge"' from Tony Bennett, *Outside Literature* (Routledge, 1990). 'Pierre Bourdieu and the sociology of culture' by Nicholas Garham and Raymond Williams first appeared in *Media, Culture and Society* 2, 3 (July 1980). 'On materialism' from Sebastiano Timpanaro, *On Materialism* (New Left Books, 1975). 'Problems of materialism' from Raymond Williams, *Problems of Materialism and Culture* (Verso, 1980). 'Art and biology' from Peter Fuller, *The Naked Artist* (Writers and Readers Co-operative, 1983). 'Fashion and ontology in Trinidad' by Daniel Miller first appeared in *Culture and History* 7 (1990). 'Grecian fillets' from Stella Newton, *Health, Art and Reason* (Murray, 1974). 'The roots of inequality' by Barbara Bender from Daniel Miller and M. Rowlands (eds), *Domination and Resistance* (Unwin Hyman, 1988). 'Art and reproduction' by Gordon Fyfe first appeared in *Media, Culture and Society* 7 (1985). 'Design, Femininity and Modernism' by Cheryl Buckley from *Journal of Design History*, 7, 4 (Oxford University Press, 1994).

Part I

Chapter 1

Introduction to Part I

Jerry Palmer

We start from the commonplace recognition that 'an aesthetics of design' is always problematic insofar as 'design' and 'aesthetics' refer to divergent traditions of understanding creative activity – indeed to different traditions of such activity – despite twentieth-century attempts to resolve divergence (both in theory and in practice) around slogans such as 'form follows function'. The essays that compose this collection all address some aspect or other of the knot of problems that arises when this subject is considered.

It is difficult to reconcile the criteria for design-based artefacts with the traditional aesthetic criteria applied to the arts. This is because the basis of the latter is the universality and non-utilitarian nature of beauty, whereas the basis of design is that the object in question is created for the benefit of some group of potential users, and is therefore aimed at satisfying some need, desire or economic demand. It is clear that there is a tension here between the thrust of aesthetic judgment, at least according to traditional theories where it is always conceived as universalizing; and design judgment, which must articulate the functions of artefacts, where such functions are ultimately historically and sociologically determined.

We recognize that any definition of 'design' is likely to be controversial, and partial, and that this is so for reasons intrinsic to the subject: in a nutshell, the boundary between 'art' and 'design' is always necessarily fluid insofar as all artefacts can be said to have elements of both in them, whether the artefacts in question are conventionally classified as 'art objects' or 'design objects'. This is necessarily so because all objects have a function of some sort by virtue of occupying some place in human society (this might include the function of being rejected as 'worthless' or 'foul', which reinforces the evaluative boundary of usefulness and worthiness), and all objects have to be created according to some imaginative process where the creator imagines them in their completed state before the completion occurs in actuality. This points to ambiguities in the definition of the terms 'design' and 'art'.

Our starting-point in trying to define them is historical and relativistic: we see no purpose in trying to arrive at some 'eternal essence' of art or of the design process at this point since the debate we set out to chart is (among other things) about whether such a definition is possible or even worth attempting Whatever else may or may not be true about 'art' and 'design', it is clear that the meanings these words have in contemporary English emerged at a particular point in history, and therefore it is open to question whether the 'reality' to which these terms refer in fact existed before these meanings became current, or whether the new meanings attached to the words refer to some new human activities. Bearing these provisos in mind, the word 'design' in contemporary English appears to refer to a process based upon the following:

(1) the possibility of a separation of the maker from someone who is responsible for the 'blueprint' of the artefact;
(2) the location of decisions about what is to be produced in the hands of the person who commissions the artefact, usually on the basis of a brief;
(3) the possibility of multiple 'runs' of the object for which the designer constructs a model;
(4) a tight relationship between this modelling and the economic function of the object in question.

In this context, we would define 'art' in a way that both underlines the distinctiveness of its separation from 'design', and which insists upon the historical localization of the term and what it refers to. 'Art' thus would refer to the creation of artefacts which potentially appeal universally, to any public, regardless of what localizes them sociologically. It is thus – sociologically speaking – the product of a particular division of labour, since it is only in certain societies that attempts have been made to produce artefacts with universal appeal; and yet because the objects in question are held to potentially appeal to anybody and everybody, the fact that they are the product of a given division of labour is of secondary importance: according to the definition we are pursuing, it is the potential universality which defines the art object, not the location of its source in space, time and social structure. 'Aesthetic judgment' is the type of judgment which is held to be appropriate to this type of object, and 'aesthetics' (as a branch of philosophy or an academic discipline) is the analysis of such judgments and the objects to which they are applied.

Furthermore, by placing attempts to debate the relationship between design and aesthetics in a historical framework, we point to a wider set of questions about the place of artefacts in human society, questions which have been central to intellectual agendas in the industrial world throughout the modern period. Many of the essays we have chosen in the first half of this collection refer to these wider debates and the

arguments about the relationship between aesthetic appreciation and design make a contribution to the wider philosophical debates about the relationship between human beings and the artefacts they create. This can best be demonstrated by analysing what is at stake in the essays we have chosen for the first half of our collection (the essays in the second half will be presented in a separate introduction – see chapter 11).

In the first place, these essays deal with the vexed and currently controversial question of relativism versus absolutism. In both moral and aesthetic questions it is possible to argue either that the meanings of objects and actions only make sense, and can only be judged, within the context of the particular frameworks that gave them meaning in the first place; or it is possible to advance the countervailing argument that both moral and aesthetic standards must be universally applicable if they are to have any purpose or relevance at all. To restrict our discussion to the realm of art and design, the relativist side of the argument starts from the proposition that artefacts have meaning only within cultural contexts: it is the contexts that set what the meaning is. For example, as has often been pointed out by anthropologists, the artefacts of pre-industrial civilization which have ended up in Western museums have been taken out of their original contexts and placed in a new context which gives them a different meaning. The original meaning of – say – a ritual adjunct in a particular ceremony becomes the meaning of 'a curious example of primitive religion' to the museum's visitors. Against this, absolutists argue that regardless of the meaning deriving from the original context, the aesthetic value of an artefact derives from the application of a set of universal criteria: whatever the meaning that ancient Greek beliefs may have given to the carvings now known as the Elgin Marbles, they occupy a place in the canon of eternal beauty which is independent of this meaning.

This is not the place to try to resolve the disagreement, but to point out some of the things that are at stake in it. First, the distinction between 'meaning' and 'beauty'. For adherents of the canonical view, it is difficult to avoid concluding that beauty must be independent of meaning, since it is empirically clear that an object like the Elgin Marbles no longer has the meaning it had in its original context; more exactly, the element of its meaning which is summarized in the term 'beauty' is independent of the other elements of its meaning. For relativists, the fact that an object is held to be beautiful by one person or a group of people is a simple empirical fact, and we could investigate which groups consider a given class of objects beautiful and which do not: aesthetic value, in this analysis, derives only from the actual judgments of actual groups of people, and has no existence outside those judgments; beauty – in short – indeed lies in the eyes of the beholders. In this analysis 'beauty' is an

attribute of an object which is not qualitatively different from any other attribute imputed to it by a public.

Second, 'beauty' as it is conceived by proponents of the canonical approach must consist of membership of an ideal order, in other words of an entity whose only existence lies outside of the actual history of humanity, at least as it has so far existed. Tony Bennett shows below how this is a necessary postulate in Kant, whose analysis is usually considered the basis of modern conceptions of the canon. Mo Dodson shows, through an analysis of Reynold's *Discourses* and their position within the cultural configuration of his time, how the relativism versus absolutism argument derives from a particular historical conjuncture, since it is at this point in time that the argument assumes its characteristic modern form. Scruton's *Aesthetics of Architecture* – of which we reprint one chapter – is one of the most sophisticated recent attempts to preserve the essence of the Kantian case, while avoiding the commonly imputed implication of some ideal future order. For Scruton, it is possible to preserve the argument that beauty is an objective feature of the world, independent of individual or group preference, by showing how aesthetic judgment operates within the human mind – where properties of mind are considered as universally present in humanity. This argument is pursued by bringing together an analysis of perception and an analysis of identity. Function – as it is theorized in design – is for Scruton a product of desire: we want such-and-such a situation to obtain and we conceive of the role of objects in achieving this aim. But when we judge an object aesthetically we do not judge it in relation to some individual objective, but in terms of its appropriateness to our whole identity; such a judgment is based on value, and value is something that acts as a focus for decisions about the future without our necessarily realizing what it is we are committing ourselves to in any clear detail. We may perceive an object non-aesthetically, in which case our understanding makes us aware of a limited series of possibilities that the object offers us; or we may perceive it aesthetically, in which case we are aware of aspects of the object – its formal properties – which are not forced on our attention by our understanding of what the object is, but which we know will be revealed to us if we are sufficiently attentive to what the object can reveal to us (Scruton 1979: 31–6, 74ff.).

In short, aesthetic judgment is necessarily a potential feature of the way in which we attend to objects. At the same time, it is entirely distinctive, with its own rules; these rules show us how certain potentialities may be realized, which leads us justifiably to demand that others accede to our judgments, because our judgments reveal how these potentialities may be realized. But such a conclusion is only possible on the grounds that the features of mental processes that he presents as deter-

mining the nature of aesthetic possibility are genuinely universal. Against this foundation are ranged two countervailing arguments.

The first of these is the lengthy empirical evidence in favour of cultural relativism, which makes the achievement of generalized true descriptions of all of humanity difficult to achieve (for a cogent recent defence of this position, see Rosaldo 1993). The second is that the supposed universalism of arguments such as Scruton's is necessarily false because it is based upon the suppression or exclusion of other possibilities. The strongest version of this case is to be found in Bourdieu, a summary of whose arguments by Garnham and Williams we include here. Bourdieu's argument, in a nutshell, is that the capacity for making the judgments Scruton calls for is an element in social class distinction, responsible for that class's continued economic and political domination of other classes; but beyond that Bourdieu argues that the capacity to produce such judgments involves the suppression of sensual enjoyment of the type of artefacts in question. Scruton speaks of the incompatibility of sensual enjoyment of objects and their aesthetic appreciation, distinguishing pleasures which are caused by objects from aesthetic delight at an object. In aesthetic pleasure

> some act of attention, some intellectual apprehension of the object, is a necessary part of the pleasure . . . and any change in the thought will automatically lead to a redescription of the pleasure. For it will change the *object* of the pleasure, pleasure here having an object in addition to its cause.
>
> (Scruton 1979: 73)

For Bourdieu, this incompatibility amounts to a suppression: the 'refinement' implied by the process Scruton describes leads to the inability to participate any longer in the other process, at least where classes of objects which have been made the object of aesthetic delight are concerned. If suppression of human faculties is involved, how can the results be universal?

Bourdieu proceeds, in part, by demonstrating through empirical analyses of patterns of artistic taste that they are very class specific: to do this he uses techniques which are widely used in the communications industries, especially in marketing, advertising and media planning; we include an essay by David Docherty, Head of Strategic Planning at the BBC, on how such techniques are used on a day-to-day basis in media organizations. In general, such organizations need detailed empirical information about audience preferences in media output in order to make informed planning decisions about future output. While such information can never replace creativity, it is commonly the case in such organizations that it is used in the process of managing creative teams. Broadcasting, in fact, pushes fundamental views on aesthetics to the centre of public debate,

for the nature of the delivery system – direct to the home – and the range of choice that is the current economic base of broadcasting makes argument about the relative influence of public versus private taste inevitable. Although the size and complexity of broadcasting organizations sets them somewhat apart from other organizations producing artefacts with a high design component, what broadcasting organizations do with empirical information is not in principle very different from any designer who sets out to investigate the tastes of potential clients – it is in the internal task differentiation and the scope and rigour of their investigations that significant differences lie.

Such arguments shift the terrain of debate away from the polemical focus of relativism versus absolutism towards the enlarged focus of the relationships between human beings and the material world of objects, both the objects we make and those that the universe places around us. That this does indeed involve a shift is clear from the terms of Scruton's discussion of the relationship between aesthetic delight and needs. For Scruton 'needs' are whatever is necessary for survival, 'animal needs' as he calls them, the satisfaction of which gives sensual pleasure and is organized through subjective preference; in design theory, he says, both aesthetic delight and the satisfaction of needs are often reduced to preference, as if nothing else existed (1979: 30–1). However, aesthetic delight is distinctive because of the element of attention to its object, as we have seen. The argument continues:

> Now some might argue that people absorb from the organic contours of our ancient towns, with their human details, their softened lines and their 'worked' appearance, a kind of pleasure that sustains them in their daily lives; while in the bleak environment of the modern city a dissatisfaction is felt that disturbs people without their knowing why. . . . Such inarticulate pleasures and displeasures have little to do with architectural taste. . . . They can be accommodated . . . only on the level of human 'need'.
>
> (Scruton 1979: 112)

However, if an enlarged non-biological notion of need is used where we could include valuation as a need in itself, then we can speak of needs such as seeing in one's surroundings 'the real imprint of human labour and the workings of human history', but only on the condition that this appreciation takes the form of aesthetic attention, which would make it transcend 'mere sociology' (Scruton 1979: 113), in other words be more than a set of shared preferences.

In short, for Scruton, 'needs' and 'aesthetic discrimination' inhabit largely separate dimensions of experience; the relationships to objects that humanity may have are bifurcated – on the one hand, those things that are necessary; on the other hand, those things that act to evoke our

full potentiality. Certainly this is one way in which the relationship between humans and objects has traditionally been theorized; but there are many others.

Science would be one: viewed from this point of view, science is a programme for regulating our relationships with objects and subordinating them to our purposes. Another would be economic distribution, the way that arguably dominates thinking on the subject in the late twentieth century; here the relationship between people and objects is thought through the concepts of production and distribution, supply and demand, costs, preferences, etc. A third way, which has arguably been the most influential in recent debates, locates this relationship in culture; that is to say, it is not the individual relationship between individual humans and objects that is of interest, but the collective relationship between specifiable groups of humans and the range of objects that they use; this, in general, is the subject matter of the essays in Part II of this collection.

This emphasis may operate in various ways. For example, in the study of consumer taste, anyone with a practical interest in design and marketing knows that one element in the design process is an awareness of consumer preferences. But while certain 'luxury' goods may be designed to suit literally individual preferences (e.g. commissioned pieces of jewellery or haute couture), this is an exceptional situation: certainly most consumer preferences are expressed by individuals, because the basic spending unit in consumer purchases is the individual; but it is clear that the reasons that lead to certain preferences being more current than others at any given time and place are located in groups, and thus the study of such preferences is a study of group behaviour. More generally, one way in which groups define themselves is through the range of objects that they produce and use, and the ways in which production and distribution are carried out. In general, nineteenth-century thinkers – especially Marx – held that it was the productive or directly associative element in human activity that defined societies by being responsible for those dimensions of their behaviour that constituted them as societies. Subsequently, many thinkers have argued that the manner of consumption of objects is at least as important as the manner of their production, and in many recent debates it has come to be seen as more important (see Appadurai 1986; Baudrillard 1975, 1981; Douglas and Isherwood 1979; Miller 1987); the theme that connects these two sets of debates is the relationship between objects and forms of association. In general, in nineteenth-century debates, objects either featured as elements in the forms of association that constituted societies, insofar as the means of their production implied forms of association, or objects were relegated to the periphery of forms of association; but in recent debates the uses to which objects are put, or (in Appadurai's phrase) 'the social life of things', have been held to be central to the forms of association that constitute

societies; this new place that objects have come to occupy in debates about the fundamental structure of societies is premised upon the argument that objects and their uses are the bearers of the categories through which societies define themselves and the place that they occupy in the world.[1]

Central to such arguments is the notion of the use or function of an object. Implied in the terms used is a relationship between an object and some element of individual and/or group behaviour, or some element of the social structure. To say, for example, that object x is a 'tool' or a 'ritual object' implies that what that object is can be exhaustively summarized by the term in question, and (in each of these two cases at least) indicates a relationship between the object and the society in question: a 'tool' is an object defined by a particular type of purpose (work), just as a ritual object is defined by the notion of a religion. Where do such 'functions' come from? They cannot come from the object itself, since objects readily change function as they move through time and space: a palace becomes a museum, an agricultural implement becomes part of the decor for a rural theme pub, an artillery shell case becomes an ashtray or a paperweight, etc. Functions are the purposes to which objects are put, but where do the purposes come from? Are they freely invented by users (as is apparently the case in the transformation of an artillery shell into a paperweight) or are they subject to laws of some kind – some objects are more suitable for some purposes than for others; only agricultural implements of a certain age are capable of theming a rural pub – of a derivation yet to be discussed?

Nothing is more central to the discussion of how objects relate to people than the notion of 'need' (see Palmer, chapter 10). A theory of need stipulates that the relationships between people and objects are constrained in their variety and their nature by forces that transcend choice and cultural variation. Some of these forces may be largely beyond our control because they derive from the biology of our species and its place in our ecosystem; this is one way in which some contemporary Marxists have inflected debates, and we reproduce three brief versions of this argument here (see the papers by Timpanaro, Williams and Fuller). Other forces may derive from the nature of sociality, especially the nature of valuation as a fundamental human activity. At this point we can see an unexpected convergence between Marxist and anti-Marxist approaches: we have already seen Scruton's recognition that aesthetic valuation may be a need, and Palmer summarizes a similar argument from Doyal and Gough (1991), which places a radically socialist inflection upon an ethical notion of need.

Countering this approach are two recent thinkers who present the relationship between people and objects in a very different light: Haug and Baudrillard.

For Haug (1986), objects in capitalism lead a split existence. On the one hand, they serve needs, on the other hand they are the objects of manipulated desire, a manipulation undertaken by the production and distribution system of capitalism in order to persuade the population that their needs are being met. In order for an object to sell it must appear to fulfil a need on the part of the buyer, and thus the aesthetics of consumer objects are integral to their economic function of creating profit for the producer. Commodities 'court' their buyers; people convert their sensual self-expression into the commodity form by buying things which become expressions of themselves, which changes 'the possibilities of expressing the human instinctual structure' (1986: 19). However, in order to support this argument about the falsity of capitalism, Haug is obliged to distinguish between the use or function of an object (its 'use-value' in Marxist terms) and its image or sign-function – how it appears to the potential consumer, in short. That is to say, for Haug there is some form of interaction between objects and human activities where the common possibilities given by a category of objects – regardless of qualities imparted by particular manufacture – correspond to a category of need/desire in the consumer. Design features such as the branding imparted by marketing strategies are distinct from this functional use, and must be if the object is to serve its capitalist economic function, which is underpinned by real needs (1986: 26).

This distinction, between the use-function of an object and its appearance to the consumer, is what Baudrillard sets out to deconstruct (1975, 1981; see Palmer, chapter 10). For him, the usefulness of objects is an optical illusion, the alibi that our economic and political system creates for itself. For Haug, humanity has needs, which capitalism goes to great lengths to appear to satisfy; for Baudrillard, there are no needs, if by 'needs' we mean some set of relationships between human beings and the material world which serve as a foundation for our existence in the world; thus there is no distinction between real and false needs because the system of their satisfaction is totally part of the symbolic order of culture.

We have tried to show that analysis of certain features of design reveals how they are related to each other. If we consider design in its potentially aesthetic dimension, we inevitably return the analysis to the question of the relation between function, preference and aesthetic judgment, a relationship which is particularly fraught because – traditionally – aesthetic judgment has been analysed in terms based in a radically different conception of objects. Moreover, as soon as we recognize that this is where the difficulty stems from we are obliged to take on board all the questions about the relationship between human beings and objects that have been integral to philosophical debates. Part I of this collection

consists of a series of writings, or commentaries on them, which have been particularly influential in recent attempts to understand these issues.

NOTE

1 The separation between nineteenth- and twentieth-century arguments is by no means as clear as I have suggested, both chronologically and conceptually. Simmel, for example, fits very awkwardly into this division; and Walter Benjamin is an instance of a Marxist for whom capitalism was incomprehensible without an analysis of consumption that accorded it as much importance as production (Buck-Morss 1990).

REFERENCES

Appadurai, A. (1986) *The Social Life of Things*, Cambridge: Cambridge University Press
Baudrillard, J. (1975) *The Mirror of Production*, St Louis: Telos Press
——(1981) *For a Critique of the Political Economy of the Sign*, St Louis: Telos Press
Buck-Morss, S. (1990) *The Dialectics of Seeing*, Ithaca: Cornell University Press
Douglas, M. and Isherwood, B. (1979) *The World of Goods*, New York: Basic Books
Doyal, L. and Gough, I. (1991) *A Theory of Human Need*, London: Macmillan
Haug, W. F. (1986) *Critique of Commodity Aesthetics*, trans. R. Bock, Cambridge: Polity Press
Miller, D. (1987) *Material Culture and Mass Consumption*, Oxford: Blackwell
Rosaldo, R. (1993) *Culture and Truth*, London: Routledge
Scruton, R. (1979) *The Aesthetics of Architecture*, London: Methuen

Chapter 2

Judging architecture

Roger Scruton

It is important, first, to dismiss a certain popular idea of aesthetic taste, the idea enshrined in the familiar maxim that *de gustibus non est disputandum*. 'It's all a matter of taste,' men say, thinking in this way to bring argument to an end and at the same time to secure whatever validity they can for their own idiosyncracies. Clearly no one really believes in the Latin maxim: it is precisely over matters of taste that men are most prone to argue. Reasons are given, relations established; the ideas of right and wrong, correct and incorrect, are bandied about with no suspicion that here they might be inappropriate. Societies are formed for the preservation of buildings to which the majority of people are thought to be indifferent. Anger is expressed at the erection of a skyscraper in Paris, or a shopping precinct in some quiet cathedral town. This anger has many causes, not all of them specifically 'aesthetic'; but, on the face of it, it is quite incompatible with the assumption that in matters of taste dispute is pointless, that each man has the right to his own opinion, that nothing is objective, nothing right or wrong. In science, too, we find differences of opinion. Perhaps some people believe that the earth is flat, and form societies to protect themselves from the abundant evidence to the contrary. But at least we know that such a belief is the sign of a diminished understanding. Why should we not say, then, that a preference for the Einstein Tower over Giotto's Campanile is simply incompatible with a full understanding of architecture? It could be said that there is more to be seen in the Giotto, that it possesses a visual and intellectual richness, a delicate proportionality, an intricacy of detail, that it is beautiful not only as form but in all its parts and matter, that every meaning which attaches to it upholds and embellishes its aesthetic power. A man who notices and takes delight in those things is unlikely to believe that the Mendelsohn bears comparison, even if he should admire its smooth contour and thorough conception. When we study these buildings our attitude is not simply one of curiosity, accompanied by some indefinable pleasure or dissatisfaction. Inwardly, we affirm our preference as valid, and if we did not do so, it is hard to see how we might be seriously

guided by it, how we might rely on it to fill in the gaps left by functional reflections in the operation of practical knowledge. Our preference means something more to us than mere pleasure or satisfaction. It is the outcome of thought and education; it is expressive of moral, religious and political feelings, of an entire *Weltanschauung*, with which our identity is mingled. Our deepest convictions seek confirmation in the experience of architecture, and it is simply not open to us to dismiss these convictions as matters of arbitrary preference about which others are free to make up their minds, any more than it is open to us to think the same of our feelings about murder, rape or genocide. Just as in matters of morality, and matters of science, we cannot engage in aesthetic argument without feeling that our opponent is wrong. 'I had always', wrote Ruskin, 'a clear conviction that there *was* a law in this matter: that good architecture might be indisputedly discerned and divided from the bad; and that we were all of us just as unwise in disputing about the matter without reference to principle, as we should be for debating about the genuineness of a coin without ringing it' (1861: ch. 1). I should like to agree with Ruskin, if only because I am convinced that, in so many matters of architectural taste, his own opinions were fundamentally wrong.

Two features of taste deserve mention at the outset: first, that only a rational being may have taste; second, that taste is changed not through training but rather through education. The two features belong, not surprisingly, together. Taste is something that is both exercised in thought and changed through thought. The dog who prefers 'Doggo' to 'Chump' is making no conscious comparison between them, and has no reason for his preference. His preference is a brute fact: it arises from no reflection upon the nature of 'Chump' or upon the nature of 'Doggo'. In rational beings, however, we may discover preferences that are not only influenced by reflection and comparison, but in many cases arise from that reflection much as do the conclusions of a reasoned argument. Such preferences may be educated; they are not as a rule the outcome of a process of training such as would be administered to a horse or a dog. On the contrary, tastes are acquired through instruction, through the acquisition of knowledge and the development of values. If taste were so simple a matter as the Latin adage implies, would it not be surprising that a man can be brought to a love of the modern style through understanding the ideas behind it, or that he could come to hate neo-classicism, as Ruskin and Pugin hated it, in the interests of moral and religious convictions? Indeed, I shall argue that changes in taste are continuous with, and indeed inseparable from, changes in one's whole outlook on the world, and that taste is as much a part of one's rational nature as are scientific judgements, social conventions and moral ideals.

It is part of the philosophy of mind to impose on the human mind a fundamental division into categories: for example, into the categories of thought, feeling and will, or into the categories of experience, judgement and desire. The point of such divisions is not to arrive at a scientific theory of the mind, nor to divide mental processes into neatly separable compartments, associated one with another only contingently, and capable of autonomous existence. It is, rather, to understand the fundamental *powers* of the mind: not what the mind is, but what it can do. And it is no part of this aim that the powers should be truly separable – that they should be either understood or exercised in isolation. The description of mental powers is therefore a conceptual enterprise, in the way that all philosophy is conceptual: it involves exploring how we might identify and describe the phenomena that surround us, before we have even begun the task of explaining them. Now suppose we ask the question – to which category should the phenomenon of taste be assigned? We find that our intuitions present no simple answer: there is no accepted category to which taste belongs. Indeed, we find that taste is the least 'extricable' of all mental phenomena, the most spread out over our several mental capacities. As we reflect on this, we shall begin to understand the value of taste, its value as bringing together and harmonizing the separate functions exercised in practical understanding. I shall consider in turn the relation of taste to the three principal categories of experience, preference and thought.

First, then, the relation of taste to experience. This would be undeserving of discussion were it not for the fact, already remarked on, that the experience of architecture has so often been misdescribed, or even ignored altogether, in the various attempts to establish comprehensive canons of architectural judgement. Thus the cruder forms of functionalism would seem to ignore the appeal to how a building is seen, finding the only true canon of taste in the *intellectual* relation of means to end. Recognizing, however, that it is really most strange to rule *a priori* against virtually every building that has ever been admired, a more subtle form of functionalism evolved, according to which the experience *is* the most important thing, but that the experience of architecture – or at least the *true* experience of architecture – simply *is* an experience of function. But even that view, as we shall see, is wrong.

We cannot be affected in our judgement of a building by its abstract significance unless that significance first affects our experience of the building. If I support my favourable judgement of a building by reference to its meaning, then this reason can only justify my preference, and indeed can only be part of what leads me to that preference (a part of *my* reason for the preference) if the meaning is revealed in an experience. To refer to history, anecdote, association, function and so on – all this must be irrelevant in the justification of one architectural preference against

another until it is shown how the interpretation modifies the experience of a building. For until that is shown we have not given a reason for looking at one building in preference to the other, rather than a reason for thinking of one and not the other, writing a book about the one but not about the other, and so on. Hence we have given no support to the aesthetic judgement, the judgement which favours the building as an object of experience.

As I tried to show, our experience of architecture, being based on an act of imaginative attention to its object, is essentially open to emendation in the light of reasoned reflection. Consider, for example, Geoffrey Scott's description of the church of S. Maria della Salute in Venice (Plate 2.1, p. 17):

> [The] ingenious paring [of the volutes] makes a perfect transition from the circular plan to the octagonal. Their heaped and rolling form is like that of a heavy substance that has slidden to its final and true adjustment. The great statues and pedestals which they support appear to arrest the outward movement of the volutes and to pin them down upon the church. In silhouette, the statues serve (like the obelisks of the lantern) to give a pyramidal contour to the composition, a line which more than any other gives mass its unity and strength ... there is hardly an element in the church which does not proclaim the beauty of mass and the power of mass to give essential simplicity and dignity even to the richest and most fantastic dreams of the baroque.
>
> (Scott 1914: 232)

At every point in this description Scott refers to some visual aspect of the building, and he allows himself the benefit of no abstract idea that does not find its immediate correlate in experience. Suppose, then, that someone, having read Scott's description, remarks, on returning to the church, that it looks just the same to him – its aspect simply has not changed, and however hard he tries he cannot see it as Scott requires him to. Like Ruskin, he sees it as an incongruous jumble of unmeaning parts (Ruskin 1861: Appendix II),[1] nothing more than an unstable juxtaposition of octagon and circle, with sixteen lumps of stone balanced at the corners. To such a man Scott's criticism has made no difference: it is not that he has been persuaded by it, but remained unable to adjust his experience. It is rather that he *has not been persuaded*. The mark of persuasion *is* the changed experience. For a man really to accept what Scott says, having previously been of another mind, his experience must change. To accept the criticism is to come to see the church in a certain way, in such a way, namely, that the description seems immediately apt, having become, for the subject, his preferred way of describing what he sees, of describing, as a philosopher might put it, the intentional object of perception.[2] Unless Scott's description has this relation to experience,

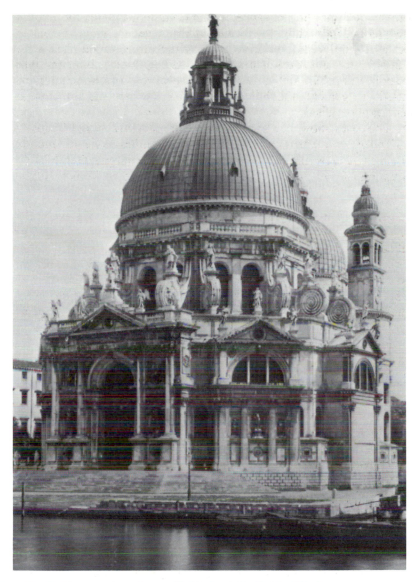

Plate 2.1 Baldassare Longhena: S. Maria della Salute, Venice

it cannot serve as a reason for the judgement of taste. It would be at best an explanation, with no justifying force.

Scott's criticism is relatively concrete. But the same principle applies even in the most abstract of architectural judgements, and, properly understood, can be used to redeem from the obscurity which surrounds

them, the doctrines of space, function and *Kunstgeschichte*. It is impossible to avoid the sense that an idea, while in itself wholly abstract, may nonetheless find something akin to an architectural *expression*, and gain validity as a result. For example, one might think of a Romanesque cloister in terms of the industrious piety of its former inhabitants: in terms of an historical identity, a way of life, with which this habit of building was associated. But were a man to present this as his reason for looking favourably on some particular cloister, say that of S. Paolo Fuori le Mura in Rome (Plate 2.2), then the onus lies on him to show exactly how such an idea finds confirmation in an experience of the building. Perhaps he could go on to refer to the variety of forms employed in the columns, to their fine industrious detailing, and to the way in which none of this abundance of observation disturbs the restful harmony of the design. He might trace the rhythm of the arcade, and describe the Cosmatesque mosaic, with its bright and childlike inventiveness that never transgresses the bounds of sensible ornamentation. In all this, he might say, we see how energetic observation and monastic piety may be successfully combined. A certain idea of monasticism becomes a visible reality: the idea is not merely a personal association occasioned by some anec-

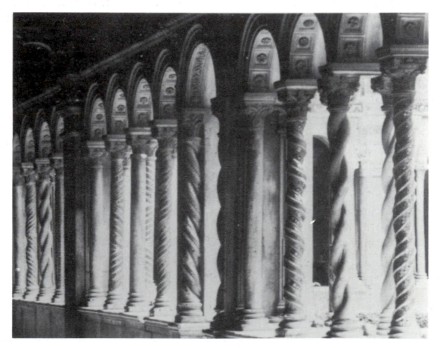

Plate 2.2 S. Paolo Fuori le Mura, Rome, cloister

dotal or historical reminiscence: we *see* it in the details of the building.

I have said that taste may involve the adducing of reasons. We may note, therefore, that whatever reasons are brought forward in support of the judgement of taste – however we may wish to defend our preferences – these reasons can be valid reasons only in so far as they enter into and affect our experience of a building. It is pointless to argue with someone about the structural honesty, social function or spiritual meaning of a building when, even if he agrees with what one says, he is unable to experience the building differently. For until he experiences it differently one's reasons will have failed to change his aesthetic point of view: here the point of view *is* the experience. Some philosophers have been so puzzled by the idea that a process of reasoning might have as its endpoint not a judgement but an experience that they have wished to deny that what we call reasoning in criticism really deserves the name.[3] [Scruton shows earlier in *Judging Architecture* (eds)] that the suggestion is far from paradoxical; for our experiences may be subject to the will, and the product of specific forms of attention. They can constitute part of the *activity* of mind. It follows that an experience, like an action, may be the conclusion of an argument.[4] If criticism is not reasoning, then, what is it? Certainly critical comments may be proper answers to the question 'why?' Moreover, they are not intended as *explanations*: they give reasons, not causes, as I shall later show. It is possible that they cannot be elevated to the status of universal criteria; and it is possible that they do not have 'objective validity': at any rate, these are matters which we have yet to consider. But neither of those possibilities should lead us to deny that the observations of a critic can be adduced as reasons for the response or experience which he recommends.

I turn now to the connection between taste and preference. With what kind of preference are we dealing here? A simple answer would be this: the experience of one building is preferred to that of another because it is more pleasant. But what do we mean by pleasure? Those philosophers who emphasize the place of pleasure in ethics and in art (empiricists, utilitarians and their progeny), usually end, either by making the notion of pleasure primitive and inexplicable, or else by identifying pleasure in terms of preference. In other words, they propose as the criterion for a man's taking pleasure in something that he should prefer it to alternatives. As an explanation of preference, and if not further analysed, the mention of pleasure then becomes entirely empty. I think we should hesitate to lay the burden of our aesthetics, as so many empiricists have done, on a concept that is taken to be self-explanatory, but which is in fact entirely vacuous.

There are various ways in which an experience might be related to pleasure. We can imagine a purely causal relation: a certain experience

causes pleasure, brings pleasure in its train, or is part of a process in which pleasure is included. When a rich man surveys his palace, it may cause him to reflect with pride on his own magnificence; and in this thought is pleasure. Here the pleasure is aroused by the experience of the building, but does not lie in that experience. It seems that, in contrast to this case, aesthetic pleasure must be internally linked to aesthetic experience. If it were not so linked, then we should be in danger of offending against the autonomy of aesthetic interest; in danger of saying that we seek aesthetic experience, and so are interested in its object only as a means to some separate effect.[5] If that were so, then the work of art becomes redundant: it would be a mere accident if the pleasure we obtain from reading *Paradise Lost* is obtained in that way, rather than from an injection or a tablet. It is true that certain people have compared the experience of art and the experience of drugs: but if their arguments have contained any sense, it is because they have been speaking, not of the pleasure of drug-taking, but of the pleasure in other things which, for some reason, the drug makes available. (As when, after a glass of wine, a man may look with more pleasure on a flower: here what he takes pleasure in is not the wine but the flower. The wine, as mere cause of his pleasure, has ceased to be its object.)

An experience may be internally related to pleasure by being itself essentially pleasurable (or essentially painful). Certain experiences, in other words, are simply *species* of pleasure: sexual experiences present perhaps the most obvious example. Other experiences, while not essentially pleasurable, are, when pleasurable, pleasurable in themselves rather than in their effects: for example, the experience of warmth. Aesthetic experiences are of such a kind: they may be neither pleasant nor unpleasant. Nevertheless, unlike the experience of warmth, their relation to pleasure is not merely a contingent one. Unless a man sometimes enjoys aesthetic experience he cannot, I think, ever be said to have it. Aesthetic experience is not *just* a form of pleasure, but nor is its connection with pleasure a mere matter of fact.[6]

A distinction should here be observed. To say that an aesthetic experience is pleasant might seem to imply that a man takes pleasure *in* the experience, as though it were the experience, rather than its object, that constituted the prime focus of his attention. But lovers of architecture take pleasure in buildings, not in the experiences that are obtained from buildings. Their pleasure is of the kind roughly described at the beginning of the last chapter; it is a pleasure founded on understanding, pleasure which has an object, and not just a cause. And here pleasure is directed outwards to the world, not inwards to one's own state of mind. The pleasure of aesthetic experience is inseparable from the act of attention to its object; it is not the kind of pleasure characteristic of mere sensation, such as the pleasure of a hot bath or a good cigar. In other words,

aesthetic pleasures are not merely *accompanied* by attention to an object. They are essentially connected with that attention, and when attention ceases, whatever pleasure continues can no longer be an exercise of taste. This is part of what might lead one to say that, here, pleasure is not so much an effect of its object, as a *mode of understanding it* (cf. Williams 1959).

Now, someone might argue that people absorb from the organic contours of our ancient towns, with their human details, their softened lines and their 'worked' appearance, a kind of pleasure that sustains them in their daily lives; while in the bleak environment of the modern city a dissatisfaction is felt that disturbs people without their knowing why. Even if this were true, it is not necessarily relevant to aesthetic judgement. Such inarticulate pleasures and displeasures have little in common with architectural taste and give us no guidance in the practice of criticism. They can be accommodated, I suspect, only on the level of human 'need', and as we have seen, that is not the level where aesthetic values occur. Of course, were we to take a wider conception of human 'need', a conception that transcends the boundaries of popular biology, then we might certainly find that there is a real issue here. And if we allow human values into the realm of human 'needs' then it becomes impossible to speak of a need for light, air and sanitation, and at the same time to ignore the deeper need to see in one's surroundings the real imprint of human labour and the workings of human history. But until we can connect these things with the values implicit in aesthetic attention, we have advanced no further with the practice of criticism. I shall make that connection; but it will be made in a way that removes all force from these merely sociological observations.

This last feature – the connection between aesthetic pleasure and attention – is one of the many reasons for distinguishing taste in the aesthetic sense from another phenomenon that often goes by the same name, the discriminating palate in food and wine. For although the connoisseur of wine may 'attend to' the qualities of what he drinks, his pleasure, when he does so, is not of a different kind from that of his ignorant companion, who takes no interest in the wine beyond enjoying its taste. The connection between pleasure and attention is here only external: gustatory pleasure does not *demand* an intellectual act.

However, it is no accident that we use the word 'taste' to refer to both sensuous and aesthetic pleasures. Reflection on this fact leads us to qualify the distinction between sensuous and intellectual pleasure. I distinguished pleasure which is internally related to thought from pleasure which depends on thought only accidentally. And it seemed that the pleasures of architecture could not belong to the second kind, since they cannot exist in the absence of attention. However, even if we accept this distinction, we cannot say that all intellectual pleasures are 'aesthetic'. Plato

considered aesthetic pleasure to be a kind of intermediary between the sensuous and the intellectual, and the pursuit of beauty to be one mode of ascent from the lower to the higher realms of mind.[7] In this theory he recognized that there are pleasures which are internally related both to thought and to sensation. A clear example is that of the 'aesthetic' interest in a painting, where intellectual apprehension is fundamental to pleasure, but no more fundamental than the sensory experience with which it is combined. The case might be contrasted with one of Plato's favourite examples, the purely intellectual pleasure of mathematics, the enjoyment of which may be obtained through reading, listening or fingering Braille; even through pure thought alone.

But not every 'sense' lends itself to aesthetic pleasure. The experience must be such that, in attending to it, one attends also to its object. In particular, we should note how different in this respect are the eye and the ear from the other senses. It seems to me that there is probably no such thing as savouring a visual impression while remaining incurious about its object – as though one could savour the sensation of red, while remaining uninterested in the red thing that one sees. Visual experience is so essentially cognitive, so 'opened out', as it were, on to the objective world, that our attention passes through and seizes on its object to the exclusion of all impressions of sense. Now it is difficult to describe the difference here, between vision and hearing on the one hand, and taste, smell, perhaps even touch, on the other. But the fact in question is clear enough, and has been noticed by philosophers from Aquinas to the present day.[8] Vision and hearing, unlike taste and smell, may sometimes be forms of objective contemplation. In tasting and smelling I contemplate not the object but the experience derived from it. A further distinguishing feature might also be mentioned, which is that in tasting, both the object and the desire for it are steadily consumed. No such thing is true of aesthetic attention. I do not propose to study these features; were one to do so, however, the full complexity of the distinction between sensuous and aesthetic pleasure would become apparent. And it would also become apparent that aesthetic experience (as has often been noticed) is the prerogative of the eye and the ear.

The contrast between aesthetic and sensuous pleasure can be made, however, without going into those complexities. It suffices to study the notion of value. As I suggested earlier, values are more significant than preferences. Values play a part, not only in the processes of practical reasoning that issue in action (which might be concerned purely with the agent's own individual interest, without reference to the interests of any other man); they also enter into the process of reasoning whereby we justify action, not just to ourselves, but to others who observe and are affected by it. And until we have this habit of justifying action, we shall never acquire a conception of its end. We must see the end as desirable,

and not just as desired; otherwise we are only half engaged in the pursuit of it. Without values, it is hard to imagine that there could be rational behaviour, behaviour which is motivated by an understanding not of the means only but also of the end. Not only do we try to support our values with reasons when called upon to do so, we also learn to see and understand the world in terms of them. Now, I have not said enough about the distinction between value and mere desire, for the distinction is difficult to capture in a simple formula and will become clear only gradually as we proceed. But it cannot be doubted that there *are* desires which we are prone to justify and recommend to others, as well as desires which we regard as personal idiosyncracies. The former have a more intimate connection with our self-identity, and involve a deeper sense of ourselves as creatures responsible for our past and future; later I shall show why that is so.

The best way to being the study of value is through examples. In culinary matters we are not dealing with values. You happen to like oysters, I happen to dislike them. You happen to like white wine, I prefer red; and so on. It is felt these are ultimate facts, beyond which one cannot go. And it is further held, on account of this, that here there can be little point in employing ideas of 'right' and 'wrong', of 'good' taste and 'bad' (cf. Hume 1741).

Such a claim is of course exaggerated. We do talk of good and bad taste in food and wine. Nevertheless, we do not normally believe that we make reference in doing so to anything like a standard of taste, which it is incumbent upon others to accept. Certainly we discuss matters of culinary taste, and we regard such tastes as in some sense capable of education. But we do not think that there are reasons which will support one culinary preference against another. For if we look at the matter closely, we find that the notion that a reason might actually give *support* to a preference of this kind is a contentious one. If one man prefers claret to burgundy (or, to be more specific, Mouton to Latour), there is no sense in which this disagreement can be resolved into some other, more basic one, without ceasing to be a disagreement about the gustatory qualities of the wines and becoming instead a disagreement about something else, for example, about their medicinal properties or social standing. Of course, there is discussion of wine. The enjoyment of wine may even aspire to those levels of self-conscious sophistication pursued by Huysman's *Des Esseintes*, in his (I think logically impossible) 'symphony' of perfumes. But even if one were to take the chatter of wine snobbery with all the seriousness that such an example (or the more English example provided by George Meredith in *The Egoist*) might suggest, this would still not suffice to turn *discussion* into *reasoning*. For here no disagreement can be resolved simply by coming to an agreement over some *other* matter of oenological preference. Such preferences are

essentially particular, and logically wholly independent of one another: there is no logical order, as one might say, among preferences of this kind. It is never possibly to say: 'But you agree with me in preferring Moselle to Hock and therefore, because of the proved similarity of the choice, you simply *must* agree in preferring claret to burgundy.' Such a remark is close to nonsense. Moreover, there is no sense in which a change of experience can here be the true *conclusion* of a process of reasoning. It is, logically speaking, a mere accident if the discussion of a wine changes its taste: the changed taste might have been caused by the reasoning which preceded it, but it bears no intellectual relation to that reasoning, and cannot in any sense be considered as its logical outcome or expression.

Compare the case of moral sentiments – the prime example of values. There would be something most odd in a moral argument which concluded with the words: 'I grant all that you have said about murder, but it still appeals to me; and therefore I cannot help but approve of it.' That is not the sincere expression of a moral point of view. We do not, and cannot, treat moral opinions as though they were isolated and idiosyncratic preferences that bear no necessary relation to one another. Thus moral sentiments, unlike preferences in food and wine, may be inconsistent with each other, they may be supported by reasons which seem conclusive, or refuted and abandoned purely on the basis of thought.

Aesthetic tastes are like tastes in food and wine, in that they are never actually logically inconsistent. I may like St Paul's today but not tomorrow. I may very much like St Bride's and very much dislike St Mary le Bow. However, the matter does not, and cannot end there. Mere caprice cannot take the place of aesthetic judgement; a preference that is merely capricious cannot be described as an exercise of aesthetic taste, for it lacks the origin, the aim and the reward of taste. A man exercises taste when he regards his enjoyment of one building as part of an aesthetic outlook, and hence in principle justifiable by reasons that might also apply to another building.[9] It would be most odd if a man thought that there was nothing in the basis for his dislike of St Mary le Bow that would not equally provide him with a reason for disliking St Bride's (Plates 2.3 and 2.4). Does he regard the baroque steeple as an unhappy stylistic compromise? In that case he must dislike both the churches. Moreover, if he has that dislike, it is perhaps because he has not understood the need for a variegated sky-line, has not understood how much the baroque forms depend for their true exuberance on an excess of light, an excess that in England is obtained only far above the level of the street. In coming to understand that, he may understand too the correctness of inspiration in the Gothic revival – correctness, that is, as an answer to the stylistic problem posed by large buildings and endless cities, crowded beneath fogs and rains and gloomy Northern skies. Again, our dissenter

might consider that Wren's inventiveness is a cold and contrived phenom-
enon, in comparison, say, with the inventiveness of Hawksmoor, which
involves the less obvious but more subtle disposition of mass, and a finish
which is consequently firmer and crisper (Plate 2.5). But again he ought
to dislike *both* the Wren churches, and again he could be reasoned with.
For has he really noticed the effectiveness of the play of light devised by
Wren, and the springing upward movement of the boundaries? All this
suggests that, while he may indeed *prefer* one of Wren's churches to the
other, he cannot strongly dislike the one and think that this gives him *no*
reason not to strongly admire the other, unless he can make some

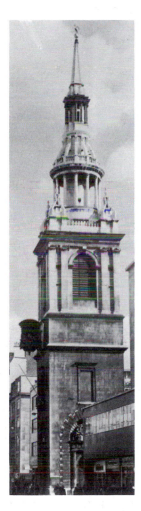

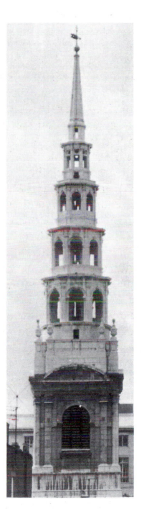

Plate 2.3 Sir Christopher Wren: St
Mary le Bow, London, steeple

Plate 2.4 Sir Christopher Wren: St
Bride's, London, steeple

adequate distinction between the two. While there is no true inconsistency between architectural tastes, it is always possible to construct these 'bridges' of reasoning from one taste to another; and therefore there may always be a pressure of reason to bring one's judgements into line.

I envisage an important objection here, which is that I have not yet sufficiently distinguished the discussion of architecture from the discussion of wine. The examples given, it might be said, are not really examples of reasoning, but rather of *ex post facto* explanation of an immediate, and in itself inarticulate, response. We admit such wealth of detailed discussion in the present case only because the matter is important to us, not because there is any real possibility of rational debate.

It is true that aesthetic interest may often be as the objection implies;

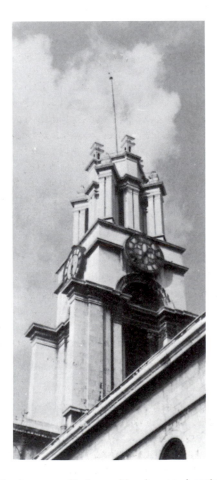

Plate 2.5 Nicholas Hawksmoor: St Anne, Limehouse, London, steeple

what it contains by way of discussion may be not reasoned justification but an attempt to explain or make articulate an unreflecting impression. However, aesthetic interest need not be like that, and indeed has an intrinsic tendency to be something else, something that exhibits genuine reasoning. It is reasoning because its aim is justification, not explanation. Justification is possible here because of the active nature of the experience, which is both partly voluntary, and in any event dependent upon an activity of imaginative attention. I can reason in favour of such experience, just as I reason in favour of actions, emotions, attitudes and beliefs. Architectural tastes need not, therefore, be spontaneous. Indeed, in so far as they are *tastes* in the aesthetic sense, they inevitably make way for deliberation and comparison. And here deliberation does not mean the cultivation of a vast and varied experience, like that of the over-travelled connoisseur. It denotes not the fevered acquisition of experience, but rather the reflective attention to what one has (cf. Wittgenstein 1966). A man might know only a few significant buildings – as did the builders of many of our great cathedrals – and yet be possessed of everything necessary to the development of taste. It suffices only that he should reflect on the nature of those choices that are available to him and on the experiences that he might obtain. Consider, for example, the development of Lincoln cathedral from nave to transept and transept to choir, where we may observe a basic architectural vocabulary being used with greater and greater refinement, with more and more subtle detailing and more and more harmony of effect. Once the Lincoln style had been established, later architects had all that they needed in order to distinguish the successful from the unsuccessful extrapolations of it. The same is even true of the bare style established by Gropius and his followers at the Bauhaus, a style which has been the stock in trade of many architects since the war, and which still can acquire its tasteful and appropriate continuations, as can be seen from comparing the factories which spread from London along the Western Road. Moreover architectural taste, like moral opinion, will be based on other attitudes and judgements. To return to a previous example: it may be that a certain monastic idea becomes appealing because it is expressed by the cloister of S. Paolo; it may also be that a man's previous allegiance to the monastic idea serves as reason for his admiration of the cloister.

But it is here that the notion of taste becomes puzzling. Certainly the clarity that attaches – or seems to attach – to much moral argument, the sense of clear premises and inexorable conclusions, does not here prevail. For example, it does not follow by logic that if I understand the baroque idiom and know how much it harmonizes with my other predilections, then I simply *must* come to like it. I may not like it all the same. But the peculiarity of architectural (as of all truly aesthetic) preference is that I *will* come to like it; or rather, I shall feel a weight of reason

in its favour. And this is not in fact so surprising. For my experience of a building, or of an architectural idiom, may change as my conception of it changes And as my experience changes, so must my taste. We have seen that such a change of experience is precisely the aim of architectural criticism. But exactly what kind of reasoning supports it? Criticism involves a search for the 'correct' or 'balanced' perception, the perception in which ambiguities are resolved and harmonies established, allowing the kind of pervasive visual satisfaction which I hinted at. But that cannot be all. The conceptions which influence our experience of architecture as far-reaching as the conceptions which govern our lives. How else is it possible for an architect like Pugin to think that it was incumbent upon him as a Christian to explore the intricacies of finials, pinnacles and tracery?

A significant point has been revealed in this discussion, which is that the connection, in aesthetic taste, between experience, preference and thought, is in some way inextricable. At no point can any one of these be truly separated from the others, or the meaning and value of the one be fully characterized without reference to the meaning and value of the others. It will help the reader to appreciate the point if we return briefly to a consideration of the functionalist doctrines, and ask ourselves how they might be redeemed from the sterile *a priorism* of their advocates and given serious critical grounding.

Now the single most powerful impetus behind the functionalist movement was the revolt against superfluous or 'useless' ornament. We have already seen that Alberti saw fit – and for very good reasons – to distinguish beauty and ornament, to distinguish that which is proper to architectural understanding from that which is not. And, as we also saw, the functionalist proposes an account of what architectural understanding consists in, an account which can be applied step by step in the criticism of individual buildings. It was the Gothic revivalists (paradoxically enough) who first gave vigorous expression to the doctrine, and first directed it against the useless accretion of ornament at the expense of structure and form. To Pugin and his followers (Pugin 1841; Viollet-le-Duc 1863) it was intolerable that people should think of architectural detail as *purely* ornamental, an idle surface, stuck over a functional frame but detachable from the true structure of the building. It seemed intolerable, for example, that one could have two buildings of identical structure, one in the Gothic 'style', the other purely 'classical', as though 'style' were a matter merely of sculptural veneer rather than architectural achievement. In opposition to such suggestions Pugin – and Ruskin in *The Stones of Venice* – attempted to demonstrate how the ornamental and stylistic details of the Gothic were by no means idle superfluities but on the contrary natural, and even inevitable, developments from the

structural and social requirements that the Gothic builders had to meet. Ruskin went further (1861; followed by Stokes 1964: 108ff.), attempting to show that the love of stone which is the single origin of all serious ornament, and the respect for sound construction, are of identical origin; that the process of building and the process of ornamentation are continuous parts of a single enterprise, not to be understood independently. There is no such thing as an appreciation of ornament that is not at the same time an appreciation of function.

To understand the critical force of this account we must make a distinction between actual structure and actual function, on the one hand, and what we might call – borrowing a term from Suzanne Langer[10] – virtual structure and virtual function, on the other. That is, we make a distinction between how a building is in fact constructed and how that construction is experienced. Our discussion of taste has shown that actual structure is irrelevant to aesthetic judgement except and in so far as it is revealed in virtual structure. But how can structure or function form part of an appearance? And how can they affect the exercise of taste? Perhaps an example will make this clear. Consider, then, the stern of a seventeenth-century ship embellished with all the magnificent trappings of the contemporary baroque (Plate 2.6 – loosely adapted from *Le Roi Soleil*). Such a composition, jutting from the façade of a house, is unlikely to strike us as tasteful or harmonious. And one might plausibly say that part of the explanation would lie in the consequent abuse of virtual structure. However well supported this pile might be on land, its *apparent* structure is one that makes proper sense only when resting upon an ubiquitous cushion of sea. We must see the boat as supported in this way from below, floating freely, so that the pilasters and structural lines appear to bind the horizontal stages together. They do not then seem directly to 'support' the horizontals, as they would if it were rigidly fixed to land. The example shows, I think, how readily our conception of structure translates itself into experience, and how our awareness of structural vectors may be inextricably connected to our sense of what is aesthetically correct. As part of a house the given structure would be bulbous and disjointed. As a boat floating free in the ocean it is the very perfection of harmony: all the details then make perfect sense.

The question which the functionalist critic now has to answer is how far his critical *aperçu* may be extended. Naturally, there is no end to the possibility of its applications. Virtual structure is in the centre of our experience whenever we accept or reject a new advance in architecture. It is this – far more than any Corbusian desire for endless football grounds – which gave rise to the taste for glass towers raised on pilotis. If you must have high towers, then at least build them in such a way that they do not seem to bear down on the observer with a crushing weight. The accepted composition, in its most successful examples (those, for example,

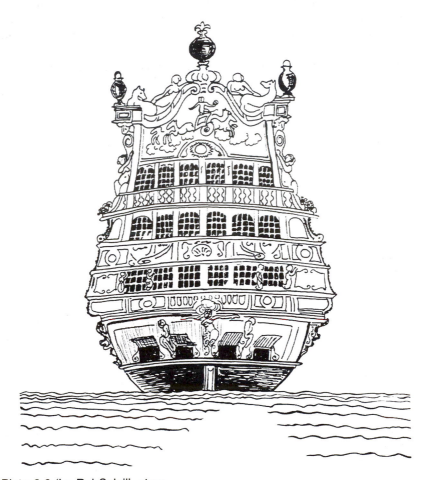

Plate 2.6 'Le Roi Soleil', stern

of Mies Van Der Rohe), compels one to see the building as a light screen or curtain strung upon thin bands of unbroken upward force. At all periods of history it has been through the problem of virtual structure that each new canon of visual taste has been forced to evolve and compromise. Compare the helpless corners of Michelozzo's cortile at the Palazzo Medici – an attempt to translate Brunelleschi's quiet rhythms at the Innocenti from straight into quadrangular form, leading to a strange amalgamation of the archivolts, and a sense of trembling weakness at the corners – with the equivalent detail from the Palazzo Venezia, built some

20 years later in Rome (see Murray 1963: 67ff.). Here the aesthetic problem – the problem of building an inner courtyard conforming to the classical style – is at the same time a problem of virtual structure, and the 'right' appearance differed from its predecessors precisely in its apparent strength. In such cases, thoughts about function, experience of form, and resulting preference, all arise from the same considerations, and co-exist in unity. That is the outstanding characteristic of all aesthetic judgement, and shows the true critical application of the functionalist doctrine.

NOTES

1 Even Ruskin concedes that the effect of mass gives to this church a certain beauty when seen from afar. As a corrective to Ruskin, see Wittkower's analysis (1975).
2 The intentional object of a state of mind is the object as the subject sees, describes or 'posits' it.
3 See, for example, Sibley (1965) and Hampshire (1954). The view is anticipated by Hume 1741.
4 The idea of an action as a 'conclusion' of an argument derives from Aristotle (*Nichomachean Ethics*, 1147a, 27–8). Alternatively, practical reasons are reasons not for thinking but for doing something. The point has been well discussed by Anscombe 1957: secs 33ff.
5 On the notion of the autonomy of the aesthetic judgement (which is related to the view that aesthetic judgement arises from treating its object not as a means but as an end), see Kant (1978) and Collingwood. The question of what this 'autonomy' really amounts to is a deep and difficult one; I am not sure that I have any satisfactory answer to it.
6 The idea that a connection may be necessary but not universal derives from Wittgenstein 1953: Part I.
7 See in particular the beautiful speech given by Socrates at the end of the *Symposium*. Plato's thought – reconstituted by Augustine and Boethius, and embellished with all the symbolic trappings of mediaeval courtly love – achieved its finest expression in Dante's *Divine Comedy*, a work in which the conflict between the carnal and the spiritual, the temporal and the eternal, is confronted and resolved.
8 See, for example, *Summa Theologica*, 1a, 2ae, 27, 1. Also Hegel 1979: Introduction.
9 Kant was the first philosopher to take this point really seriously, as defining the basis of aesthetic judgement. He spoke in this connection of the 'universality' of taste, of the fact that it always claims for itself a *right* which others ought to acknowledge or obey (Kant 1978).
10 See Langer (1953: ch. 1). It is the term 'virtual' that I borrow. The same idea has been expressed by Prak (1968: 30) as 'phenomenal structure'.

REFERENCES

Alberti, L. B. (1485) *De re aedificatoria*, Florence; Eng. trans. (1726) as *Ten Books on Architecture*, London
Borromini, F. (1725) *Intention*, Oxford: Blackwell

Hampshire, S. N. (1954) 'Logic and Appreciation', in W. Elton (ed.) *Aesthetics and Language*, Oxford: Blackwell

Hegel, F. (1979) *Introduction to Aesthetics*, trans. T. M. Knox, Oxford: Clarendon Press

Hume, D. (1741) 'Of the Standard of Taste', in *Essays Moral, Political and Literary*, London

Kant, I. (1978) *Critique of Judgement*, trans. J. C. Meredith, Oxford: Clarendon Press

Langer, S. K. (1953) *Feeling and Form*, London: Routledge & Kegan Paul

Murray, P. (1963) *The Architecture of the Italian Renaissance*, London: Thames & Hudson

Prak, N. L. (1968) *The Language of Architecture*, The Hague

Pugin, A. W. (1841) *The True Principles of Pointed or Christian Architecture*, London: J. Weale

Ruskin, J. (1861) *The Stones of Venice*, London: G. Allen

Schopenhauer, A. (1958) *The World as Will and Representation*, trans. E. F. J. Payne, Colorado: Falcon's Wing Press

Scott, G. (1914) *The Architecture of Humanism*, London: Constable

Sibley, F. N. (1965) 'Aesthetic and Non-aesthetic', *Phil. Rev.*

Stokes, A. (1964) *The Stones of Rimini*, London: Schocken

Trystan Edwards, A. (1924) *Good and Bad Manners in Architecture*, London: Philip Allen

Viollet-le-Duc, E.-E. (1863) *Entretiens sur l'architecture*, Paris; trans. B. Bucknall (1889) as *Discourses on Architecture*, Boston

Weisbach, W. (1921) *Der Barock als Kunst der Gegenreformation*, Berlin

Williams, B. (1959) *Pleasure and Belief*, Aristotelian Society Supplementary Volume

Wittgenstein, L. (1953) *Philosophical Investigations*, Oxford: Blackwell

—— (1966) *Lectures on Aesthetics, Freud, etc.*, ed. C. Barrett, Oxford: Blackwell

Wittkower, R. (1975) *Studies in the Italian Baroque*, London: Thames & Hudson

Chapter 3

Really useless 'knowledge'
A political critique of aesthetics

Tony Bennett

[In his book *Outside Literature*, from which this extract is taken, Bennett gives us a Marxist analysis of the production, functioning and effects of artistic practices and their relationship to ideology. This is to be done, he says, by locating them in the 'spheres of social and cultural action that are produced for them by the forms of classification, valorization and institutional use through which they are inscribed within, and articulated across, different regimes of power, its exercise and its contestation'. In this analysis, the categories of aesthetic thought are useless, and even worse: a positive hindrance to adequate understanding. And yet the Marxist classics regularly do use aesthetic concepts, always with detrimental effects. Bennett proposes we should dump this 'really useless form of knowledge', and starts the process with an analysis of its foundation in Kant. Eds.]

THE PROPERTIES OF AESTHETIC DISCOURSE: VALUE AND THE VALUING SUBJECT

In his *Immanuel Kant*, Lucien Goldmann cites the early Lukács's view that 'the *Critique of Judgement* contains the seeds of a reply to every problem of structure in the sphere of aesthetics; aesthetics need thus only clarify and think through to the end that which is implicitly there to hand' (Goldmann 1971: 192) This was precisely what Lukács did in subsequently historicizing Kant's conception of the subject and object of aesthetic judgement. The approach adopted here is rather different. The *Critique*, I shall argue, *does* provide a clear statement of 'every problem of structure in the field of aesthetics', but less by way of resolving those problems, or anticipating their resolution, than by specifying the conditions that would need to be met were they to be resolved. Viewed in this light, Kant's treatise is most fruitfully read as a commentary on the necessary conditions, properties and requirements of aesthetic discourse.

Before doing so, however, it is necessary to distinguish between aesthetic discourse and discourses of value in order to register a distance

from, and resist the gravitational pull of, Kant's transcendental method. By aesthetic discourse, I have in mind the many variants of philosophical aesthetics which exhibit related properties in their attempts to distinguish some unique faculty, lodged within and constitutive of human subjectivity, which would serve as a basis for establishing the potential, if not actual, universality of aesthetic judgement. Aesthetic discourse, that is to say, construes the aesthetic as a distinctive mode of the subject's mental relation to reality. The means by which this is accomplished vary from Kant's transcendental critique of the faculty of judgement to the analysis of the progressive historical construction of an unified subject and object of aesthetic judgement favoured by Hegel and Lukács, to attempts to locate the basis of aesthetic judgement in the biological substratum of the human individual as, for example, in Peter Fuller's work. Whatever the methods used, however, aesthetic discourse exhibits a substantially identical structure: an analysis of the constitution of the subject, whether this be conceived as self-wrought or culturally produced, provides the justification for the view that aesthetic judgement is, ought to be or one day will be universal just as this, in turn, supports the contention that there is a distinctive aesthetic model of the subject's appropriation of reality. This circularity is an inherent property of aesthetic discourse. Susceptible to neither logical nor empirical demonstration, the existence of a distinctive aesthetic faculty is always ultimately sustained, but entirely intra-discursively, by the projection of a set of conditions in which the subject of value can be represented as universal.

By discourses of value, by contrast, I mean the much more numerous and heterogeneous array of discourses which regulate the social practice of valuing within different valuing communities. Such discourses typically constitute systems for the classification and valuation of persons effected by the means of systems for the classification and valuation of objects and practices. They delimit a set of valued objects and practices and produce, for these, an appropriate valuing subject; that is, a subject marked out from other subjects by his/her ability to recognize the value which such objects and practices are said to embody. This subject is also a *valued* subject, valued precisely because of its ability to correctly apply the rules for valuing which are legislative within a particular valuing community. In this way, the valuing subject functions, ultimately, as the primary valued object also. To the degree that discourses of value address the individual as always-already, either wholly or in part, the valuing subject they produce and require, they constitute a means for the individual's valuation of self as both subject of discernment and ultimate valued object. Their structure is thus narcissistic.

Such discourses are by no means limited to the sphere of artistic practices. Nor, from a sociological point of view, is this necessarily the most important sphere of their operation. As Pierre Bourdieu shows in

La Distinction, discourses of value may be organized in relation to a wide variety of objects and practices, including sporting and culinary pursuits, for example. Moreover, in Bourdieu's analysis, such discourses, in transforming objects and practices into signs of differentiated social identities, play an important role in relation to more general mechanisms of group formation and group differentiation. They are, in effect, practical social ideologies. As such, Bourdieu focuses on their role in relation to class differences in offering both different modalities for the transformation of economic into cultural capital and supplying the means for the self-differentiation of the bourgeoisie and petit-bourgeoisie from the popular classes as well as from each other. However, discourses of value may also function similarly in relation to national, regional, ethnic or gender differences. Whatever the sphere of their operation, though, they work by constructing an ideal of personality, in both its mental and physical aspects, in relation to which the individual is interpellated as valuing, valued and self-valuing subject.

There are no necessary connections between such discourses of value and aesthetic discourse. In most cases, the two operate in different registers. The rules for valuing as well as the subjects and objects of value which discourses of value propose are legislative and have effects solely within the limits of particular valuing communities. Such discourses are prescriptive, but only for those who occupy or take up the position of the valuing subject they construct, a position which may be refused since such valuing subjects are identifiably socially specific. Aesthetic discourse, by contrast, is the form taken by discourses of value which are hegemonic in ambition and, correspondingly universalist in their prescriptive ambit and which have, as their zone of application, those practices nominated as artistic. The position of universal valuing subject which is necessary to such discourse – and, invariably, such a position is produced by generalizing the attributes of the valuing subject associated with a socially specific discourse of value – can be refused *to* but not *by* the individual. Such refusals, however, always leave open a route whereby the valuing practices of each and every individual may be conformed to the principles of judgement embodied in the universal valuing subject. This is achieved by the deployment of cultural, and hence remediable, criteria which permit the disqualification of those individuals whose judgements are assessed as being wayward or incomplete from the point of view of the position of the universal valuing subject which such discourse constructs. Such criteria, while maintaining a liberal façade, provide a means of discounting as impertinent any and all aberrant systems of aesthetic evaluation which would otherwise call into question the universalizing constructions of aesthetic discourse.

As such, aesthetic discourse rests on two specific conditions. First, there must already be cleared a space within which the construction of a

universal valuing subject can be located. It is epistemology which clears this space in securing a general conception of the subject form which enables rules for valuing derived from particular valuing communities to be theoretically represented as universally legislative, either actually or tendentially. This is not merely to suggest that, historically, epistemology provided the surface of emergence on which the problems of aesthetics could become visible, although this is certainly the case.[1] The more important point is that theories of the aesthetic logically presuppose an already elaborated theory of knowledge. The *differentia specifica* of the aesthetic as a specific mode of the subject's mental relation to reality, that is to say, can only be established in relation to some prior conception of the knowledge relation between subject and reality, for it is this which provides the co-ordinating centre of philosophy's theorization of the mental economy of the subject in supplying a self-supporting point of anchorage in relation to which the characteristics of the other modes of the subject's relations to reality can be specified. Moreover, this knowledge relation must already be secured to provide the necessary conditions for an inquiry into the constitutive properties of the aesthetic, for such an inquiry presupposes a subject that is capable of investigating its own constitution. As Catherine Greenfield has put it, epistemology establishes a conception of 'the subject as both the known object of its own introspection and simultaneously the principle which makes such knowledges possible', thereby producing the necessary preconditions for 'the proper activity of mind as the study of its *own* contents' (1984: 40) – which aesthetics pre-eminently is.

As its second precondition, aesthetic discourse presupposes the existence of the artistic as an identifiably distinct institutional sphere within society for there to be something, on the object side of the equation, for aesthetic discourse to latch on to. To paraphrase Habermas, we might say that aesthetic discourse can acquire momentum and a social purchase only when there exists a 'public artistic sphere' produced by the deployment of specific forms of classification and exhibition in such separated exhibition contexts as art galleries and museums.[2]

The combined effect of these two conditioning factors is that, more frequently than not, aesthetic discourse fetishises the object of value in ways which serve as a complement to, and are produced by means of, its universalization of the valuing subject. This point requires some elaboration. Since it is clear that value is a relational phenomenon produced in the passage between subject and object, it is readily admitted in most forms of aesthetic discourse that beauty neither is nor can be a natural property of the object. As Kant puts it:

> If we wish to discern whether anything is beautiful or not, we do not
> refer the representation of it to the Object by means of understanding

with a view to cognition, but by means of the imagination (acting perhaps in conjunction with understanding) we refer the representation to the Subject and its feeling of pleasure or displeasure. The judgement of taste, therefore, is not a cognitive judgement, and so not logical, but is aesthetic – which means that it is one whose determining ground *cannot be other than subjective.*

(Kant 1957: 41–2)

Even so-called objectivist aesthetics, which construe the aesthetic as a distinct set of mental effects produced by those practices nominated as artistic, secure their determining ground in the properties of the subject in assuming a general subject form capable of experiencing or recognizing those effects. Once this determining ground has been universalized, however, aesthetic discourse tilts on its axis as the properties of the subject which guarantee the universality of aesthetic judgement are transferred to the object. Value, transfixed in the singular gaze of the universal subject, solidifies and takes form as a property of the object just as, once the universal valuing subject has been constructed, its active, value-constitutive role becomes passive: all it can do is to recognize the value that was already there, secreted somewhere in the dense folds of the object.

David Hume's essay 'Of the Standard of Taste' (1757) provides an economical example of many of these regulative procedures of aesthetic discourse, and one in which their association with the exercise of cultural power stands forth particularly clearly. Hume's starting-point is to dispute the view that varying judgements of taste should be ranked equally since their claims cannot be adjudicated by appealing to the properties of objects:

Whoever would assert an equality of genius and elegance between Ogilby and Milton, or Bunyan and Addison, would be thought to defend no less an extravagance, than if he had maintained a mole-hill to be as high as Teneriffe, or a pond as extensive as the ocean. Though there may be found persons, who give the preference to the former authors; no-one pays attention to such a taste; and we pronounce, without scruple, the sentiment of these pretended critics to be absurd and ridiculous. The principle of the natural equality of taste is then totally forgot, and while we admit it on some occasions, when the objects seem near an equality, it appears an extravagant paradox, or rather a palpable absurdity, where objects so disproportioned are compared together.

(Hume 1965: 7)

The ground for demonstrating that the principles of aesthetic judgement are universal is prepared, here, via the initial disqualification of those

whose judgements depart significantly from the standard of agreed taste. Moreover, this is justified by an appeal to the properties of the objects compared. This is confirmed by the next step Hume takes in arguing that true and universal principles of taste can only be derived by removing all the exterior, disturbing circumstances which are likely to disrupt the true operation of the finer aspects of judgement or, as Hume calls it, sentiment. The principles of taste, Hume thus contends, are most clearly manifested in 'the durable admiration which attends those works that have survived all the caprices of mode and fashion, all the mistakes of ignorance and envy' (*ibid.*: 9). In short, the classics. The value of these objects is guaranteed by the universality of their acclaim, and vice versa, within what Bourdieu has characterized as 'the circular circulation of inter-legitimation' in which judgements of value both consecrate and are consecrated by the 'inherently valuable' properties of the objects which they approve (Bourdieu 1979: 54–5). The failure to recognise value where it is thus objectively lodged can therefore, Hume argues, only derive 'from some apparent defect or imperfection in the organ' (1965: 9). Even where there is no congenital defect, however, the capacity for valid judgement may be unequally developed since different individuals have different opportunities and inclinations to exercise and develop this capacity. It is worth quoting Hume's conclusions on these matters in full since they aptly demonstrate the respects in which the qualification of some subjects of judgement is effected by the simultaneous disqualification of others.

> Thus, though the principles of taste be universal, and nearly, if not entirely, the same in all men; yet few are qualified to give judgement on any work of art, or establish their own sentiment as the standard of beauty. The organs of internal sensation are seldom so perfect as to allow the general principles their full play, and produce a feeling correspondent to those principles. They either labour under some defect, or are vitiated by some disorder; and by that means excite a sentiment, which may be pronounced erroneous. When the critic has no delicacy, he judges without any distinction, and is only affected by the grosser and more palpable qualities of the object: the finer touches pass unnoticed and disregarded. Where he is not aided by practice, his verdict is attended with confusion and hesitation. Where no comparison has been employed, the most frivolous beauties, such as rather merit the name of defects, are the objects of his admiration. Where he lies under the influence of prejudice, all his natural sentiments are perverted. Where good sense is wanting, he is not qualified to discern the beauties of design and reasoning, which are the highest and most excellent. Under some or other of these imperfections, the generality of men labour; and hence a true judge in the finer arts is observed, even during the most polished ages, to be so rare a character: a strong

sense, united to delicate sentiment, improved by practice, perfected by comparison, and cleared of all prejudice, can alone entitle critics to this valuable character; and the joint verdict of such, wherever they are to be found, is the true standard of taste and beauty.

(Hume 1965: 17)

The 'universal' principles of taste, then, may be held in check by a variety of interior and exterior impediments. They develop to perfection only when the internal organs of sensation are correctly balanced and when exterior circumstances permit their full and unimpeded exercise and progressive refinement. The proof – the only proof – that such principles of taste exist is provided by the few 'valuable characters' who manifest them in their fully developed form. Happily, however, everyone (everyone whose judgement is allowed to count, that is) knows who these are: 'some men in general, however difficult to be particularly pitched upon, will be acknowledged by universal sentiment to have a preference over others' (*ibid.*: 18).

The problem Hume is addressing here is clear. Writing against the arbitrary authoritarianism of earlier aristocratic aesthetic prescriptions, his essay articulates the Enlightenment demand that the principles of taste should be arrived at by means of rational and open debate between members of a public who meet as equals. However, the definition of the relevant public, produced by disqualifying the judgements of the congenitally and culturally defective multitude, results in a cultural partiality that is equally arbitrary and authoritarian. The universality of taste turns out, in effect, to be based on the most insubstantial and flimsy of foundations: the consensus of the drawing room. At this point, Hume's analysis is driven into a further contradiction in the respect that the requirements of rationalism require Hume to allow that, within the defined limits of polite society, genuine and irreconcilable aesthetic disagreements may occur.

But where there is such a diversity in the internal frame or external situation as is entirely blameless on both sides, and leaves no room to give one the preference above the other; in that case a certain degree of diversity of judgement is unavoidable, and we seek in vain for a standard, by which we can reconcile the contrary sentiments.

(Hume 1965: 19–20)

In brief, once the judgements produced within the bourgeois public sphere have been generalized to equate with the level of the universal, Hume's discourse turns tail on itself, securing a commitment to the principles of rationality necessary to the constitution of the bourgeois public sphere only by sacrificing the possibility that judgement might be represented as universal even in this limited social domain. Put crudely, the

bourgeois public maintains a united front, the illusion of a universality, in face of the masses, conducting its disagreements behind closed – and barred – doors.

Kant's *Critique* is a work of immeasurably greater power and rigour. None the less, in universalizing the rules for valuing that are legislative within civilized society, it accomplishes the same ideological work, albeit that it does so in the laundered sphere of the transcendental method. This 'dirty work', moreover is accomplished only hypothetically, for Kant does not so much found an aesthetic as establish the conditions that would be necessary for doing so. The *Critique* is, in consequence, as Lukács would have put it, 'the critical self-consciousness of aesthetic discourse'.

Kant's opening question in the *Critique* is whether the faculty of judgement 'which in the order of our cognitive faculties forms a middle term between understanding and reason' is governed by independent and *a priori* principles which would constitute it as a 'special realm' (Kant 1957: 4). The existence of this faculty, it is important to note, is presupposed as is its function: that of mediating between and connecting understanding and reason, the subject of cognition and the subject of moral action. Indeed, its existence is required to support the conception of the subject form as a unified trinity of thought, feeling and action. However, the existence of such a faculty cannot, in Kant's view, be proved logically or empirically. 'It is only throwing away labour', Kant argues, 'to look for a principle of taste that affords a universal criterion of the beautiful by definite concepts' (*ibid.*: 75). Moreover, this would defeat the purpose of the exercise since the faculty of judgement itself must furnish the means of specifying its own distinctive properties. Otherwise, if these could be known by concepts, then judgement would be subservient to understanding and would not, Kant contends, constitute a 'special realm' within the mental economy of the subject. As for the empirical evidence favouring the view that the sensation of delight or aversion is universally communicable, Kant concedes that this is 'weak indeed and scarce sufficient to raise a presumption, of the derivation of a taste, thus confirmed by examples, from grounds deep-seated and shared alike by all men, underlying their agreement in estimating the forms under which objects are given to them' (*ibid.*: 75).

Kant therefore ostensibly places in brackets the specific application of the faculty of judgement and the particular objects to which it is applied within specific valuing communities, in favour of a transcendental analysis of the principles regulating its exercise no matter what the circumstances of its employment. However, the brackets are soon removed. Kant distinguishes the beautiful from the agreeable and the good, both of which imply a concept of an end and the interest of the subject in that end, as that which pleases without regard to any interest of the subject.

'The delight which determines the judgement of taste', he writes, 'is independent of all interest' (*ibid*.: 43). Bourdieu has argued that Kant, in making disinterestedness a defining attribute of the aesthetic, merely rationalizes a bourgeois class ethos as manifested in the sphere of taste. This view is based on his empirical studies of different class-based valuing practices. These show, at least in the case of contemporary France, that the premium placed on the disinterestedness as an appropriate aesthetic attitude correlates directly with the degree to which a class or class fraction is distanced from the practical need to secure the necessities of life. Indeed, it is a way of *displaying* that distance.

For Bourdieu, then, disinterestedness constitutes a particular form of posturing on the part of the subject which, while serving specific social interests, simultaneously masks those interests as well as its own use in their service. For Kant, by contrast, the quality of disinterestedness provides the means whereby his discussion shifts from the level of a phenomenology of bourgeois taste to that of a transcendental analysis of the faculty of judgement, but only by equating the two. The crucial step in Kant's argument in this respect consists in his contention that: 'The beautiful is that which, apart from concepts, is represented as the Object of a UNIVERSAL delight' (*ibid*.: 50). It is, however, only within discourses of value governed by the attribute of disinterestedness that beauty is and can be so represented:

> For where any one is conscious that his delight in an object is with him independent of all interest, it is inevitable that he should look on the object as one containing a ground of delight for all men. For, since the delight is not based on any inclination of the Subject (or any other deliberate interest) but the Subject feels himself completely *free* in respect of the liking which he accords to the object, he can find as reason for his delight no personal conditions to which his own subjective self might alone be party. Hence he must regard it as resting on what he may also presuppose in every other person; and therefore he must believe that he has reason for demanding a similar delight from every one.
>
> (Kant 1957: 50–1)

It is not my purpose to develop a social critique of Kant's aesthetics. None the less, it is worth noting that he hitches his own discourse up into the sphere of universality, which the transcendental method requires, by means of the very slippery toe-hold provided by the illusions of the subject of a specific discourse of value. It is only the demand for agreement arising from the subject's feeling of distinterestedness in performing judgements of taste which provides the ground for Kant's supposition that there might be a universal, or universalizable, faculty of judgement constituting a special realm. However, my interest lies mainly in Kant's

clear perception of the properties of such discourse and of the conditions necessary to sustain it at the level of universality to which it aspires. With regard to the former, Kant is quite unequivocal: universalizing discourses of value both fetishize the object of value and deploy a discourse of disqualification in relation to those subjects who do not, or refuse to, conform to their edicts. Of the man who speaks of beauty, Kant says:

> He judges not merely for himself, but for all men, and then speaks of beauty as if it were a property of things. Thus he says the *thing* is beautiful; and it is not as if he counted on others agreeing in his judgement of liking owing to his having found them in such agreement on a number of occasions, but he *demands* this agreement of them. He blames them if they judge differently, and denies them taste, which he still requires of them as something they ought to have; and to this extent it is not open to men to say: Every one has his own taste. This would be equivalent to saying that there is no such thing at all as taste, i.e. no aesthetic judgement capable of making a rightful claim upon the assent of all men.
>
> (Kant 1957: 52)

Kant, it is important to add, does not provide a warrant for such claims at the level of their empirical application within specific valuing communities. Indeed, he argues that nothing is postulated in such claims but 'the *possibility* of an aesthetic judgement capable of being at the same time deemed valid for every one' (*ibid.*: 56). In his hypothetical deduction of the conditions which must obtain in order to give such claims both a historical and a logical validity, however, Kant is clear that they require a simultaneous universalization of the object and subject of value, and the identity of the two. They require the former, Kant argues, in the sense that the ideal of the beautiful which regulates the exercise of the faculty of judgement can only be man:

> Only what has in itself the end of its real existence – only *man* that is able himself to determine his end, by reason, or where he has to derive them from external perception, can still compare them with essential and universal ends, and then further pronounce aesthetically upon their accord with such ends, only he, among all objects in the world, admits, therefore, of an ideal of *beauty*, just as humanity in his person, as intelligence, alone admits of the ideal of *perfection*.
>
> (Kant 1957: 76–7)

It is, then, man, as the ideal of the beautiful, which provides the standard governing our estimation of the aesthetic value of objects. For the moment, in the here and now, this ideal exists as 'a mere idea, which each person must beget in his own consciousness, and according to which he must form his estimate of everything that is an Object of taste,

or that is an example of critical taste, and even of universal taste itself.' (*ibid.*: 75–6). However, it is clear that only the actualization of this ideal in the world of objects – only, that is, the production of man as the ultimately valued object of whose beauty and perfection all other objects partake and to which they testify – can provide a justification for such claims in finally enabling beauty to be predicated as a concept of the object, now universalized and perfected.

It is equally clear that this universalization of the object must be complemented by a universalization of the subject of judgement. Kant thus argues that aesthetic judgements both presuppose and project a *sensus communis*: a common sense on which a yet-to-be-realized unanimity of aesthetic judgement can be founded. 'The judgement of taste, therefore,' he writes, 'depends on our presupposing the existence of a common sense' (*ibid.*: 83). This is not to suggest that such a common sense actually exists – its status is that of 'a mere ideal norm' (*ibid.*: 84) – but that the demand for agreement which accompanies aesthetic judgement presupposes the possibility of its eventual existence. 'The assertion is not that every one *will* fall in with our judgement,' Kant says, 'but rather that every one *ought* to agree with it' (*ibid.*: 84). It is in the gap between what is and what ought to be, of course, that discourses of disqualification insert themselves: a *sensus communis* will be produced once the various impediments which inhibit others from applying the faculty of judgement correctly have been removed and once, accordingly, unified subject of value meets unified object of value in a mutually confirming and, no doubt, valuable encounter.

With regard to the likelihood of the production of such a *sensus communis*, Kant is, once again, engagingly, if also revealingly, open:

> Is taste, in other words, a natural and original faculty, or is it only the idea of one that is artificial and to be acquired by us, so that a judgement of taste, with its demand for universal assent, is but a requirement of reason for generating such a *consensus*, and does the 'ought', i.e. the objective necessity of the coincidence of the feeling of all with the particular feeling of each, only betoken the possibility of arriving at some sort of unanimity in these matters, and the judgement of taste only adduce an example of the application of this principle? These are questions which as yet we are neither willing nor in a position to investigate.
>
> (Kant 1957: 85)

AESTHETICS AND THE REFORM OF THE SUBJECT

In summary, then, the inconclusive conclusion of Kant's *Critique* can be reduced to the following questions: Will the universality of taste, once it

has been produced, turn out to be a natural and original property of the human subject? Or will the subject to which a universality of taste can appropriately be attributed turn out to be the product of a process of cultural and historical unification? This Kantian cliff-hanger has provided one of the central cleavages within the history of aesthetics, and has been particularly influential in distinguishing between conservative and radical positions. It is, however, of quite incidental significance since, whichever position is adopted, the structure of argumentation employed is essentially the same. Each requires that some means be found of anticipating, to recall Alan Durant's phrase, the 'discernment of a hypothetical posterity' and further, in order to validate this construct, of disqualifying those whose judgements do not agree with the yet-to-be announced, but constantly deferred, edicts of a unified valuing subject. In Lukács's man-centred aesthetics, in which the questions Kant leaves open are closed in the name of a historicized narcissism, the empirical failure of subjects in the present to anticipate the judgements that will be pronounced once the cultural and historical process of man's unification has been completed is attributed to the effect of false consciousness on social agents. But Peter Fuller, who espouses a form of historicized biologism, is obliged to resort to similar arguments. Although positing an aesthetic sense based on certain innate biological properties, Fuller – given that few people seem to be correctly appreciating as their biologies say they ought to – must project this 'natural and original' property as a post-historical construct, destined to realize itself only in culturally propitious circumstances. Meanwhile, by deploying a many-stranded discourse of disqualification, Fuller ensures that there is no need to take account of any contradictory evidence which might call this theory into question.

> But, of course, despite what some of my critics have said, my position is in no sense whatever ahistorical. I argue that – like so many human potentialities – this biologically given aesthetic potentiality requires a facilitating environment to develop, and to flourish. The trouble at the moment is that the decline of religious belief, and the change in the nature of work brought about by the rise of modern industrialism, and its subsequent development, have combined to erode the conditions under which this great human potentiality can flourish. That's why it is no use going to the man in the street.
>
> (Eagleton and Fuller 1983: 79)

Moreover, it matters relatively little, practically speaking, whether the criteria of disqualification which accompany aesthetic discourse are malignant or benign. So far as questions of cultural policy are concerned, the orientation of aesthetic discourse predisposes it to generate proposals directed to the subject rather than the object side of the aesthetic relation, and to do so no matter what its political affiliations. Although in one

respect tilted forward in anticipating 'the discernments of a hypothetical posterity', aesthetic discourse is also obliged to be backward-looking since, as a condition of its construction, it must, at least to some degree, accept and endorse the dominant systems of evaluation handed down from the past. If the aesthetic is to be founded as a universally present mode of the subject's mental relation to reality, then, first, the objects valued in the past must be regarded as the right ones and, second, they must also be regarded as having been valued for the right reasons even if only, as Lukács argued, in limited ways, whose real meaning is to be progressively revealed. As a consequence – and Brecht's comments on Lukács demonstrate this most forcibly (Brecht 1974) – aesthetic discourse, when directed to the object side of the aesthetic relation, can result only in a politics of preserving what has already been preserved and consecrated in the judgements of the past, or of emulating, extending and adapting earlier aesthetic models to fit new circumstances. Since, for the reasons outlined earlier, value is ultimately fetishized as a property of the object, an inability to judge correctly must be attributed to a failing of the subject, a failing accounted for by a series of cultural impediments whose removal thus becomes the primary goal of cultural policy – through education in liberal bourgeois aesthetics or, more usually in Marxist aesthetics, through the transformation of social relations. It is not surprising, therefore, that the predominant tendency within Marxist aesthetics has been to constitute the members of oppressed social groups as subjects whose aesthetic judgement needs to be transformed by being conformed to some already elaborated aesthetic norm. There is, as Fuller puts it, no need, in such approaches, to go to the man in the street, no need to articulate a socialist cultural policy to the different discourses of value which circulate within and between oppressed strata. It is therefore small wonder that Marxist aesthetic discourse has proved quite irrelevant outside the academy since it impedes, in its very structure, an adequate theorization of the field of social-cultural relations within which a socialist cultural politics must intervene.

And it does more than that. Earlier in his exchange with Terry Eagleton, Peter Fuller argues that 'my aesthetics (though not my politics) are closer to those of Roger Scruton and the "Higher Toryism" of Peterhouse than to all that discourse – semiotics and post-structuralist deconstruction – which goes on up the road at King's' (Eagleton and Fuller 1983: 78–9). And with good reason, although he is mistaken to believe that aesthetic and political positions might be so clearly disentangled. Indeed, I have tried to show that the structure of aesthetic discourse is inherently suspect in its political leanings no matter how radical the political protocols displayed on its surface. Jan Mukarovsky, writing of the mutual intolerance of aesthetic norms in polemical situations, succinctly summarizes the consequences which discrepant judgements of taste bring in their tow:

The aesthetic norm is replaced by another, more authoritative norm –
e.g., a moral norm – and one's opponent is called a deceiver, or else
by an intellectual norm, in which case the opponent is called ignorant
or stupid. Even when the right of the individual to make aesthetic
judgements is emphasised, one hears in the same breath the request
for responsibility for them: individual taste is a component of the
human value of the person who exercises it.

(Mukarovsky 1970)

In making this remark, Mukarovsky has in mind the relative intolerance
produced by the functioning, within specific discourses of value, of ideals
of personality that are identifiably socially specific in their articulations.
In the case of aesthetic discourse, obliged to operate at the level of
universality in order to establish the aesthetic as a distinctive mode of the
subject's mental relation to reality, such relative intolerance becomes
absolute. Within such discourse, the subject who fails to appreciate cor-
rectly is regarded as being incompletely human rather than merely being
excluded from full title to the membership of a specific valued and valuing
community. To fail to appreciate correctly as a proletarian revolutionary,
Scottish Nationalist, radical feminist, or, indeed, Peterhouse Tory is one
thing – a failure to take up a particular articulated aesthetic, social and
political positionality. An aesthetic, by contrast, no matter how benign
the discourse of disqualification it deploys, must operate more far-reaching
and complete exclusions and do so by virtue of its very structure.

Notwithstanding the scientific claims which often accompany it, aes-
thetic discourse is ideological in the Althusserian sense that it functions
as a discourse producing subjects. The universal valuing subject (man) it
constructs interpellates the reader into the position of a valuing subject
who is defined, in relation to the valued object (man), within a mirror
structure of self-recognition. Yes, indeed, man is manifested in this object;
yes, indeed, I recognize myself in it; isn't it/aren't I wonderful? – such is
the effect of aesthetic discourse for the subject who takes up the position
it offers. As ideology, however, aesthetic discourse is characterized by a
number of contradictions and torsions, albeit ones which vary in their
consequences depending on the political articulations of such discourse.
In the case of bourgeois aesthetics, the production of a unified valuing
subject, although necessary in providing a theoretical legitimation for the
re-presentation of class-specific aesthetic norms as universally valid, is
also, at another level, sham, and necessarily so. Such discourse *requires*
its ignorants if it is to fulfil its practical function of social differentiation.
The problem associated with attempts to appropriate aesthetic discourse
for socialism are, in many respects, the reverse for, willy nilly, such
discourse produces its ignorants and, however benign, an accompanying

condescension which serve as a blockage to both political analysis and cultural policy formation.

'Shouldn't we abolish aesthetics?', Brecht asked in the title of an article he wrote in 1927 (Willett 1978: 20). His answer, of course, was: yes. As a producer, Brecht clearly found the prescriptions of aesthetic systems restricting. If you want an aesthetic, he asked two decades later (clearly implying that he didn't), it could be summed up in the slogan that socialists need 'many different methods in order to reach their objective' (*ibid.*: 112). This did not imply any neutrality with regard to the question of value on Brecht's part, but his concern was always with political use-value – local, temporary and conjunctural – which he felt able to address without the need to develop any general, universally applicable theory of the aesthetic as a distinct mode. I think Brecht was right. The political utility of discourses of value operating via the construction of an ideal of personality to which broadly-based social aspirations can be articulated is unquestionable. There is, however, no reason to suppose that such discourses must be hitched up to the sphere of universality in order to secure their effectivity. To the contrary, given the configuration of today's political struggles, it is highly unlikely that an idea of personality might be forged that would be of equal service in the multiple, intersecting, but equally non-coincident foci of struggle constituted by black, gay, feminist, socialist and, in some contexts, national liberation politics. In particular conjunctures, to be sure, an ideal of personality may be forged which serves to integrate – but always temporarily – such forces into a pro-visional unity. But this is not the basis for a generalizable and universaliz-able cultural politics. Nor is this the time for such a politics.

NOTES

1 This historical pre-givenness of epistemology to aesthetics is made perfectly clear by Baumgarten, conventionally regarded as the founder of aesthetics, who first introduced the term (in 1735) in the following context:

> If logic by its very definition should be restricted to the rather narrow limits to which it is as a matter of fact confined, would it not count as the science of knowing things philosophically, that is, as the science for the direction of the higher cognitive faculties in apprehending the truth? Well, then, Philo-sophers might still find occasion, not without ample reward, to inquire also into those devices by which they might improve the lower faculties of know-ing, and sharpen them and apply them more happily for the benefit of the whole world. Since psychology affords sound principles, we have no doubt that there could be available a science which could direct the lower cognitive faculties in knowing things sensately. . . . Therefore, *things known* are to be known by the superior faculty as the object of logic; things perceived are to be known by the inferior faculty as the object of the science of perception, or aesthetic.
>
> (Baumgarten 1954: 78)

2 The reference here is to Jurgen Habermas's concept of 'the public sphere': a critical institutional space within which bourgeois public opinion was nurtured and developed in opposition to the structures of absolutism. For the best account of the relevance of this concept to the concerns of aesthetic theory, see Hohendal 1982. I have drawn heavily on this in my discussion of Hume.

REFERENCES

Baumgarten, A. G. (1954) *Reflections on Poetry*, Berkeley and Los Angeles: University of California Press

Bourdieu, P. (1979) *La Distinction: Critique sociale du judgment*. Paris: Editions de Minuit

Brecht, B. (1974) 'Against Georg Lukacs', *New Left Review*, 84

Eagleton, T. and Fuller, P. (1983) 'The Question of Value: A Discussion', *New Left Review*, 142

Goldmann, L. (1971) *Immanuel Kant*, London: New Left Books

Greenfield, C. (1984) 'Theories of the Subject: Rewritings and Contestations', *Australian Journal of Communication*, 5–6

Hohendal, P. U. (1982) *The Institution of Criticism*, Ithaca and London: Cornell University Press

Hume, D. (1965) *Of the Standard of Taste and Other Essays*, Indianapolis: Bobbs-Merrill

Kant, I. (1957) *The Critique of Judgement*, Oxford: Clarendon Press

Mukarovsky, J. (1970) *Aesthetic Function, Norm and Value as Social Facts*, Ann Arbor: University of Michigan Press

Willett, J. (ed.) (1978) *Brecht on Theatre*, London: Methuen

Chapter 4

Pierre Bourdieu and the sociology of culture

An introduction

Nicholas Garnham and Raymond Williams

For Bourdieu all human actors are involved in strategies in situations of which the outcome is uncertain because these strategies are opposed by the strategies of other actors. The problem therefore is to specify the mechanism by which unbeknownst in principle to the actors (for if they knew they would alter their strategy to take account of this knowledge) these strategies of improvisation are objectively co-ordinated (Bourdieu 1977: 1–30).

The regulating mechanism Bourdieu proposes is the habitus (*ibid*.: 72–95). This he describes as 'the strategy-generating principle enabling agents to cope with unforeseen and ever-changing situations ... a system of lasting, transposable dispositions which, integrating past experiences, functions at every moment as a matrix of perceptions, appreciations and actions and makes possible the achievement of infinitely diversified tasks, thanks to the analogical transfer of schemes permitting the solution of similarly shaped problems'. The habitus is not just a random series of dispositions but operates according to a relatively coherent logic, what Bourdieu calls the logic of practice.

This logic is shaped primarily in early childhood within the family by the internalization of a given set of determinate objective conditions both directly material and material as mediated through the habitus and thus the practices of surrounding adults especially the parents. While later experience will alter the structure of the habitus's logic of practice, these alterations from school or work will be appropriated according to the structural logic of the existing habitus (*ibid*.: 77–8).[1]

This logic of practice since it must be operated unconsciously and since it cannot be explicitly inculcated must be both an impoverished logic in the sense of working with simple categorical distinctions and also flexible so that it can be applied as the structuring principle of practice across a wide range of situations. Thus the logic of practice operates with such simple dichotomous distinctions as high/low, inside/outside, near/far, male/female, good/bad, black/white, rare/common, distinguished/vulgar, etc., principles of categorization that develop in the immediate environment

of the young child but can be subsequently applied across a wide range of fields and situations as unconscious regulating principles (*ibid.*: 96–158).

Moreover the habitus is a unified phenomenon. It produces an ethos that relates all the practices produced by a habitus to a unifying set of principles. The habitus is also by definition not an individual phenomenon. That is to say it is internalized and operationalized by individuals but not to regulate solitary acts but precisely interaction. Thus the habitus is a family, group and especially class phenomenon, a logic derived from a common set of material conditions of existence to regulate the practice of a set of individuals in common response to those conditions. Indeed Bourdieu's definition of class is based on the habitus (*ibid.*: 81–7).

Thus individual practice as regulated by the logic of practice is always a structural variant of group and especially class practice. However since the habitus regulates practice according to what Bourdieu calls a probabilistic logic, that is to say practice in a given present situation is conditioned by expectation of the outcome of a given course of action which in its turn is based, through the habitus, on the experience of past outcomes, while class origin is overdetermining of the structure of the habitus, practice is also determined by trajectory. Broadly by this Bourdieu refers to upward or downward social mobility of either the family, the class fraction or the class in a hierarchy of determinations from class to family. Crudely, upward mobility will give an optimistic view of possible outcomes and downward mobility a pessimistic view, each of which will determine a different set of practical orientations towards the various fields of social struggle. Bourdieu's classic example of the effect of expectations on practice is that of working-class attitudes to involvement in formal education. The point about these expectations is that like other aspects of the logic of practice they reflect not just random individual reactions to the social environment but on the contrary they are realistic assessments in terms of the habitus of the objective probabilities offered by a given state of the social field to an actor in a given class position (Bourdieu 1974, 1979b: ch. 2).

So when Bourdieu turns to the specific field of cultural consumption, or rather appropriation, the regularities his survey data reveals in taste patterns across a wide range of fields from food, clothing, interior decor and make-up to sport and popular and high art are markers or indices of the habitus of classes and class fractions and what Bourdieu is concerned to reveal is not a particular pattern of consumption or appropriation, since in a different state of the field other markers could be used for the same relational positions, but the logic which explains this particular relationship between a range of cultural goods and practices and a range of class habitus. Bourdieu's analysis of the concrete specificities of contemporary French cultural practice are thus part of his wider theory of

symbolic power, its empirical validation and refinement and at the same time a political intervention in a symbolic class struggle.

> Art is the site par excellence of the denial of the social world. But the same unconscious intention of denial is the underlying principle of a number of discourses whose overt purpose is to talk of the social world and which as a consequence can be written and read with a double meaning. (How many philosophers, sociologists, philologists came to philosophy, sociology or philology as places which because they are not properly fitted into social space allow one to escape definition? All those in effect utopians who do not wish to know where they are, are not the best placed to know about the social space in which they are placed. Would we have otherwise so many readings and 'lectores', materialists without materials, thoughts without instruments of thought, thus without an object, and so few observations and as a consequence 'auctores'.) We cannot advance and expand the science of the social world unless we force a turn of the tide by neutralizing this neutralization and by denying denial in all its forms of which the denial of reality inherent in the exaggerated radicalism of certain revolutionary discourses is by no means the least significant. Against a discourse that is neither true nor false, neither verifiable nor falsifiable, neither theoretical nor empirical which like Racine speaks not of cows but of lowing, cannot speak of Daz or of the singlets of the working class but only of mode of production and of proletariat or of the rôles and attitudes of the 'lower middle class', it is not enough to criticize it is necessary to show, objects and even people, to touch things with one's fingers – which does not mean pointing a finger at them – and to make people who are used to speaking what they think they think and so no longer think about what they say to make such people enter a popular bistro or a rugby ground, a golf course or a private club.
>
> (Bourdieu 1979b: 596–7)

Bourdieu in the Durkheimian tradition sees symbolic systems, as such, as arbitrary, undetermined taxonomies, structuring structures in the sense that they do not reflect or represent a reality, but themselves structure that reality. Moreover, as in the Saussurean model of language, such systems are based upon 'difference' or 'distinction'. However he criticizes the idealism of the Durkheimian/Saussurean tradition by stressing that these systems, although arbitrary in themselves, are not arbitrary in their social function which is to represent, but in a misrecognized form, the structure of class relations and indeed it is their very arbitrariness that allows them to do this since if they were not arbitrary they could not be the object of class struggle. They represent class relations and in the same movement disguise that representation because their logic is that of 'distinction'. In

English as in French the double meaning of that word, both a categorical and a social term, precisely mirrors the function of symbolic power.

Thus symbolic systems serve to reinforce class relations as internalized in the habitus since in the internalizing of appropriation their specific logic confirms the general logic of class determined practice. The internalization of the specific logic of symbolic systems or rather, since it is unified, the symbolic system, confirms a hierarchically organized range of distinctions such as rare/common, distinguished/vulgar, distinterested/interested, freedom from necessity/necessity, etc.

For Bourdieu all societies are characterized by a struggle between groups and/or classes and class fractions to maximize their interests in order to ensure their reproduction. The social formation is seen as a hierarchically organized series of fields within which human agents are engaged in specific struggles to maximize their control over the social resources specific to that field, the intellectual field, the educational field, the economic field, etc. and within which the position of a social agent is relational, that is to say a shifting position determined by the totality of the lines of force specific to that field. The fields are hierarchically organized in a structure overdetermined by the field of class struggle over the production and distribution of material resources and each subordinate field reproduces within its own structural logic, the logic of the field of class struggle:

> the field which cannot be reduced to a single aggregate of isolated agents or to the sum of elements merely juxtaposed is, like a magnetic field, made up of a system of power lines. In other words the constituting agents or system of agents may be described as so many forces which, by their existence, opposition or combination, determine its specific structure at a given moment of time. In return each of these is defined by its particular position within this field from which it derives positional properties which cannot be assimilated to intrinsic properties.

> (Bourdieu 1971: 161)

Social groups and classes enter in each generation a historically given structured state of these fields and they develop and deploy their strategies of struggle on the basis of a historically given level of material, social and cultural endowment which may, in a given historical state of the field, be transformed into capital. Although the symbolic field like all fields is a field of class struggle and what is at stake is legitimizing or delegitimizing power, there is a tendency for the symbolic field to legitimize a given state of material class relations by means of the specific mechanism of misrecognition by which symbolic systems represent in a transformed, 'euphemized', 'disinterested' form the balance of forces and

hierarchical structure of the field of material class relations (Bourdieu 1977: 159–97; 1979b).

Bourdieu is also working with a model of historical development. He argues, based upon his anthropological field work with the Kabyle in Algeria, that in pre-industrial, so-called primitive social formations characterized by limited spatial extension, limited division of labour and simple reproduction, the material and symbolic, the mode of production and the mode of domination, cannot be separated. In such societies, with a low level of material resources, symbolic power has a direct economic function (e.g. in labour mobilization) and symbolic violence is the preferred mode for the exercise of power because overt differences in wealth could not be tolerated in such societies. Moreover, since, lacking the objectification of power in institutions such as a market or a church, and associated instruments of objectification such as writing, power relations have constantly to be reasserted in direct human interaction, the overt direct exercise of material force would be too expensive in material resources to allow for simple reproduction. Such societies exist in a state of Doxa, where the symbolic system is both common to all and taken-for-granted because existing at an implicit level as a logic of practice rather than as an explicit discourse (Bourdieu 1977: 171–83).

In the next stage of historical development, Bourdieu argues, economic development leads to the growth of an autonomous economic sphere related to the development of exchange relations and in the same movement breaks the thralldom of the Doxa and creates a relatively autonomous symbolic sphere which, by making the symbolic system more explicit, creates class struggle in the symbolic sphere between Orthodoxy and its necessary corollary Heterodoxy. At the same time there is created both a specialized group of symbolic producers with an interest in securing a monopoly of the objectified instruments of symbolic struggle, especially written language, an interest that pits them against the dominant economic class in a struggle over what Bourdieu describes as 'the hierarchization of the principles of hierarchization'. At the same time this specialized group shares a mutual interest with the dominant economic class in maintaining the overall set of material class relations both because cultural capital must ultimately be transformable into economic capital or material resources and because the dominant economic class now require the services of the producers of symbolic goods in the imposition and maintenance of orthodoxy. Because of this mutual interest the symbolic system tends to reproduce the given state of class relations. However once Heterodoxy has been created both political consciousness and science become possible and class struggle and its relation to science can never be totally exorcized from the symbolic field.

However in a transitional stage historically, Bourdieu argues, the creation of a market economy and of competitive capitalism did lead to

the more open exercise of material class power. However this in its turn lead to more overt revolutionary and reformist opposition such that the dominant class was forced in order to maintain its dominance to progressively shift back to the use of symbolic power as the preferred mode of domination.[2] It is with the specific modalities of this third contemporary phase and with its historical roots in the nineteenth century that Bourdieu is now principally concerned. Human agents enter the field of struggle that is the social formation with historically given endowments, either in an incorporated state within the habitus as dispositions and competences, or in an objectified state, as material goods. It is these endowments that Bourdieu refers to as capital, for the purposes of this exposition divided into economic and cultural capital. Each agent enters the struggle with the aim of reproducing the capital of his or her group and if possible augmenting it. To this end he or she pursues strategies of investment which involve choosing the sub-fields and the modes of intervention in those sub-fields likely to yield the highest profit on a given investment, one of the objects of struggle being the relative returns to a given investment in a given field *vis-à-vis* investments in other fields (Bourdieu 1977: 171–97; 1975b; 1980a). As Bourdieu puts it, he treats 'all practices, including those purporting to be disinterested or gratuitous, and hence non-economic, as economic practices directed towards the maximizing of material or symbolic profit' (Bourdieu 1977: 183).

This general struggle is ultimately determined by economic struggle in the field of class relations because while there is convertibility between economic and cultural capital in both directions (at differing rates of exchange according to a given state of the struggle in each field and in the social field as a whole) it is the convertibility of cultural into economic capital that ultimately defines it as capital and determines not only the overall structure of the social field but also, in a transformed form, that of the sub-fields, because economic capital being more easily transferable from generation to generation is a more efficient reproductive mechanism. This is why the educational system plays such an important rôle within Bourdieu's theory, because historically the development of such a system, as a system of certification, created a market in cultural capital within which certificates acted as money both in terms of a common, abstract socially guaranteed medium of exchange between cultural capitals and, crucially, between cultural capital and the labour market and thus access to economic capital (Bourdieu 1977: 183–97).

Cultural practice, as with all practices in general, involves appropriation rather than mere consumption. If one can use the analogy of food, the act of ingestion is merely the necessary condition for the process of digestion which enables the organism to extract those ingredients it requires for physical reproduction and reject the rest. In certain conditions digestion will not take place at all. Thus while it remains important

that cultural stratification is in part determined directly by the unequal distribution of economic capital and thus of cultural goods (i.e. the working class cannot afford picture collections, large personal libraries, frequent visits to the theatre and opera, etc.) in terms of the legitimation function of cultural practice the ways in which these objective class distinctions are internalized within the habitus as differing dispositions, differing attitudes towards culture and differing abilities to utilize cultural objects and practices, and thus result in a different logic of cultural practice, are more important. This is why Bourdieu has been particularly concerned to analyse the class determinants of the use of and attitudes towards relatively widely available cultural practices such as museums and photography (Bourdieu 1965; 1966; 1979b: 301–21).[3]

The cultural field serves as a marker and thus a reinforcer of class relations for two reasons. First, because a field occupied by objects and practices with minimal use-value, indeed in the sub-field of art with a positive rejection of use-value, is a field in which *par excellence* the struggle is governed by a pure logic of difference or distinction, a pure logic of positionality. Second, because the specifically historical creation of art as a special category of social object and social practice defined by its difference from and distance from everyday material reality and indeed its superiority to it, together with its matching ideology, namely the post-Kantian aesthetics of 'pure' form and 'disinterestedness', are an expression of and objectively actually depend upon the relative distance from economic necessity provided by the bourgeois possession of economic capital. Works of art, Bourdieu argues, require for their appropriation first an aesthetic disposition, that is to say an internalized willingness to play the game of art, to see the world from a distance, to bracket off a range of objects and practices from the immediate urgency of the struggle for social reproduction and that this disposition is the determinate expression in an incorporated form in the habitus of the material conditions of existence of the dominant class, the bourgeoisie (Bourdieu 1980b). Specific competences are required, that is to say a knowledge of the codes specific to a given art form, competences that are not innate but can only be acquired either through inculcation in the setting of the family through experience of a range of artistic objects and practices and/ or through formal inculcation in school. Bourdieu argues that distinct patterns of cultural consumption are associated with these different modes of acquisition of cultural competence, modes of acquisition that oppose culturally but also in a social hierarchy related to the age of the family's economic capital, the old bourgeoisie who acquire their cultural competence in the family so that it appears to be second nature, a natural gift for discrimination, and those who acquire their cultural competence through school and are exposed to all the cultural scorn and insecurity directed at the autodidact, an insecurity that leads them to stick closely

to the hierarchies of cultural legitimacy while the children of the old bourgeoisie can express the assurance of their natural taste in a contempt for such hierarchies and by legitimizing new forms of cultural practice such as cinema and jazz.

One of the main ways in which the convertibility of economic and cultural capital is assured is via control over that scarce resource time. This control takes two forms. First, the ability to invest economically in educational time whether in the family, for instance by an educated mother not working and devoting her time to the cultural development of her children, or in school, in order to pass on or acquire cultural capital in the form of dispositions and competences. It is this relation between economic and cultural capital that is reflected in differential class access to different levels of education and to the certification that accompanies it, which in its turn legitimates the stratification of cultural practice linked to achieved level of education, for instance newspaper readership. But second, and more originally, Bourdieu argues that it has been characteristic of the development of cultural practice in the narrowly artistic sense to maximize the complexity of coding (expressed in common parlance as the level of 'difficulty') both textually and inter-textually (thus requiring a wider and wider range of cultural reference, art being increasingly about other works of art) and this development has meant that art necessarily requires for its appropriation high levels of consumption time (for instance in order to see films from the point of view of auteur theory one has to see all the films by that auteur). Since cultural consumption time is differentially available between classes and between fractions of the dominant class, this development steadily reinforces class divisions while legitimizing these divisions by labelling those excluded from the cultural discourse as stupid, philistine, etc.

But the investment of consumption time is not an absolute governed simply by its availability. Since time is always a scarce resource the decision to invest time in a given mode of cultural appropriation will depend upon the relations of force within a given field or set of fields which in their turn will determine the returns that can be expected from a given investment. Those expectations will in their turn, as in all fields of practice, be determined by the habitus. Thus for instance whether a given agent chooses to cultivate literary, musical or artistic competences in general as opposed to sporting or technical competences will depend upon the market objectively open for the investment of his capital and the relative valuation within these markets of these competences. Thus whether someone chooses to acquire and mobilize in social intercourse knowledge of the field of football or of Western European art, of train spotting or avant-garde cinema, competences between which it is crucial to restress no hierarchical valuations are being or can be made, will depend upon the cultural and economic endowments with which he or

she enters the social field, the fields objectively and realistically open for investment given the position of class origin from which he or she starts and the relative weight of various fields (Bourdieu 1975a; 1975b; 1979b). Thus it may be possible to acquire relatively rapidly and mobilize against weak opposition a competence in film criticism whereas if one entered the field of fine art scholarship with weak cultural capital one would be doomed to marginality and failure. In this context, for example, the recent much discussed differences between Britain and some of her industrial competitors in terms of the differential social and therefore economic profit resulting from investment by an individual and by a class in cultural rather than technical competences is very relevant (Bourdieu 1979b: 68–101).

Thus the logic of the cultural field operates in such a way as to create, reproduce and legitimate (reproduce because legitimate) a set of class relations structured around two great divides, those between the dominant and dominated classes and within the dominant class between the dominant and dominated fractions. The dominant class, roughly equivalent to what the Oxford Social mobility study calls the service class (Halsey 1979), is those possessing high amounts of economic and cultural capital and the dominated class those possessing exiguous amounts of both (Bourdieu sometimes refers to them as working-class (*classe ouvrière*) and sometimes as *les classes populaires* (i.e. including the peasantry as a distinct class)). The primary distinction operated by the dominant culture and the cultural practices it legitimates (and by so doing those practices it delegitimates) is of culture as all that which is different from, distanced from the experiences and practices of the dominated class, from all that is 'common', 'vulgar', 'popular'. In response, at the deepest level of the class ethos the dominated class reject the dominant culture in a movement of pure negation. However in opposition they construct, at an implicit level, as what Bourdieu calls the aesthetic of the culture of necessity, an aesthetic that relegates form at expense of subject and function, that refuses to judge works of art or cultural practices on their own terms but judges them according to the social and ethical values of the class ethos, that values participation and immediate semi-sensual gratification at the expense of disinterested and distanced contemplation (Bourdieu 1980b). Bourdieu clearly sees his work as part of an essentially political effort to legitimize this implicit aesthetic against all current formalisms whether of the right or left, against both what he calls the racism of class which dismisses working-class taste as beyond redemption by culture and against a naive populism that tries to assimilate that taste to the norms of legitimate culture, seeing miners' banners as works of art. He is particularly severe upon the left 'deconstructionists' whose theories and practices he sees as the latest and most effective of the ideologies of those monopolizers of cultural capital, the dominated fraction of the

dominant class, ideologies that always serve to reinforce through misrec-
ognition the dominance of the dominant class (Bourdieu 1979b: 545–64).

> Brechtian 'distanciation' can be seen as the movement of withdrawal
> by which the intellectual affirms, at the very heart of popular art, his
> distance from popular art, a distance that renders popular art intellectu-
> ally acceptable, that is to say acceptable to intellectuals and, more
> profoundly, his distance from the people, a distance that this bracketing
> of the people by intellectuals presupposes.
>
> (Bourdieu 1979b: 568)

The two fractions into which the dominant class is divided are defined
in terms of the relative weight in their patrimony of economic and cultural
capital. Broadly Bourdieu sees a historical development whereby the
dominant class has divided into two specialized groups, the dominant one
concerned with material reproduction in the sphere of production, the
dominated concerned with the legitimation of material reproduction
through the exercise of symbolic power. While for reasons already given
the specialized producers of symbolic goods will ultimately always remain
subordinate to economic capital they nonetheless are involved in a
struggle with the dominant fraction over the relative legitimacy and there-
fore value of cultural as opposed to economic capital. Thus intellectuals
in the widest sense of that term will always struggle to maximize the
autonomy of the cultural field and to raise the social value of the specific
competences involved in part by constantly trying to raise the scarcity of
those competences. It is for this reason that while intellectuals may mobil-
ize wider concepts of political democracy or economic equality in their
struggle against economic capital they will always resist as a body moves
towards cultural democracy. It is the specificities of this contradiction in
particular that requires analysis in any given historical conjuncture if one
is to understand the political position and rôle of intellectuals (Bourdieu
1975b; 1980a).

It is precisely by stressing their 'disinterestedness' in the sense of their
distance from crude material values that they maximize their interest in
terms of the value at which they can ultimately convert their cultural
capital into economic capital or alternatively ensure the reproduction of
their cultural capital, in particular through their control of the education
system and increasingly of the state bureaucracy in general. For the
problem that Bourdieu is concerned with is not merely that of establishing
a determinate relationship between class and cultural appropriation in a
given state of the field of cultural consumption nor between cultural
production and class in a given state of the field of cultural production.
The problem is more difficult and complex than that for what his general
theory of practice as well as his specific theory of symbolic power require
him to explain is how the free, apparently autonomous practices of the

agents involved in the two different fields and thus whose actions are governed by a different specific logic of practice, how they so interact as to not just produce but reproduce the class patterns of cultural practice in general and by so doing tend to reproduce the given set of class relations in general.

Bourdieu argues on the basis of detailed studies of the class origins, cultural practices and associated ideologies (i.e. critical theories) of French intellectuals in the nineteenth and twentieth centuries and of the corresponding consumption patterns among the dominant class as a whole that the struggle between the fractions takes the form of a struggle between intellectuals for dominance within their specific sub-field, i.e. painting, literature, social science, the academic world, etc., and for the dominance of their sub-field within the intellectual field as a whole. It is this constant struggle that explains sociologically and historically that process of constant renewal, or at least change, that the Russian Formalists identified as the dynamic principle of art itself. The notion of 'making new' (Bourdieu 1975a; 1975b).

Thus a new entrant, especially a new generation of potential symbolic producers, a potentiality already heavily class determined, faces a field in which the dominant positions are already occupied. This hierarchy of dominance is ultimately determined by the economic market for symbolic goods provided by the dominant fraction and thus by the rate at which different forms of cultural capital can be transferred into economic capital. The field is thus arranged along two axis. One axis relates to the direct transfer of cultural capital into economic capital via an immediate transfer in the cultural market, i.e. by painting pictures for rich buyers, writing novels or plays which appeal to the dominant fraction or by entering sub-disciplines which the dominant fraction values highly and to which it thus gives high salaries, research grants, consultancies, etc. (i.e. for medicine and the natural sciences rather than the social sciences or humanities and within medicine heart surgery rather than geriatrics). However too obvious a success in the market or what is worse too obvious a desire for such success leads to cultural delegitimization because of the overall struggle between cultural and economic capital. Thus the other axis relates to the maximization of cultural capital which translates the principle which structures the economic class field, namely wealth and the distance from necessity that wealth both allows and represents, into rarity and cultural purity. Thus along this axis the avant-garde is more highly valued than mainstream, so-called 'bourgeois' art, pure science than applied science, fine art than graphic art, until recently at least left-wing rather than right-wing politics and so on (Bourdieu 1971; 1975a; 1975b; 1979b; 68–101).

Facing this specifically structured field, which presents a variety of investment possibilities, are a cohort of potential producers themselves

structured according to the laws of the formation of the habitus by the same objective set of class relations that structure the field of symbolic production. First, entry to the field at all is structured on class lines by the range of dispositions resulting from the objective assessment of the likelihood of success from any given class starting-point. Thus a working-class agent is simply less likely to see him or herself as a painter or novelist (or at least as a professional painter or novelist) than a member of the bourgoisie because such a career requires a high investment of cultural capital which implies for a member of the working class a high investment of time in education to acquire the necessary competences. However since economic success also requires the ability to fit the disposition for cultural appropriation of the bourgeoisie (e.g. surgeons or conductors or successful novelists and playwrights require objectively bourgeois social attributes) a working-class entrant will be forced in the direction of attempting to maximize the return on acquired cultural capital, which is indeed the point of entry into the dominant class for members of the dominated class, by choosing to enter fields which maximize the possible return while minimizing the possible risks. However in general the strategy of maximizing cultural capital is both economically risky and expensive since it requires in the early years of practice an ostentatious refusal of direct economic interest and is directed against those who are occupying the culturally most powerful positions within the symbolic field. Thus Bourdieu argues, particularly in relation to Flaubert and the Art for Art's Sake movement, that the strategy of maximizing cultural capital although it often takes on necessarily, as part of the strategy, the lineaments of political radicalism, of opposition to the bourgeoisie, requires existing membership of the dominant fraction of the dominant class to be a viable strategy. Thus Bourdieu argues specifically against Sartre's psychological analysis of Flaubert's artistic development, arguing that this cannot explain the properly sociological fact that all the leading practitioners and theorists of Art for Art's Sake came from the provincial bourgeoisie, thus disposing them to challenge the dominant cultural forms of the Parisian bourgeoisie, while at the same time they all had private means to sustain an uneconomic cultural strategy. He also argues that Flaubert's position as a younger son was typical and that there is a consistent class strategy of using the symbolic field much as the church and the army were used by the aristocracy to ensure a comfortable, high status career for younger sons and increasingly daughters without dissipating the family's economic capital (Bourdieu 1975b). As a new twist to this strategy he sees the growth of new media-related professions and marginal service industries such as restaurants, craft shops, health clinics, etc., as related to the need, because of the relative democratization of education, to create jobs for members of the old bourgeoisie where

inherited, as opposed to acquired, cultural capital can be put to most profitable use (Bourdieu 1979b: 415).

Thus both direct economic pressures and the cultural investment required for successful competition for cultural dominance ensure a tendency for the class structure of the dominant class to reproduce itself and its control over symbolic production since those entering the field will possess a habitus which either predisposes them to support the dominant ideology i.e. members of the dominant fraction directly entering dominant positions or upward mobile members of the petty bourgeoisie forced to invest their small amount of hard-earned cultural capital in the lower echelons of economically favoured positions ensuring a relatively risk free but low return on their investment. On the other hand, what opposition there is is transmuted into the terms of the practical logic of cultural struggle which values rarity and cultural distinction with its associated modes of cultural appropriation, requiring high levels of cultural competence and capital, and thus excluding objectively the dominated class from consumption while legitimizing class distinction as cultural distinction.

NOTES

1 The primacy and relative inertia of early-childhood influence on the habitus leads to what Bourdieu calls the hysteresis effect and explains his concern with inter-generational as well as inter-class differences and struggles (Bourdieu 1980a). In particular he uses it to explain the conservative and nostalgic tendencies in much progressive politics as well as its reactionary alternatives.
2 For this model of historical development see Bourdieu 1977: 183–9.
3 For the relationship between the notion of cultural competence and the political role of opinion polls see Bourdieu 1979a: 112–19 and 1979b: 463ff.

REFERENCES

Bourdieu, P. (1965) (with L. Boltanski, R. Castel and J. C. Chamboredon) *Un art moyen: Essai sur les usages sociaux de la photographie*, Paris: Les Editions de Minuit
—— (1966) (with A. Darbel and D. Schnapper) *L'Amour de l'art: Les Musées d'art européens et leur public*, Paris: Les Editions de Minuit
—— (1971) 'Champs de pouvoir, champ intellectuel et habitus de classe', *Scolies* 1
—— (1974) 'The School as a Conservative Force: Scholastic and Natural Inequalities', in J. Eggleston (ed.) *Contemporary Research in the Sociology of Education*, London: Methuen
—— (1975a) 'The Specificity of the Scientific Field and the Social Conditions of the Progress of Reason', *Social Science Information*, 14: 19–47
—— (1975b) 'L'invention de la vie d'artiste', *Actes de la Recherche en Science Sociale*, 2
—— (1977) *Outline of a Theory of Practice*, trans. R. Nice, Cambridge: Cambridge University Press

—— (1979a) 'Symbolic Power', in D. Gleeson (ed.) *Identity and Structure*, Driffield: Nafferton Books

—— (1979b) *La Distinction*, Paris: Les Editions de Minuit

—— (1980a) 'The Production of Belief', *Media, Culture and Society*, 2: 261–93

—— (1980b) 'The Aristocracy of Culture', *Media, Culture and Society*, 2: 225–54

Halsey, A. H. *et al.* (1979) *Origins and Destinations: Family, Class and Education in Modern Britain*, Oxford: Clarendon Press

Chapter 5

Cartographies of taste and broadcasting strategies

David Docherty

Until the early 1990s, it was easy to draw a map of the UK television world which had two, well-charted continents – the BBC and ITV/C4. By contrast, the new world forming under the impact of the government's new regulatory regime, the rise of the integrated, global media giants and the emergence of new delivery technologies is cracked, fragmented and fissured. Finding a passage to success and gaining an understanding of how to operate in this new market place will demand a sophisticated cartography of taste.

The key strategic problem for the future is to harness technology to search out and deliver services to new audiences. Or, as new viewers are only the old ones recycled, the new services will offer to the television market fractions of each individual's tastes and interests previously unfulfilled. Very, very few viewers will abandon broadcast television; however, significant segments will take up the opportunity to acquire a greater range of products and productions.

Audience research will picture the new world and will, in the act, further transform it. As the size and buying power of an audience is discovered, so satellite and cable companies will seek to serve it. As the national public and commercial broadcasters lose audiences and viewing, they will seek to discover who is disappearing and look for means of shoring up their defences or of attacking the new entrants.

Another characteristic of the new age is the growing distance between the purpose of commercial and public broadcasting. A vital distinction must be made in public policy – and public broadcasting – between consumer-centred and an audience-centred television: the former is driven by commercial relationships, the latter by the welfare of viewers. However, each approach requires research to achieve its goals.

In the consumer-centred system, research focuses on programmes, presenters and ideas which find the fastest and strongest echo with the most people or with the target demographic group. It asks: 'What do you like?' as opposed to: 'What might you like?' or even: 'When was the last time you changed your mind?' It does not promote adventure or challenge.

The underlying logic of a consumer-centred world was most obvious in the US networks before the emergence of cable stations (and, some commentators suggest, is the emerging world view of British commercial television). In the US, research seemed to confirm the similar tastes of audiences. Programme-makers build their strategies around sameness.

Cable revealed the research to be too narrow and too focused on broadcasting. When the technology made it economically feasible to make money from fragmented audiences, some of the audience, some of the time, sought out different services. These many tastes already existed – although they may have been expanded by the new services; however, as the broadcasting companies were not looking for difference, they missed out on the new audiences. As a consequence, the Networks spent most of the 1980s in a strategic flat spin.

Classically, public broadcasting should have an audience-centred approach which changes tastes and interests as well as reflects such preferences. John Reith once famously rebuked the consumer-centred approach by writing: 'Most people do not know what they want, let alone what they need.'

Reith was more likely to grant listeners an audience than to listen to the views of the audience. However, under the impact of current theories of public service, the BBC focuses on public, audience-centred indicators of programme performance, accessibility and accountability. These performance indicators encompass every programme and service which the BBC provides and pose difficult questions about the ways in which the BBC responds to and stays ahead of viewers.

Public taste is at the heart of public culture. It is the BBC's role to understand as well as to stretch the boundaries of public interest in news, drama, the arts and entertainment. There is, however, a fear widespread among programme-makers that research will set limits to adventure and sap the courage and instincts of programme commissioners. Until quite recently, however, audiences were seldom really considered in any systematic way by the four key users of research: programme-makers, commissioners, schedulers and strategists.

In order to understand how audience research is and can be used in a broadcasting organization, it is important to understand what it is, how it is done and what knowledge it can deliver. In the rest of this paper, I will show how audience research is put together by the research bodies, packaged by the broadcasting analysts and planners within the broadcasting companies and used by programme-makers to develop their programmes and evaluate their performance.

RESEARCH TECHNIQUES

There are three principal research techniques in mainstream audience research in the UK: panels; qualitative interviews and focus groups; and one-off quantitative surveys. Most of the interesting research projects emerging nowadays attempt to blur the distinction between 'hard' quantitative data and 'soft' qualitative interviews.

Panels

Panels capture the views and behaviour of the same people over a number of years. British television relies on an electronic panel for measuring viewing behaviour and a paper diary for gauging attitudes to programmes. Both are managed by the Broadcasters' Audience Research Board (BARB) which was set up in 1980 and is owned by the BBC and the Independent Television Authority.

The TV Audience Reaction Service is based on a weekly diary sent out to 3,000 households. Each diary lists every programme broadcast on terrestrial television and invites the viewers to give them a mark out of six if they have watched.

The key measure produced from the diary is the Appreciation Index (AI). This is a score out of 100 which is calculated by weighting the scores of each viewer, adding them together and dividing by the number of viewers.

The TV Audience Measurement Service collects every fifteen seconds the actual viewing of around 11,000 people in a representative sample of 4,435 homes. These data are acquired by a peoplemeter (sic), currently the grandly titled AGB 4900 Peoplemeter System. This device consists of a monitor unit which is built into the set and which maintains a record of the channel which is transmitting (and whether the VCR is being used) and a remote-control handset on which viewers inform the unit of their presence by punching in their unique number. The system picks up the responses for all sets in the household and of up to seven guests.

People remain on the panel for as long as their behaviour and their demographic status qualifies them. The present panel was drawn from a survey of 44,000 people in 1990. A rolling annual survey of the same number of people ensures that the panel is representative and balanced. If significant shifts occur, such as the rapid take-up of satellite, the survey sets out the new shape of the panel and BARB recruits people accordingly.

The key measures produced by the system and used in the industry are: TV rating; TV ratings for individuals; audience share; and audience reach.

TV rating (TVR)

The rating for a minute of airtime is the percentage of households watching for that time.

TV ratings for individuals

This is a measure of a programme's success among a particular type of viewer. If a show has a TVR of 20 among men, it means that 20 per cent of men watched.

These two measures tend to be the ones most used by ITV and Channel 4. They reflect the underlying commercial logic that the programmes are a means of delivering audiences (TVRs) to advertisers.

The BBC tends to use two similar but discursively different measures.

Audience share

The share is the average percentage of the audience which watches a programme. If a show has a share of 20 per cent of the male audience, it means that 20 per cent of the men currently watching tuned in rather than 20 per cent of the total number of households.

The weekly share records the total share of viewing achieved by each channel. In 1992, this was divided as follows: 42 per cent ITV, 34 per cent BBC1, 10.5 per cent BBC2, 10 per cent C4 and 4 per cent satellite and cable.

Share has been used politically as a means of measuring whether the BBC is doing its job effectively. The BBC used to argue, and government accepted the view, that if the BBC was achieving close to a 50 per cent share of the audience, this was an acceptable measure of success. As the number of channels multiplies, clearly the BBC's share will decline and other measures will be brought into play.

Audience reach

Reach is a measure of the number of people or households who watch a channel over a given period. It is currently set at three minutes across the week; on this measure, 96 per cent watch BBC1 and ITV and 74 per cent watch Channel 4 and BBC2. If you push reach to mean two hours per household per week, you still retain high measures of 90 per cent for ITV and BBC1 and 66 per cent for BBC2 and Channel 4.

If you take, say, *Casualty*: it has a TVR of 40, a TVR among men of 35, a share of 60 per cent and reach of 80 per cent across the series. Each figure would be called up separately to meet many different needs.

Reach is a useful measure of the success of a channel or a series.

Although a programme may have a small share, over the period of its run it may have a significant reach. *Horizon*, for example, has a share of 12 per cent but a reach of 60 per cent. The value of the series is confirmed more in its reach figures than in its share.

All these figures feed into post-hoc judgements of the performance of a programme. At the meetings between the commissioners and the producers, the share and TVR figures are a currency which establishes the track-record of the producer. Future commissions may be dictated by the messages emerging from the audience. However, the emergence of demographic analysis and the complex nature of modern consumer behaviour has demanded a discourse based on complex socio-cultural audience fractions.

Advertisers of expensive goods do not wish to buy the wrong demographic. If you want to sell Mercedes Benz, you do not want to buy access to 8 million, old, working-class women in the middle of *Coronation Street*. Instead, you might want the middle break of *News at Ten* or a spot in a drama series in Channel 4. The assumption underlying a great deal of media buying these days is that numbers are good but the social shape of the audience matters.

In the BBC and – to a certain extent – Channel 4, the cultural and political remit to cater to a wide range of tastes and interests guarantees and grounds diversity of judgements. The BBC's youth strand, *DEF2*, is judged by its success among a very small target group. Similarly, the views and behaviour of children are the key to evaluating the success of children's programmes. Therefore, although the BBC has the minority share of the audience during the children's slots, this is not a problem as long as the share and reach among children holds up.

Qualitative interviews and focus groups

Judgements become more troublesome and tricky when you drop into the realm of taste. The appreciation indices are a very limited measure of viewer's pleasure and judgement. Although they are disaggregated into demographic segments, the AI is not often used by programme-makers or commissioners to aid them in setting up or judging a show.

Increasingly, people are turning to diagnostic techniques such as focus groups or viewing groups. The standard group involves six or eight people sitting around for an hour and a half discussing a programme idea or a tape; many projects will rely on four groups, reasonably balanced demographically; however, in a study which I set up for Channel 4, we used 42 groups! This technique has the great benefit of bringing you closer to the language which people use to describe their own evaluations and, often, it has more power with producers and commissioners than a

hundred quantitative studies. In television, words still count for more than numbers.

This technique has the drawback of not being particularly rigorously sampled and you are at the mercy of the interviewer. If the interviewer is good, the information which they provide is gold dust. If they are bad, the information is at best wrong and at worst dangerous.

Spinning out from the softer techniques, television companies have begun to turn to the use of viewing monitors for piloting programmes. In the normal study, a group of twenty to thirty viewers will gather in a room well in advance of intended transmission and watch a pilot programme. Each will have a hand set on which they will record the intensity of their enjoyment or of their interest. These are averaged in real time and the producer can see from the shape of the track where the show is more boring than at other parts, or which interviewers or guests are engaging the audience and which do not.

There are hundreds of problems associated with this technique, ranging from the artificiality of the setting through to interviewer fatigue; however, it has considerable diagnostic power in the hands of people with normative data against which to judge the results. In other words, if a presenter scores low, you need to know how interviewers normally score otherwise you will make the wrong judgements.

One-off quantitative surveys

This technique is seldom used on individual programmes. However, if a company is launching a particularly important long-running show, it will commission day-after studies of characters, plots and development to sharpen up the producers' feelings (and provide counterbalance to the critics).

Apart from attitudes to the representation of sex and violence, the big one-off studies tend to be used to give flesh to corporate image questions or to issues surrounding accessibility or fairness or originality of programmes.

The BBC deployed a survey recently in its bid to have its Charter renewed. The research delved into the economic and political philosophy underlying public broadcasting and sought out the nature and intensity of public support. This public exploration of a company's image is very rare; however, the BBC is committed to a very public, annual research programme on its performance. This will enable the Corporation to develop a strategy in such a way as to serve the audience and to respond to public dislike or indifference by changing internally or by launching campaigns to explain itself.

THE USES TO WHICH RESEARCH IS PUT: THE CHANGING STATUS OF AUDIENCES

In the past, audiences too often played walk-on parts in both television companies and television studies. The crude defenestration of viewers in early media semiotics mirrored the television professional's lack of deep-seated interest in the real people who watched their shows. There were many honourable exceptions in both camps, of course, but theoreticians and programme-makers did not like the way in which the messy views and values of real people rained on their aesthetic parade.

When audiences were de-coders for the semioticians, packets of buying power for advertisers and abstract licence-payers for the BBC, audience research was respectively a side show, a selling tool and protective number crunching. For most programme-makers, most of the time, research played little part in the judgement of their output.

Strategy-setting and political evaluation of the public service and consumer welfare benefits of broadcasting also nodded in the direction of audiences but, in reality, seldom drew on research to set up or settle problems. Public consultations, peer group reviews and the letters and telephone calls of viewers often carried more weight with legislators, regulators and management than the precise, dry data of systematic audience research.

The language of advertising demographics – of ABC1s and C2DEs – previously the argot of over-lunched executives, has penetrated into the discourse of public broadcasting. In a recent description of the BBC's programme strategy, Alan Yentob, the Controller of BBC1 and, as the originator of *Arena* and Head of Music and Arts, high priest of instinctive programme-making, claimed that the BBC had forsaken the C2DEs in favour of the ABC1s. A significant element of the speech was the research-language in which it was couched. This discursive shift is true not only of the Corporation's grey-suited strategists and planners (of which more later) but of the programme-makers throughout television.

The new language raises the crucial issue of the ways in which programmes are to be judged. Will a heavy reliance on audience research lead to a closed aesthetic loop in which judgements ferreted out empirically become canonical? Or, can the very complicity of audience taste loosen up the judgements of strategists and commissioners in such a way as to act as a source of freedom rather than an iron cage?

Research only answers the questions asked. If the question is 'How do I attract the biggest audience?', the answer tends to be safe; if the question is 'How do I give most satisfaction to this group of viewers?' the answer becomes more interesting; if the question is 'How can I change people's attitudes and attract them to something they would not otherwise have liked?', the problems become creative. The four principle users of

research – strategists, schedulers, commissioners and programme-makers – have different but related needs and means of applying the findings.

Strategists

Strategists look to research to tell them where their companies are weak in output, demographic balance or policy. If audiences have shifted their attention from hour-long love stories to two-hour-long detective films, the strategist will look for ways of spending more money on that genre. If the research is top of the range, it might anticipate trends and allow the company to move out of some types of programmes and into others.

Strategic research looks also at how to change the corporate image of the company. If viewers cease to trust, say, the news output of the BBC, this is a deeply serious strategic problem and would require a great deal of work to put right. It would be an equal catastrophe if viewers ceased to believe that the BBC provides the best and most exciting range of comedy shows. This would unwind one of the firmest bonds between the public and the BBC and would again require serious remedial action. In both cases, audience research would detect the problem and, at its best, help seek out reasons and solutions.

Schedulers

Schedulers and planners are the tacticians in the business. In the past, research played an important but relatively minor role in their deliberations. This is no longer possible. Audience behaviour is too fluid – particularly among the under-35s – not to need the full research toolkit. In order to schedule to maximum advantage, you need to know who is available to view at that time; who wants to watch and what they want to watch. Schedulers look at audience flows between programmes and seek to maximise the flow from one programme to the next; or, they seek to bring audiences back from the opposition.

Programme audiences have different demographic shapes. For example, *The Generation Game* has a much younger audience than that of *You Bet*, and *Happy Families* is much weaker among younger viewers than *Gladiators*. Schedulers use this information to place or move a show.

Another example from Saturday night shows the power of demographics. In the autumn of 1993, ITV had been using *The Bill*, a long-running series, as an effective weapon to gain an audience at the expense of the BBC. The BBC schedulers and researchers took a long look at a game show called *Big Break*, which had been scheduled earlier in the evening, and – in view of its family profile – placed it between a family entertainment programme and the BBC's most successful drama, *Casualty*. This move carried the audience through the three BBC programmes

and seriously damaged *The Bill*'s audience. It was by no means obvious that this would work, but the audience figures encouraged the schedulers to make the move.

Commissioners

Many commissioners – the people who commission work from programme-makers, such as the BBC Channel Controllers, Channel 4's Commissioning Executives and the ITV Network Centre – use audience research to tell them whether to buy a series or programme. The bigger the decision, the more important the research programme. Most commissions still go through unresearched. But if you intend to invest £5 million in a drama series and you hope that it will run for five years, it would be ludicrous not to invest £1,500 to find out if it has much chance of working and where it might most succeed in the schedule. The grandees of the old world of British television seldom had need of such research. The hustlers in the new world increasingly won't leave home without it. Increasingly, commissioners demand of producers evidence that they have thought through the audience for a programme before it is commissioned. The potential size of the audience and the shape of the demographic will influence not only the commission but the amount which will be paid for the programme.

Commissioners look to their audience researchers, sales executives and strategists to convert the research into a framework for making buying decisions. It is at this point that research becomes potentially stultifying.

Programme-makers

Programme-makers use research to isolate those parts of their productions which can be firmed up or dropped. It is easier to do this on game shows or entertainment programmes. However, even with drama or situation comedy, research either done at the piloting stage or after the first series can stop many expensive mistakes.

There are considerable worries among producers that Britain will be Americanized and that audience research inevitably leads to bland, middling programmes. Such dangers exist. If a more liberal version of John Reith's statement that most people do not know what they want let alone what they need is allowed into the equation, then it is true that most people do not know that they want some types of characters or shows until they appear.

If you had market-tested the idea of a group of Home Guardsmen bumbling around in the war, you probably would have turned it down. Viewers in their homes, however, rapidly made the judgement that *Dad's Army* was a treat to be savoured. Audiences take time on occasion to

form their judgement and acquire a taste. Characters take time to filter through the complex social processes which drag figures such as Tony Hancock or Victor Meldrew from the everyday to the extra-special.

Television commissioners and producers are well aware of this dilemma. The old guard often simply ignored the audience to the first series in the belief that it would work in the end. No one can afford to do this anymore. Commercial television has large bids to pay for and the BBC is financially limited. It is the task of the researchers and the planners to read the runes: who likes the show and why? What will it play against? Will it work better at another time? If it is meant to be a mass-market show, who makes the judgement that takes it there? If it is a targeted show, who has the influence among the demographic group in question?

CONCLUSION

Research is becoming an important part of the armoury of television companies. However, it cannot solve problems on its own. It is not a substitute for production talent. You could put the best researchers in the world onto a show and give them £100,000 to conduct a study and still not guarantee success for the product they were researching. What you might be able to guarantee, however, is relative lack of failure.

Research can support safe assumptions. Viewers in focus groups often have sound judgements about what they do like, but not necessarily about what they might like. Producers and inspired editors, directors and commissioners are still the most sought after judges of new ideas.

Success or failure, however, even of small audience rated programmes, stand or fall on audience reaction. The most difficult challenge for research specialists is to ensure that the research which is deployed is sensible, sophisticated and hard-nosed. Although psychobabble and socio-drivel are a waste of money, empiricism is dangerous. The problem is: how many people can tell the difference?

Chapter 6

On materialism

Sebastiano Timpanaro

[The publication of Timpanaro's *On Materialism* in 1970 caused debate on the Left about the role of human biology in history. Notably, his ideas were debated by Peter Fuller and Raymond Williams. Here we reprint some brief extracts from Timpanaro which summarize the main thrust of his argument, followed by extended commentaries on his work and its topic by Fuller and Williams. Eds.]

By materialism we understand above all acknowledgement of the priority of nature over 'mind', or if you like, of the physical level over the biological level, and of the biological level over the socio-economic and cultural level; both in the sense of chronological priority (the very long time which supervened before life appeared on earth, and between the origin of life and the origin of man), and in the sense of the conditioning which nature *still* exercises on man and will continue to exercise at least for the foreseeable future. Cognitively, therefore, the materialist maintains that experience cannot be reduced either to a production of reality by a subject (however such production is conceived) or to a reciprocal implication of subject and object. We cannot, in other words, deny or evade the element of passivity in experience: the external situation which we do not create but which imposes itself on us. Nor can we in any way re-absorb this external datum by making it a mere negative moment in the activity of the subject, or by making both the subject and the object mere moments, distinguishable only in abstraction, of a single effective reality constituted by experience.

This emphasis on the passive element in experience certainly does not claim to be a theory of knowledge – something which in any case can be constructed only by experimental research on the physiology of the brain and the sense organs, and not by merely conceptual or philosophical exercises. But it is the preliminary condition for any theory of knowledge which is not content with verbalistic and illusory solutions.

When Marxists affirm the 'decisive primacy' of economic and social struc-

tures, and therefore designate this level and not the biological level underlying it as the 'base' of human society and culture, they are right in relation to the great transformations and differentiations of society, which arise fundamentally as consequences of changes in economic structures and not of the geographical environment or physical constitution of man. The division of humanity into social classes explains its history infinitely better than its division into races or peoples; and although, as a given fact, radical hatreds and national conflicts have existed and continue to exist, and although the ambiguous and composite concepts of nation and of homeland always have a racist component, there is nevertheless no doubt that these conflicts, at least from the end of prehistory onwards, are fundamentally disguised or diverted economic and social conflicts (increasingly so), not 'genuinely' biological or ethnic contrasts. Hence the immense methodological superiority of Marx's historiography by comparison, not merely with a vulgar racist historiography, but even with an ethnic historiography such as that of Thierry.[1]

By comparison with the evolutionary pace of economic and social structures (and of the superstructures determined by them), nature, including man as a biological entity, also changes, as evolutionism has taught us, but at an immensely slower tempo. 'Nature is ever green, or rather goes/by such long paths/that she seems still', says Leopardi.[2] If therefore we are studying even a very long period of human history to examine the transformations of society, we may legitimately pass over the physical and biological level, inasmuch as relative to that period, it is a constant. Similarly, we may agree it is permissible for a Marxist, when writing the history of political or cultural events within the restricted context of a fundamentally unitary and stable socio-economic situation, to take the latter as a constant and study the history of the superstructure alone. Engels, and later Gramsci, warned that it would be naïve to think that each single superstructural fact was the repercussion of a change in the infrastructure. Luporini has recalled that Marx himself, in the 1859 preface to *A Critique of Political Economy*, explicitly affirms the dependence of the superstructure on the structure only 'in its macroscopic and catastrophic aspects, so to speak, that is, in relation to social revolutions'.[3]

But if, basing ourselves on this relatively immobile character (over a certain period) of the economic and social structure, we were to conclude that it has no conditioning power over the superstructure, or even no real existence, we should be committing a typical 'historicist' fallacy. Now, it is a precisely similar sophism to deny the conditioning which nature exercises on humanity in general, just because this conditioning does not conspicuously differentiate individual epochs of human history. Marxists put themselves in a scientifically and polemically weak position if, after rejecting the idealist arguments which claim to show that the only reality is that of the Spirit and that cultural facts are in no way dependent on

economic structures, they then borrow the same arguments to deny the dependence of man on nature.

The position of the contemporary Marxist seems at times like that of a person living on the first floor of a house, who turns to the tenant of the second floor and says: 'You think you're independent, that you support yourself by yourself? You're wrong! Your apartment stands only because it is supported on mine, and if mine collapses, yours will too'; and on the other hand to the ground-floor tenant: 'What are you saying? That you support and condition me? What a wretched illusion! The ground floor exists only in so far as it is the ground floor to the first floor. Or rather, strictly speaking, the real ground floor is the first floor, and your apartment is only a sort of cellar, to which no real existence can be assigned.' To tell the truth, the relations between the Marxist and the second-floor tenant have been perceptibly improved for some time, not because the second-floor tenant has recognized his own 'dependence', but because the Marxist has reduced his pretensions considerably, and has come to admit that the second floor is very largely autonomous from the first, or else that the two apartments 'support each other'. But the contempt for the inhabitant of the ground floor has become increasingly pronounced.

The historical polemic against 'man in general', which is completely correct as long as it denies that certain historical and social forms such as private property or class divisions are inherent in humanity in general, errs when it overlooks the fact that man as a biological being, endowed with a certain (not unlimited) adaptability to his external environment, and with certain impulses towards activity and the pursuit of happiness, subject to old age and death, is not an abstract construction, nor one of our prehistoric ancestors, a species of pithecanthropus now superseded by historical and social man, but still exists in each of us and in all probability will still exist in the future. It is certainly true that the development of society changes men's ways of feeling pain, pleasure and other elementary psycho-physical reactions, and that there is hardly anything that is 'purely natural' left in contemporary man, that has not been enriched and remoulded by the social and cultural environment. But the general aspects of the 'human condition' still remain, and the specific characteristics introduced into it by the various forms of associated life have not been such as to overthrow them completely. To maintain that, since the 'biological' is always presented to us as mediated by the 'social', the 'biological' is nothing and the 'social' is everything, would once again be idealist sophistry. If we make it ours, how are we to defend ourselves from those who will in turn maintain that, since all reality (including economic and social reality) is knowable only through language (or through the thinking mind), language (or the thinking mind) is the sole reality, and all the rest is abstraction?

NOTES

1 Augustin Thierry (1795–1856): French historian who concentrated on national conflicts in European history.
2 *La Ginestra*, lines 292–4.
3 Engels, letters to Bloch and Schmidt, in *Marx-Engels: Selected Correspondence* (Moscow, 1965), pp. 417–25; Gramsci, *Prison Notebooks* (London, 1971), pp. 407ff.

Chapter 7

Problems of materialism

Raymond Williams

MAN AND NATURE

Timpanaro's most general definition of the fundamentals of materialism can be accepted, at first sight, as it stands: 'By materialism we understand above all acknowledgment of the priority of nature over "mind", or if you like, of the physical level over the biological level, and of the biological level over the socio-economic and cultural level; both in the sense of chronological priority (the very long time which supervened before life appeared on earth, and between the origin of life and the origin of man), and in the sense of the conditioning which nature *still* exercises on man and will continue to exercise at least for the foreseeable future' (Timpanaro 1975: 34). It is difficult to see how anyone could deny the intention of the first proposition, though it is better expressed in its specifying than in its general terms. The cautionary notation of 'mind' needs to be extended also to 'nature', but there can be no serious argument against the existence of a physical world before life and of other life-forms before man. And it is important that while these facts are never denied, within any relevant area of argument, they are quite often dismissed as banalities which have little practical bearing on the more interesting questions that lie ahead. One of the excuses for this impatience is that the general terms used to summarize the enormous and complex body of facts, on which the propositions necessarily rest, are shot through with inherently subsequent interpretations of a philosophical and cultural character. Thus it is not unproblematic to say that 'nature' has 'priority over' 'mind', but we can only approach these problems in good faith if we have, with full seriousness, taken the weight of the astronomical, geological and biological evidence before entering the more congenial ground of the humanist categories. And it is in this area, at first sight, that the effect of the declining contribution of the natural sciences to the general culture of Marxism has been most apparent. While the sense of proportion imposed by this fundamental materialism is either forgotten

or dismissed as a preliminary banality, the way is indeed open for every kind of obscurantism and evasion.

Yet it is in the area of the second proposition that the most serious damage is actually done. And this is more difficult to see, because the language in which its undoubtedly correct intention is expressed is even more inherently problematic. 'The conditioning which nature *still* exercises on man': the problem here is the use of 'nature', coming through in the language as the humanist personification of all that is 'not man', to describe a very complex set of conditions which are indeed, in part, quite extrinsic or extrinsic with only marginal qualifications (the range is from the solar system through the physical composition of the planet to the atmosphere), but which are also, and crucially, *intrinsic* to human beings (evolved physical organs, the genetic inheritance). Thus a particular linguistic structure, the separation and contrast between 'nature' and 'man', largely developed in periods of the dominance of idealist and humanist thought, makes it very difficult for us to move from the complex and differential facts which are indeed our material and physical conditions to any statement of the general relationship between these 'conditions' and what, within the linguistic complex, we still isolate as 'conditioned'.

Timpanaro writes: 'We cannot . . . deny or evade the element of passivity in experience: the external situation which we do not create but which imposes itself on us' (*ibid.*: 34). This is another attempt to express 'the conditioning which nature *still* exercises on man'. But it leaves much unresolved. There is indeed an 'external situation' which is beyond human choice or control: the far and middle reaches of our material environment. It is right to emphasize this, while adding that there are near reaches, even at this level, which are already interactive with human industry and politics. And it is right to describe all these reaches as *conditions*. To see them either as simple 'raw material' for 'man's conquest of nature', as in the dominative progressivism shared by many tendencies in the nineteenth century but now – late in the twentieth century – more exclusive to a predatory late capitalism, or on the other hand as mere banal preconditions for the more interesting human social enterprise, is indeed damaging. They are necessary conditions and as such necessary elements of the relations of all life. But then what can properly be described as an 'external situation' modulates, in complex ways, into what is already an 'interactive situation', and then, crucially, into an area of material conditions in which it is wholly unreasonable to speak of 'nature' as distinct from 'man' or to use the (political) language of 'impose on' and 'exercise', now terms of a (dualist) relationship which misrepresent the precise *constituted materiality* which the argument began by offering to emphasize.

Thus 'the element of passivity in experience' emerges as a key question.

'Passive' is already a curious description of our actual relations to the far and middle reaches of the physical universe, and would be misleading in its near reaches. For it is not at these levels a question of passivity or activity, as alternative human responses. There are dimensions quite beyond us, or there are basic forces – the obvious examples are gravity and light – which have entered so deeply into our constituted existence that they are conditions of everything we are and do, over the whole range from the most passive to the most active modes. What 'passive', in one of its senses – the relatively 'given', the relatively 'unwilled' – might usefully emphasize is: first, the character of many of our basic physical processes, which are indeed conditions of life; and second, though with more difficulty, something of the character of our participation in such matters as our genetic inheritance. In either case 'constitutive' would be better than 'passive', for what matters is what follows from the striking of this particular relational and emotional note. To re-emphasize, as a fundamental materialism, the inherent physical conditions – a specific universe, a specific planet, a specific evolution, specific physical lives – from which all labour and all consciousness must take their origins, is right and necessary. Failure not only to acknowledge these conditions, but to continue to take them into active account, has indeed, as Timpanaro indicates, led to shallow and limited kinds of Marxist and other political and social thought, and has left open a large and unavoidable area of experience and knowledge which has been repeatedly occupied by an indifferent positivism or, worse, by significantly popular kinds of irrationalism (astrology, earth-cults, new theologies of collective subjectivity, forms of organized psychic manipulation).

The direction of Timpanaro's response is, then, initially very welcome. But 'passive', we soon come to see, carries its own freight. When he is arguing, correctly, that many Marxists overlook, or acknowledge as mere banalities, our fundamental physical-material existence and processes, it is remarkable how often he specifies this existence and these processes in their negative and limiting capacity, and how rarely in any other sense. He is, of course, right to specify the effects of old age, of disease, of inherited physical disabilities; as he is right also to specify the predictable end of the solar system and the continuing conditioning presence of many more immediate natural forces. But this leads us to an argument which has already taken place, in response to existentialism and its interactions with Marxism. The existentialist emphasis of anguish, isolation and 'the absurd' was replied to with socialist emphases of comradeship, solidarity and 'the future', or with more general emphases of love, relatedness and 'community'. Each emphasis is a version of *response*, but is presented as an account of the true 'human condition'. One level of argument is then the exchange of alternative specifications. But the most serious level of argument must be the analysis of how the really basic conditions of life

– the conditions of physical existence and survival – are perceived, selected and interpreted.

For the crucial question is the extent to which these fundamental physical conditions and processes affect or qualify the social and historical interpretations and projects which are the central specifications of Marxism. But then it is at once necessary to resolve this general question, resting on its general categories of 'nature' and 'man', into more precise and more differentiated questions. These seem to me to be three in number. First, what is the effect of scientific evidence of a physical kind, notably that of the solar system and of our planet and its atmosphere, on the proposition (ideology?) of the 'conquest of nature' which has often been associated with Marxism? Second, what factors, if any, in our evolutionary inheritance qualify the project (ideology?) of absolute human liberation? Third, what is the real relation between projects of human liberation cast in collective and epochal terms and the physical conditions which determine or affect actual individual human lives?

THE 'CONQUEST OF NATURE'

On the first question it is undeniable, historically, that Marxism includes a triumphalist version of 'man's conquest of nature'. Nor is this merely a variant of the tradition; in one form or another it lies near the source. But it is then important to recognize that, in both its moderate and its extreme forms, the notion of the 'conquest of nature' belongs not simply to Marxism but to a whole period of bourgeois thought. Indeed, it became an almost inevitable generalization from the extraordinary achievements in material transformation of the industrial revolution and of advances in the physical sciences. And in one relatively unproblematic emphasis, it is a sustainable generalization, giving substance to the basic emphasis of historical materialism. Human beings have, by associated labour, moved in thousands of ways out of passive dependence on their environment, and out of mere adaptive marginality at its edges. The reshaping, remaking and innovative transformation of the pre-human material world is absolutely significant, historically. But of course this can only be described as the 'conquest of nature' if the initial terms of a separated 'man' and 'nature' are taken for granted. And it is to the extent that they have been taken for granted that real theoretical deformations have occurred.

For it is of course apparent, after all the achievements and projected achievements, that there are major natural forces, and these not only at the level of the physical universe and the solar system, which are still and in any reasonable projection beyond our control. Moreover, even within the more practical definition of the project, of sustaining full and free human life on our planet within forseeable historical terms, that

part of the 'conquest' which is represented by scientific knowledge now increasingly shows us the complexities and the often unwanted effects of that other part of the 'conquest' which is physical appropriation and transformation. The triumphalist version overrides all this real knowledge. Faced with the predictable end of the solar system, it responds with the by no means exclusively or even predominantly Marxist projection of emigration of the species to new stars, and by-passes the question of whether this remote project would not also be a change of species. Faced with the limits and complexities of appropriation and transformation, on our own planet, it extends the correct and reasonable response of improved knowledge and renewed effort into a brash mystique of 'overcoming all obstacles'. But it can now be clearly seen that this triumphalist version is, in an exceptionally close correspondence, the specific ideology of imperialism and capitalism, whose basic concepts – limitless and conquering expansion; reduction of the labour process to the appropriation and transformation of raw materials – it exactly repeats.

How then did Marxism, at any stage, come to be compromised by it? In part by the infection of its formative period. Engels, influentially, in *The Dialectics of Nature*, emphasized *mastering* nature as 'the final, essential distinction' between 'man and other animals'. Yet in the course of the same argument, he made a necessary criticism of just this idea. Detailing the unforseen effects of many such 'conquests', he wrote:

> Thus at every step we are reminded that we by no means rule over nature like a conqueror over a foreign people, like someone standing outside nature – but that we, with flesh, blood and brain, belong to nature, and exist in its midst, and that all our mastery of it consists in the fact that we have the advantage over all other creatures of being able to know and correctly apply its laws.

(Engels 1954: 241–3)

This is a profound (if still potentially ambiguous) correction of the ordinary notions of 'mastery' and 'conquest'. Moving in a materialist way from labour to science, Engels indeed saw the development of science, as both knowledge and control, leading to a situation in which men 'once more' (a separable but revealing and unsustainable reference) 'not only feel, but also know, themselves to be one with nature, and thus the more impossible will become the senseless and anti-natural idea of a contradiction between mind and matter, man and nature'. This is again a profound correction, but the ideas of 'control' and of 'mastery' nevertheless survive it, in some real ambiguities. By the point in the argument at which he has made these corrections, it is necessary, in fact, to abandon the notion of 'mastery', to see even 'controls' in a more secular and more qualified perspective, and to bring through, instead, the full materialist consciousness of associated labour and science within definite but know-

able material conditions. Instead, partly here, but even more in a derived orthodox tradition, the enhanced notions of 'mastery' and 'conquest' went on being powerfully asserted. For a long time, then, there was a failure in Marxism to carry through its own fundamental restatement of the 'man'-'nature' relationship: its decisive emphasis on the intricate and constitutive processes of 'man-in-nature', with labour as the specifying instance of an always significant, always dynamic, and always – though differentially – limited set of material relationships. In this world of a properly materialist history there is no room for the separated abstract categories of 'nature' and 'man', but then what often happened was that they were made falsely equivalent, or that the historical process was seen as substituting one – 'man' – for the other. This soon became a compromise with triumphalism. But it is then ironic to see the argument merely running in reverse. Timpanaro correctly and valuably re-emphasizes the weight of the natural forces that are beyond our actual or probable control, yet comes to sum them up as 'nature's oppression of man' (Timpanaro 1975: 67). Given that relationship, his argument then moves to consideration of the appropriate philosophical and ethical response to that kind of 'fact': a materialist pessimism, which adds rejection of the consolations of triumphalism to the established rejection of the consolations of religion.

But at one level, certainly, this is beside the point. Settled and universalizing emotional or philosophical responses to the complexities of the real material process are in fact themselves residual from pre-materialist religion and philosophy. Neither materialist triumphalism nor materialist pessimism is of any material help in the necessary processes of an extended secular knowledge and of definitions and redefinitions of our social processes in its light. To the extent that these are genuinely secular and materialist, they involve the whole range from new major opportunities of the kind triumphalism had generalized – say plant-breeding and land-reclamation – to new major difficulties – say the plutonium economy. In all relevant secular terms, what is needed at this level is not 'philosophy' at all, but associated science and labour, under conditions to be achieved only by socialist transformation of control of these means of production.

BIOLOGY AND LIBERATION

The second question, on the limiting factors of our evolutionary inheritance, has been widely posed in contemporary bourgeois thought. There has been an extraordinary revival of some of the crudest forms of Social Darwinism, with emphasis on the inherent and controlling force of the aggressive instinct, the territorial imperative, the genetically determined 'hunter killer', the lower 'beast' brain and so on. These crude evasions

of historical and cultural variation, these even cruder rationalizations of the crises of the imperialist and capitalist social order, have to be patiently analysed and refuted, point by point. But the difficulty to which Timpanaro draws attention has also to be remembered. There is indeed some danger, in response to these intolerable confusions of biological and social facts, of another kind of triumphalism, in which the emphasis of human history and human culture simply ignores or treats as a preliminary banality the relatively stable biological conditions which are at least elements of much human cultural activity. Timpanaro relates this problem, correctly, to some well-known difficulties of the formula of base and superstructure, and in particular to certain kinds of art which clearly relate to elements of our biological condition, often much more strongly than to elements of our socio-historical experience. It is, of course, at once added that these elements of the biological condition are mediated by socio-historical experience and by its cultural forms; but Timpanaro is right to argue that this mediation provides no basis for that still common kind of reduction, in which the biological is a mere datum and all the effective working social and historical. He usefully reminds us that certain works of art expressing feelings of sexual love, of fear of death, of grief and loss at the death of others, while undoubtedly varied by particular cultural forms, retain elements of common content which enable them to communicate, actively and not only as documents, beyond and across historical periods and cultures.

As a matter of fact he could have taken even stronger examples, since these are cultural responses to and within biological conditions, and what needs to be estimated, in each case, is the character of the mix. The deepest cultural significance of a relatively unchanging biological human condition is probably to be found in some of the basic material processes of the making of art: in the significance of rhythms in music and dance and language, or of shapes and colours in sculpture and painting. Because art is always *made*, there can of course be no reduction of works of this kind to biological conditions. But equally, where these fundamental physical conditions and processes are in question, there can be no reduction either to simple social and historical circumstances. What matters here – and it is a very significant amendment of orthodox Marxist thinking about art – is that art-work is itself, before everything, a material process; and that, although differentially, the material process of the production of art includes certain biological processes, especially those relating to body movements and to the voice, which are not a mere substratum but are at times the most powerful elements of the work.

Yet to put the matter in this way is again to emphasize an open, secular recognition and inquiry. It is not to reserve a 'human nature' as a 'long wave' against the 'short waves' of history, as Timpanaro comes close to implying. It is rather to acknowledge – and indeed to emphasize against

the simpler forms of sociological and superstructural reductionism – that intricate and varying set of productive processes, and of the human situations which they realize and communicate, in which the physical facts of the human condition are permanently and irreducibly important. Once again, it is not a matter of limits only. Moreover, though these real physical conditions qualify some projects of absolute liberation – such as the Shavian-progressivist 'liberation from this flesh-stuff' – it is significant that many contemporary projects of liberation, though at times too exclusively, and even as false alternatives to social liberation, have decisively reclaimed our physical existence and fulfilment as inseparable from any significant project of political and economic liberation.

SOCIAL PROJECTS AND THE INDIVIDUAL

The second question here blends with the third, on the relation between our physical conditions and our social projects. Timpanaro argues eloquently for the acknowledgment of those physical realities which are there whether there is social change or not. We become ill, we become old, we die, and it is indeed a kind of petty bullying, at times a seemingly incurable shallowness, to respond to these conditions with an overriding reference to history or to a cause or to a future. That kind of reference belongs to the cultures of absolutism or to the closer contemporary cultures of bureaucracy. To die *for* a cause, and to be honoured for it, is one thing. To attempt to override the physical realities which persist in and through and beyond all historical causes is quite another. Indeed to restore this substance of human life to all effective social perspectives is a matter of great urgency. First, because no significant social perspective can exclude these substantial experiences, or treat them as marginal. It is only by infection from the social orders that we are fighting that any such exclusion or reduction is possible. But also, second, it is the perspective that then suffers, since the people who hold to it, and who struggle according to it, are all themselves within these conditions. What happens as this becomes clear, in millions of individual lives, is profoundly difficult to analyse. Many people have said, as they become old or ill, and as they now *know* that they will die, that the long historical project becomes meaningless or indifferent. Timpanaro is properly on his guard against this, for it is the mere converse of the error of overriding such realities in the name of a historical cause.

Yet the emotional freight which is carried by his particular definition of our basic physical conditions exerts, at just this point, an ambiguous influence. For consider another very relevant relation. It is another inescapable fact of 'our' physical condition that for a time 'we' are young and healthy and active. It is also a fact that this condition offers us abundant opportunities of physical fulfilment which, though of course

related to the character of our specific social order, are hardly ever wholly determined by it. Thus in one equally relevant definition of our basic physical condition we have many, and at times more immediately access-ible, opportunities of happiness in the exercise of our physical resources than in the project of social liberation. In the advanced capitalist coun-tries, in our own day, a deduction of priorities from this version of the basic relations has been very widely made. It is not just when staring death or disability in the face that we can question or draw back from revolutionary effort. It is also when sexual love, the love of children, the pleasures of the physical world are immediately and very powerfully present. To attempt to deny the reality of the kinds of fulfilment that are possible in these ways, even under repressive social orders, to say nothing of social systems which have cleared significant space for them, comes in the end to appear a desperate dogmatism,.

But then why is the question posed in such ways, leading to every kind of false solution? Timpanaro's purpose is almost equally to check both collective and subjectivist forms of triumphalism. Intellectually he is then on sure, if not fully worked, ground. But emotionally there is less real balance. The profound sadness of our epoch is fully expressed in his necessary reminders of our continuing physical limits. Yet the true sources of this depth of sadness are surely predominantly historical. For in the most basic physical terms our epoch can be characterized as (if the ethical term is appropriate) one of widening happiness: the limits of old age, of disease, of infant mortality, have been significantly pushed back, in an extending area of world society. More people are living longer, are health-ier and better fed, than at any time in human history. The barriers to extending these conditions from the richer to the poorer countries are economic and political, and not of some basic physical character. Even the relation between population and resources is a political and economic issue. So why then a materialist pessimism? There is ground for a sense of tragedy in the long and bloody crisis of the ending of an imperialist and capitalist order. But at the most basic physical level there is only the contradiction intrinsic to any conscious life process, and this is not a settled but a dynamic contradiction, in which life is not only negated by death but affirmed by birth, and practical consciousness itself at once defines and redefines its proper limits. In any fully materialist perspective, it then seems impossible to rely on any singular political or ethical dimen-sion, and especially on the received alternatives of triumphalism or pessi-mism. The properly objective process, to which these alternatives are directed, is itself contradictory and dynamic; while at any point, in the life of an individual or in the history of a movement, there is an intrinsic variability in the positions from which this nevertheless objective process is seen. A materialist ethics, like a materialist politics, has then to be grounded in these inherent relational conditions, only not as relativism,

which is merely their registration, but as activity, which is the conscious effort towards their common realization as human history.

REFERENCES

Engels, F. (1954) *The Dialectics of Nature*, Moscow: Progress Publishers
Timpanaro, S. (1975) *On Materialism*, London: New Left Books/Verso

Chapter 8

Art and biology

Peter Fuller

Marx himself once recognized that art could not easily be accommodated within his theories; he wondered about how it was that if the Greek arts were bound up with certain forms of social development (as they so manifestly were), they could still afford us pleasure today. Since Marx's time, this question has become ever more acute with the uncovering of the arts of ancient cultures of which he knew nothing. As the late Glyn Daniel, an eminent prehistorian, once pointed out, if we want to *understand* prehistoric art we certainly need to know something about the chronology of prehistory and its various cultures; but, even without such knowledge, we can *enjoy* in a discriminating way the artistic creations of prehistoric man. Until very recently neither Marx, nor any of his followers, had anything at all intelligent to say about this vast problem of the aesthetic transcendence of great works of art.

When we are dealing with the problem of art, we are always dealing with two separate but closely related questions: aesthetic response, and aesthetic (or perhaps 'expressive') *work*. The sorts of questions we need to begin by asking are what are the rudiments of these twin roots of art in species other than our own, and what can we learn from the study of them about the nature of these phenomena in our own species?

Take first the question of aesthetic response. Self-evidently, although we experience this in relation to works of art, we also experience it in relation to other things – like flowers, animals, mountains, minerals, waterfalls, vistas and natural scenery of all kinds as well. Darwin pointed out that this sort of response was almost universally observable among men, however variable the objects they admired might be. The problem, for him, was to account for this widespread trait in evolutionary terms.

Darwin tried to separate out a 'sense of the beautiful' (by which he intended to refer only to the pleasure given by certain colours, forms and sounds) from complex ideas and trains of thought with which, he says, it is self-evidently associated in 'cultivated men'. 'Obviously,' Darwin writes, 'no animal would be capable of admiring such scenes as the heavens at

night, a beautiful landscape, or refined music.' Such 'high tastes', he explained, 'are acquired through culture and depend on complex associations; they are not enjoyed by barbarians or by uneducated persons'. (One has to forgive Darwin his Victorian prejudices!) Nonetheless, Darwin believed that this 'sense of the beautiful' was something man had in common with other animals. 'When we behold a male bird elaborately displaying his graceful plumes or splendid colours before the female,' Darwin wrote, 'whilst other birds, not thus decorated, make no such display, it is impossible to doubt that she admires the beauty of her male partner.'

As we shall see, others have doubted it; but Darwin went on to argue that, with the great majority of animals, 'the taste for the beautiful is confined . . . to the attractions of the opposite sex'. In this term, 'sense of the beautiful', Darwin of course included not just visual phenomena but also, as he put it, 'the sweet strains poured forth by many male birds during the season of love'. He also noted that certain humming and bower birds even gathered petals, coloured stones and other bright objects with which they decked their nests; an activity in which, perhaps, we can see the instinctive sense of the beautiful beginning to phase into residual aesthetic *work*. Darwin offered no explanation as to *why* certain colours, tunes or combinations of shapes might be found pleasing to individuals within any given species, beyond suggesting that habit came into it, and, as he put it, 'habits are inherited'. He did refer, *en passant*, however, to the work of the great Helmholtz, who had explored the physiological bases of harmonies, certain cadences and tones among men.

But Darwin was concerned only to argue that when such preferences arose – in whatever species – they played a role in natural selection because, as he put it, 'the males which were the handsomest or the most attractive in any manner to the females would pair oftenest, and would leave rather more offspring than other males'. He went on to suggest that the original function of the 'sense of beauty' was not radically different among human beings, drawing attention to the apparent likeness between the patterns with which 'even the lowest savages' (as he called them) ornament themselves, and the similar adornment with which natural selection endows certain parts of some animals – for example, the facial and genital regions of many male monkeys. We do not even have to go along with Darwin's specific explanation of the phenomenon in terms of sexual selection, to which there are serious objections to accept his general point, namely that the rudiments of a sense of beauty are discernible in species other than our own.

Since the late nineteenth century, however, Darwin's view has been challenged, not only by aestheticians, but also by other biologists who have sometimes argued that lower animals experience only 'an instinctive congenital response', to 'signal stimuli', and not true aesthetic feelings.

Those who take this line, however, invariably have to admit that certain phenomena like complex bird-song, with all its infinite variations, often incorporating mimetic elements, are peculiarly difficult to explain. Jack-daws, for example, after being trained to certain rhythms, are able to recognize them even when played by different instruments, i.e. with a different tone quality (or timbre), or even when the tempo, pitch or intervals are altered.

This suggests something more complex than 'congenital response'. But Darwin and his critics may not be as far apart as they appear. In the nineteenth century, Grant Allen argued in his book *Physiological Aesthetics* that aesthetic experience was the specifically human manifestation of an instinct deeply rooted in animal nature; he tried to explain why we enjoy certain combinations of colours, certain forms, patterns and musical structures in anatomical and biological terms. I, too, believe that the aesthetic response in human beings probably has its roots in congenital, instinctive responses, but these are subject to some peculiarly human (rather than merely bird-like) processes of transformation.

The pursuit of the physiological roots of aesthetics passed out of fashion when it was ridiculed by such idealist thinkers on art as Benedetto Croce, at the turn of the century. But I believe that researches of this kind have a lot to teach us about why it is that we can enjoy, say, medieval madrigals, Japanese kimonos, Islamic architecture, Navajo Indian rugs or many kinds of decoration and rhythm without knowing the first thing about the societies from which they came. They may also eventually tell us quite a lot about why we enjoy decorative and rhythmical elements in much more complex works. Perhaps they will ultimately demonstrate something that should make 'pure' formalist painters think: that is that there is, indeed, an isolatable, 'pure', aesthetic faculty, but this is no more than a crude animal capacity like oral taste which man shares with many lower species. Indeed it seems to me that the formalists who say that aesthetic response is just a matter of having a 'good eye', or a 'good ear', are on a very dangerous wicket. But so was John Ruskin when he said 'I take no notice of the feelings of the beautiful we share with spiders and flies'. In the narrowest, formalist sense the aesthetic achievements of animals clearly outstrip our own. For example, all birds, dogs and even fish (gudgeons as a matter of fact) ever investigated in this respect were found to have perfect pitch. Few humans possess this. Gudgeons then presumably have 'better ears': but, as we shall see, it is precisely because the 'sense of the beautiful' in man, though rooted in the sense organs, and genetically inherited responses, is *not* wholly dependent on them that it acquires its specifically human character.

Let us turn now to the question of aesthetic expression as opposed to aesthetic response. If you think about so-called 'primitive' cultural activity with its roots in song, dance, body ornament, ritual, rhythm and mime, it

really is not difficult to point towards parallels for such pursuits in nature. I have already had something to say about the songs of birds; but think now of an equally interesting aspect of bird-life, the elaborate courtship and mating rituals, with all their attendant dances and displays, in which so many birds engage.

A pioneering study in this terrain was Julian Huxley's extraordinary little book *The Courtship Habits of the Great Crested Grebe*, first published in 1914. Its implications extend far beyond ornithology: Huxley observes that there are many birds – penguins, swans, divers, guillemots and so on among them – which lack special physical display, or ornamental structures, on the male but which nonetheless go through courtship rituals of very great complexity. The nature of these rituals fascinated Huxley. He realized they could not be accounted for by Darwin's theory of 'sexual selection'. Their overall pattern seemed in some ways determined by genetically inherited codes; nonetheless they could be shown to include elements which had lost all functional use for the species, and seemed to be being pursued for their own sake – or rather for the ritual's sake. Moreover, the choice of dance movements, shaking-bouts, displays, etc. was subject to wide-ranging individual variation. Huxley records the surprise and reluctance with which he was forced to the conclusion that these rituals were essentially the *expression of emotions* among male and female birds; the material through which such expression was realized being the often functionally useless inherited behaviour patterns. As Konrad Lorenz has pointed out, the revolutionary element in Huxley's work was that he discovered the remarkable fact that certain movement patterns, in the course of phylogeny or the evolution of a species, lose their original, specific function and become almost symbolic ceremonies. Here, I think, we are coming very close to a rudimentary version of certain aesthetic pursuits among men.

Indeed, in a fascinating study on behaviour and civilization, Otto Koenig (1976) showed that the laws of biological phylogeny are apparently valid for certain cultural historical processes: he demonstrated that in many man-made objects, like items of dress and armaments, the gradual loss of functional significance of a particular element or feature is commonly associated with an increase in its ornamental character. One example among many which he gave was the evolution of the chin-strap in Austrian military helmets, and its transformation from a protective device to an ornamental element with no functional purpose at all. Thus the strap that once secured the helmet became an embellishment of it, an expressive or *aesthetic* feature.

But it is by no means clear that the movement is always *from* the functional *towards* the aesthetic – at least not in any straightforward way. We cannot get far in our investigation of the biological roots of art without considering the question of *play*. Play, of course, is an activity

which humans share with many other species: the play of, say, kittens and young chimpanzees is known to everyone. In the late nineteenth century, there was a flurry of really rather interesting books studying the play of both man and animals and relating both to artistic activity and expression. For example, Herbert Spencer argued that artistic activity was just a specially valuable form of play. In beauty, we enjoy the greatest quantity and intensity of stimuli with the least effort. I do not think we have to go along with Spencer's dubious theories likening biological processes to mechanical concepts of 'energy' to realize the importance of his general point that there *is* something about art which resembles play, and that this something has to do with the fact that both seem to belong, as Spencer himself put it, to a realm beyond that of function and necessity.

Nonetheless, it must also be admitted that, in creatures other than man, play is clearly biologically functional. Jane Egan once made a very interesting study of the play of a kitten with a woollen ball. She concluded that this play was not a category of behaviour distinct from true predation. In its play the kitten's behaviour follows the same motor-patterns as in prey-catching, and it responds to the same stimuli – small size, fur, 'animal smell', movement and so forth. The kitten's relation to the wool ball is thus functional: it is a form of learning about solitary hunting; and, indeed, when the kitten has mastered the skills necessary to hunt, it ceases to play. As we shall see, play in children, and indeed in adults, seems much less immediately adaptive – much more dissociated from the development of specific, instinct-rooted skills.

It is possible that although phenomena like courtship and play are precursors of artistic activity in general they tell us very little about expression in those art forms with which we are primarily concerned: activities like painting, sculpture and drawing. The decisive difference here is that between a performance and workmanlike pursuits, culminating in an aesthetic (or non-functional) object which exists outside the organism's own body. Of course, many animals – like bees, ants, birds and beavers – work; but their labours are highly functional. A possible exception is that mentioned earlier: the case of the bower birds with their brightly coloured ornaments. But, as Darwin suggested, their activities seem like the precursors of mere fancy, rather than the imaginative labour characteristic of high art.

There is however a much more instructive exception than that: that is the case of *primate* art. John MacKinnon (1978) has pointed out that chimpanzees, in captivity, dress up and enjoy self-decoration; they have a natural sense of rhythm and love to beat on drums; they make wind-borne patterns with dust, scratch in the mud, and execute splendidly colourful paintings. These paintings have been studied by several researchers. For example, Desmond Morris – on whose findings (Morris

1962, 1967) I have drawn heavily – worked with an ape called Congo in the 1950s; and Congo even got a one-chimp show at the ICA.

Morris compared the development of the chimpanzee's drawing closely with that of the child. Chimps and children both become interested in the activity at about one-and-a-half years of age. They start by covering the sheet with scribbly lines, which become firmer, more rhythmical and more organized as time goes by. But, during the third year, child and ape art become markedly different. The average child starts to simplify its confused scribbling, to experiment with basic shapes – crosses, circles, squares, triangles and so on. Meandering lines are led round the page until they join to enclose a space. Lines turn into outlines. The simple shapes are then combined one with another, to produce abstract patterns. A circle is cut by a cross; the corners of squares joined by diagonal lines. Then, when the child is about three, comes the great breakthrough into representation; in the chimp, it never comes.

Like the child, the young chimp develops its composition – even using colours more harmoniously. The chimp gets to the point of making fan patterns, crosses and circles . . . and it goes no further. It is particularly tantalizing that the marked-circle motif is the immediate precursor of the earliest representation produced by the child. A child will place a few lines and dots inside the outline of a circle, and then, with a sudden flash of recognition, realize that a face is staring back at him, that his marks, out there in the world, stand for, or represent, something else . . . thenceforth, representation dominates in child art over and above abstract and pattern invention. The ape stops without making that leap: once it has drawn and marked its circle, on the threshold of an image, it continues to grow, but its pictures do not.

Now let us look back at the evidence we have been exploring: all these rudimentary biological precursors of aesthetic experience and aesthetic expression; the sense of beauty; natural ornament and decoration; expressive rituals, even ape painting. Why among all of them is there nothing we would feel happy to call 'a work of art'? The clue, I think, lies in the phrase itself: a work of art. This implies a complete symbolic world, which can exist independently of the organism's own body, but which belongs, as it were, neither to the organism itself nor to existing external reality (in the sense which both natural and man made functional objects do). It is certainly possible to discern something approaching symbolic activity among animals. Remember the grebes, or the kitten's ball of wool? But there is always something meagre about this symbolism, something intolerably close to the functional appearances and behaviour patterns as given by natural selection. The degree of symbolic transformation remains slight; the animal appears to be constantly constrained by its immediate functional relationship to reality; the ape's circle is always

just that. An ape's circle. It never constitutes a face. In short, the animal's aesthetic activities exist without a culture.

We must now ask, and very briefly answer, a vital question: 'What is culture?' Everyone argues about what culture is. As Leslie White (1962) has written, 'Stone axes and pottery bowls are culture to some anthropologists, but no material object can be culture to others. Culture exists only in the mind, according to some; it consists of observable things and events in the external world, according to others.' But White drew attention to what he calls, 'a class of phenomena, one of enormous importance in the study of man, for which science has as yet no name: this is the class of things and events consisting of or dependent on symboling'. White called such phenomena 'symbolates'. A symbolate, he said, can be a spoken word, a stone axe, a fetish, avoiding one's mother-in-law, loathing milk, saying a prayer, sprinkling holy water, a pottery bowl, casting a vote or whatever. A symbolate, he argued, could be considered in two contexts. From what he calls 'the somatic context', that is the point of view of the behaviour of the individual organism; but symbolates can also be considered in an 'extrasomatic context'; i.e. in terms of their inter-relationships among themselves. Culture, White suggests, 'is the name of things and events dependent upon symboling, considered in an extrasomatic context'.

Culture, therefore, is an outgrowth of man's capacity for labile symbolization, and his ability to detach his symbols from himself into a third area of experiencing which is neither quite 'objective' nor quite 'subjective'. But here it is important to emphasize a point made by two well-known socio-biologists (with whom I don't agree too often), Lionel Tiger and Robin Fox. 'Men', they say, 'are not simply creatures of culture, they are the creatures that create culture because that is the kind of creature that they are.' Or, as Grahame Clark (1946) puts it at the beginning of his little book *From Savagery to Civilization*: 'the evolution, nay the very possibility of culture depends on physical attributes which in man have attained a unique stage of development. However much the organism is overlaid by culture, (the organism itself) remains the basis of life, and though it may be modified by culture, culture itself must perish without a firm and sound foundation in biological reality.'

REFERENCES

Clark, G. (1946) *From Savagery to Civilization*, London: Cobbett
Koenig, O. (1976) 'Behaviour Study and Civilization', in G. Altner (ed.) *The Nature of Human Behaviour*, London: Allen & Unwin
MacKinnon, J. (1978) *The Ape Within Us*, London: Collins
Morris, D. (1962) *The Biology of Art*, London: Methuen
——(1967) *The Naked Ape*, London: Cape
White, L. (1962) 'The Concept of Culture', in M. F. Ashley Montagu (ed.) *Culture and the Evolution of Man*, New York: Oxford University Press

Chapter 9

Taste and virtue; or, the virtue of taste

Mo Dodson

... till that contemplation of universal rectitude and harmony which began by Taste, may, as it is exalted and refined, conclude in Virtue.
(Reynolds, 'Discourse IX')

I want to explore some of the problems at the heart of our notion of 'taste' by using as a starting-point a series of normally biennial lectures (the *Discourses*) delivered by Sir Joshua Reynolds to students of the Royal Academy of Arts, starting at the official opening of the Academy in 1769, and ending in 1790, two years before his death.

Taste, in eighteenth-century Britain, was much more than we now take it to be. Janus-like, it looked backwards to a version of classical civic humanism, whereby 'taste' could be construed as closely related to the ability to discriminate between what was beneficial to the 'public' good and what was merely advantageous to the private interests of an individual; but it also, as Reynolds indicates throughout his *Discourses*, referred to the capricious whims of an individual who is trapped within the specificities of local customs, manners and fashions, and perhaps even worse, subject to the vagaries and singularities of a particular upbringing.

Reynolds was the first President of the Academy, and the first British painter to attempt to claim a place in the great tradition of painting that had begun in Renaissance Italy two centuries before his birth. He was too late, and by the time of his death he probably knew this. The great tradition needed to be adapted to the condition of a mercantile society, and this type of society posed problems for a type of art that had originally been justified by reference to a simpler 'ideal' society, a 'republic' governed by 'citizens' whose 'disinterestedness' was guaranteed by their economic independence based on titled inheritance of land (Barrell 1986).

The holy grail for Reynolds was to establish in Britain a type of narrative painting that by the early eighteenth century was called 'history painting'. History painting had been developed by Italian and French

Renaissance painters and took as its subject matter important events enacted by important people, and almost always events of a distant past. Until northern Europe became Protestant the most important history painting for the whole of Christendom was biblical, and even in Protestant countries biblical themes sometimes escaped the iconoclastic censors. The development in France and other Catholic countries of an enlightened attitude towards the more fabulous aspects of Catholic interpretations of biblical narratives also made it increasingly difficult for 'Catholic' painters to take these themes with enough seriousness to use them in the most important paintings they could attempt to paint. After the iconoclasm of Protestantism, and the rationalist critique of biblical narrative, the major sources of narratives were the histories, poems and dramas of ancient Greece and Rome.

If, therefore, the rationale for history painting could no longer be grounded in religious doctrine and practices, then it had to find its rationale somewhere in classical philosophy, even if an updated version of it. This philosophy was deeply political; modelled on ancient classical examples, it had as one of its bases 'civic humanism':

> Since the revival of the ideal of active citizenship by Florentine civil humanists, there had been a gathering reemphasis on the ancient belief that fulfilment of man's life was to be found in political association, coupled with an increasing awareness of the historical fragility of the political form in which this fulfilment must be sought. *Virtue* could only be found in a *republic* of equal, active and independent citizens ... the corruption of the republic must entail the corruption of the individual personality, which could only flourish when the republic was healthy.
>
> (Pocock, quoted in Barrell 1986: 3)

In his attempt to establish a practice of history painting in Britain, Reynolds was bringing together several different purposes and tying them to this 'trajectory' of the grand manner, the great tradition. At an individual level, he was staking a claim for himself in a genealogy of fame and glory that had never taken root in British cultural soil: by the time Britain was ready to receive the Italian Renaissance it had already undergone its Protestant Reformation. From the sixteenth to the eighteenth century painting was almost completely abandoned by British artists. The first major British painter in the 'history of art canon' is Hogarth.

Behind Hogarth there is virtually a desert in terms of local traditions of painting. And, as Hogarth rejected the ambition to join the continental Renaissance tradition of history painting, Reynolds was the first (and nearly the last – Barry and perhaps Fuseli were the only painters of the next generation who seriously attempted history painting) British painter to begin to try to construct a niche for himself in the canon of great

European history painters. At the same time, Reynolds was attempting to graft this tradition onto British cultural soil, and a crucial tool in this grafting was the Royal Academy of Arts. Through the Academy young artists would be able to learn not only the 'mechanical' skills and techniques necessary to the practice of painting, but also the mental skills required to be able to abstract the essential forms from beneath the accidental varieties of the actual physical world. This ability to abstract was necessary to the practice of the grand manner of history painting – it allowed the painter to strip away the inessential particularities of phenomena, and to construct images that portrayed the ideal 'real'. This ability to see the Platonic ideal 'real' beneath actual and local reality, to generalize from the multiplicity of the phenomenal world, was called 'imagination'. And the ideal was archetypically seen in the paintings of Michelangelo, particularly those in the Sistine Chapel in Rome.

The Academy was to be the counterweight to the 'customary' form of apprenticeship, giving students that generosity of 'imagination' that allowed them to enter into the long discourse of history painting that had started in ancient Greece and had falteringly made its way to sixteenth-century Italy, and was now being imported by Reynolds and his companions into Britain.

But there was a deeper level of purpose in Reynolds's attempt to bring the grand manner to Britain. That purpose was to establish a 'republic of taste' (Barrell 1986: Introduction) that would correspond to, and be part of, a larger political (and moral) republic. This republic of taste is not the invention of Reynolds: rather it is an offshoot of the writings of a body of British intellectuals who drew strong connections between what we would now call aesthetic judgement, and the more weighty political and moral judgements necessary to leading the 'good life':

> As we have seen, the civic humanist theory of painting distinguishes the liberal man from the mechanic in terms which emphasize that its value-language is a political language: the 'liberal' man is an enfranchised citizen, a participating member of a civil state or public. The highest genre of painting, according to this theory, is heroic history-painting, for this of all genres is best able to represent man according to his nature and end which is to be so entirely a citizen that he pursues no interest which is not the interest of the public. It is because the 'heroic kind' addresses itself primarily, if not exclusively, to a public of free citizens that its primary function is ... to teach public virtue, the virtue necessary to the full realisation of this civic identity.
>
> (Barrell 1986: 18)

Barrell goes on to demonstrate how Reynolds takes this notion of the civic function of history painting to persuade citizens to act well, and transforms it into an 'aesthetic of contemplation' whereby the audience

for this type of painting understands the reality of public spirit, but does not need to perform 'heroic acts' in order to join this republic of good (i.e. correct) taste (Barrell 1986: 27).

The first point I want to make from this summary of Reynolds's project is that it was supported by an established body of theorizing from Shaftesbury and Richardson to Reynolds and his circle of friends. Reynolds was in fact a founder-member of The Club, composed of some of the most important British intellectuals of the second half of the eighteenth-century. A short-list would include Samuel Johnson, Edmund Burke, David Garrick, Edward Gibbon, Adam Smith, Joseph Banks and Oliver Goldsmith. This group met often, and discussed issues that on the one hand were of 'public' interest, and on the other were personal issues in so far as their discussion in terms of public virtue gave these relative parvenues their identities as men of substantial intellectual, political and moral weight. These men were reconstructing their identities by attempting to construct around themselves the classical tradition as mediated via the Italian Renaissance; and yet they remained profoundly alienated from this tradition. And so, deracinated from their local cultures (many of The Club had migrated to London from the provinces; coming from relatively humble backgrounds) they joined the 'great game' as Reynolds termed it (Reynolds 1992: 29).

The economic base of this sense of alienation was, of course, the shift to a 'consumer society' (McKendrick *et al.* 1982), that is a society that needed to produce and market consumer durables that would become obsolete within short time-spans. The continual change at the consumer level of the economy was matched by a continuing process of technological innovation. The cultural and social consequences of this shift have been dealt with abundantly elsewhere, but one major theme of debate in this period is the attempt to reconcile the felt need for cultural stability (by reference to a classical tradition) with the increasing pace of change brought about by the application of reason to commerce and industry. At the consumers' level, this meant reconciling adherence to notions of classical style while at the same time accepting a process of change in the style of consumer goods and services that we would now call 'fashion'. In the *Discourses*, Reynolds battles with this problem of the classical universal needing to be inflected by the variations of local styles. (Reynolds 1992: 338, 355ff.; Barrell 1986: 141ff.). Adrian Forty has pointed out the ways in which pioneering entrepreneurs like Wedgewood discovered that the Neo-classical style, even though susceptible to annual variations and shifts, was 'the style that made the late 18th century middle and upper classes feel most at ease with progress' (Forty 1986: 17). Among these pioneering entrepreneurs we might include, in spite of his own reluctance, Sir Joshua Reynolds.

And yet Reynolds, like many of his circle, felt a real distaste for that

which seemed merely fashionable and therefore artificial (that is, *not* 'natural' – 'nature' in this instance referring to that ideal reality that underpinned the local and accidental variations of the physical world). In one of the most important of his *Discourses*, the third, delivered in 1770, Reynolds condemns hair-dressers, tailors and dancing-masters. It is worth quoting at length:

> [The artist's] next task will be to become acquainted with the genuine habits of nature, as distinguished from those of fashion. For in the same manner, and on the same principles, as he has acquired the knowledge of the real forms of nature, distinct from accidental deformity, he must endeavour to separate simple chaste nature, from those affected and forced airs or actions, with which she is loaded by modern education.
>
> Perhaps I cannot better explain what I mean, than by reminding you of what was taught us by the Professor of Anatomy [a Dr William Hunter], in respect to the natural position of the feet. He observed that the fashion of turning the feet outwards was contrary to the intent of nature, as might be seen from the structure of the bones, and from the weakness that proceeded from that manner of standing [the turn-out' of the feet, a requirement in so-called classical ballet, started in seventeenth-century courtly dancing, possibly as a result of dancers wearing large boots; see Quirey 1976: 45]. To this we may add the erect position of the head, the projection of the chest, the walking with straight knees, and many such actions, which we know to be merely the result of fashion, and what nature never warranted.
>
> (Reynolds 1992: 109–10)

In the same passage, Reynolds describes the motives behind 'fashion' as 'vanity' or 'caprice', and says that these 'distort and disfigure the human form'. Fashion throws up 'a thousand . . . ill-understood methods, which have been practised to disguise nature among our dancing-masters, hair-dressers and tailors, in the various schools of deformity' (Reynolds 1992: 110). This seems to look forward to the rational dress movements of the ninteenth century (see Newton 1974, and chapter 13 in this volume), the natural dance movement of Isadora Duncan and the Natural Shoe Shop in Covent Garden! But the predominant motives behind Reynolds's strictures are surely not hygiene – they arise from what I have called 'alienation'. What Reynolds is, I think, expressing here is his own iso-lation, largely self-imposed, from local European traditions of 'oral' cul-ture, handed down through face-to-face contacts. This 'oral tradition' was certainly subject to an increasingly rapid pace of change through market-manipulation, but styles of grooming and behaviour, of participant per-forming, have a resilience that has been commented on fairly extensively (Blacking 1973, 1976, 1977; Czekanowska 1994; Monaghan 1994).

To distance oneself from one's 'oral culture' is to distance oneself from

a strong and repetitive culture that probably has the power to construct a very specific set of experiences that enable identity and subjectivity to emerge from the 'incoherence' of early infant experiences (Blacking 1973, 1977). Reynolds's generation of intellectuals in Europe began radically to distance themselves from specific aspects of their local oral cultures – those aspects we are now still accustomed to treat as superficial: social performance activities, including grooming, social dancing and social singing. Some of the reasons for this alienation have been suggested above: a search for universals that would underpin a social community that was still not achieved properly, and which had to fight against the disintegrating and socially atomizing forces of mercantile and industrial capitalism; a desire to enter into the long discourse of classical cultural traditions; an anxiety about the encroachment of the artificial in terms of a supposed 'feminization' of taste towards the merely sensual, ephemeral and often physically harmful (Guest 1992); in Britain, the loss of the local tradition of painting due to the Protestant Reformation's iconoclasm. Complementary to these reasons for a real and experienced alienation are some of the 'tools' which Reynolds and his generation used to combat this problem of being set adrift both from the classical tradition and from their 'local' cultures. Two basic instruments used to re-excavate a place in the classical tradition were literacy and monumental visual art. This takes us to the heart of one of the central questions of this anthology, the 'life of objects', and the subjective responses we have to these objects, often denoted by the word 'taste'. Communication that uses artefacts or media that have 'long lives' poses an immediate problem to meaning: how can the meaning survive over long periods of time, or across long distances of cultural geography? Although Derrida's provocative attempts to celebrate this fragility of meaning across temporal and cultural distances (in literary communication) as a paradigm of the essential ambiguity of all communication have achieved notoriety, Bernstein (1971) had demonstrated, with some elegance, the ways in which context-bound communication differs from context-free communication. Bernstein, instead of concentrating on the contrast between the spoken and written word, concentrated on the differences between working-class speech and middle-class speech. Bernstein proposed a theory that explained his empirical data: he found that middle-class speech often focused on constructing elaborately specific forms of word-structure to fit specific meanings: in empirical terms, a middle-class speaker would throw up a large variety of lexical and syntactic constructions. The intention behind this variety seemed to be to make sure that the meaning of a particular speech-act was fully articulated in the verbal utterance, relying as little as possible on the social context and non-verbal communication elements. Working-class speakers according to Bernstein tend to focus on the obverse: a limited range of syntactic and lexical variation, and a heavy reliance on the social context and non-

verbal communication to give specific and different meanings to the same or similar verbal structures. A crude example would be the variety of meanings and intentions that could be attached to a standard insult, depending on social context, tone of voice, etc. Bernstein characterized these two types of speech as an 'elaborate code' and a 'limited code'.

Bernstein went on, however, to analyse some of the implications of this difference of speech style. Because the middle-class elaborate code of speech attempted to encapsulate meaning entirely in words and their grammatical relationships, Bernstein suggested that this type of utterance could carry its 'meaning' from one context to another context relatively easily. It was 'context-free', and it was therefore 'universalizing': to use this speech mode was to fall into a 'game' of creating utterances that were universally valid, divorced from their specific social contexts and social functions: the intentional and pragmatic aspects of the utterance were down-graded in favour of its representational function. Another implication of this speech mode, therefore, was that it emphasized the separateness of speakers from each other, both because each speaker was 'encouraged' by the 'game' to represent their *own* meanings as accurately (and as differently from the other speakers' meanings) as possible; and because the representational function was being prioritized over the social/intentional functions.

Working-class (limited code) speech, on the other hand, focused on context. The 'meaning' of an utterance required the speakers and listeners to pay attention to their personal/social relationships; without this close attention to the context, the meaning of the utterance could not be grasped. The 'consequences' of this mode were an emphasis on the necessity, in most instances, of social 'harmony', of a shared set of social intentions, and on a minute attention to the non-verbalized meanings of utterances, especially if these meanings had consequences for the personal relationships of the speakers and listeners.

Bernstein's model of context-free and context-bound communication can be subsumed under the more general model of the oral/literate cultural divide. Middle-class speech (when it is elaborate-coded) can be seen as strongly influenced by the literate mode of communication (Gledhill *et al.* 1988). The universalizing tendency of Bernstein's elaborate middle-class speech is partly a result of the influence of written speech not only on oral performance, but also on the consciousness – the cognitive framework – of those who have been exposed directly or indirectly to the modes of thought made possible by written language (Ong 1982).

Written speech is by its very nature much less physically bound to a particular context of communication – in fact, it requires some degree of extra labour to re-insert written speech into the most typical context of communication – people facing each other. It can be done, and in transitional moments it is often done: as late as the nineteenth century

authors like Dickens were reading their novels aloud to live audiences. But there is a centrifugal force in written speech, pushing it towards a condition of 'assuming' itself to be almost completely free from its origins in a face-to-face ('oral') situation. This 'freedom from oral context' requires a price: an alienation, both real and felt, from the experiential and cognitive structures promoted by oral cultures (Ong 1982).

My contention is that if the literate mode is pushed too far, along with other social forces pushing people too far away from their 'oral' cultures, problems of communication and identity can arise from this alienation.

One of the strongest characteristics of oral cultures is their sense of immediate continuity with their past: 'oral' people relate to their 'past' on a personal and familial level, as if face-to-face. Although sometimes capable of constructing elaborate genealogies that extend into tens of generations (often and typically 'fictional' as these reach further backwards), without written records these people cannot mark out the past in a potentially infinite regression that is accurately in perspective. In other words, the conceptualization of accurate distinctions between points in time, extending into a temporal distance that is increasingly out of our physical and psychological reach, is simply not available to oral cultures.

Oral people relate to their forebears as if in a fleshly chain of being, a continuity of cultural similarity that is underpinned by biological repro- duction. The past 'literally', according to this notion of historical con- tinuity, lives on the bodies of those currently alive, and will live in the future through their acts of cultural and biological reproduction.

This immediate, local, and oral and ephemeral culture (though, pre- cisely because it cannot be recorded or embodied in long-lasting media, it is a culture that will be reproduced with very little change from one generation to the next) can, if allowed to, be conflated with that local, non-universal singularity that Reynolds, with many others in the Euro- pean classical tradition, found so antithetical to the Virtuous, the Beauti- ful, the Universal 'Real':

> He [the painter] must divest himself of all prejudices in favour of his age or country, he must disregard all local and temporary ornaments, and look only on those general habits which are everywhere and always the same; he addresses his works to the people of every country and every age, he calls upon posterity to be his spectators, and says with Zeuxis, *in aeternitam pingo* ['I paint for eternity' – a Latin tag probably made available to British intellectuals in *The Spectator* (1711), from Plutarch's *Life of Pericles*; see Reynolds 1992: 374n.]
>
> The neglect of separating modern fashions from the habits of nature, leads to that ridiculous style which has been practised by some painters, who have given to Grecian Heroes the airs and graces practised in the

court of Lewis [sic] the Fourteenth; an absurdity almost as great as it
would have been to have dressed them after the fashion of that court.
(Reynolds 1992: 111)

Reynolds's perception of the 'ridiculous' nature of dressing Grecian
heroes in 'contemporary' dress can be almost exactly paralleled by our
own sense of absurdity when faced with what Edgar Wind, following
Reynolds, calls the 'composite portraits' of seventeenth-century nobles
and monarchs: 'It seems natural for a modern spectator to laugh when
he sees portraits in the style of Louis XIV, in which men continue to
wear their perukes and moustaches while posing as Apollo, Endymion or
Hercules' (Wind 1937: 138). These portraits that shamelessly combined
meagre and often inaccurate references to classical costumes with contem-
porary forms of dress in a successful effort to exhibit and therefore
'possess' Olympian characteristics (strength, power, grace, etc.) while
retaining a sense of one's particular identity in the present, were exactly
paralleled by the courtly performances wherein nobility, dressed in a
similarly contradictory combination of garbled classical and shamelessly
contemporary costume, portrayed classical heroes and gods; the archetyp-
ical example would be Louis XIV (the Sun King) playing the balletic role
of Apollo the Sun God. Wind's central argument hinges around the
force of the Enlightenment in destroying the capacity of artists and
patrons to use metaphor in a quasi-magical way. After the Enlightenment,
'There is nothing left of that magical power of words which forced Diane
de Poitiers to have herself worshipped in the style of the goddess after
which she was named' (Wind 1937), whereas before that period there
was still a generalized belief in the occult power of pun-like resemblances
between names and objects (Ahl 1988; Foucault 1970: Part 1; Palmer
1993: 132–41). An implication of Wind's argument is that the seventeenth-
century noble still felt him or herself in a strong genealogical continuity
with not only their immediate ancestors, but also, in some quasi-mystical
way, with the heroes, nobles and divinities of the classical age.

This personalized history seems to me a result of surviving elements of
an oral culture in seventeenth-century Europe, even at the very top of the
social hierarchy. It is also significant, I think, that this sense of an
unbroken and personalized historical continuity between what were
known to be very distant pasts and the immediate present was often
expressed through a spectacular dance/music/drama that was still incur-
ably participant in the age of Louis XIV, for anthropologists place this
type of participant, face-to-face 'ritual' at the very heart of an oral cul-
ture's ability to reproduce itself.[1]

Reynolds, though scathing about the stark and contradictory admixture
of ancient and modern dress in seventeenth-century pictorial art, was

able to condone a composite portrait that was a *compromise*, and not a contradiction:

> [The portrait painter] therefore dresses his figure [the subject of the portrait] something with the general air of the antique for the sake of dignity, and preserves something of the modern for the sake of likeness. By this conduct his works corresponds with those prejudices which we have in favour of what we continually see.
>
> (Reynolds 1992: 200)

Reynolds here refers to the 'vulgar' pleasure an audience takes in recognizing a 'likeness' in pictorial art. He continues, 'and the relish of the antique simplicity corresponds with what we may call the more learned and scientific prejudice'. Reynolds here refers *not* to a quasi-magical connection between the portrait's subject and a classical past, but rather an historicist interest in an increasingly accurate (archaeological) reference to classical forms, which served a wider Neo-classical impulse to find in the classical culture the archetype of reason and truth.

This was indeed a compromise without bite, a rational, sensible blend that drained the original elements of all their meaning and potency: 'No doubt to the man who thought he could enhance his daily attire by adopting some of the traits of Apollo – Apollo was much more real' (Wind 1937: 19). But the 'present' reality of Apollo that had existed so strongly for Louis XIV, in being lost to Reynolds also signalled and contributed to a concomitant loss of Reynolds's own sense of himself in the present: Reynolds's lack of an 'oral connection' to a powerful 'temporal community' (a tradition) diminished his own being-in-the-world.

When it came to oral cultural forms that were incapable of rational compromise, Reynolds rejected them outright: music, dance, grooming. His rejection of the oral culture of dancing corresponds to his rejection of his own provincial local culture of Devon in favour of the 'literate' metropolitan culture of London (and yet this London culture was securely underpinned by the 'oral' culture of clubs, discussion groups, academies, salons, coffee-houses, etc.).

Social and ceremonial dance/performance was perhaps the greatest cultural victim of this loss of 'orality' so clearly demonstrated by Reynolds's *Discourses* in general, and by his strictures against 'fashionable' past-times in particular. The argument is by now all too familiar – oral and popular culture is incapable of elevating its practitioners beyond the limiting boundaries of a hedonistic present: only a high culture that stands the test of time can open the door to a more generous, universal, understanding of eternal truth. This high culture needs a medium that outlasts its first moment of utterance in perfect physical stability, and a form that preserves its individual author's original intentions. Monumental visual art is one medium that can serve this longevity. But even stronger

is the written word, and it is no coincidence that writing developed out of visual art (Gaur 1984; Gombrich 1978: ch. 1).

Contemporary social dance, as we have seen in 'Discourse' III, was incapable of that generalizing, universalizing truth that was essential for Reynolds's notion of serious 'cultural work'. That this was not the case for Louis XIV and previous generations has been explored by Belinda Quirey in her reconstructions of pre-Romantic dance (based on the work of Melusine Wood). Miss Quirey, with her colleague Margery Howe, has persuasively argued that social dance in Europe was extremely important as a means of articulating collective experiences in a public, sometimes ceremonial form that were at the core of an ideological hegemony. The spine of this ideology was the notion of a nobility, inherited not only biologically, but also, as it were, by the 'grace of god'. Through a typically tortuous path of cultural manoeuvring, to move, behave and dance 'gracefully' was by the Renaissance period seen as equivalent to being filled with divine grace (and the precise nature of this divinity was always the result of a conflation of Christian and classical references, each as strong as the other). The 'exhibition' of grace through movement, through grooming, through ceremonial pomp was simultaneously the cause and the effect of being grace-full, or graceful:

> such is the secret wisdom of social habits that the symbolic acts which display these possessions [gifts of strength or leisure or fortune] tend to work as a means of securing them. They preserve in the actor the sense of his dignity and produce in the beholder an attitude of awe.
> (Wind 1937: 139; for anthropological parallels, see O'Hanlon 1989; Strathern 1979)

Miss Quirey and Mrs Howe have presented a cogent hypothesis about the development of social dance in Europe between the Medieval and the Romantic periods. Several points are relevant here:

(1) the social/ceremonial dances of the nobility were in a strong continuum with the dances of the common people, and in my terms, strongly retentive of oral-cultural characteristics;
(2) even when the dances were 'spectacular', the most important roles were taken up by highly skilled non-professionals whose social status was reflected and articulated by the role and the style of dancing;
(3) the continuity of this tradition (of what I would characterize as an oral culture) was almost completely destroyed in the eighteenth century;
(4) the figures (floor patterns), steps, stylistic properties and the experience of the dancers (a subtle and highly skilled response to the music) were inextricably linked with the expression of social relations, and the construction of social relations (Blacking 1973; Grau 1983).

The loss of this form of social dance can be situated within the broad

historical movements of this period, characterized by such terms as the Industrial Revolution, the Enlightenment, Political Revolution and 'consumerism'. At a more specific level of analysis, the professionalization (Louis XIV was the first king to employ professional 'dancers' to play the noble roles in a courtly spectacle) of dance, and then its commercialization in the eighteenth century, are crucial to the history of this loss (Quirey and Holmes 1993).

Reynolds's inability to value both the culture of dance, and the composite portraiture of the seventeenth century, demonstrate his almost total alienation from a temporal community based on 'orality'. The great tradition of classical culture that he wanted to join was, therefore, one he profoundly misunderstood: though often using monumental visual art and the written words of distant ages, it was a culture that still retained strongly oral characteristics, especially in its relation to the past. Reynolds's attempts to prise himself into this tradition almost entirely through the media of the written word and monumental visual art exacerbated his alienation, precisely because he was almost wholly reliant on these media to do the job – and these media are inimical, when used so exhaustively and intensively, to the 'orality' he needed but could neither reach nor even conceptualize as necessary.

His *Discourses* can be read as a desperate (though the desperation is well-disguised) search for a re-entry door to the great tradition. To 'discover' this desperate alienation in the interstices of Reynolds's *Discourses* is not to claim his was a unique alienation – his alienation is here part of a collective structure of experience, corroborated by the well-documented inter-textuality of the *Discourses*, placing them well within contemporary discourses on art and politics (remember that Edmund Burke and Samuel Johnson were intimate friends of Reynolds), while also confirming their particular and original contribution to that discourse. It is difficult to quote a long enough extract to demonstrate this 'desperate' alienation, as the sense of it is generated by a reading of the totality of the texts. But one passage from the ninth 'Discourse' is particularly poignant, though it appears to be based on commonplace ideas derived from classical philosophy and its Christian off-shoots, especially Neo-Platonism:

> The Art which we profess has beauty for its object: this it is our business to discover and to express; the beauty of which we are in quest is general and intellectual, it is an idea that subsists only in the mind; the sight never beheld it, nor has the hand expressed it: it is an idea residing in the breast of the artist, which he is always labouring to impart, and which he dies at last without imparting.
>
> (Reynolds 1992: 231)

Reynolds can also descend to the minutiae of small 'rules' for painters

(as in 'Discourse' VIII), seemingly an optimistic gesture of faith in his students' ability to 'impart' beauty). But these rules are continually hedged with a sense of the impossibility of the task of finding 'true beauty'.

Reynolds stands, therefore, at the dividing point between oral and literate, between the ancien régime and modernity. His emphasis on the civic virtue of good ('correct') taste is a preamble to that long history of the authority of God being replaced by the authority of good taste in art, and by implication good taste in design (see Palmer, chapter 1 in this volume; see also Szczelkun 1993).

This good taste was required increasingly to establish itself as supra-historical *sub specie aeternitatis*, and yet still to serve a moral function within the social fabric. From Shaftesbury, through Ruskin and Morris, to the heroes of modernism and their pale descendants like Conran, this moral function of good taste in 'objects' is paralleled by a similar impulse in literary criticism leading up to Leavis in the twentieth century (Mulhern 1979). The tension between the specific social/civic/moral function of this good taste in visual or literary 'objects', and the notion of a supra-historical beauty or truth, is held together successfully up until the Romantic period by means of the concept of civic virtue. By the time Ruskin gets hold of this set of equations between art and morality, the notion of civic virtue has been transmogrified into a notion of spiritual morality, with only utopian references to a *future* social order.

Reynolds's attempts, therefore, to resurrect a 'republic of good taste' on British soil, instead of helping this cause, in fact helped to accelerate a decline into a museum culture where communication artefacts (be they written words or visual representations) took on a moral life of their own, increasingly separate from actual social relations. It may be that this was inevitable:

> When Reynolds was writing his early discourses, it was still easy to believe that the recently founded Academy could achieve its main end, of promoting an art which would promote the public interest. By the turn of the century, however, there was, to most commentators, no sign that the Academy had succeeded in encouraging the development of a school of history-painting worthy of a great and free nation. Various explanations were canvassed, but all of them came back to the same point: that there no longer was a public in Britain, in the sense of a body of citizens animated with the public spirit which alone could encourage a public art; the body of the public was now a corpse, corrupted by the luxury and commerce that the civic humanist dis-course had so strenuously attempted to arrest; the account of society offered by the economists, that it was structured as a market, was only too accurate.
>
> (Barrell 1986: 64)

In his last 'Discourse', Reynolds, instead of attending to this radical shift towards a social disintegration that attacked the very heart of his project to establish a good society underpinned by a public art, chose instead to write a celebration of his 'hero' Michelangelo. This seems to me to be a turning towards what would become the museum culture of modern times, where great artists are venerated through their 'holy relics', cultural artefacts that are fetishized – both metaphysically as a kind of organic canon or great tradition that seems to have a life of its own divorced from its human creators, and economically as commodities of huge exchange-value. In the end, the artists themselves become abstract fetishes before which we strike attitudes of deference, defiance or indifference, none of which has any real connection to the actual histories of these men and women and the objects they made to communicate with each other. The text of 'Discourse' XV is prophetic:

> We are constrained, in these latter days, to have recourse to a sort of Grammar and Dictionary, as the only means of recovering a dead language ... The style of Michael Angelo ... which may ... be called the language of the Gods, now no longer exists, as it did in the fifteenth [sic] century ... To recover this lost taste, I would recommend young artists to study the words of Michael Angelo.
>
> (Reynolds 1992: 332–3)

Reynolds concludes this, his last, 'Discourse' with a humble paean to Michelangelo, while admitting his own failure to engage in history painting. It seems sad that what started out as a project to establish a 'republic' ends in a fetishized form of hero-worship that is in turn being used to gloss over intuitions of a deeper failure of the whole of society:

> it will not, I hope, be thought presumptuous in me to appear in the train, I cannot say of his [Michelangelo's] imitators, but of his admirers. I have taken another course, one more suited to my abilities, and to the taste of the times in which I live. Yet however unequal I feel myself to that attempt, were I now to begin the world again, I would tread in the steps of that great master: to kiss the hem of his garment, to catch the slightest of his perfections, would be glory and distinction enough for an ambitious man ... and I should desire that the last words which I should pronounce in this Academy, and from this place, might be the name of MICHAEL ANGELO.
>
> (Reynolds 1992: 336–7)

It is striking that here 'taste' has become an excuse for the failure of his project to take its place in the great tradition.

The emergence of the concept of 'taste' is arguably coextensive with the emergence of a civilization that has a plurality of cultural choices placed before it by its social 'complexity' and by its use of literate and

monumental visual art (which give it access to artefacts of different periods and places). The further this civilization strays from its oral-cultural matrix, the more it needs to lean on its literature and monumental art, and the more it will need the guidance of 'rules of taste' to make choices. If the seeming plurality of choices reaches an uncontrollable variety and richness, taste itself will be in danger of descending to a perceived state of caprice and superficiality. Reynolds is the last of the old heroes to defend a higher function for taste, or perhaps the first of the new heroes to do so.

This battle between 'taste' as a form of judgement that can discern the essential and universal needs (see Palmer, chapter 10 in this volume) of humankind, and taste as a capricious whim leads into some extraordinary U-bends of logical flow. The first U-bend is at the juncture of 'oral' culture and 'popular' culture: popular culture, or, in Reynolds's terms, 'fashion', is seen as the sphere of taste in its guise of ephemeral and local 'desires' that have no relevance to the universals of human virtue. Opposed to this is high culture, which functions primarily through monumental media, and which claims to operate through a taste that aspires to the condition that Reynolds attempted to stake out for it in the *Discourses*.

Yet it is at this point that the logic turns backwards: the argument for a form of culture based on universal needs is now often taken up by students of oral cultures, who claim (e.g. Blacking 1977) that the universals can be discerned most clearly in oral cultural forms; and contemporary forms of oral culture are situated within a sphere that would include many variants of popular culture. And in so far as my argument above is acceptable, high culture and its use of monumental media serve to alienate us even further from the fragile oral traditions still left to us. High culture, it can be argued, is part of the problem and not the solution (as it claims to be) to the problem of the absence of a healthy republic of universal 'needs and desires' mediated through judgements that, perhaps, we should no longer attempt to call 'taste'.

NOTE

1 'Oral' is a patently inaccurate term to describe a culture involving all five senses within a matrix of 'socio-sensuous' mutualities.

REFERENCES

Ahl, F. (1988) 'An est caelare artem', in J. Culler (ed.) *On Puns*, Oxford: Oxford University Press

Barrell, J. (1986) *The Political Theory of Painting from Reynolds to Hazlitt*, New Haven and London: Yale University Press

—— (1992) *Painting and the Politics of Culture: New Essays on British Art 1700–1850*, Oxford and New York: Oxford University Press

Bernstein, B. (1971) *Class, Codes and Control*, London: Routledge & Kegan Paul

Blacking,J. (1973) *How Musical is Man*, London: Faber & Faber

—— (1976) 'Dance, Conceptual Thought and Production in the Archaelogical Record', in G. de G. Sieveking *et al.* (eds) *Problems in Social and Economic Archaeology*, London: Duckworth: 1–13

—— (1977) 'Towards an Anthropology of the Body', in J. Blacking (ed.) *The Anthropology of the Body*, London: Academic Press: 1–28

Czekanowska, A. (1994) 'John Blacking's Work as Perceived by Polish Ethnomusi-cologists' (unpublished paper)

Douglas, M. (1966) *Purity & Danger*, London: Penguin Books

Elias, N. (1978) *The Civilising Process*, Vol. 1, *History of Manners*, Oxford: Basil Blackwell

Finnegan, R. (1992) *Oral Tradition and the Verbal Arts*, London and New York: Routledge

Forty, A. (1986) *Objects of Desire*, London: Thames and Hudson

Foucault, M. (1970) *The Order of Things*, London: Tavistock

Gaur, A. (1984) *A History of Writing*, London: British Library

Gledhill, J., Bender, B. and Larsen, M. T. (1988) *State and Society*, London: Unwin Hyman

Gombrich, E. H. (1978) *The Story of Art*, 13th edn, London: Phaidon Press

Grau, A. (1983) *Dancing, Dreaming, Kinship: The Study of Yoi, the Dance of the Tiwi and Melville and Bathhurst Islands, North Australia*, PhD thesis in Social Anthropology, the Queen's University of Belfast

Guest, H. (1992) 'Curiously Marked: Tattooing, Masculinity and Nationality in Eighteenth Century British Perceptions of the South Pacific', in J. Barrell (ed.) *Painting and the Politics of Culture: New Essays on British Art 1700–1850*, Oxford and New York: Oxford University Press: 107

Howe, M. (n.d.) *Shades of the Dancing English* (unpublished manuscript)

McKendrick, N., Brewer, J. and Plumb, J. H. (1982) *The Birth of a Consumer Society: The Commercialisation of Eighteenth Century England*, London: Europe Publications

Monaghan, T. (1994) *The History of the Lindy Hop* (unpublished manuscript)

Mulhern, F. (1979) *The Moment of Scrutiny*, London: Verso

Newton, S. (1974) *Health, Art and Reason*, London: John Murray

O'Hanlon, M. (1989) *Reading the Skin: Adornment, Display and Society among the Wahgi*, Bathurst, New South Wales: Crawford House Press

Ong, W. J. (1982) *Orality and Literacy*, London and New York: Methuen

Palmer, J. (1993) *Taking Humour Seriously*, London: Routledge

Quirey, B., Bradshaw, S. and Smedley, R. (1976) *May I Have the Pleasure*, London: BBC

Quirey, B. and Holmes, M. (1993) *Apology for History*, Charing Kent: Dance Research Committee

Reynolds, J. (1992) *Discourses* (1769–90), P. Rogers (ed.), London: Penguin Books

Strathern, M. (1979) 'The Self in Decoration', *Oceanic*, 49(4): 241–56

Szczelkun, S. (1993) *The Conspiracy of Good Taste: William Morris, Cecil Sharp, Clough Williams-Ellis and the Repression of Working Class Culture in the 20th Century*, London: Working Press

Wind, E. (1937) 'Studies in Allegorical Portraiture I', *Journal of the Warburg and Courtauld Institutes* 1: 138–43

Chapter 10

Need and function
The terms of a debate

Jerry Palmer

According to one of the most fundamental axioms of modernism, form follows function. For van der Velde – who appointed Gropius to the Bauhaus – engineers are artists because they subordinate form to function and raw materials, and because they make objects that are useful; praising industrial products such as 'locomotives, bicycles, automobiles, steamers, perambulators, bathroom fittings, electric hanging lamps and surgical instruments', he says 'All these articles are beautiful because they are exactly what they should be' (quoted in Whitford 1992: 18). That is to say, all these objects correspond to some social purpose and the form which is created for them is appropriate to it; in this appropriateness lies their beauty. If this axiom is difficult to apply to some of the fine arts – and indeed undermines their claim to separate status – its application to design has been obvious, for it is difficult to theorize design without reference to the purpose of the objects in question. However, the nature of this purpose is not itself equally clear, and is commonly analysed in terms which are not necessarily compatible with each other: these terms may be summarized as need, desire and demand. That is to say, the relationship between design and aesthetics is always filtered through a discussion of the relationship between these notions.

It is possible to analyse design purely in terms of its functions for those who pay designers – manufacturers and consumers – in other words, in terms of its role in the interplay between supply and demand. But we condemn ourselves to a very partial understanding of the nature both of design and of demand if we approach design in this way, for consumer preference cannot be separated from the act of valuation of commodities by those who buy or fail to buy them, and those acts of valuation are not understandable in purely economic terms (Douglas and Isherwood 1979). Two examples indicate how consumer preferences are not explainable in terms deriving solely from economic rationality. First, strict rationality would demand that any object or service should be available for commodification, and yet it is well known that many are largely excluded (for example, through the criminal law, or through distaste – such as, in

our culture, dead bodies); also, objects enter and exit from commodity status in ways that defy purely economic accounts. For example, religious artefacts (such as icons) are excluded from commodity status in their origins, but may well become commodified at a subsequent stage – for example through the antiques trade – and then become redefined as exempt from commodification – for example by becoming part of 'national heritage' (cf. Appadurai 1986: 16–17). That is to say, in order for an object to become the subject of possible consumer preference, it must first be allowed to be commodified. Second, while consumer preferences within categories of goods are easy to explain, preferences between categories of goods are not. It is not difficult to give a rational economic explanation of – say – the choice between different makes and ages of car; but it is far more difficult to give a rational, utility-based explanation of an individual's decision to refrain from buying a car and buying a stereo set instead: to say that the stereo is of greater utility is simply a way of avoiding giving an explanation (Douglas and Isherwood 1979: 96–104). In Douglas and Isherwood's terms, this is because the consumption of goods is primarily a way in which people incarnate the categories of a culture, in other words the use of goods for consumption is primarily a way of making sense of the world and stabilizing the sense-making mechanisms that a culture proposes to its members: 'Goods, in this perspective, are ritual adjuncts; consumption is a ritual process whose primary function is to make sense of the inchoate flux of events' (*ibid.*: 65). In other words, all goods are symbols as well as utilities.

Thus the life of objects cannot be understood in purely economic terms; we must refer to the dimension of desire or need as well as that of demand. Much debate about design in the twentieth century has been about the relationship between 'desire' and 'need', and the extent to which design appeals, or ought to appeal, to one or other of these dimensions of behaviour. The rest of this essay is devoted to a discussion of recent theories of need (for a discussion of the history of the desire for commodities, see Campbell 1987).

Need is conventionally understood as something which is universal and objective, whereas desire (or preference) is variable and subjective (although often shared). The bases upon which this distinction may be made vary, but common to them is the notion that 'needs' are a precondition of the satisfactory functioning of humanity. Although all attempts to set up an exhaustive empirical 'check-list' have failed, it is clear that certain features of human life are indeed essential: air, water, a climate following certain patterns, food, etc. This dimension of human need is probably best understood as a set of functional inter-relationships in an eco-system of which we are part. Here we refer to what the human species needs in order to survive as a species – which implies nothing about the survival, or well-being, of any particular individuals. However,

if we take it as axiomatic that humans are intrinsically social beings, we note that the processes involved in the satisfaction of those needs are organized through culture, and therefore these shared things take on a different meaning, or value, because of their place within the cultural order – or the various cultural orders – constituted by all the processes in question. Thus although it is true that there are obvious preconditions to our continued survival both as individuals and as a species, nonetheless these do not exhaust the list of what we conventionally think of as needs. Ultimately the reason for this is that the human species is such that the organization of culture depends upon the faculties that are also responsible for our self-individuation, those things through which we constitute our individual selves as social beings. The notion of 'need' exists at the point where we can no longer distinguish between ourselves as incarnations of a species and ourselves as 'individuals' in the usual sense of the word: endowed with certain capacities for self-differentiation from other members of the species. The list of needs must include things that are posited by the nature of human societies because we are such that the satisfaction of the rudimentary preconditions for our collective survival is always organized socially, and in processes which involve self-individuation.

Thus far I have written as if it was certain that 'needs' do in fact exist, as if the concept 'need' was necessarily meaningful; but this has yet to be shown, and these remarks only indicate that if such is the case, there are certain necessary features in the definition of needs. We can advance by considering whether there are necessary features in our collective organization of ourselves into a society or societies; if so, they could be thought of as needs. This is the terrain on which Doyal and Gough (1991) situate their analysis: they demonstrate that the process of the satisfaction of needs has certain essential features, which thus themselves become needs because they are the necessary preconditions of any conceivable society satisfying eco-systemic needs.

It is clear, they argue, that there is a basic irreducible minimum which can be deduced from the observable nature of human societies, which is life plus the 'competence to deliberate and choose', or – in other words – the capacity to participate in the life of society: without that nothing is possible, since participation constitutes the capacity for agency (Doyal and Gough 1991: 52–60). Action, they argue, is impossible without the recognition of responsibility in oneself and others; this implies recognition of the preconditions of responsibility, in other words whatever is necessary for responsibility to be exercised, which is essentially rationality and autonomy, without both of which responsibility cannot exist. At the same time, rights and duties necessarily involve reciprocity too. For any obligation to effectively exist, the person who is so obliged must be able to meet the obligation in order for it to exist as an obligation; this implies

access to appropriate levels of need satisfaction to meet it. Therefore those who accept reciprocal rights and duties must also accept the obligation to respect that necessary level of need satisfaction and contribute to it in whatever way is appropriate under the circumstances. The purpose of this analysis is explicitly anti-relativist, it is to provide a universal model of need satisfaction which can be used as a yardstick of social progress (Doyal and Gough 1991: 69, 90).

Central to their argument is the notion of being a 'full member of society' (*ibid*.: 51–2): if you are not a full member of society, then you suffer from reduced autonomy because you are genuinely less in charge of your destiny than others, and as a result it cannot be said that your needs are being satisfied – for example, a slave may be said to be autonomous in the existential sense of being able (indeed obliged) to make choices, but is not truly so because of reduced opportunity to participate in decisions about the conduct of public affairs, reduced by comparison to slave owners (*ibid*.: 66, 78–9). Further, inequality is equivalent to impaired agency and therefore equal obligation is premised upon equal levels of need satisfaction (*ibid*.: 97). Clearly this argument has much to recommend it: reciprocity is indeed the foundation of obligation. Yet there are features of the social world which are hard to reconcile with this approach.

The first is the apparently superficial question of which society one is a member of: is it of 'human society' in the widest sense, the whole community of mankind? Or is it of some localized version – English society, or Algonquin society, or capitalist society, etc.? This goes to the heart of Doyal and Gough's analysis. They constantly argue that the mechanisms of reciprocity and need satisfaction are universal criteria for assessing any society, regardless of its actual capacity for need satisfaction, since participation and need satisfaction are subject to whatever constraints are normal at a given point in time and space – need satisfaction is basically the enjoyment of 'the good things in life, however they may be defined' locally (*ibid*.: 69). That is to say, at any point in time and space there is such-and-such a capacity for satisfying needs, and provided it is evenly distributed across a population then everybody is participating equally and having their needs equally met. But what happens when civilization A, with a highly developed capacity for need satisfaction – for example, high labour productivity and superior military technology which gives enhanced aggressive capacity – meets civilization B with a lower capacity in both respects? At the moment of meeting, there is a clear imbalance of need satisfaction: are we talking about one society or two, about 'one race, the human race', or about 'developed' society and 'underdeveloped'? From a political point of view we are talking about two societies, and probably at least two nations: but morally, things are not so clear. According to Doyal and Gough, it is incumbent upon anyone

to share the possibilities of need satisfaction universally; otherwise there is no reciprocity and therefore no possibility of moral community of judgment; in this sense there is only ever one society in the world. Yet they also argue that when an individual moves from one politically defined society to another, that individual should accept the rules of the second society; the contrary argument could only be sustained if the rules of the old society made assimilation of the new rules cognitively impossible; but in that case even recognition of difference would not be possible, and the entire process of reciprocity would collapse entirely (*ibid*.: 73). These two points do not sit happily together: the rule of moral universalization is clearly intended to overcome corporate self-interest and the localism of 'charity begins at home'; but at the same time the argument about what happens when individuals cross cultural boundaries is premised upon the existence of morally valid boundaries, whence the argument that such boundaries would only be invalid if they were morally incapacitating.

The second ambiguity occurs in their argument about minimum and maximum levels of autonomy. In one sense, the existential one, all humans are always autonomous in that choices must always be made; indeed it is because of this that it makes sense to recommend that autonomy be increased, for without the universal experience of autonomous choice making, the real autonomy of democratic process would not be possible (*ibid*.: 66–7). But there is a qualitative difference, Doyal and Gough argue, between this minimum, universal, existential autonomy, and the 'critical' autonomy that is made possible by democratic institutions, where autonomy comes to mean real participation in public affairs, and therefore a qualitatively different participation in collective life. No doubt this is true: but on what grounds should we feel obliged to make the move from autonomy (1) to autonomy (2)? What do we say to someone who prefers limited autonomy, and the limited responsibility that goes with it? It is at this point that the central thrust of Doyal and Gough's argument becomes clear: what they have developed is a theoretical model for the comparative assessment of different degrees of social progress, where a greater level of need satisfaction indicates a higher degree of progress; we should recommend the move from existential autonomy to critical because this represents progress. While this argument is seductive, it should be noted that it is based on an assumption, that progress itself is desirable (and wanted); this in its turn is part of the generalized set of assumptions, deriving from the Enlightenment, that constitute the programme of modernity.

We may continue by comparing Doyal and Gough's argument with another conception of need to which it bears some resemblance, the theory of need to be found in Marx (Heller 1976). While Marx himself never tried to formulate a coherent theory of need, it is possible to deduce something approaching one from his various works. Marx distin-

guished various types of need, which Heller (using elements of Marx's own inconsistent terminology) calls 'natural' needs, 'necessary' needs and 'radical' needs. Natural needs are those things essential for species survival – although Marx does not really distinguish between survival of the species as a whole and the survival of individual members of it. Necessary needs are a rough average of what a given mode of production (e.g. feudalism, capitalism, slave society) is capable of producing at a given moment. Thus we could reasonably say that in twentieth-century capitalist society access to reliable modern forms of communication and transportation is a 'necessary' need for our population, whereas it clearly was not a century ago; it has become a need because of its ready availability and because its availability has transformed the spatial relationships of our society. Radical needs are those things for which a given society creates a use or awakens a desire, but which a substantial proportion cannot in fact achieve within that society because of some feature of the society in question. For example, capitalist society arguably installed for the first time a clear distinction between free time and work time – because of the way employment came to be based on a fixed number of hours for the majority of the population. Control over the boundary between the two, the capacity to fix the division between them, is – for the majority of the population – given over to others, alienated, by the contract of employment; the desire to control it oneself becomes a radical need because it cannot be satisfied (arguably) within the framework of society as it currently exists, and fixing the work/leisure boundary is an essential element of participation in public affairs.

There are clear parallels between this approach and that taken by Doyal and Gough. Marx's 'necessary needs' is a rough average of what is available at a given point in time and space; people who receive less than that are being deprived of their needs. Doyal and Gough say that the satisfaction of needs occurs when all people in a given society have roughly equal access to what is available. But Marx's notion of 'radical needs' is incompatible with Doyal and Gough's framework. For them it is incompatible because it is relativistic, indicating that what is necessary in one society is not necessary in another (Doyal and Gough 1991: 13). This interpretation of Marx (via Heller) is questionable, for it is not radical needs that are specific to a given mode of production, but necessary needs; radical needs are precisely those that transcend the division between modes of production (the sentence from Heller that Doyal and Gough quote does not make this distinction, but it is clear from the context in Heller). Perhaps the finer points of interpretation of Marxist texts are only a minority activity, but what is lurking behind these minutiae is of much wider importance: it is the question of the relationship between morality and the motor forces of social change, which is precisely what is at stake in Doyal and Gough and the debates to which they are

contributing: Is history understandable in a positivistic way, as an objective force? How can we make judgments about its course? How do we deal, morally, with those conflicts that arise at the boundaries between ethical – and more generally cultural – systems? We should note that the concept of needs, as elaborated in either of the two versions summarized here would, if coherent, provide a substantial criterion for such judgments.

Recently no contribution to these debates has been more influential than Baudrillard's. His many critiques of all previous models of consumption, production and distribution go to the heart of the matters under debate here.

We can begin by considering Baudrillard's criticisms of Marx (Baudrillard, 1975, 1981). Baudrillard sets out to show that Marx's theory of capitalism – indeed, of history – is based on an entirely false premise, that commodities correspond to needs. Marx argues that a commodity is two-sided. On the one hand it has a use for whoever eventually consumes it – food is eaten, clothes are worn, etc. On the other it has economic value and is exchanged for a price. The two are not identical because value is a ratio in which objects are exchanged which have nothing in common except their valuation. The value is dictated not by the use that the consumer has for the object but by the amount of averagely necessary time that is consumed in its manufacture. Certainly consumer demand affects price movements, but only within a set of restrictions imposed by manufacturing costs, which always ultimately are reducible to labour costs, since raw material costs are only another set of labour costs incurred by someone else.[1] The two dimensions of a commodity Marx calls 'use-value' and 'exchange-value'. As is well known, Marx then erects on this base a theory of how capitalism works, how it is inherently exploitative, and how this situation can be remedied. Baudrillard's critique, in a nutshell, is that Marx remains the victim of the political economy he is attacking, that his critique of capitalism is complicit with the real fundamentals of capitalist society and that as a result the projected future communist society would not be radically different from what we already have. But it is the detail of Baudrillard's argument that is important for our purposes.

For Baudrillard, the essence of Marx's case is this: under capitalism, the usefulness of objects and the work that produces them are always subordinated to the demands of capital; it is only those things that can produce profit that can be made, and hence it is only those skills that are useful for profitability that can be exercised; under communism, however, all objects that correspond to needs will be produced rather than only those objects which are profitable. In this equation, says Baudrillard, usefulness is central. Marx says that the uses of objects are 'incommensurable' with each other: a pair of shoes cannot be exchanged with a lump of cheese as an equivalent use, only as an equivalent value expressible in monetary terms. Therefore it is the equivalence of value, or exchange-

value, that makes capitalist relations possible. Therefore, if we remove exchange-value, we can found a non-capitalist society.[2] For Baudrillard the commonsensical obviousness of utility – and the corresponding possibility of founding a new society on it – is highly problematic. Of course there is some correspondence between the nature of an object and the use to which it is put, but the 'concrete destination and purpose, [the] intrinsic finality of goods and products' is false (Baudrillard 1981: 130); it is false in that it presupposes that the relationship of the object to the user is always one of utility, whereas (says Baudrillard) it is only under certain specifiable social circumstances that objects relate to their users as utilities. For example, in the gift – the act of giving an object, not the object itself – the being of the object is premised primarily upon the relationship between giver and receiver rather than upon the 'concrete purpose [or] intrinsic finality' of the object in question. It is only in civilizations which conceive of objects as exchangeable that it is possible for them to be utilities, or at least exclusively utilities. In other words, it is exchange that is the basis of utility, not the other way round. Moreover, making objects into utilities already makes them equivalents to the extent that 'they are assigned to the same rational-functional common denominator' (*ibid*.: 132), in other words the shared attribute 'utility' makes them equivalent in so far as they are 'useful'. In this sense, Baudrillard says, use-value in Marx is nothing but the 'horizon' of exchange-value, in other words it is something which is posited by exchange-value as a necessary support for its existence, in the apparent form of something intrinsically different from exchange-value; but in reality it is a necessary part of exchange-value, not in any way separate from it.

The results of this form of equivalence are significant, according to Baudrillard:

> Far from the individual expressing his needs in the economic system, it is the economic system that induces the individual function and the parallel functionality of objects and needs. The individual is an ideological form, a historical form correlative with the commodity form . . . and the object form . . . Use value [is inscribed] at the heart of the object . . . as the finality of the 'need' of the subject.
>
> (Baudrillard 1981: 133)

Human labour – which for Marx is the expression of human sociality, what distinguishes man from the animals and represents the beginning of history – is to be deconstructed in the same way, says Baudrillard. Under capitalism, says Marx, 'abstract' labour is distinguished from 'living' labour; living labour is the capacity that people have to produce objects that serve needs, particular skills – just as the objects are incommensurably different, so are the productive capacities responsible for them; but insofar as labour is paid for through the wage, it is reduced to the abstract

form of the quantity of it necessary on average to produce the exchange-value in question. Under communism, living labour will be freed from its dependence on the sale of abstract labour-power to the capitalist, and will function within society on the basis of the famous slogan: 'From each according to his abilities, to each according to his needs'. But – argues Baudrillard – living labour is only incommensurable insofar as the utilities it produces are incommensurable; and they are not, precisely because they are utilities. The qualitatively different capacities of living labour are an optical illusion in the same way as the incommensurability of utilities: they too are a 'horizon' of exchange-value, that of labour power. In Baudrillard's words:

> The definition of labour power as the source of 'concrete' social wealth is the complete expression of the abstract manipulation of labour power: the truth of capital culminates in this 'evidence' of man as producer of value. Such is the twist by which exchange value originates and logically terminates in use-value. In other words, the signified 'use-value' is still a code effect, the final precipitate of the law of value.
>
> (Baudrillard 1975: 25)

There is no reality in the contemporary world other than the reality of the general system of equivalences produced by exchange-value. But the notion of incommensurable use-values is an essential ideological support for this system of generalized equivalences because it gives the illusion of a realm beyond exchange-value in which we are all incarnations of some human essence, and to that extent equal. In the capitalist version, we are all consumers and have an equal right to make our choices as we will; in the Marxist version, although we are unequal in the structure of exploitation, we are equal in our needs. This is the basis of the illusions of political economy, Marxist and capitalist alike (Baudrillard, 1981: 137).

These arguments no doubt seem a long way removed from debates about the nature and role of design. But Baudrillard makes design absolutely central to his attack upon political economy, both Marxist and capitalist.

For Baudrillard, design is the perfect incarnation of political economy (1981: 185–205). In design the traditional notion of beauty is turned into 'aesthetic value', and thus brought into tandem with functionality, or utility. In a design economy, three essential processes occur:

(1) the potential complexity and polyvalence of relationships between people and objects is divided up into elements whose constitution is based on analytic rational criteria (for example, demographics and taste cultures); the purpose of this exercise is to maximize control over the economic environment;

(2) the division of labour is extended and generalized, so that
contributes only a fragment to the overall production proces

(3) and most importantly: all objects become signs. They become signs
in the sense that each object becomes the signifier of its own func-
tionality, each object proposes to its 'user', 'My purpose is to be such-
and-such' (once again, Baudrillard is comparing this role of the object
with the role of the object in social forms such as the gift). In this
form of the life of objects, each object's being is only its capacity to
fulfil the function in question, and this is given by its place in the
matrix of all objects, i.e. in a generalized diacriticality.

As a result of these three processes, the apparent 'functionality' of a
correspondence between the nature of the object and some hypostasized
'need' in the user is no more than the 'concrete alibi' for the maintenance
of the generalized system of equivalences (*ibid.*: 190–1). In this system –
which Baudrillard argues is based around the Bauhaus revolution – the
fashion system in the way in which it is usually thought is only an apparent
exception. In fashion, we apparently use objects to make statements about
ourselves as individuals or members of a sub-group within society; that
is to say, we individualize our relationship with the objects in question,
we invest them with a kind of magical potency to effect some modifi-
cation, extension or affirmation of our being. But in kitsch – Baudrillard's
generalized label for all such processes – all that happens is that we make
ourselves complicit in the system of generalized equivalences by making
ourselves bearers of the differences which the objects in question are
capable of instituting. In this sense, kitsch and the Bauhaus are two faces
of the same system, and Surrealism is a third (*ibid.*: 192–4).

Subsequently, Baudrillard will argue that the various processes
described here have overtaken the whole of our social order: the 'simula-
cra', as he will later call them, take precedence over the real, indeed
replacing it with a new realm which he will call the 'hyper-real'.

It is not difficult to pick holes in Baudrillard's arguments. For example,
we might propose that his alignment of the whole history of design with
the Bauhaus is to say the least an oversimplification. But Baudrillard is
not trying to write a history of design in the twentieth century: he
is proposing a schema within which we should rethink what that history
means.[3] The point in his argument which is central for our purposes is
his deconstruction of the notion of need. For Baudrillard, 'need' is an
optical illusion, the 'horizon' as he calls it, the ideological support, of the
system of generalized equivalence which is political economy; it is also
the illusory hope held out by the communist tradition, which ruthlessly
exploited it by claiming philosophically privileged access to the distinction
between true and false needs.[4] However, it is arguable that here Baudril-
lard is creating a straw man out of Marx. First, he claims that for Marx

the use-value of labour power consists entirely of its incommensurability, its capacity to produce things which are in accordance with needs. But it is clear that under capitalism labour power (as opposed to concrete labour) has the use-value of creating surplus value (from which comes profit) for the capitalist; indeed it is this more than anything else which distinguishes living labour from abstract labour for Marx. Certainly Marx thinks that concrete labour takes the form of creating specific objects with uses; but Marx is also clear on the relationship between such objects and human transcendence: in objects, the human capacity for creative transformation of nature comes back to confront us as the realization of that capacity incorporated in particular forms, ultimately as 'dead labour' simply because it is now fixed in its realization. For Marx, it is in this constant interaction between creative capacity for transformation, and the fact that at any given moment in time this capacity must take whatever form it currently has, that needs arise. We should remember that 'necessary needs' are a rough average of whatever a particular set of productive arrangements is capable of delivering at a given moment; that is to say, needs exist in the circulation between the human subject's constant self-constitution through productive and consumptive activity, on the one hand, and on the other the subject's objectification in the form of the objects produced; or – in other words – the production of objects creates a subject for the object in the same process as it creates an object for a subject (Marx 1973: 92). Marx does not say: there are needs, to which objects and productive capacities conform, which is how Baudrillard interprets him; he says: in the process of collective self-objectification through work, we collectively construct both needs and their satisfactions simultaneously.

At this point we can start to see what this discussion of the concept of 'need' has produced.

Crudely speaking, two opposing conceptions have been stood up against each other. In Doyal and Gough we can see an attempt to construct a theory of need from the basics of ethical possibility: here need is both what makes ethics possible and what ethics demands. We saw that it partially fell foul of the fact of the moral division of humanity into groups: the ethical universal which Doyal and Gough made the centrepiece of their theory could not, in practical terms, become a real universal guide to action as a result – or any rate not in the context of any set of social relationships with which we are so far familiar. On the other side, there is Baudrillard, according to whom (the entire theory of) need is an elaborate disguise for the self-valorization of political economy; and in general – in post-structuralist or post-modernist theory – 'need' is rejected as a false category, yet another attempt to provide a foundation for a universalizing theory. It is arguable that the Marxist tradition occupies a half-way house between these two poles, where need is not universal

and foundational but nevertheless a transhistorical reality. It is not universal and foundational because there is no such thing as 'need' per se, there are only ever the various different types of needs. 'Necessary needs' are the point at which human labour in its objectified form returns to confront us with our capacities and our desires made concrete; 'radical needs' make present to us the demand for, and the possibility of, as yet unrealized capacities and satisfactions. 'Radical needs' are never purely empirical entities, they are always entities that exist as valuation.

One element of Baudrillard's critique of Marx, however, escapes these strictures. Making the human capacity for work – the meaningful transformation of the man/nature interface – into the crucial feature of humanity limits human transcendence to a narrow band (Baudrillard 1981: 136; 1975: 45). Transcendence in this model is no more than the capacity to realise value-in-use, whereas it is clear that human transcendence in fact takes on many forms. For Baudrillard, these are summarized in what he later calls 'symbolic exchange', but they can also include, centrally, communicative competence, which does not conform to the 'work' model, in which it is transformation of material that demonstrates the capacity for transcendence (Benhabib 1986). Central to such an expanded model of transcendence is the capacity for valuation in general, in other words the (desire for an) ethical dimension to human life.

NOTES

1 Marx later shows how two apparent exceptions are not really such – land and capital, in the form of rent and interest.
2 Marx's argument is infinitely more complex than this, but insofar as the nature of the commodity is central to his argument this oversimplification is not a fundamental misrepresentation. For a rejection of the centrality of the commodity to Marx's argument, see Negri 1979.
3 Moreover, his comments are not out of line with recent design histories arguing that the differences between the Bauhaus and apparently opposed schools are less than has often been proposed; see e.g. Sparke 1987.
4 On this point there is agreement between Baudrillard and Heller, for the central agenda of *The Theory of Need in Marx* is that the Communist Party is wrong to claim that it knows more about what people need than people themselves.

REFERENCES

Appadurai, A. (1986) *The Social Life of Things*, Cambridge: Cambridge University Press
Baudrillard, J. (1975) *The Mirror of Production*, St Louis: Telos Press
—— (1981) *For a Critique of the Political Economy of the Sign*, St Louis: Telos Press
Benhabib, S. (1986) *Critique, Norm and Utopia: A Study of the Foundations of Cultural Theory*, New York: Columbia University Press

Campbell, C. (1987) *The Romantic Ethic and the Spirit of Modern Consumerism*, Oxford: Blackwell

Douglas, M. and Isherwood, B. (1979) *The World of Goods*, New York: Basic Books

Doyal, L. and Gough, I. (1991) *A Theory of Human Need*, London: Macmillan

Heller, A. (1976) *The Theory of Need in Marx*, London: Allison & Busby

Marx, K. (1973) *Grundrisse*, ed. and trans. M. Nicolaus, London: Penguin

Negri, A. (1979) *Marx au-delà de Marx*, Paris: Christian Bourgois Editeur

Sparke, P. (1987) *Design in Context*, London: Quarto Books

Whitford, F. (1992) *The Bauhaus: Masters and Students by Themselves*, London: Conran Octopus

Part II

Chapter 11

Introduction to Part II

Mo Dodson

This section of the anthology turns towards an analysis of particular artefacts and their contexts of production and consumption. A feature common to all of the essays is the shift from an emphasis on the material properties of the artefacts to their role within a process of communication and within the social relations established by this communication. This shift in emphasis does not preclude a focused engagement with the materiality of the artefact, indeed each essay depends to some degree on what used to be called 'stylistic analysis'. But it is the artefacts' function within a social network that takes precedence here, and this would seem to suggest a bias towards a relativist view of the designed object, and against a universalizing aesthetics. The two essays dealing with what would be traditionally labelled 'fine art' – Bender's and Boys's – do not even attempt to refute the relevance of the categories of art or aesthetics to their subjects of study. Nevertheless, this apparent bias does not necessarily preclude aesthetic analysis, but it would need to be an analysis that goes well beyond the sophistication of either Timpanaro (materialist aesthetics) or Scruton (idealist aesthetics). A tentative direction for such an analysis would presumably have to focus on the processes of communication itself, underpinned perhaps by a model of universal 'grammars'. But this would take us back to the structuralism of Chomsky and Lévi-Strauss, and this is an intellectual journey that most of us would be reluctant to book tickets for, as the booking agent might not be able to guarantee us return tickets! The essential problem facing those 'ancient' structuralists was 'history' – how could their 'structures' include the dimension of time? The failure to produce an adequate answer to that question has resulted in three long decades of post-structuralist demolitions not only of the notion of history in any usable sense, but also of the notion of structure itself. This section of the book therefore reflects what is perhaps a general mood of theoretical caution, and a more respectful or sensitive return to the 'empirical' inflected by theoretical sophistication, but unwilling yet to reach for any totalizing (or universalizing) explanations.

Miller's article can be read as an attempt to discover in modern con-

sumer culture an active, 'authentic and profound' creativity on the part of the consumer. This reversal of the longstanding conception of the consumer as a passive recipient of ideologically saturated messages (or as a 'spectator' in the writings of the Situationists and of Baudrillard) is not entirely new. Pop art and the French resurrection of the Hollywood B Movie in the 1950s can be seen as the beginnings of a transformation of the consumer of mass culture into the 'practitioner' of popular culture (the consumer as a kind of latter day folk-person whose appreciation of Elvis Presley or David Bowie was equivalent to the respectful attention given to a rural ballad singer by his fellow villagers). Though easily satirized, this 'tradition' of mainly leftist celebrations of the consumer of popular culture has achieved notable landmarks on the intellectual horizon of the last three decades, from the early participant observation studies of the Birmingham Centre for Cultural Studies to the elegant 'poetics' of Dick Hebdige and Iain Chambers. Miller's essay is also perhaps part of a broader intellectual perspective that was developed by Mary Douglas: the dissolution of the boundary between 'primitive' and 'modern' cultures. A key notion that Douglas attacks is the idea, widely held, that primitive societies made and exchanged objects in a more social and 'authentic' way than did modern societies where the production and exchange of objects is trivialized by a thorough-going commercialization.

Miller takes up Douglas's project, arguing that people do not need to produce their own artefacts in order to construct (to 'objectify') their experience of the world through the use and display of these objects. Miller's use of the ex-slave society of Trinidad as a case study does give him the opportunity to argue that the people he is studying have been radically cut off from their traditions, and that their reliance on the modern world of consumer durables produced outside their own ethnic boundaries is a pure form of modern consumerism. The core of his argument is that the two contrasting modes of consumption he has observed in Trinidad are both 'fashion' in the sense of being susceptible to rapid change, a change often stimulated by new products; but, Miller argues, these fashions in consumer durables are used not only to reflect but also to construct social relations and the subjective experiences that accompany these relations. Although Miller sees this as the epitome of modernity and/or postmodernity, an alternative reading of Miller's findings might focus on the generative principles of an oral culture surviving the slavery period and being used in the modern period to construct social relations that in many ways are continuous with an 'ancient' orality (i.e. primitiveness) while fully modern/postmodern in the sense of being completely cut off from any conscious sense of history or tradition that is anything more than a fictional construct (e.g. Rastafarianism).

Stella Newton's *Health, Art and Reason*, from which is extracted her contribution to this volume, broke new ground when it was first published,

and the issues it raised still deserve close attention. Her project was to demonstrate how small nineteenth-century elites attempted to reform dress-style to bring it in line with three inter-related principles: artistic (aesthetic) beauty, rationality and hygiene. From Mrs Bloomer's rational and hygienic bloomers to Pre-Raphaelite 'aesthetic' dresses, these nineteenth-century reformers enacted a 'drama' that is endemic to modern societies – the attempt to combat the sense of a transient and trivializing culture mediated through commercialized consumption ('fashion') by reference to universal aesthetic, rational and moral principles. One fear that these reformers have is that 'fashions' take a popular hold because of an irrational desire that people have to be like other people no matter what the cost in comfort or health. Even worse, it might be that fashions articulate and stimulate a sense of playful, wasteful fun. 'Fashions' can appeal to the crudely and locally sexual rather than to a more spiritual and universal beautiful as seen in great art (including Pre-Raphaelite paintings).

Newton's book shows how the appeal to the universals of artistic (aesthetic) beauty and reason in dress-style could combine powerfully with a moral and reforming zeal. The appeal to health or hygiene could be seen on the one hand as rational – bloomers or pantaloons did not scrape the filth and ordure off the streets and into the living rooms as did the long dresses of the period – and on the other hand as 'natural', fitting the natural contours of the 'body' so as to achieve free movement. This was a powerful combination. The appeal to the 'natural', what 'nature' intended, not only looks forward to a variety of twentieth-century movements, social and intellectual, but also backward to a classical formulation where Nature (the Ideal or Intended Ideal underlying surface phenomena), Beauty (the aesthetic) and Good were apprehended in their tripartite totality by Reason. The eighteenth-century painter Reynolds attempted an attack on fashion that prefigures many of the attempts made by the nineteenth-century dress reformers Newton deals with in her book (for Reynolds, see chapter 9 in this volume).

Newton's skilful narrative demonstrates how the dress-reformers' attempts to construct a universal style, free from the vicissitudes of commercial fashion and fun, were continually subverted as the market recuperated and used these reforms to create *new* fashions themselves – a story that was to play itself out in the twentieth-century with the universalizing efforts of modern art, when advertisers incorporated Cubism and Surrealism into their advertisements, and young women wore Mondrian coats and dresses in 'swinging London'.

Newton is careful to situate this dress-reform movement within a wider set of reform movements, from Reformed Design (a movement that provoked the Great Exhibition in London) to social and moral reform. And underlying all these reforms is their 'naturalization' through various

appeals to the body, to a 'universal' rational faculty and to a universal morality (a chain of logic that also runs through the thought of nineteenth-century philosophers such as Kant, Hegel and Marx).

Briggs and Cobley have used a by-now familiar marketing technique – 'focus groups' – to explore as far as they can within a professional context some of the most recently debated issues in audience-ethnography, reception theory and reader-reception analyses.

Focus groups involve, crudely speaking, interviews with varying degrees of moderator involvement with four to twelve people who are considered to be representative of a potential market or segment of a market for a particular product. The creative use of this technique by media theorists such as David Morley not only to gather empirical data but also to inflect debates about the contexts and uses of mass media artefacts has in the last decade and a half brought about a strange, perhaps post-modern, entente cordiale between advertisers and cultural theorists – two groups of cultural workers who for sometime regarded each other with suspicion, if not open hostility.

Briggs and Cobley's research has revealed interesting attitudes among British youth not only to AIDS, but also to the media itself. Starting with a simple binary opposition in their subjects' response to the media – realism (recognizable but boring) and fantasy (attractive but irrelevant to lived experience) – Briggs and Cobley demonstrate how these two categories can be mixed to make arresting and seemingly relevant images for young people. News reports (realistic) of famous people (glamorous and 'mythical') can be both arresting as well as relevant; and if the famous people are stars of fictional (fantastic) but everyday narratives like soaps (realistic) then even better.

It is interesting that this research was originally carried out as a professionally commissioned project to assist the design of an AIDS awareness campaign. Briggs and Cobley's successful combination of up-to-date marketing technique with the most sophisticated theoretical frameworks available to date in cultural studies indicates not only the originality of the project itself, but also a potential point of growth where audiences can take more control over the media artefacts designed for them through well-established commercial techniques of marketing – and, moreover, a type of control that allows for a much more precise response to the audience's subjectivity. It is difficult to imagine how a universalizing aesthetic analysis could easily penetrate this feedback loop between audience and media campaign designers.

Barbara Bender's essay pursues one of the most interesting interpretations of the cave-paintings of the Upper Palaeolithic since Leroi-Gourhan's structuralist analyses. The starting-point of her analysis (we have had to omit, for reasons of space, most of this preamble) is a critique of the, by now, well-known thesis that the development of societies with

complex divisions of labour, status, privilege and power ('complex societies') was initiated and upheld by the technological innovation of agriculture. This model of the economic determination of social development dates back at least to the eighteenth-century, and is one that still finds vigorous support among some contemporary anthropologists (e.g. M. Harris).

One of the notions about pre-history taken for granted until recently was that complex, unequal societies did not occur until agriculture or husbandry appeared as well. The causal relation between the two phenomena could be argued about, but the coincidence of the two phenomena was more or less accepted. Bender goes further than a critique of the supposed causal relation between economy (agriculture) and society (complex and unequal). She disassociates the temporal coincidence of these two 'moments' in (pre)-history. Her analysis pushes the 'development' of inequality further back, well before the first occurences of agriculture, into the Upper Palaeolithic (c. 35,000–10,000 BP).

The core of her argument is that sometime in the middle of the Upper Palaeolithic (c. 17,000 BP) males began to exclude females from important rituals, some of which involved cave-painting. These rituals were keystones in a system of knowledge and power that in turn determined the way in which resources were used and distributed. Excluding women from the physical arena, and the production of the cave-paintings, was, Bender argues, a method of achieving differentiation and distinction for the men. This instrumental use of culture is one that Bourdieu has characterized with the phrase 'cultural capital' – 'cultural capital' being the possession of a particular set of cultural skills and tastes (e.g. the ability to appreciate 'great literature') that enable one to achieve status and to wield power within specific social, economic and political hierarchies.

Bender argues therefore that genetic, environmental and technological forces cannot be used to account for social conflict and inequality. An implication of this argument (an implication that Bender does not consider in this essay) is that conflict is an inherent quality of human relations that will amplify itself until we have, through a combination of theory and practice (including the practice of conflict itself), reached a different 'level' of human 'being'. Given Bender's (and Bourdieu's) analysis of cultural artefacts, it might be further argued that art and design cannot be considered, yet, outside the context of political conflict in the widest sense of the phrase, a context of conflict that extends back at least to the Upper Palaeolithic. Thus, Palaeolithic 'art' is not only reducible to the status of 'design' (i.e. locally functional) but also subsumed under a much longer historical process.

One of the most interesting conjunctions in the history of European art is the meeting place of the artist and the engraver who translates the artist's paintings into a scratched or burned or marked plate (metal, wood

or stone) that can be used to print hundreds of copes of this 'translated' copy of the painting, to be sold in the market-place. This process of 'reproduction', or the mass reproduction of a visual image, starting as far back as the fifteenth-century in Europe, requires us to look at the inter-relation of phenomena we normally associate with nineteenth- and twenti-eth-century media history: the market; authorship; the uniqueness or aura of the one-off image as against the reproduced and 'democratized' image; the explosion of 'museum culture' into the larger environment, the 'museum without walls' in Malraux's telling phrase; the hyperreal of Baudrillard; and the high social status of the artist, as against the crafts-man's lower status. The 'copying' of paintings via a black and white or tinted print (usually made with 'lines', but also with patches of half-tone shades in the eighteenth-century) became, by the sixteenth century, one of the main channels for disseminating artistic styles. Prints of paintings by Renaissance artists travelled north, influencing not only such artists as Dürer and Bruegel, but also many lesser-known painters (architectural prints also circulated, ensuring the spread of the classical style), and by the eighteenth-century pattern books of prints of consumer durables were produced for manufacturers.

Fyfe's article focuses on a particular moment of the relationship between painter and engraver of the painter's painting, when the engravers finally lost the battle to achieve some status as artists, or at least 'artistes', in their own right. A similar meeting between composers and musicians who performed a composer's work had occurred by the eighteenth century, but musicians eventually won a discrete status of their own, their interpretative performance of the composer's 'original' being much more crucial to the existence of the composer's work. Some artists of course had done their own engravings using the plate as a medium for an original work, and this artistic printing was taken to its logical climax in the invention of colour monoprinting by William Blake in the eight-eenth century – Blake would paint an image onto a page and then press a one-off image in reverse from the original wet image. Monoprinting is now a standard technique taught to fine art students. This tradition of art engraving has survived in a transformed manner in twentieth-century art photography, while the humble engraver who translated the original works of painters has no twentieth-century counterpart – the skilled technicians who now supervise the reproduction of images in publishing are regarded merely as technicians and their performances never provoke the public applause that almost any musician who interprets another's musical composition with technical competence can expect.

Cheryl Buckley's fascinating exposition of two radically different inter-pretations, both positive, of Susie Cooper's pottery-making and designing offers us a rare glimpse of the way in which the same artefact can be 'read' in the same period as having two entirely different meanings,

both internally consistent, both forcefully persuasive in a way that even authoritative 'readings' of modern and postmodern art and design are rarely persuasive. And, Buckley persuades us, both in themselves 'wrong'.

Cooper both established a pottery company and designed for this company in the 1930s. Her successful business administration was closely interrelated with, but separate from, her success as a designer. Her designs were interpreted as subtly 'feminine' while being innovative by critics writing in trade journals, who admired her business acumen as well. Nevertheless, these admirers were firm in their categorizing of Cooper's designs within the traditional sphere reserved for women potters, decorative surface design rather than shape and three dimensional form, which were the preserve of male potters in the industry. Intriguingly, modernist critics and theorists like Pevsner emphasized Cooper's 'masculine' design skills in the integration of function, form and decoration.

Neither of these interpretations, Buckley argues, were adequate. Cooper's ability to chart a reasonably successful route through the complex system of manufacture, marketing and consumption patterns deserve, according to Buckley, due weight in an evaluation of her importance. Cooper had to navigate an industry that Buckley amply demonstrates to be heavily weighted towards male-domination at all levels of training and responsibility, and which was simultaneously put under stress by an unstable economy, technological innovation, stylistic change and new marketing techniques. Most of us have heard of Bernard Leach, and a few of us can picture a Leach pot in our mind's eye. But the gender imbalance both in industry and in design history has ensured that Cooper's work is relatively unknown. This gender bias is supported by a bias towards fine art as opposed to applied art, and especially against applied art that has achieved commercial success. Buckley's article opens up for inspection a whole set of interesting problems that converge on 'the designed object': mass production; gender-bias in design, production and distribution; and the ambiguity of the material form of an object when an attempt is made to assign meanings to that form based on its 'materiality' alone.

Over the last two decades, architecture has come in for a lot of critical discussion from every quarter imaginable: royalty, tabloid newspapers, ecologists, anarchists, feminists, community architects and, of course, that raggle-taggle army of cultural theorists who range from the arch-conservative to the arch-postmodern, from the dead-pan serious to the outrageously sarcastic. Architecture is for the eco-anarchist something that should be practised by the consumer only. Historians of vernacular architecture often give their qualified approval of such a view, based on painstaking field-work and social-historical research. Community architects have evolved complex systems of planning with end-users and post-production feedback and evaluation, allowing a practical participation of the consumer in the production process. The self-build movement, aided by

architects and pre-fabricated parts manufacturers, is an example of this approach. Ecologists have also drawn on new technologies, and energy self-sufficient housing is now almost available to anyone who has the credit-power to buy an averagely-priced house.

But two of the most egregious critical (and sometimes practical) movements to emerge in architecture have been the feminist critique and the 'Deconstruction movement' (based on J. Derrida's writings) that shifted many discussions of postmodernism to side-stage in the late 1980s, adding a philosophical seriousness to a debate that was in danger of sliding into tabloid superficiality. Deconstruction injected post-structuralist philosophy into the theory (and some practice) of architecture. Any theorist, and many architects, felt it incumbent on them to master a great deal of the post-structuralist perspective in order to argue their own case.

Feminists in the 1980s, on the other hand, had come out of an exciting and fruitful period of art-historical and social-historical reconstruction. Theories of female domestic space versus the public sphere of masculine activity had given feminists some very strong footholds in the critical debates around modernist and postmodernist practices, demonstrating the pervasiveness of a patriarchal ideology within built space and place.

Boys's article takes up this debate around the notion of 'representation' as it is, and has been, applied to architecture and planning. She weaves a complex narrative though postmodern theory, concluding that to use the notion of 'representation' as both a principle of production and a tool of interpretation leads to distortions of both. Architecture, like other cultural activities, 'is a struggle over cultural and socio-economic resources', and the 'meanings' of architecture must in some way be seen as part of this struggle and not just as 'associative abstractions of visual and spatial representation'.

Chapter 12

Fashion and ontology in Trinidad

Daniel Miller

INTRODUCTION

A title of this nature invites the accusation of pretentiousness. This would follow the juxtaposition of two terms, fashion and ontology, which ordinary discourse would construct as opposing ends of a spectrum of social phenomena. Fashion is often taken as the most superficial content of social activities, ontology the deepest and the least susceptible to an analysis as mere content. Fashion is therefore one of the least promising candidates as a vehicle for ontology or even as having ontological consequences. The juxtaposition of the two stakes the claims of this paper, that is to equate modes of consumption with an understanding of the fundamental nature of being.

There is, however, one tradition at least to which such a juxtaposition would not seem so strange, and this is the discourse over the nature of modernity. Familiar from writers such as Simmel and Benjamin, this has recently re-surfaced around a now highly fashionable term 'post-modernism'. In the traditions of this discourse the linkage between the two terms is quite easy to recognize. Whether it is Simmel talking about the outstripping of subjective culture by objective culture, or recent writers talking of a loss of authenticity under the conditions of late-capitalism, fashion is held up as a mechanism which accentuates all those elements of the modern condition, its fragmented, transient and superficial nature, which seem to result in almost a quantitative loss of being.

In this discourse fashion is then highly relevant but its consequences are well established and relate entirely to the negative side of modernity. By contrast, this paper will use an ethnographic case-study to argue that fashion need not be regarded as intrinsically antagonistic to authenticity, but may be the cultural vehicle through which ontological forms are constructed and understood. The problem is rather with the ethnocentric nature of our dominant metaphors for such discussion. As long as we think of being in terms of depth and permanence, and fashion in terms

of superficiality, it will be very hard to regard one as an appropriate mechanism for the objectification of the other.

It is surprisingly hard to find discussions of fashion which investigate in any detail its implications for the more profound consequences of modernity. Even Simmel who (often seen as the original sociologist of both), in an article which specifically addresses fashion (Simmel 1957), emphasizes a more general question of the relationship between individuality and sociality, rather than what might have seemed a more promising extension of his studies of the tragic contradictions of modern life whereby we attempt to appropriate a material culture that has grown to such an extent that we can no longer assimilate it (Simmel 1978). Most other accounts can be divided into three classes. Those (e.g. Bell 1976; Veblen 1970) which emphasize the use of sartorial forms as status symbols; those (e.g. Barthes 1967) which examine the internal structure of fashion as code; and those (e.g. Ewen and Ewen 1982) which critique fashion as the vehicle of capitalist control over consumption behaviours.

Wilson (1985) provides a recent summary of British work on the subject, and in her final chapter goes beyond these authors to address this more general question of authenticity through an examination of the extremely interesting relationship between fashion and feminism. In her work fashion is allowed a major role as an expressivist medium potentially both exemplifying but also confronting the key problems of alienation and identity in the modern world. Out of all the various attributes which fashion is deemed to possess this present paper will attempt to emphasize those which seem to determine its specific nature, that is its relationship to time and change, but also its implications for individualism, competition and order.

My aim is not to undermine the critiques which are being made of the fashion industry, but to argue that these relate essentially to the mechanisms of capitalist forces themselves. If, however, some alternative is to be sought to the conventional mechanisms which link production and consumption, then we might start by looking at alternative forms of consumption. As I have argued elsewhere our best place for such a task is not in grand schemes of alternative worlds, but through an investigation of the actual forms of consumption which by their very existence under the difficult conditions of the present, offer a more feasible guide to future possibilities than do more purely theoretical models (Miller 1987: 206–14; 1988).

This clearly suggests a rather unusual role for anthropology. In the overall discourse on modernity, anthropology tends to provide examples of the authentic and inalienable in societies as remote as possible from modern life to provide, for example, the model of the gift as against the commodity society (Gregory 1982). By contrast, the aim of the fieldwork

described below is to examine a society in relation to the comparative and relativistic nature of modernity itself.

TRINIDAD

This accounts for the particular choice of Trinidad. The West Indies were founded upon slavery and indentured labour. As such, the majority population emerged from an extreme form of rupture. Slaves from different parts of Africa were deliberately brought together and thus regional cultural forces dissolved as quickly as possible, a strategy which contemporary marriage patterns suggest was largely successful (Higman 1979). Plantations in the West Indies were created as a deliberate periphery to the metropolitan core. In Trinidad the slave population from Africa was complemented by indentured labourers from India who were brought in to work the sugar plantations following the emancipation of the slaves. These two features, the rupture from tradition and the pure form of a peripheral economy make the West Indies perhaps the first and potentially clearest example of a 'modern' society.

What makes Trinidad a particularly suitable site for a study of fashion is the oil-boom which took place between 1973 and 1981. The phenomenal rise in incomes during this period appears to have been relatively widespread in its effects compared to other oil-boom countries, so that for a short period one is able to view the consumption patterns not only of the wealthy and nouveau riche but also of what may be called the habitual poor, people who are brought up in poverty and now with recession have returned to poverty, but who for a short period were able to obtain resources to construct consumption forms which allowed them to realize cultural projects that would normally not be visible under the constraints of scarcity.

The study was based on four communities within the small town of Chaguanas (the birth-place of the novelist V. S. Naipaul) and all symptomatic of the expansion of that town in the oil-boom. In general, Chaguanas has been a centre for the ex-East Indian population, but is now home to a large number of ex-African and mixed groups so that the ethnicity of the field study area reflects that of the nation as a whole (approx. 40 per cent ex-East Indian, 40 per cent ex-African, 20 per cent mixed with a dozen other points of origin). The four communities comprised Newtown – a government housing scheme populated mainly by public service workers imported from the capital and elsewhere, St Pauls – a village incorporated into the town, Ford – a large squatting area including immigrants from the smaller Caribbean islands, and The Meadows – a middle-class residential area, the wealthiest in the district.

What is emerging from the fieldwork is the development of two forms of consumption which I will first present as a duality in the material

culture and then link this to wider cultural forms. These may be general-ized as a 'transient' mode and a 'transcendent' mode.

THE NORMATIVE LIVING ROOM

The 'transcendent' mode first emerged from an analysis of 800 slides taken from 130 living rooms in the four communities studied, alongside more general interview information. In brief, the normative living room which emerges from a study of the slides is a polythetic category which tends to contain a number, though rarely all, of the following attributes. The floors are carpeted, often with the high pile carpet locally termed plush. The furniture consists of thick foam-based seats covered in a fake velvet arranged in sets of one or often two couches plus armchairs often providing upholstered seating for eight or more people. The dining table has a dark veneer as often do the dining chairs which have ornate spindle backs, upholstered seats and sometimes also backs. Adverts speak of 'padded high backed chairs in fine Belgian fabrics'.

The furnishing will be in the main maroon (actually a variety of shades from burgundy to red but clearly of a general type), the main alternative to this is a range of gold to brown shades. These two I would guess may account around 80 per cent of all furniture. The maroon of the upholstery may be picked up in curtains, carpets, coverings for tables, artificial flowers such as roses and countless other decorations, amounting to a general 'any colour as long as it's maroon' principle, or its equivalent in gold/brown arrays.

Artificial flowers are extremely common, often set into elaborate arrangements with perhaps half a dozen examples within the living room. When flower arranging is quoted as a hobby it is these artificial flowers which are being referred to. Such displays may be supplemented or replaced by house plants. There is a buffet which is a glass-fronted cabinet filled with china and glassware. It may also have internal lining of white or maroon plush. A key piece of furniture is wooden shelving linked by spindle legs in two or three layers. It is called, somewhat inappropriately, a space saver (equivalent to the English 'what not'). Apart from holding stereos (with associated records and tapes), televisions and videos, their main function is to hold an array of ornaments, which in the normative type are very abundant indeed. The most common decorative ornament is a swan, but one also finds cats, dogs, chickens, peacocks, eagles, stallions, dolls, etc. There may be sports trophies, and still more common are one or more sets of encyclopedias, but not novels. Somewhere in the room will be examples of what are known as stuffed toys or animals, such as teddy bears, dogs and rabbits. As confirmed by a market research, these are for decoration rather than children's play and commonly appear with the cushions on the sofas.

Wall decorations will be dominated by a machine-made tapestry with a religious theme, such as the Last Supper or a mosque, or a secular scene such as puppies, or toddlers. Fake oil paintings with gilt surrounds will almost always be of scenes of coniferous forest glens, e.g. with deer and a background of snow-capped mountains. Prints with a West Indian theme would very rarely be found in the normative living room. Equally common are plates with decorative edges, and brown ceramic plaques with homilies both religious and secular. Other features may be: certificates such as educational qualifications or long service awards; brass plates with Portuguese/Dutch style merchants associated with taverns or sailing ships; Mother's Day paraphernalia such as certificates of best mother or homilies on mothering in common, sometimes including a photo of the person concerned. Equally important are calendars, often with a religious theme.

In low income homes, wall decoration may rely more on cuttings from colour magazines, where bronzed European or American models are found, or local models from the more salacious weekly newspapers. In such homes particular ornament styles such as a plastic red rose set in a glass dome are common. In all areas family photographs are common and are dominated by either wedding pictures, usually of the couple who own the property, deceased relations or young children. Souvenir pictures and plates are also found, by far the most common being of Toronto.

A feature of the normative type living room is for things to be covered over; this includes 'throws', that is a sheet or piece of cloth thrown over the couches and armchairs and removed to reveal the upholstery only on special occasions, if at all. As an alternative the upholstery may be covered by clear plastic so that one doesn't sit on the actual surface. 'Lace' covers or doilies are found over the head position on couches and armchairs, also over tables, shelves, loudspeaker tops, videos and indeed any exposed surface. A notable feature of some living rooms are items such as stuffed animals which are displayed within their original plastic wrappings, or dolls kept in their original boxes. Here the covers may have accumulated so much dust as to barely reveal their contents. In the bathroom an ubiquitous item is the five-piece set of covers, with the cistern and the spare toilet roll commonly covered.

The above is a brief summary which can obviously be elaborated. The result is a normative tendency to which only a proportion (though a majority) of houses would actually attempt to conform. In general, three main features may be synthesized from this material. First, the idea of 'transcendence' emerges from a preference for artificial things which are viewed as long-lasting, and things covered over which are seen as 'cherished' for the future. This combined with the accumulation of ornaments and the deep pile plush and upholstery provides a general enclosing and incorporative sense of creating and filling a space with a series of layers.

Second, although the furniture itself may be pricey, the general effect is not a display of conspicuous wealth or status symbols since the bulk of ornamentation and decoration within this normative style is usually of the cheapest variety. It is rather conformity to a type. This is confirmed by conversations with local Chaguanas shopkeepers, who may be exasperated by finding that often the known wealthier customers are uninterested in the more costly items but want the cheapest example of a given category, while it is often the less wealthy customers who look to the more expensive ornaments. Conformity here is not to be equated with lack of availability of diverse goods, or a constraint posed by what the shops will stock. In oil-boom Trinidad, many of these same householders had easy access to prestige goods and ornaments from countries such as the United States or Venezuela, and going by verbal accounts alone one would expect far more evidence of these links within the home.

Finally, in turning to the symbolic content as opposed to form there is the juxtaposition of several themes. Symbolism centres on pictures related to religion juxtaposed with scenes of family, especially weddings, and a subsidiary theme is education represented either as encyclopedias or certificates. Cementing the links between such themes are the scattered homilies with their general sense of an expressive morality.

In general, neither ethnicity nor class emerge strongly from this analysis. The bricolage uses material from West African, East Indian and colonial sources to construct its own normative form. Poorer areas such as the squatters do not usually have the quality of possessions but the torn coverings on the foam, and the plaques and ornaments, suggest an emulatory aesthetic and no evidence for an oppositional taste complex of the type found by Bourdieu in France (Bourdieu 1984).

CLOTHING

Forms of clothing that relate most consistently to the normative living room are associated with women's clothing at life-cycle events such as weddings or christenings and also religious events such as attendance at church or temple. Clothing for such occasions is marked by shiny surfaces (as opposed to the matt of informal attire); preferences may be for silver, gold, metallic greens, blues and reds, and shiny or slinky black, pearl and white. The covering-up aesthetic is continued into this arena with the considerable use of layering and rucheing (gathering up in layered crescents) in dress and skirt patterns, always complemented by stockings and high-heeled shoes. Stockings appear to be one of the key emblems of a more formal dress, which carries over to work situations. Shoes also must be appropriate, the tendency being to wear closed-in forms for church and open toes for leisure. There are variants to this, for example, the dress code for elderly females and for young girls of East Indian

descent is based around white and pastel dresses with an abundance of frills, flounces, bows and lace effects. These forms are not shiny but equally are quite distinctive from the matt informal wear of most other groups. Young women would also vary the basic code by using similar fabrics but creating slinky low-cut or body-hugging dresses or striking combinations of, for example, black blouses and silver skirts complemented by highly conspicuous displays of elaborate costume jewellery.

The analysis of such dress forms is complicated by two apparently opposing tendencies. On the one hand, these are precisely the kinds of occasion at which many people felt it is essential to wear a new and exclusive dress. Informants felt they could wear such a dress twice if the wedding or christening was held at opposing ends of the country or if they knew that the people in attendance were quite separate, but on several occasions during the year's field-work friends did not attend a function because they felt they could not afford the requisite new dress owing to the recession conditions. Interviews with several seamstresses confirmed this tendency. This is also an area where (in contrast to the living room) the direct expression of wealth through the donning of conspicuously expensive apparel is encouraged.

Despite all this, however, attendance at a few such events reveals a striking degree of conventionality and repetition. It is as though nearly all the clothing is made from a few agreed elements of material and design. The use of shiny surfaces of rucheing, slits and straps are simply recombined so that one works merely with the permutations of this highly restricted set. Indeed, often the dresses themselves appear as patchworks of elements with a silver lozenge set within a pearly-white layered bodice, for example. Amongst the older generation, in particular, these are associated with wide-brimmed hats of similar shiny materials. The result may be new but not novel and is therefore still conventional. The players act competitively but within constrained and agreed parameters of display, such that again it seems reasonable to talk of a normative form.

Here then the idea of newness is accepted as an expression of individual competition but in a manner which does not encourage genuine innovation. This is also reflected in the response to another kind of fashion, the new ideas for women's clothing which break like waves over the island's shores during the course of the year. Examples were exceptionally wide belts or belts with butterfly clasps, treated denim such as acid wash or individually painted T-shirts and dresses. Those who emphasize the normative fashion are not vanguard in their acceptance of such fashions, but it seems that if the style reached a kind of critical mass then virtually the entire community acknowledge it through purchasing at least one representative item, as indicated through the survey questionnaire. In a sense by doing so they suppress the threat of disconformity through the ubiquity of acceptance. They have turned the new into the conventional.

This is reflected in a dichotomy noticed by workers in marketing research. In their analysis of regional difference the central area and south are seen by the major companies as areas of high brand loyalty, such that the name of a brand was usually synonymous with a product range: all toothpaste is . . . etc. This was associated with general stability compared to the capital but when change came it came quickly and massively. The previous dominant brand was drastically reduced and a new brand emerges so that the beer which was always brand A is not brand B, etc. The pattern seems closer to the cusp image of catastrophe theory than the more familiar lenticular curve of product diffusion. Retailers gave many examples; a paint shop recorded how a new set of colours known as off-whites had come on to the market some four years previously and had occasioned such a massive shift in demand that within a couple of years they had accounted for three-quarters of the local market with all remaining colours relegated to the quarter share.

Another way the transcendent mode operated was through stylistic unity across fields. The importance of upholstery in the living room has been noted. By far the major industry in Chaguanas was also based on upholstery but this time car upholstery. The three very large establishments devoted to this craft dwarfed most other commercial enterprises. Today they are mainly engaged in repair work and taxi work, but in the oil-boom the industry was centred upon new cars which had their purchased upholstery stripped and replaced with new upholstery, for example fake tiger or snake skin or a leatherette stripped in blue and silver and marketed under the label 'New York by Night'. As with living room couches such car seats are often 'protected' by clear plastic coverings. Upholstery also features in another commercial enterprise in the area: the production of coffins and caskets which are almost always lined in deep upholstery. Upholstery as a form of interiorization may be matched in a wide variety of other areas from an emphasis on elaborate cake decorations to the housing forms in the middle-class area with their layers of grass verge, gates, guard dogs, porch and interiors.

THE OTHER SIDE

The sartorial relations which relate to an alternative mode emerge in a form which might be termed style rather than fashion. One of the differences between these two is that style appears as a highly personalized and self-controlled expression of particular aesthetic ability, as opposed to the dissolution of individual identity through the appearance in a strictly conventional if internally diverse category of appearance. In the transcendent mode there is relatively little concern with how a costume is put together; the effect is more like a checklist in which elements such as rucheing or silver are present in the composition. With style, however,

there is the search for the particular combination of otherwise unassoc-
iated parts which can be combined to create the maximum effect. Here
originality is a major criteria of success as is the fit to the wearer. Thus
the bearing of the person, the way they move, walk, turn and act as
though in natural unity with their clothes, is vital to the success of the
presentation.

The distinctions are easier to view in men's clothing. In general men
are much more resistant to the development of separate conventional
clothing firms for major functions. At a wedding, the best man and closest
relatives may appear in a suit though often with some flamboyant element
such an extravagant bow tie which distinguishes this from the merely
conventional suit. Other men, however, wear clothing which is only
slightly more formal than daily wear, appearing in well-creased, belted
trousers and sports shirts (termed jerseys) and buttoned shirts. In general
these would be similar to clothes worn for work. Some of these same
men will, however, embrace a highly competitive sartorial display for
occasions such as fetes and house parties. Here the key elements are
shoes such as designer trainers, jeans and a wide variety of hats. Out of
this group a certain portion attempt to carry through such conspicuous
dressing into their everyday appearance. Twenty years ago such males
were termed *saga boys*; today there is no clear term but the word *dude*
borrowed from the United States is perhaps the most common label.
These males combine sartorial originality with ways of walking and talking
that create a style which is generally regarded as never letting up from
conspicuous display.

The notion of style as a personalized context for fashion items emerges
more clearly through an examination of fashion shows. These shows are
an unbiquitous feature of modern Trinidadian life, and are found at all
income levels. The people of The Meadows might go to the show of a
well-known Port of Spain designer hosted by the Lions or Rotary club,
or at a major hotel in the capital, but they also might meet people from
St Pauls or Newtown at a fashion show hosted at one of the shopping
malls, while fashion shows are also held for small fund-raising ventures
in Ford, and at many schools or church bazaars. For wealthier audiences
the models may perform as rather cold or austere mannequins; as such
they are essentially vehicles for demonstrating expensive items for sale.
This is, however, the less common form of modelling and is reserved for
the more exclusive designer shows. In most fashion shows and in all those
held by low income groups, the clothes are displayed in a very different
mode which emphasizes a unity between the form of dress and the
physicality of the body which displays them. Movements are based on an
exaggerated self-confidence and a strong eroticism, with striding, bouncy
or dance-like displays. In local parlance there should be something 'hot'
about the clothing and something 'hot' about the performance. For

fashion shows at bazaars, schools, and in Ford or similar communities, the models are not professional but local people and the clothes are either purchases of, or made by, the wearer. At these local events there is no attempt to sell the clothing and the whole ethos of the show is outside of the commercial arena. The origin of the clothing is often of no concern to the audience and nor has any intrinsic quality or monetary value. The clothing is really an adjunct to the performance itself, to the way the persons move on the stage, and the frame for the performance is established by the models being friends, relatives or schoolmates of the audience.

The concept of style which emerges from such shows comprises two main components: individualism and transience. The individualism emerges through a necessary fit between the clothes and the wearer. The person attempts to develop a sequence of sartorial forms which are seen as expressive of them and their character. The clothing is complemented here by selections of belts, costume jewelry, shoes, a wide variety of hair forms and styles, and skin tone. The aim is to construct a style which can be judged in the performance. Although they may refer to current general trends such as 'ragamuffin' style or tie-dye, they are also idiosyncratic juxtapositions of elements in ways that make the wearer conspicuous and able as against the competition. The sartorial achievement is easily incorporated into a general sense of easy accomplishment at a variety of arts, ranging from music to witty speech.

The second element of style is its transience; the stylist may take from the major fashion shifts in Trinidad but only as the vanguard. Hand-painted shirts are fine when they have yet to be acknowledged as the dominant fashion, but at that point the forms are given over to be incorporated into more conventional forms such as young teenager fashion while the stylist moves on to something new. Apart from the fete the key arena for such display is the workplace, especially for the female working in an office environment. Although the office party is particularly the occasion for tight-fitting dresses with sequins and frills to the bottom, and bare back and shoulders, the daily workplace is also an arena of intensive sartorial display and competition. Where there is a standard uniform as at a bank, small variations and alterations are still discernible that allow room for this element of transient display.

The link between clothing and transience is most forcefully expressed through carnival for which traditionally individuals constructed elaborate and time-consuming costumes which even if identical forms were worn each year had to be discarded and re-made annually. Seasonally relevant clothing may also be purchased for other events such as Christmas, or commonly a new swimsuit for going to the beach during the long Easter weekend.

The source of the originality in a sense is irrelevant; it may be copied

from the soap operas or the fashion shows which come on television, it may be sent from relatives abroad or purchased while abroad. The oil-boom encouraged imported elements when 'everybody and their tantie went to the Big Apple and returned with designer or imitation designer things', it may be simply re-combinations of locally produced elements but it is, if possible, always new and vanguard and destined for a particular occasion. In practice only certain persons can achieve these ideals but others will attempt to follow as soon as possible and at any rate before their own peers.

The desire for unique style encourages a reliance on the seamstress and tailor (or self-production) but even ready-made clothes may be altered through hand painting or additional accessories. Alternatively, imported clothes can be both ready-made and unique. Local production also meant that ideas from soap-operas or other influential television shows such as Miami Vice can be appropriated that much more quickly. The seamstress is a common figure in every part of Chaguanas. It is one of the ideal forms of work for the still often severely restricted East Indian woman, since it can be carried out at home and since nearly all women were brought up with some knowledge of the sewing machine. It is also a possible profession in areas such as The Meadows and Newtown where the house deeds do not permit much conspicuous commercial activities. In 1988 there were, however, far more people who desired work as seamstresses than those actually working as such, owing to the collapse of demand with the recession. Both seamstresses and their clients talked of the extreme demands of the oil-boom where clients were expected to have a new outfit made for every event to which they were invited. Two new outfits a week was often quoted as common for women in work.

The oil-boom also saw a speeding up of change in other areas, for example items such as drive-in movies, amusement arcades, snooker, microwaves and food processors came and went, generally leaving little trace. The continuous demand for newness, a refusal to replace with the same as last year's form, was also noted by retailers in goods such as paints and curtains. In some cases newness was closely related to increasing status and expenditure, as, for example, the oil-boom transformation in pet retailing, where mongrels were replaced by fashions for miniature pedigree dogs for women, and Alsatians and later Rottweilers for homes, all expensive breeds requiring considerable maintenance costs. Similarly local tropical fish were replaced by goldfish and other exotica; only the older tradition of training birds for whistling competitions seems to have retained its traditional forms and affectionados.

The above description was becoming increasingly invalid during the year's fieldwork as the recession acted as constraint on such strategies. This was not, however, observed as a simple correlation with wealth.

People from The Meadows often reined back on their clothing purchases long before those of lesser incomes. One group of largely unemployed males in St Pauls managed to keep a tailor busy simply because new pants remained of extreme importance even in a period of highly insecure and plunging incomes. Nevertheless, taken more generally, wealth was reasserting itself as the key criteria for determining the levels of purchases.

The demand for new clothes is often linked to the presence of a current relationship (or marriage), since the money that males are expected to provide to the females they are with, may be the source of any new clothing. But the demand for new outfits is equally strong for the single working woman, so that it is the existence of the resource rather than the relationship itself that seems to be the key to the level of purchase (though not necessarily its interpretation). The workplace is itself a key arena for sartorial competition closely followed by the fete or house party. By contrast, for most females dress codes at home are extremely relaxed and women will meet visitors in very informal attire including night clothes without any suggestion of impropriety.

The demand for new outfits may have very different consequences within the opposed frame of their appearance. Although the wedding epitomizes a normative sartorial style it is more accurate to broaden this into sections of the population who, even at other events, tend to wear clothes within the permutations of the selected range or elements, thus the newness of the event-based item is countered by the ever-sameness of the collective apparel. The clothes do represent the individual wearer in competition, but only within highly restricted forms where to go beyond the convention would be to fail within the terms of the event. For the stylist, however, the appeal is precisely to the unprecedented (at least for them) nature of the event and the appearance. Fashions may be used but they are not sufficient for the purpose which must then be supplemented by the creative ability of the wearers. This should not be exaggerated, since most individuals also have particular items such as dresses which are especially comfortable for dancing or a hat by which they have become known and which establishes a more stable personalized repertoire.

These two different attitudes to clothing re-emerge from discussions with the retailers. For example, a salesgirl at a jewelry store in one of the shopping malls noted dual strategies of shopping. On the one hand there is the shopper whose aim is to purchase an object which represents a conventional category. She wants a 'gold' earring. It is immediately clear that it matters little which particular gold earring is chosen, the main concern is likely to be price, and the cheapest item which fits the requisite category of a gold-coloured earring is purchased. The alternative shopper who probably has less disposable income wants jewelry to match an outfit, but has few preconceptions about what would work, until she has tried a

wide range of possibilities: the final outcome may be cheap or it may be expensive, its attraction may come from its fashion element or an unusual juxtaposition of a conventional form. Once determined, however, the shopper must have that particular piece whatever the cost or any other problems involved.

Here then lies the complexity of interpreting fashion since it can be both an agreement to conform and a struggle for a symbol of transience and disconformity; indeed the same object can work in both ways depending upon what point in its trajectory as fashion it is located and analysed. This complexity is furthered by the relationship of persons and events. Many Trinidadians will dress conventionally for a wedding and stylistically for a fete. Many are able to dress normatively but have little ability or desire to compete in stylistic terms. Others focus on style and either avoid occasions such as weddings or use the occasion to break ranks and offer a style-based disconformity as would be the case for the permanent dude. Obviously the aspiration to be truly original is a relative pretension and the actual competition is usually to be first within a particular group which may consist of only three other individuals.

As a means of characterizing traditional clothing norms in order to transcend them the two most common derogatory terms were *moksi* (pronounced mooksi) and *cosquel*. *Moksi* is a general term for things which look old fashioned and has related connotations of country-based as against town, or poverty-based as against middle-class. *Moksi* then is the unsophisticated backwoods look which has yet even to acknowledge its own demise or indicates the inability of the person to enter into competitive display. There is not surprisingly a resistance to such depreciation. Householders with a dominant maroon will affirm the maroon is *bright* in contrast to red. Bright, which is the term for modern, here refers back to the period when maroon did indeed replace red as the more up to date version of this colour category.

The other pejorative term, *cosquel*, is a term for something overdone or juxtapositions which fail; it is a vulgarity that indicates an attempt to style but a failure of taste. The wrong colours have been placed against each other, or an effect has been overdone and thus its possibilities lost. There are also some more general taste parameters, for example too exclusive a concern with matching colours shows wealth in that this can be an expensive project, but also a certain lack of taste, since as a retailer put it 'some who would know better, will contrast'. Terms of approval often use reverse slang, as the well dressed are flattered by being told that they are looking 'sick', 'bad' or 'cork'.

It is likely that style is an imminent tendency emerging from other areas of social life but emerging most clearly as a consumption pattern with the oil-boom. The advent of recession is a useful indicator as to the place of fashion and style in the kinds of new prioritization of basic needs

imposed by constraints on available resources. In the survey question-
naires one of the enquiries made was about shoes, and from this emerged
a pattern in which some families which appeared to be hard hit by
recession, had very little in the way of material items in their houses and
generally appeared to be struggling, still included individuals with a dozen
or twenty pairs of shoes (this despite the narrow definition of the term
shoe which excludes sandals, so that even a silver closed-toed female
footwear may not be counted as a shoe because it is flat). These persons
were continuing to spend money on new shoes where at all possible as
judged by the question as to when they last purchased a pair. Shoes are
indicative of style since the notion of the shoe matching the outfit is
central to the taste criteria applied to style, such that many shoppers
would feel incumbent to purchase new shoes for every new display outfit.
An example has already been noted of the continuing demand for new
pants amongst the unemployed males. For teenage males the equivalent
would be demand for designer trainers.

The only item of material culture which seems to go beyond clothing
as an expression of individualism is the car. From early on in the fieldwork
I became used to the idea that persons were to be found not through
their house number but the car in front of the house, friends were
recognized as having gone fishing through the number plates parked near
a river. A person is introduced as the only seamstress in the area who
drives a J The weekly newspapers use this tendency as a key compo-
nent in their classic form of innuendo. A typical weekly feature will
feature the woman from San Juan who drives a blue C . . . and whose
lesbian activities have been scandalizing the neighbourhood, or the office
worker from St James who drives a red G . . . and has been revealed to
be in touch with powerful magicians from Guyana. Every week fictive
persons are given sufficient plausibility by the specification of their car
to ensure that gossip can flourish. Retailers routinely decide their expec-
tations of a particular customer entering their shop on the basis of their
car, and so I would be told that a L . . . driver bought this but a C . . .
driver would not buy that. The identification of persons by their associated
cars is then not the exception but the norm of daily social discourse.
Cars are also subject to individualizing control, for example, passengers
complain of the strong preference for window, door and other controls
to be centralized under the driver's control, who can then respond to or
ignore requests as they choose.

The same form of identity carries through into relationships. A common
term addressed to young women is that of 'gasbrains'. A friend defined
'gasbrains' as 'girls who choose their man from the body of the car, while
often ignoring possible deficiencies in the body of the driver'. Street
wisdom certainly insists that women will not look at men who don't have
cars, and this is repeated even in Ford by women whose men have not

been able to afford a car for some years. While in some societies cars are seen as relatively private space, in Trinidad cars are forms of individualization which are displayed in public, indeed the point often made (especially by men) was that people see the results of one's aesthetisization of the car but may not see the money and time spent on the house. Apart from the frequent conversing between cars, people often see themselves as being looked at and appraised at the ubiquitous traffic jams. Ironically for this symbol of movement, much of the time spent within cars is almost static.

This relationship was compounded by an often extreme concern for car care. Anecdotes were common about one's neighbour who washes the car at least once a day, and twice if it has rained, and with particular attention paid to the area within the treads of the tyres. Such concerns are often seen as gender differentiated. For example, an informant describes the contrasting relationship with the car held by her brother and sister. The brother not only had made a wide range of changes to the car, described below, but was obsessive about anyone scratching the paint work and clearly froze in tension should anyone slam the door. The sister was cavalier about the car and clearly saw it as the brother's role to fix up anything that might go wrong. Similarly, it is often remarked that when men have money the first priority is the car while the woman might look to the home.

Cars are certainly prestige items, for example the royal and super saloon brands were continually identified as suitable bribes (as with the case of the local Chaguanas magistrate who was jailed for this offence during the year), or as a conspicuously extravagant payment to a Hindu pundit for services rendered, or as the anomalous vehicle for a mere drain cleaner who worked in The Meadows and thereby affronted its inhabitants. This particular competition was again muted by the recession. A typical trajectory came in a discussion with a self-confessed 'car freak' who detailed how in the oil-boom he had moved swiftly from expensive to more expensive cars with larger engines, until the recession 'after which good sense prevailed' and he settled for a modest car. Instead he would now add an extra item 'and be happy with that little fantasy that I am driving a nice car. So you spend 100 dollars on a steering wheel and you feel a million dollars instead of spending a million dollars and making yourself poor.'

DUALISM

Having discussed two separate and opposed trends in material culture aesthetisization, these may be brought out by certain conspicuous contrasts. When discussing the transcendent mode, note was made of the prominence of the car upholstery industry and the associated process of

interior decoration. In the same street as some of the major car upholsterers are other establishments which concentrate on the decoration of the car exterior; in particular they work on tinting the windows, adding stripes along the exterior, adding extra wide wheels and fashionable wheel hub caps, or less frequently more extreme features such as bonnet scoops. The existence of different shops concentrating on car interiors and car exteriors appeared to relate to the activities of different groups of people. The stereotypes are suggestive; conversations reveal the driver 'with hair greased back and gold on his fingers who wants crushed velvet upholstery but can only afford short pile acrylic but spends ages brushing it the right way' who is contrasted with the dude and his deputy (mistress) hidden behind the tinted glass and projecting very loud music out of his car as out of his home.

When asked for her definition of bad taste, one informant noted the practice of having the best side of the curtains facing outwards onto the street. In practice, most modern curtains have no inferior side, but where they do the tendency is to have the good side face inwards. The alternative of 'dressing' the street was seen either as facade covering up the problems of recession or, as for this informant, an indication of the loose morals to be expected of the woman whose orientation was to the street rather than to her home. It was noticeable that housing which did not conform well to the normative type, for example those in Newtown, often showed considerable concern with the individualization of house facades in porches and the style of front garden walls etc.

A similar division is to be found even in the body itself. Here, as is the case with cars, the division is particularly evident with males though some females are also involved. In recent years a fashion for body-centered activities has developed in Trinidad, as also internationally, which focus upon the individual as opposed to more traditional sports. Gyms, for example, are constantly featured in local television adverts. Within this fashion, however a division may be discerned. There has been considerable interest shown in body-building activities with associated magazines and high profiles for body-building competitions in the media. In this case the emphasis is on the externality of the body as a vehicle for display, and the competitions themselves consist of the striking of a variety of poses which flex and display the body form.

By contrast, a rather different group emphasize the fashion for jogging and the concept of keep fit. This relates to an emphasis on internal health within the body where the effects are not necessarily evident to an observer unless they are seen jogging. Similarly a trait noted by several doctors was the determined desire by what were seen as more conservative patients to insist that only injections were appropriate as cures for ailments. Patients were seen to tear up prescriptions when they referred to oral medicines, since injections were seen as relating to the true body

interior, i.e. the blood stream. As well as ethnicity, gender may be used locally to establish this contrast, for example, women were said to concentrate on interior painting and decoration, men on the exterior.

SUMMARY OF MATERIAL CULTURE

I have only used a few elements of material culture to develop this dualism, ignoring areas such as food and music. It should also be noted that there is often a discrepancy between verbal and observational information. For example, most quotations which talk of a dualism do so in ethnic terms, while I will (elsewhere) be challenging the assumed primacy of this distinction on the basis of observational data.

The dualism relates to two modes which can be labelled *transcendence* and *transience*. The transcendent aesthetic is marked by a process of interiorization and an orientation to the inside, a filling up of the living room with cheap but abundant ornaments, various forms of covering over and layering. In clothing there is individual competition kept within structural consensus which in response to innovations acts in such a manner as to preserve the homogeneity of the category as far as possible. This process is associated with symbolism related to the family, to religion and to one's home.

In opposition to this the transient aesthetic favours individual originality in new combinations which focus on the exterior and on display and are based around particular events. There is a more free-ranging individualism, and competition and lack of normative order. Not surprisingly given the general form of modern aesthetics, the former strategy tends to be denigrated not only by local terms but also by international fashion standards, and would today appear dowdy, vulgar and unappealing, while the latter aesthetic is closely bound up with new forms of the arts and design and is usually appraised positively by visitors and linked with Trinidad's highly developed sense of *style*.

THE WIDER CONTEXT

I now want very briefly to suggest that this opposition in the use of material culture may be related to a much wider set of oppositions which it does not reflect but rather helps to constitute. In each case the mode may be traced via aspects of culture such as social structure and festivals through to a particular mode of being. Those who emphasize the transient mode tend to conform to kin patterns which have been encountered in many other parts of the Caribbean (e.g. Clarke 1957; Rodman 1971; Smith 1988; Wilson 1973). An individual may know of and recognize a very large number of potential kin, but at any given time relationships are not based on role expectations given by the structure of kinship but are

essentially dyadic and pragmatic, based on the particular circumstance and need. Relationships are fluid and do not conform to ideal types as sanctioned by the church. Typically sexual relationships are serial, women having children while young and fathers providing resources for their particular children with whom they live only for a few years after birth, if at all. Marriage is regarded as something for late in life and closely linked with having a house and settling into a new, more religious, mode often around the period one's first grandchildren are born. Prior to that accommodation is normally renting or squatting. There is a lack of structured relationships defined by fixed roles, for example children are commonly brought up by females other than their biological mother. In summary this mode comes close to social structure devoid of structured kinship.

Men in general tend to avoid stable home-based relationships. While young, they prefer to keep company with other men establishing what are termed 'liming' groups with whom they spend their leisure in drinking and peer visiting sessions which take their own spontaneity as central to them. On such a 'lime', men enjoy giving stories about other 'limes' in which they went out to post a letter in their slippers and returned three days later after a series of adventures taking them to other islands etc. They express their freedom equally from institutional constraints such as work or the state and from domestic household constraints. There may be an orientation to fetes and parties, and money would be invested in cars and clothes rather than in homes. The apotheosis of this mode is carnival. Although outside of carnival it is men, in particular, who are associated with this freedom from institutional or structured form, in recent carnivals it is women who have, as it were, taken the lead in activities termed locally as 'free up' or 'getting on bad' in which the dancing and exuberance of fetes and parties reaches a climax in the two days of what's termed 'jump up' at carnival, which in the analysis I am conducting employs several idioms to express a fantasy of absolute freedom.

For relationships constructed within this mode clothing and money for clothing may play a central role; indeed, women's sartorial ability is often taken as a key sign of the state of her relationships with men. The transience of fashion in relation to the event is expressed most forcefully in carnival in the elaborate costumes which are constructed for that event but which have then to be discarded, even where the identical costume is made each year.

One of the main cultural expressions of contemporary Trinidad associated with carnival is the calypso or, in its current form, soca. The best known living master of the genre is the Mighty Sparrow, although there are new soca stars such as David Rudder. Calypsos are seasonal, they come out soon after Christmas and reach their climax in the competitions

at carnival. In the first carnival period which I observed, Sparrow's calypsos were simply never played on radio, his tent attracted small audiences and to all intents and purposes he seemed finished. The star of that year on the media and the streets was David Rudder, but in the following year the position was reversed: Sparrow's calypso 'Congo Man' was the most widely played and Rudder could barely raise applause from the audience. Although there are some expectations based on the past, people cannot expect careers with clear trajectories; rather, each year is a new event in which one starts almost from scratch and one is only regarded highly in as much as that year's performance appears to warrant it.

This mode also made sense of the enormous appeal of competitions in Trinidad on radio, television and other media; indeed, it often seemed that the main impact of commercial companies was through sponsorship of competitions, in which typically, as in the lottery, it was luck that determined the winner, such that each competition is a new event and a new possibility. Informally, competition around clothing was of an extreme form, and the intensity of competitive display was pronounced, especially for women at the workplace. To note a more complex argument, it may be that the ability of women to free up at carnival in a manner that surpasses men is closely related to their intense competitive relations which result in individualistic almost atomistic social forms. These, in the case of men, are muted by the peer group of the 'lime'. The existence of commercial competitions and of sartorial competition in the workplace are hardly unique to Trinidad; it is their ubiquity and prominence as against other forms of commercial sponsorship or workplace relationship which makes them outstanding features of the island.

In the transcendent mode the major incentive behind marriage is certainly religion, although until recently most East Indians have felt more constrained by this expectation even for those individuals whose way of life in other respects leans towards the transient mode. Within Trinidad there exists simultaneously with the transient mode a movement towards fundamentalist Christianity and highly observant forms of Hinduism and Islam. In association with this is a keen regard for highly structured family life in which the individual is expected in many respects to subsume their person within the group. The family is centered around a particular home and there is a keen concern for the home as owned by and often built by the family, as opposed to renting. Category integrity is paramount as evident in the passions aroused by almost ubiquitous disputes over property and family identity. Individual members who for some reason have fallen foul of family values are often cut off entirely and no longer recognized by their family. In inheritance disputes brothers and sisters who up to that time has been intensely close, with some frequency resort to violence and chopping with machetes, a passion I interpret as closely

connected with the function of property in defining the family group. Relationships within the family are highly structured with a developed sense of particular responsibilities.

The apotheosis of this set of values is the festival of Christmas. In Trinidad the main consumption pattern surrounding Christmas is not the buying of gifts for others but the purchase of items in regard to one's own home. It is the time for re-painting the house, re-upholstering furniture, buying ornaments and other goods, replacing curtains and bed linen. Considerable sums are spent on these activities, and Christmas preparations are the subject of specialist media programmes and discussion. Christmas is also the key family occasion when the home is opened up to a round of visiting and also for the entertainment and feeding of friends or workmates (a relationship to work which is rarely recognized otherwise).

Christmas is, then, generally regarded as the climax of yearly consumption, with many retailers only half jokingly reporting that they could close the rest of the year since it is at Christmas that profits are to be made. If carnival is the festival of exterior display, Christmas seems almost as exuberant in its passion for interiorization.

ONTOLOGY

This dualism can be elaborated almost endlessly but the profundity of its consequences may be illustrated with respect to the major event of the fieldwork period, the rapid decline into recession as the fall in the oil price has been translated into drastic cuts in public expenditure and a rapid rise in unemployment. One of the questions used in the more formal survey of the four areas related to what class people considered themselves to be. The interest in the response was not the substantive answer but the form of reasoning applied. Those who would tend towards the transient mode almost inevitably saw themselves as changing class; they would say that during the oil-boom they had achieved a middle-class position but given the recession this was no longer the case since circumstances indicated otherwise. Indeed their general response to recession and a return to poverty was remarkably cool and detached except in as much as it was seen as building up pressure. In contrast, one of the main sections of those who tended towards the transcendent mode saw the achievement of middle-class status as something that had become an interiorized aspect of identity. The problem now was that external circumstances no longer conformed to that which they felt themselves to be, and the main response in 1988 was to engender a massive emigration to places such as Toronto which for Trinidadians is enshrined as the centre of the moral universe defined as being middle class.

Similarly in response to recession some within the transcendent mode

were leaving secure jobs in order to gain further qualifications. As a
strategy in recession time this is likely to be disastrous for them, but the
feeling was that by having a qualification which defined one in terms of
a higher rung in a ladder one was safer from the vicissitudes of future
misfortunes. The stronger the interior the better preserved from circum-
stance.

In this response to recession we can see more fully the mode of being
and existence which is constructed in transcendence. The unit as either
individual, family or ethnic group is bound as a category whose integrity
is paramount and which is best preserved through filling up its interior
and stablizing it in terms of the future and the past. Traditional land and
its inalienability was linked to ancestral origins (usually only one or two
generations but nevertheless given the aura of temporal eternity). This
became the defining feature for the family, while it was the home which
gives identity. Today this is often supplemented by a more individualistic
strategy by which the children are given educational qualifications or
professional work through which they become solid beings of substance
in the face of change. Resources such as money are also stored and where
possible increased, preferably in foreign bank accounts. Such ideals are
realized only by those with resources but it is a strategy which, as with
the living room, can be seen in clear emulation by those whose reality is
a squatted home and the foam of upholstery without a cover, but where
family form and religious concerns still allow vehicles for its expression.
As religion secures the future other techniques are used to incorporate
the past, for example identity with roots which may be the history of
East Indians in Trinidad, a more general nationalism for many Creoles
or roots in Africa as with the Trinidadian Rastafarians who are increas-
ingly moving today from the transient to the transcendent mode.

In contrast to this is a transient mode which as far as possible avoids
any such interiorization of being. Indeed one of the most common
expressions heard in response to any misfortune from a passing insult to
the break up of a relationship, is 'don't take it on'. For example, there is
a mental break-down known as *tabanca* which is felt to develop in men
when their woman has left them, but only if they have invested so much
in the relationship as to have internalized it, in which case they will suffer
the consequences (Littlewood 1985). It is much better to remain cool and
phlegmatic, the ideal values. The verbal repartee of the 'lime' consists of
witty and barbed invective in which friends tear into each other such that
the 'lime' becomes a kind of training ground in which one is steeled
against taking in the abuse which can be received in life.

If the consumption pattern of interiorization may be seen as the objecti-
fication of one form of being, so fashion as a consumption mode provides
a key link to this transient mode. Given the opposition of this mode to
any form of interiorization but also to any fixity with institutional or

established form such as ranking, the concept of identity appears to be rendered quite empty. There is no social status or agreed position to give placement, or substance which is constant within. This is, however, ontologically incredible, if we assume that human existence requires some knowledge of self in the world. The strategy employed, then, is one of display and response. In going to a fete or forming a relationship, the individual usually aims high, attempting the best style, the wittiest verbal agility and if possible the most prestigious partner. From the response of the day or from this particular and assumed transient activity one finds who one is. It is the event itself that gives judgment, that acts as a kind of reverse omen-taking which establishes also who one has been (compare Strathern 1988: 268–305). However, this is only a specific event or relationship, there is no accretative value. Its implications hardly carry beyond the event itself, so that the position has to be recovered again on the next occasion. It is in this manner that an identity is constructed which is free, that is minimally subject to control. In this strategy fashion plays a vital role, since it is the ability to change which renders one specific to the event.

In general the transient mode is associated with lack of money, since one of the forms in which money is experienced is as a pressure, i.e. a stored substance which needs to be released. The analogy is with semen which also can lead to madness if not permitted release. However, severe lack of money can also lead to pressure since it means that one is unable to carry forward the project upon which identity is structured and therefore leads to a sense of loss of identity in the recession. Ideally money should be something that regularly flows through, accepting some hassle to obtain resources but not too much. Indeed the flourishing of the transient mode in the relatively extreme logical manner I have described is itself probably a transient artifact of the oil-boom which allowed people who would otherwise lack resources to buy two new outfits a week. In recession, despite the phlegmatic response, contradictions are crowding back in to thwart this project and the oppressions of class, seen here as the lack of ability to objectify through forms of consumption, are re-emerging with new severity.

There are many sociological correlates to this dualism. In the area in which I worked the East Indian population often attempted to construct the dualism with themselves as transcendent and the Creole population as transient. This was often expressed in terms of differences in forms of saving and consumption. Within the Creole population, however, there is a traditional division on race and class terms which sees the mixed or coloured population as emulating a conservative transcendent role and the lower-class black community as following a transient form. Such identifications, however, have to be seen in comparative context, since other Caribbean islands with no East Indian population have similar

dualisms. For example, Wilson (1973) projects an opposition between what he calls respectability and reputation essentially onto gender distinctions which would only partially work for Trinidad. Abrahams (1983) emphasizes a distinction between exterior oriented play and interior oriented seriousness, focusing more on age and the general models of culture.

Within Trinidad most people probably adopt both modes at different times. The bulk of the population would appear transient at carnival and transcendent at Christmas. There are, however, substantial sections of the population which manage to construct social structure and daily life almost entirely within one or other mode.

ORIGINS

One may therefore ask briefly where this duality comes from. If, as it appears, versions of it are Carribean wide, then the background to it must be slavery and indentured labour. The Caribbean in a sense was the first true modern society. It was an immense factory system in which the native population was largely wiped out and an imported labour was used in plantations to create commodities for the world market. Slavery and indentured labour created an historically extreme form of the de-humanization of labour. Not surprisingly the ending of slavery called forth a massive cultural response from this population, in which the nature of desire was formulated in opposition to this previous state of being, although as Fanon, Wilson and others have suggested these new structures may have incorporated colonial values into themselves. In essence this created two modes whose contradictions reflect the nature of modernity itself with a clarity which does not emerge in more metropolitan societies still encumbered by transformations of the peasantry and of class in longer, less ruptured, histories.

On the one hand property and roots seem precisely what was denied in slavery when persons were merely the property of others, so that the building up of new traditions, new senses of the inalienable as in land tenure, an interiorization giving a new substance and dignity to being, new values which appeal to a humanity and then through that a deity in a manner which had been almost crushed in slavery, amounts to a manifestly comprehensible response. On the other hand, there is a concept of freedom which attempts to deal with the state of abuse, of de-humanization by the construction of being which externalizes and refuses any fixity or institutionalization in which the person would inevitably be placed at the bottom or the exploited fraction of society.

Obviously the historical development is more complex than can be represented in two paragraphs, but if this account is taken as given for present purposes then it would have to be allowed that both modes are attempts to construct a viable form of being against a history in which

existence itself was rendered a worthless project, Indeed one of best recorded responses by slaves to their condition was mass suicides and poisonings (e.g. James 1980: 15–16). Although this history is one of extreme rupture it places these societies in a position where they are confronting with unusual clarity the contradiction of modernity. The very concept of freedom which is being worked on culturally here is that which many philosophers and social theorists have emphasized as both the potential but also the cost of modern mass life.

CONCLUSION

It is at this point that the question of fashion and ontology may be related back to the debate over post-modernism. Taking these three terms in turn, *fashion* (now re-incorporating the term style) here has been generalized to modes of consumption in which temporal aspects are central. Fashion may be used to express transience but also to combat it by difference which denies change through preserving normative order, for example adopting a new fashion on such a massive scale that conformity is preserved. Fashion in oil-boom Trinidad has tended to be taken as symptomatic of a crass materialism but in both modes this assertion looks awkward given its usual connotations. The transient mode spends extravagantly on clothing, especially in relation to an often limited income. But since these clothes are related to events it is rare that relationships are built up between persons and objects of any substance. A concern with things as vehicles of expression obviates a concern with any particular thing. It is hard to argue that people are obsessed with things at the expense of other people in a mode which is all about constructing identity through eliciting social response. Similarly, with the transcendent mode there is an accumulation of things and objects which may have strong personal connotations but are used in the project of creating inalienable relations between persons and in creating a sense of temporal perspective which transcends their materiality. As in religion, objects are thus a vehicle for spiritual concerns. Either case might be termed materalistic of a sort but in neither case would this fit the general concept of crass materialism, just as neither fits the conventional category of inflated status symbols which the oil-boom is supposed to have effected on the assumption that the new consumption forms were simply copies of consumption elsewhere.

From fashion which does not conform to our generalities about fashion, to *ontology* which is similarly idiosyncratic in its current employ. My notion of ontology derives from the Marxist tradition in which fundamental philosophical problems are rooted in history and not in universal questions of epistemology which are immutable. Here the very possibilities of a sense of being, of self-knowledge, forms of personhood and

identity are derived from anthropological projects as culture tied dialectically to history. Slavery and colonialism thus had clear ontological consequences, but equally the move out of those conditions has provided for possibilities which are now mainly constrained by the nature of the contemporary conditions of the Carribean which I have described as an extreme modernity.

This last phrase, 'an extreme modernity', expresses a historical context established by the rupture of slavery in which historical roots were sundered as a population started as individualized, de-humanized and in specific relation to world economic systems. In many respects, however, Trinidad seems also the quintessence not of modern life but of the *postmodern* condition. There is almost nothing which can accord with the general strictures of authenticity. The roots which are being constructed are all derived from the wrong sources. They relate only marginally to the actual histories of the communities but are a bricolage of colonial and cultural bits. Much of the religious foundation comes from missionaries, many of the images of longevity come from colonial notions of respectability, but even the new local forms of nationalism or rebellious religion such as Rastafarianism work by creating new linkages to a concept of Ethopia which seem conjured up almost as pastiche.

The case is even worse for the transient mode which seems almost to have been invented by Baudrillard. There is no fixed identity, just a world of circularity, of display, of newness, in which it is the most superficial forms such as fashion upon which social relations are constructed. Although there have been claims made for authentic new cultural forms, these have mainly been with respect to activities such as carnival, calypso, steelband, and political protest. It is, however, precisely the kinds of objects which have been discussed above, the cars and the styles, which have been regarded as symptomatic of a general trend to Americanization, which as Hebdige has argued has become in Britain (and often the ex-British colony) almost a synonym for both vulgarity and lack of authenticity (Hebdige 1988: 45–76).

Worse still, in both cases the sources of this briolage in both modes are today mainly the consumption of international mass production. Fashions flood in from outside. American consumer goods are mini rages which sweep across the island. The bric-à–brac of the living room is often made especially for the Trinidadian market in places such as Korea or Taiwan. There is very little self-production of craft or forms in which people identify with the source (Rastafarians are the notable exceptions here), indeed what is striking is the degree to which people simply don't care where the object comes from.

In general, the history of the West Indies seems to lend itself to the diatribes on post-modernism. It was a world of brutality and coarseness which some have seen as almost intrinsic inauthenticity. Naipaul speaks

for this view: 'The history of the islands can never be satisfactorily told. Brutality is not the only difficulty. History is built around achievement and creation and nothing was created in the West Indies' (Naipaul 1962: 29). In his books *The Middle Passage* and *The Mimic Men*, Naipaul has been foremost in arguing that with such a history the area is doomed to inauthenticity and mere pastiche of metropolitan cultures, especially those of North America. In describing his protagonist in *The Mimic Men* building a Caribbean house based on Roman Pompeii with his 'illuminated swimming pool (our modification of the Roman *impluvium*)' (Naipaul 1967: 73) Naipaul seems to prefigure the current critique of post-modern pastiche. In the transient mode Trinidad appears full of vulgar Americanization, a desperate search for the latest that high capitalism has to offer, without any ability to construct for itself.

Such arguments might appear plausible if there was only one mode of consumption under study, but the existence of the two as polarized opposites leads to certain questions. If they are both the consumption of late capitalist production then this implies that the consequences of late capitalism are rather more variable and contingent than the critique of post-modernism allows for. Does the history of slavery really mean that traditions and forms of inalienability which are constructed as rapid façades often using interiorized elements of colonialism thereby have no possibility of authenticity? Similarly does a project which so profoundly projects the complexities of a general concept of freedom that has been central to debates over modernity really also lack authenticity simply because it is based on the event?

My argument would be quite the reverse. The example of Trinidad shows the emptiness of the debate over post-modernism, a debate which is parochial, assuming simple linkages between forms of production, consumption and problems of identity which are crude and simplistic. As I have argued elsewhere (Miller 1987: 167–77; 1988), there is no *a priori* reason why modes of consumption cannot be the main vehicle by which modern populations construct culture, a culture that is authentic and profound. In Trinidad forms of consumption may well have replaced kinship and land tenure as the main vehicle for the objectification of these projects of freedom. If the response is contradictory based on a duality, then this may well reflect the actual nature of modernity whose own nature (which I derive largely from Simmel 1978) is itself contradictory. Thus the very duality demonstrates both the relevance and authenticity of this culture given these historical conditions.

NOTE

1 The ideas expressed here are more fully developed in Miller 1994.

REFERENCES

Abrahams, R. (1983) *The Man-of-Words in the West Indies*, Baltimore: Johns Hopkins University Press

Barthes, R. (1967) *Système de la Mode*, Paris: Editions du Seuil

Bell, Q. (1976) *On Human Finery*, London: The Hogarth Press

Bourdieu, P. (1984) *Distinction*, London: Routledge & Kegan Paul

Clarke, E. (1957) *My Mother Who Fathered Me*, London: Allen & Unwin

Ewen, S. and Ewen, E. (1982) *Channels of Desire*, New York: McGraw Hill

Gregory, C. (1982) *Gifts and Commodities*, London: Academic Press

Hebdige, D. (1988) *Hiding in the Light*, London: Routledge

Higman, B. W. (1979) 'African and Creole Slave Family Patterns in Trinidad', in M. Crahan and F. Knight (eds) *Africa and the Caribbean*, Baltimore: Johns Hopkins University Press

James C. L. R. (1980) *The Black Jacobins*, London: Allison & Busby

Littlewood, R. (1985) 'An Indigenous Conceptualization of Reactive Depression in Trinidad', *Psychological Medicine* 15: 275–81

Miller, D. (1987) *Material Culture and Mass Consumption*, Oxford: Basil Blackwell

——(1988) 'Appropriating the State on the Council Estate', *Man* 23: 353–72

——(1994) *Modernity: An Ethnographic Approach*, Oxford: Berg

Naipaul, V. S. (1962) *The Middle Passage*, London: André Deutsch

——(1967) *The Mimic Man*, London: André Deutsch

Rodman, H. (1971) *Lower Class Families: The Culture of Poverty in Negro Trinidad*, New York: Oxford University Press

Simmel, G. (1957) 'Fashion', *American Journal of Sociology* 62: 541–58

——(1978)*The Philosophy of Money*, London: Routledge & Kegan Paul

Smith, R. (1988) *Kinship and Class in the West Indies*, Cambridge: Cambridge University Press

Strathern, M. (1988) *The Gender of the Gift*, Berkeley: University of California Press

Veblen, T. (1970) *The Theory of the Leisure Class*, London: George Allen & Unwin

Wilson, E. (1985) *Adorned in Dreams*, London: Virago

Wilson, P. (1973) *Crab Antics: The Social Anthropology of English Speaking Negro Societies of the Caribbean*, New Haven: Yale University Press

Chapter 13

Grecian fillets

Stella Newton

At the time of its demise in 1868, the crinoline was thought of as ugly. Its rapid and complete disappearance was a sign that it had lasted too long and outlived its period. Its replacement, very temporarily, by a straight skirt with a long train, and then almost immediately by what *Woman's World* and others quite irrationally called the 'Watteau toilette', involved one of those major changes of fashion that produce a new aesthetic composition and which demand, in consequence, a change in the behaviour of the wearer.

The dome-shaped skirt of the 1840s, enlarged in the 1850s by a crinoline sub-structure, because it was symmetrical, had looked the same from whatever side it was viewed. By the middle of the 1860s this all-round appearance was modified a little by a slight extension at the back, but this did not really make much difference. Manufacturers of the various supports designed to hold out the skirt did their best to give some variety to a basic shape that had become a bore. For instance, just before the crinoline's disappearance the 'Ondine', made in large flutes, was intended, as its name implies, to produce in the skirt a gracefully wavy effect, and the same firm's 'Ebonite', composed of light and very flexible india-rubber hoops, was advertised, like the 'Ondine', not only in women's magazines but also in the masculine *Owl*.[1] Both the undulating shape and the extreme flexibility were certainly aimed at destroying the uncompromisingly stable appearance of the basic dome, in the centre of which each female wearer was unapproachably planted.

The sudden jettisoning of this symmetrical design for one of complete asymmetry was dramatic. In contrast to the crinoline, the new fashion possessed, for instance, a 'most favourable viewpoint'; for while the frontal elevation of the 'Watteau toilette' had little character to commend it, its side elevation was very striking indeed. Corresponding to the bunched-up puff of fabric which swelled out below the waist at the back – held and emphasized by bows of ribbon with fluttering ends – the hair was drawn away from the face and massed at the back of the head to

Plate 13.1 A condemnation of the chignon and the Watteau toilette, from *Madre Natura*, 1874

produce what was named a 'chignon', formed of huge, loose, intertwined plaits or rolling curls (Plate 13.1).

Seen from the side the wearer seemed to press forward, followed by her trappings: to be transformed into an unctuous version of the winged Victory of Samothrace – a resemblance of which she may have been vaguely conscious. For the arrival of the new fashion was soon followed by a new deportment – a thrusting forward of the breasts and backward of the buttocks – termed the 'Grecian bend'. The new fashion also coincided with a craze for the new sport of roller-skating, in the practice of which it showed at its best. Flying round the skating-rink, curls and draperies were blown violently backwards while the torso, firmly encased in a close-fitting mould, looked as brave and compact as the prow of a ship.

This change in composition was radical and unexpected; changes in fashionable colour-schemes, though they emerged more slowly, were no less fundamental. The rococo combinations of, for example, rose-pink with pea-green, or lilac with pale chrome-yellow, which make the dress of the 1850s appear in retrospect one of the 'prettiest' in history, were replaced in the 1860s by far more sullen effects. During this decade dome-shaped skirts of thick pewter-grey silk were cut horizontally by a wide band of black velvet, and black ornamentation was, in fact, very popular.

In strongly defined borders and bands composed, often, of thick fringes with intermittent hanging tassels, black was used to decorate a new colour of the period – 'electric' blue, a harsh and slightly greenish thunderous shade. By the middle of the 1860s only dresses designed for high summer were allowed to retain the airiness of the 1850s and even these, as can be seen, for instance, in Monet's *Femmes au Jardin* (Plate 13.2), were punctuated by accents of colour in contrasts stronger in tone than would have been permissible during the ten previous years.

Those who see in the design of clothes a reflection of at least some aspects of the society which produces it, would be justified in regarding

Plate 13.2 Femmes au Jardin, detail, by Claude Monet, 1867, Paris, Jeu de Paume. The late crinoline period, when trimmings and colour-contrasts were much bolder than anything worn in the 1850s

the transformations of the late 1860s as vindicating their theory. From the point of view of composition women could be thought of as having stepped out of the encircling bird-cage to assume a forward-looking attitude well suited to their sociological and educational aspirations, while, at the same time, the insipid charm of earlier colour-schemes was replaced by effects which if not actually violent were certainly aggressive.

This was not, however, at all the way that the crinoline and the Watteau toilette looked to those who actually saw them being worn, for both were thought of as ugly. Charles Reade had described the skirt of Elizabeth I as a 'bloated bell' which was 'imitated by her successor in New York' and the Watteau toilette was alleged by later commentators to make women look deformed. At the beginning of the 1870s, by which time the Watteau toilette had been generally adopted, it was not only artists and their friends but many others too who began consciously to long for the abolition of fashion altogether in favour of something permanent, something which, because it combined beauty with utility, need never be changed. Among these were women who naturally looked for reform in other directions too.

The craving seems to have been officially expressed first at a congress of the Council of German women held in Stuttgart in 1868 and reported in the final number of *Woman's World*. It was the second congress of the Council, which included in its aims the establishment of a chain of 'Women's Museums' where lectures on those subjects presided over by the Muses could be held. The Stuttgart congress of 1868 (the year of the abandonment of the crinoline in favour of the Watteau toilette) put forward a Motion for a 'reform in dress' after a discussion on 'ways and means' of resisting the 'tyranny and vagaries of fashion'.

The Stuttgart Motion was prophetic of ideals that were to be cherished both in Germany and in England over the following two decades; its terms were:

(1) that nothing that has already proved to be beautiful and convenient, to be declared old-fashioned or out-of-date;
(2) nothing to be adopted that does not meet demands of taste and suitability;
(3) to hold aloof from garments and articles of toilet that are injurious to health, and that women should adopt a style of dress in accordance with their husbands' and fathers' incomes.[2]

This was not the first time that suggestions for a reform of women's dress had appeared in Germany: at the end of the eighteenth-century, Daniel Chodowieki, a Danziger working in Berlin, had designed rather lumpy versions of the neo-classic garments that were about to make their way into the current fashion. Since, however, Chodowieki's reforms were overtaken by fashion itself, his designs are mainly interesting as reflections of the concern expressed by his contemporary German philosophers on the

subject of aesthetic morality. Earlier in his career Chodowieki had produced a pair of engravings contrasting 'sincere' with 'artificial' sentiment. Both portray a man and a woman admiring a sunset: the sincere couple gaze upon it with sober reverence whereas those whose sentiment is artificial greet it with baroque gestures of appreciation. By this standard Chodowieki's reformed dress belonged to a category 'sincere' – that is to say it was plain in outline and almost without ornamentation.

With the radical change in the design of fashionable dress at the end of the 1860s a new kind of beauty began to be admired. The small frail girls with feet no bigger than mice – the young heroines of novels by Dickens – were no longer in favour with artists or in fiction. When Mrs Oliphant published her novel *At his Gates* in 1872, the fashion was too new for her to adopt it for her actual heroine, but Clara, the foil, spoilt daughter of the plutocrat villain, had the looks of the moment. At eighteen, 'she was a full-blown Rubens beauty, of the class that has superseded the gentler, pensive, unobtrusive heroine in these days' (Oliphant 1872: II 151).[3] This was the woman already adopted as a model by Watts and Leighton and Poynter and soon to be painted by Albert Moore in compositions based on the Parthenon frieze. She was indeed Greek in inspiration, for the Venuses so much admired by artists and doctors of medicine were beginning to attract a wider public – the names of Phidias and Praxiteles were becoming familiar enough to be useful to any journalist. In 1868 Matthew Arnold had reviewed, for the *Pall Mall Gazette*, the translation of the first volume of the *History of Greece* by Ernst Curtius, as he was to write about the successive volumes in the following eight years, and from the beginning of the 1870s throughout the next three decades less distinguished writers were repeatedly to call upon the art of the ancient Greeks to support their aesthetic and their sanitary theories.

For aesthetics and health, which to a mild extent had been linked by Dr Combe and his followers, were in the 1870s often to be found in each other's company; this meant that the subject of dress was no longer confined to the drawing-rooms of conventional women. Since men now discussed dress, clever women were no longer compelled to avoid it. In 1868 the Council of German Women had already associated beauty and convenience in their demands for a reform in dress; in England it was not women but men who first called attention both to the dangers to health of contemporary fashions and to their lack of resemblance to the clothing of the Greeks.

In 1874 appeared the fourth edition of a decorative little book first published earlier that year with the title, *Madre Natura versus the Moloch of Fashion: A Social Essay*; its author called himself 'Luke Limner esq.' and dedicated his work to 'John Marshall esq. FRS etc. etc., Professor of Surgery, and Art Anatomy to the Royal Academy and to the Department of Science and Art'.

The presence in the title of the Moloch of Fashion is not particularly surprising, for Moloch (presumably thought of as a deity who fed upon the innocent) was constantly required at this period to represent all that was evil in contemporary life, such as overcrowding in cities and industrial greed. It could almost be said to be unusual to discover an article on sociological problems in which his name did not crop up. His appearance as the evil supporter of fashion, therefore, must have had the effect of enhancing its status as a topic.

A coat-of-arms appearing on the title-page of *Madre Natura* is described within:

The Mantua-Maker's Arms
On a shield *sable*, a Corset *proper*; crest upon a wreath of roses and Hour-glass *or*, typical of golden hours wasted. Supporters, Harpies: the dexter 'Fashion' crowned with a chignon *or*, corsetted and crinoletted *proper*, her train being decorated with bows, and the wings with scissors; the sinister, 'Vanity', crowned with a coronet of pearls and strawberry leaves bears the wings of a papillon, eyed *proper*, the queue a la Paon. Motto, 'Fashion unto Death!' [Plate 13.3]

The motto reads, in fact, *A la Mode à la Mort*. The author begins with a particulary severe reproof, to the crinoline, a fashion but lately laid aside which disqualified those who wore it from the performance of their duties to society, in a more summary and terrible manner than any perversion of clothing yet devised by the milliner for the ever-ready

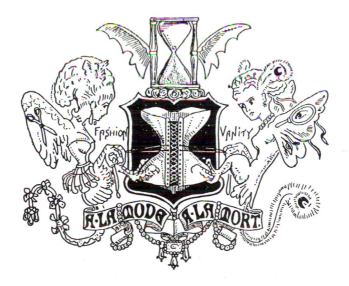

Plate 13.3 Coat-of-arms, title page of *Madre Natura*, 1874

dupes of her specious handicraft. We allude to the victims destroyed by wearing hoops and crinoline. There are many who escaped death, who to this day bear evidence of the sad custom of using aids to distend the dress, carrying terrible brands, in the form of scars, where the flesh has been seared, and contracted joints where bones have been broken, derangements of the system by which chronic aches and pains are continued to the end of existence. [Plate 13.4]

(Limner 1874: 11)

The small compressed waist which resulted from the tight-lacing of the corset is next attacked, as

reversing all the type-harmonies of form and graceful fitness of the woman's structure ... We make bold to assert that Praxiteles would have deemed her hideously unworthy of reproduction by his chisel and her statue by his masterly hand would never have graced the Temple of Delphi. [Plate 13.5]

(Limner 1874: 16)

The author then embarked on his main theme:

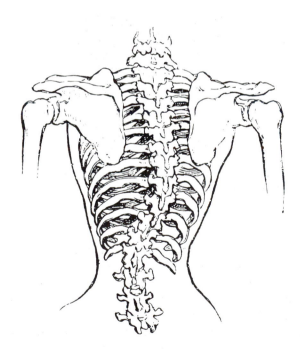

Plate 13.4 Effect of stays on the spine. 'Curvature of the spine' was diagnosed as frequently in the nineteenth century as slipped discs are today. From *Madre Natura*, 1874

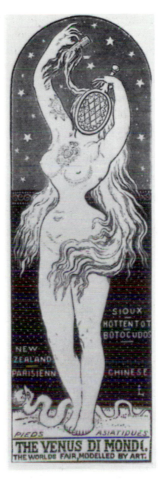

Plate 13.5 The Venus di Mondo: 'impeded respiration and crippled locomotion'.
From *Madre Natura*, 1874

But from a point of view more grave, were it even possible – which it
is not – to disconnect the intimate accordance of the aesthetical form
from its connate hygienic design throughout the whole structure of the
human body, we consider the subject is one which, if thought con-
venient for a theme likely to be a 'taking one' as 'a question of the
day' should at least have been treated more in regard to real interests
of society than in the specious and flippantly sophistic style defined by
Logicians as the *Argumentum ad Ignorantiam* . . .

(Limner 1874: 18)

but the sentence is very long and by no means ends there.

Apart from the connection which the author saw between 'aesthetical form' and 'hygienic design' his reference to the possibility of the whole thing becoming a 'question of the day' is significant, for both here and in contemporary novels there is a suggestion that ideas were on the move and among them appeared a new conception of the essential character of women. In the pages of *Madre Natura* a new sort of woman made her début. This was the 'Girl of the Period' who was to be referred to under that label repeatedly both in sociological studies and in fiction during the two following decades.[4]

'Luke Limner's' championship of *Madre Natura* is written in a colloquial style but its intention is certainly serious. Into a long list of eighteenth-century medical authors – most of them continental – who had published condemnations of physically harmful fashions in dress he inserted the names of philosophers and writers on aesthetics who had been equally critical of the fashions of their day, among them Buffon, Schlegel, Hogarth and Burke (Limner 1874: 57ff.). He quoted Vaughan's *Essay Philosophical and Medical, Concerning Modern Clothing*, which had appeared in 1792, in considerable and blood-curdling detail, and included Vaughan's view that 'the fault is more in men than in women' for admiring the wearers of harmful fashions.

Following two drawings of female skeletons distorted by the wearing of tight stays, the author of *Madre Natura* placed another which had retained the natural form, saying:

> Having indicated the influence of compression upon the interior-organs, we now show its workings with the bony structure, and the terrible effect it exercises upon the lower ribs and spine – the lines of the contracted skeletons contrasting sadly with that of the beautiful Venus de Medici, represented above.
>
> (Limner 1874: 69n.)

These comparative drawings are followed by a list of 97 'diseases' which medical authorities, whose names are attached to each entry, ascribed to the wearing of stays and corsets. They are divided into complaints of the head, the chest, the abdomen and 'general', and include sleepiness, apoplexy, whooping-cough, consumption, ugly children, dropsy of the belly and epilepsy (*ibid.*: 71–3).

'Luke Limner esq.' had evidently read widely. He had discovered Daniel Chodowieki's 'natural forms' of dress which had been published in the *Frauenzimmer Almanach of 1785 (ibid.*: 46), as well as strictures on the vagaries of the fashions of their times by writers of classical Rome ranging from Plautus to Tertullian. He had found too sumptuary laws issued at various later periods of history, including those of Pope Urban VIII in 1635 (*ibid.*: 80). He claimed that 'The Gout even, is said to have

aided *le gout*; the broad-toed and slashed shoes of Henry VIII being attributed to a royal malady' (*ibid.*: 87).

Most of the trouble he ascribed to the inadequate education offered to women and their consequent

> deficiency of mental acquirements ... As a class-book, for the heads of families and governesses in particular, we would recommend – *The Principles of Physiology, applied to the preservation of Health*, by Andrew Combe M.D., a work that if read with care could not fail to contribute a powerful influence in modifying the received opinions of the innoxious effects of the corset and of its indispensible improvement of the female natural form.
>
> (Limner 1874: 103)

This is the book, published in 1834, which had run into fourteen editions by 1852. The recommendation of it more than twenty years later shows that its principles still seemed relevant.

Although desperately anxious to persuade women to abandon the dangerous corset, 'Luke Limner' was evidently no feminist, for he recognized that it might, indeed, have its negative uses: 'it would prevent Females with stronger heads, than understanding, walking our hospitals – as tight corsets might prevent "Sweet Girl Graduates" from solving problems in the Occult sciences' (*ibid.*: 112).

Madre Natura had no difficulty in discerning the evil in current fashions and, as well, in those recently gone out; high heels, crinolettes (today called 'bustles'), chignons and tight-lacing were all both dangerous to health and ugly; but she pointed to no alternative outline that might have been followed for a more desirable form of dress. Praxiteles would have rejected the crinolette; but what would he have liked nineteenth century English women to wear? We are not told. Luke Limner could draw *Madre Natura's* perfect feminine skeleton, but he could not clothe it. In 1874 a stereotype for aesthetic and hygienic dress had not yet been circulated though it had been designed.

By this time, indeed, clothes by which artistic, strong-minded or platform women could be recognized were beginning to appear. There must always have been some women in any society who had preferred clothes which were original in design. Mrs Nassau Senior, for instance, in her portrait by Watts painted in 1858,[5] wears a very uncommon dress which conveys no more than that she was a woman of taste; but the clothes of the progressively minded little Mrs Duncombe in Charlotte Yonge's novel *Three Brides*, published in 1876, are certainly meant to belong to a recognizable *type* of woman, though they bear no label. Mrs Duncombe was small and slim when, in 1876, it was fashionable for women to be Phidian in appearance. She was also daring in her behaviour for, although she was fairly acceptable in good society, she had risen to her feet at a

village meeting arranged to discuss its sanitation, and had expressed an opinion and one, moreover, which differed from that of the Chairman – the local MP and landowner.

It is clear that not only those at the meeting but also the author herself thought that this behaviour was extraordinary. Mrs Duncombe ought to have got her husband to voice her views for her but he was a racing-man and opposed to views. Her character established, Mrs Duncombe's clothes are described. Cecilia, one of the ladies present at the meeting, was surprised at Mrs Duncombe' mode of dress:

> She would have taken Miss Slater for the strong-minded woman rather than this small slim person, with the complexion going with the yellower species of red hair and chignon not unlike a gold-pheasant's, while the thin aquiline nose made Cecilia think of Queen Elizabeth. The dress was tight-fitting black silk, with a gorgeous many-coloured, gold-embroidered oriental mantle thrown loosely over it, a Tyrolean hat, about as large as the pheasant's comb, tipped over her forehead, with cords and tassels of gold; she made little restless movements . . . And before the astonished eyes of the meetings, the gold-pheasant hopped upon the platform, and with as much ease as if she had been Queen Bess dragooning her parliament, she gave what even the astounded gentlemen felt to be a sensible, practical exposition of ways and means.
>
> (Yonge 1876: 53)

Mrs Duncombe was not the heroine of *Three Brides*; that would have been impossible. She was a little ridiculous but the author treats her with compassion. When she invited the gentry to dinner in the modest villa which was all her gambling husband, a retired captain, could manage, it is made plain that she was no housekeeper and that her two boys were badly brought up. Nevertheless, although the menu went wrong and the sons were rude, the dinner was a success.

The dinner had been given to introduce an American clergyman and his wife, an advocate of women's rights who was invited to lead an after-dinner discussion on the 'Equality of the Sexes':

> 'Women purify the atmosphere wherever they go,' said the lady.
> 'Many women do,' returned Julius, 'but will they retain that power universally if they succeed in obtaining the position where there will be less consideration for them, and they must be exposed to a certain hardening and roughening process?'
>
> (Yonge 1876: 162)

We are back in the *Woman's World* of eight years earlier.

Apart from its conventionally romantic aspects the two themes of the *Three Brides* – women's rights and healthy drains – were both fashionable: the drains led to an outbreak of typhus in the village in which not only

villagers but some of the gentry who nursed them died; the rights of women were confined to the sort of discussion quoted above. Mrs Duncombe proved to have been wrong-headed in her views on sanitation and suffered a further downfall with the bankruptcy of her husband. She fades out of the book before the end, via conversion to the Church of Rome.

In 1876 Charlotte Yonge had contented herself with labelling Mrs Duncombe's appearance 'picturesque'. In 1870 Benjamin Disraeli had published his heady *Lothair* and swept up his reader into higher circles than Miss Yonge had ever ventured to explore. They were inhabited by cardinals, dukes and, we must believe, from the coolness with which he viewed them – by the author himself. No character of Disraeli's could have been so coarse as to appear 'picturesque', nor could the author have been so imprecise in describing a member of his cast, all of whom either fed upon ortolans in aspic or rejected them as too banal and called for cold meat. Even the elderly women were very beautiful and the young ones proportionally more so. Of the three heroines, all of them perfect, one, Mrs Campian far surpassed the others.

Theodora Campian was thought of as being Roman by race; when Lothair first caught sight of her at a dinner party she was wearing her habitual expression 'if not of disdain, of extreme reserve ... pale but perfectly Attic in outline, with the short upper-lip, and the round chin, and a profusion of dark chestnut hair bound by a Grecian fillet, and on her brow a star' (Disraeli 1870: 34). Although still young, when she appears in the novel Theodora is mature. However, we are told that at seventeen she had served as model for the head of Liberty on the five-franc piece of a short-lived French Republic. This establishes both her type and the world she moved in. Lothair

> thought he had never seen anyone or anything so serene ... what one pictures of Olympian repose. And the countenance was Olympian: a Phidian face with large grey eyes and dark lashes; wonderful hair abounding without art and gathered into Grecian fillets.
>
> (Disraeli 1870: 100)

Mrs Campian and her American husband moved correctly in English society. Their own circle included a successful painter, Mr Phoebus: ' "I fancied," said Lothair to Mr Phoebus, watching Mrs Campian glide out of the pavilion ... "I had heard that Mrs Campian was a Roman." '

> 'The Romans were Greeks,' said Mr Phoebus, 'and in this instance the Phidian type came out.'
>
> 'I fear the Phidian type is very rare,' said Lothair.
>
> 'In nature and in art there must always be surpassing instances,' said Mr Phoebus.
>
> (Disraeli 1870: 138–9)

Commissioned by the Czar of Russia, Mr Phoebus painted a *Hero and Leander*, which he was graciously permitted to exhibit in London before despatching it to St Petersburg. It revealed

> a figure of life-size, exhibiting in undisguised completeness the ... female form and yet the painter had so skilfully availed himself of the shadowy and mystic hour and some gauze-like drapery, which veiled without concealing his design that the chastest eye might gaze on his heroine with impunity.
>
> (Disraeli 1870: 184)

It is not overtly stated that Theodora Campian had sat for *Hero*, that would have suggested immodesty, but the 'Phidian type' appeared in its purest nineteenth-century form in Disraeli's descriptions both of Theodora Campian and of Mr Phoebus's *Hero*. The type had already been painted by Lord Leighton in his *Greek Girl Dancing* of 1867 and it was to appear on many canvases both by him and by his contemporaries before he fatally caricatured it in his *Last Watch of Hero* of 1889. Only a little later, at the beginning of the 1890s, George du Maurier modified the type very slightly for his French laundry girl, Trilby; and by this time Mrs Langtry, the 'Jersey Lily' with the 'short upper-lip and the round chin', had become the most-talked of beauty in England. Greek beauty had a long innings, certainly due in part to its appearance of vigorous health in an age that was greatly concerned with the dangers of sickness in over-crowded conditions.

As for Mrs Campian's 'Grecian fillets', they were the one feature of the new taste in dress that could be identified as early as the end of the 1860s. Before the publication of *Lothair* they had already appeared in *Punch*; and in 1869 Thomas Armstrong exhibited in the Royal Academy a painting of three young women, manifestly portraits, standing in a hayfield (Plate 13.6). All three wear dresses of extremely simple cut and their hair, gathered into a knot at the nape of the neck, is bound with fillets in the Grecian style. The dresses of the young women in Armstrong's *Hay Time* (who wear aprons and hold rakes but are certainly not peasants) appear to be unrelated to the current fashion, but they are not. The picture must have been painted in that brief interval between the disappearance of the crinoline and the arrival of the Watteau toilette, when fashionable women wore straight dresses with a long train as do the haymakers – that is to say, in the summer of 1868. However fashionable the composition of the dresses, the stuff of which they are made could not have been bought in a shop of the period; although basically linen or perhaps cotton, one dress is embroidered all over in a pattern of flowers and leaves, the other is probably hand-printed from a woodblock.

The unconventional appearance of these girls (rather pretty to our eyes) may have provoked the disapproval expressed about the painting.

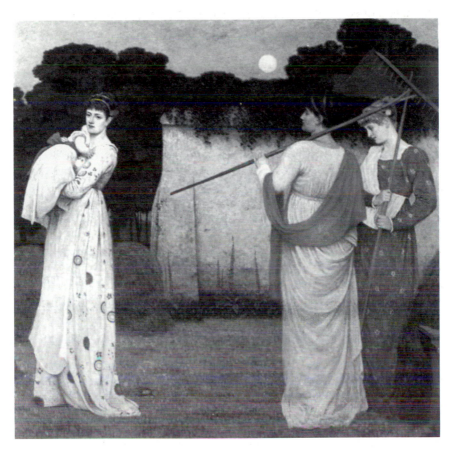

Plate 13.6 Thomas Armstrong: *Hay Time* (*The Hayfield*)

Discussing it in his notice of the Royal Academy exhibition which was published on 12 May, the art critic of the *Owl* wrote: '*Hay Time*. Three very plain persons who, having evidently not made hay while the sun shone, are now doing it by moonlight'.[6] The art critic of the *Owl* either did not, or pretended he did not, recognize the 'plain persons' for what they actually were – exponents of ultimate refinement in tasteful dress. It would be difficult to account for the meandering pattern on the stuff worn by the girl on the spectator's left except as a very early example of the crewel-work that was to become a craze in artistic circles during the 1870s. This embroidery in loosely twisted wools of muted colours, resembling the products of natural dyes, was usually worked on thin wool or linen or cotton sheeting (often unbleached), and had ousted the stiff mid-Victorian patterns of brilliantly coloured full-blown roses, closely bunched

together, that had been embroidered in 'Berlin work' as chair-seats and fire-screens and were by the end of the 1860s considered vulgar.

In 1877, nearly ten years after the date of the clothes worn in *Hay Time*, the *Queen*, not a magazine of advanced ideas, presented its readers with a supplement in the form of a coloured print of trailing convolvulus sprays, intended as a design for a crewel-work decoration on a tennis-apron. The flowers, sparsely and gracefully springing from fine wandering stems are, in style and spacing, very much like the pattern worn by the *Hay Time* girl. It was the first of a succession of such designs published or advocated by the *Queen* during the last three years of the 1870s.

Later in 1877, the year of the tennis-apron embroidery, the *Queen* reviewed favourably a new novel by Mrs Oliphant, *Carita*, the theme of which is expounded by three generations of middle-class women, one old, one in middle-life and one a girl. At one point in the story Miss Cherry, a middle-aged virgin, and her youthful niece, Cara, persuade a young neighbour, Edward, to read to them from the *Idylls of the King – Elaine* to be precise – while they occupy their hands with needlework. Miss Cherry explains:

It is a new kind of needlework, Edward. I don't know if you have seen any of it. It is considered a great deal better in design than the Berlin work we used to do, and it is a very easy stitch and goes quickly. That is what I like in it... but I am not sure that I don't prefer the Berlin work. After all, to work borders to dusters seems scarcely worth while, does it? O yes, my dear, I know it is for a chair; but it looks just like a duster. Now we used to work on silk and satin – much better worth it.

(Oliphant 1877: II 229–31)

So Mrs Oliphant places her Miss Cherry, up from the country and ignorant of the sensibilities of the new middle-class intellectuals whose taste was for simplicity rather than opulence, as even the *Queen* had begun to perceive.

It is clear that by 1877, as a means of describing a recognizable group of ideas that amounted to the current taste, the word 'art' had become serviceable, though it had not yet, apparently, been applied to the dress worn by people to whom art was important. Charlotte Yonge was using the word 'picturesque' for the clothes of Mrs Duncombe, with her casts of the Venus de Milo and the Praxiteles Faun in her neglected conservatory; Disraeli had not labelled the dress of Theodora Campian, although he twice referred to her 'Grecian fillets' which were not worn with the hairdressing dictated by Paris in 1870 when *Lothair* was written. However, in 1878 the *Queen*, which had a large circulation, evidently considered the new taste in dress sufficiently important to be worth discussing at length. Having reviewed, the previous year, a book with the title of *The*

Art of Beauty by Mrs Haweis, the editor must have decided that she was the right person to discuss the particular kind of dress that was seen to be increasingly worn by women of a minority group in the society of the time – a dress that had a homogeniety of design. So the *Queen* published three articles by her with the general title of 'PreRaphaelite Dress'. It is hardly necessary to point out that by this time the PreRaphaelite movement itself was far from new; indeed, although its influence remained, it was technically dead.

NOTES

1 *The Owl*, 16 February 1865. Back page, 'Ondina, or waved jupons, 18*s.* and 21*s.* "Let our wives and daughters and their sons' wives and daughters patronise the patent Ondina" – *Punch*. "The dress falls in graceful folds" – *Morning Post*. "Learned in the art of petticoats" – *Le Follet*. E. Philpott, 37 Piccadilly.'
 Ibid. 20 March 1865. Back page, 'Ebonite Crinolines, 15*s.* 6*d.* and 17*s.* 6*d.* "Made from Indiarubber, light and graceful" – *Queen*. "Good taste, with an artistic eye" – *Morning Post*. Addley Bourne (late Philpott), 37 Piccadilly.'
2 *Woman's World*, November 1868: 47. Headed 'From the Continent'.
3 Later in the novel (p. 227) we read that Clara, 'contracted her white forehead which was not very high by nature'. The low forehead is a characteristic of Greek sculpture.
4 'French *artistes* or their imitators . . . transform them into far less *natural* creatures than monkeys, as "Girls of the Period" ' (Limner 1874: 30).
5 Wightwick Manor, near Wolverhampton, Staffs. (National Trust).
6 *The Owl*, 12 May 1869, 'The Royal Academy'.

REFERENCES

Disraeli, B. (1870) *Lothair*, London: Longmans, Green
'Limner, L.' (John Leighton) (1874) *Madre Natura versus the Moloch of Fashion: A Social Essay*, 4th edn, London
Oliphant, Mrs (1872) *At his Gates*, London
—— (1877) *Carita*, London
Yonge, C. (1876) *Three Brides*, London

Chapter 14

Designing HIV awareness strategies
An ethnographic approach

Adam Briggs and Paul Cobley

INTRODUCTION

In Spring 1994 Britain witnessed a heated controversy around the sexual knowledge and practice of the nation's youth. The controversy was multiply determined by, among other things, the aftermath of the Conservative 'Back to Basics' campaign, spearheaded by Prime Minister John Major; government concern over teenage pregnancy; concern on the part of the government, parents and teachers over formal sex education in schools; the Health Minister's censorship of official Health Education Authority publications on the topic of youth, sexuality and HIV; and by media-driven debates over the use of images of sexuality in advertising (see, for example, 'Flakey and Juicy', *Today*, 14 March 1994: 20–1).

The dominant government position within this controversy was a prescriptive and moralistic one dedicated to preserving the imagined innocence of the nation's young people and preventing schools from becoming, in Education Secretary John Patten's words, 'value-free zones'. Patten's December 1993 draft guidelines for schools involved the removal of information on AIDS, HIV and other sexually transmitted diseases from the National Curriculum ('What did you Learn in School Today?', *Sunday Times*, 27 March 1994: 12). At the same time, statements by the then Under Secretary of State for Health, Tom Sackville, regarding the need for 'explicit' advertising to cut teenage pregnancy, revealed contradictory government programmes (see ' "Explicit" Adverts to Cut Teenage Pregnancy', *The Independent*, 3 March 1994: 4). Additionally, another Under Secretary for Health, just six weeks later, backed the distribution of free condoms to girls in the 12–18 age group ('Give Condoms to Girls of 12', *The Independent*, 24 April 1994: 12).

The contradictory imperatives emanating from the Ministry of Health proved problematic for those responsible for translating these imperatives into public communication strategies. What was at issue in this manifestation was, as we shall see, the question of design.

Design can be understood in two ways: first, as the general strategy

which is realized in individual sets of tactics; second, as the mechanics of realizing such tactics. For example, design can entail a long-range 'marketing' campaign based on market research and changing political climate in addition to entailing individual adverts with carefully designed textual features. In order to realize both of these design functions it is necessary to have a thoroughgoing comprehension of how individual messages are likely to be read by a target audience, a necessity which, we will argue, demands a detailed knowledge of that audience's attitudes, values and experiences. This study focuses on the targeting of 16–22 year olds in HIV awareness strategies, and because such strategies do not operate in a vacuum we need to address the whole range of sexual knowledges and their acquisition among the target audience.

Our investigation concerned the way in which 16–22 year olds make sense of HIV awareness strategies, what attitudes, experiences and knowledges were brought to the reading process and what actual reading processes were involved in the making of meaning. In order to do this we did not simply gauge responses to official health education material on the topic of HIV infection; instead, we carried out a survey of the reception of contemporary material of a sexual nature from the mainstream print media. This was done by means of a qualitative method known as focus group research (Morgan 1988; Stewart and Shamdasani 1990). In total sixteen focus groups comprising 16–22 year olds in London and the provinces were conducted during March 1994. These consisted of between four and ten members and had a duration of between one and two hours. During the course of the group discussion a series of prompt materials – some adverts, some not (see Appendix 2) – were introduced and comment was invited. The variable composition of the focus groups yielded interesting data regarding age and gender differentials; for the purposes of this study, however, we will focus on the general responses representative of 16–22 year olds.

SOURCES OF SEXUAL KNOWLEDGE IN THE 16–22 AGE GROUP

Our research took place in the midst of the controversy over sexuality and youth and our cohort clearly had a considerable amount of knowledge of this contemporary unease about the issue.

> Yesterday on the news it was saying about how they'd been teaching about oral sex to 11 year olds, and kinky sex and it was completely unacceptable but the school said it was only because the children started asking questions about it, that's why it was brought up.
>
> (Female, 16–18 single gender group [FG13])

In this country with sex education it's a 'Back to Basics' attitude.
 (Female, 19–22 single gender group [FG16])

Although the focus group members had a considerable amount of knowl-
edge of sexuality – enough to discuss this fact in itself as a contemporary
issue – it was apparent that formal sex education was not the primary
source of information about sexual matters. The two main information
sources are the peer group and the media, the former often drawing on
the latter. However, the peer group, while acting as a significant source
of information, is not necessarily seen as an authoritative one:

When you talk to your friends you boast a lot and so do they.
 (Male, 19–22 single gender group [FG15])

The crucial point about the provision of information on matters such as
HIV is that it engages its intended audience *and* that it is perceived
as authoritative.

All groups in the sample demonstrated an ambivalent attitude to the
media and its treatment of sexual issues. On the one hand many har-
boured disdain for what was seen as the over-emphasis on sex in the
communications industries:

Do they think that sex is all that teenagers' lives are based around?
We know it's not but they don't.
 (Female, 16–18 single gender group [FG10])

On the other hand there was a widespread recognition that 'erotic' ima-
gery and subject matter invariably gains attention:

If it says sex on the front that's always the first article you turn to.
 (Female, 19–22 single gender group [FG1])

This is not to say that there was an undifferentiated disdain for sex as a
subject matter. What was decisive was the perceived instrumental intent
of sexually orientated material: a distinction was drawn, for example,
between the use of sexuality as an aid to the marketing of consumer
goods and as a component of a non-commercial communication:

As it's from the Health Authority it's not so offensive, really.
 (Female, 19–22 mixed gender group [FG2])

Recognizing the instrumentality of a message is one of a number of
ways in which decisions are made regarding the acceptability of sexually
orientated material and demonstrates the cohort's awareness of the subt-
lety of methods and varieties of marketing.

Another factor in young people's disdain for the use of erotic imagery
concerns the details of the scene depicted. Young women's dislike of
sexually orientated material did not revolve around a rejection of erotic

imagery *per se*; on the contrary, it was often found to be a source of pleasure. However, they observed that many erotic depictions did not correspond with their attitudes to sex, particularly where there was sole emphasis on the female body as an object of display and/or the male was seen to be dominating the woman:

> It's really unfair – because women are there with their legs spread and God knows what and you get so few magazines on men anyway and if you do it's all modestly covered up isn't it?
>
> (Female, 16–18 mixed gender group [FG4])

These comments, if nothing else, show that the process of reading sexual material often involves a detailed and critical scrutiny of the message.

It is worth emphasizing that the process of reading does not involve passively receiving and understanding the intended message. Rather it is an active process in which pre-existing 'knowledges' and attitudes are brought into play. Such knowledges, as we have seen, include an understanding of how certain communications function, for example the specific instrumental intent of advertising. In addition to this, far broader knowledges, experiences and understandings of the social world inform the reading of a text. Because this is the case, the more a communicator is privy to the attitudes, values and experiences that an intended audience brings to the reading process the more likely it is that a communicator can successfully design a message and predict a reading of it.

The instance of young people as an intended audience presents specific problems for potential communicators arising from the heterogeneity and mutability of youth culture.

> There are different types of language – people think young people all speak the same language but there's different types within. We still understand each other most of the time – but there's still subcultures within youth culture.
>
> (Female, 16–18 single gender group [FG10])

Since its conception as a category in the late 1940s 'youth' (and particularly 'the teenager') has been perceived as a distinct market and data has been collected about youth lifestyle and values (Hill 1986: 10). The problems of this are twofold: first, data on youth becomes quickly outdated.[1] Second, qualitative data on youth in particular presents problems of interpretation. For marketers, analysts and educators, the unassimilable diversity of attitudes which make up young people's experience obscures the fact that these attitudes and values are specifically organized in the reading process.

THE AESTHETICS OF SEXUAL KNOWLEDGE

Across the whole of the sample a distinction was consistently drawn between those images from the prompt material which were perceived to be 'realistic' and those which were 'More of a fantasy' (Female, 19–22 single gender group [FG16]). In general it was thought that many 'adverts show idealistic life' (Female, 16–18 single gender group [FG13]), but this did not necessarily mean that they were disliked; on the contrary, fantasy and idealism were often positively appraised. Clearly, disdain for marketing strategy does not prevent an appreciation of the image.

> If I see a man with a nude body I think 'Yeah'. Like the Levis one with the camera and the model – he's gay unfortunately – very unfair. But he has got a nice body.
>
> (Female, 16–18 mixed gender group [FG4])

> I suppose if it was realistic there wouldn't be as much attention drawn towards it.
>
> (Male, 16–18 single gender group [FG14])

Yet, while these adverts are enjoyed as images in themselves they do not impart credibility to any accompanying message. Fantasy, more than realism, draws attention; however, it was found that it invalidates informational content.

The value of what was considered 'realism' by the cohort was that it involved recognizable features of their lives and situations that were not contrived.

> I like it when it's not set up.
>
> (Female, 16–18 single gender group [FG9])

> This doesn't look constructed – this looks natural – the others look staged.
>
> (*Doisneau poster* – Female, 19–22 single gender group [FG16])

> I think it's not tasteful – well not striking – 'cos people go to clubs and they see that all the time.
>
> (*Joe Bloggs* – Male, 16–18 single gender group [FG14])

Different people, however, lead different lives and so one person's realism is another's fantasy:

> Its trying to put across a fantasy of 'You're in a nightclub . . .'
>
> (*Joe Bloggs* – Male, 19–22 single gender group [FG15])

In spite of the value put on realism, there was a problem in that it was often felt to be a reminder of the mundanity of everyday life.

If it was in a magazine I would just turn over because it's an everyday thing.

(*Joe Bloggs* – Male, 16–18 single gender group [FG14])

This is the 'Catch 22' of realism and fantasy. Realism is seen as credible but unattractive; fantasy is seen as attention-grabbing but artificial. Fantasy images commanded attention but caused the credibility of the message to be brought into doubt; realistic images, on the other hand, failed to consistently produce the all important initial engagement even though, when read, they lent authority to the message.

The problem for marketers operating on this information is that what constitutes realism for one person represents fantasy for another. The process by which the distinction of realism and fantasy is made points to a pair of interrelated issues of textuality which have consequences for those engaged in the production of HIV awareness strategies. The first concerns the design of the text in that the text is scanned by readers for clues about its putative enunciative intent:

It's got more taste – is it just a poster or is it advertising?

(*Doisneau poster* – Female, 16–18 single gender group [FG3])

Here 'taste' is identified as an 'intrinsic' feature and yet its intrinsicality depends upon a judgment about the exteriority of the text. What is crucial in this judgment is that 'taste' is in danger of being seen as part of an instrumental intent to market consumer goods (i.e. advertising as it is understood here). Thus judgments about what an image consists of, or what a text contains, are determined by considerations which exist outside the text. Marketers therefore need to know at the very outset who their audience is and what its common experiences and beliefs are. Equally, they need to know the highly particular ways in which such experiences and beliefs are implicated in the production of meaning and how these enable judgments about the status of texts to be made.

PROBLEMS OF DESIGN IN A SENSITIVE AREA

In addressing the target group of 16–22 year olds with the intent of promoting HIV awareness and safer sex practice it is essential before designing a strategy to know as accurately as possible the vocabulary and levels of credulity of that target audience with regard to the whole sensitive area of sexuality. A key feature of the controversy of Spring 1994 was the vocabulary and tone employed in the HEA publication by Nick Fisher entitled *Your Pocket Guide to Sex* which was described by the then Health Minister, Dr Brian Mawhinney as 'smutty' (see 'More Guides to Safer Sex to be Withdrawn', *Guardian*, 18 April 1994: 5); other critics felt that the same publication promoted promiscuity as 'the social norm'

('No Sex Please, Unless we Say How', *Independent*, 29 June 1994: 12).
Our cohort recognized language use as an important issue but their
recommendations were mixed:

> Informal . . .'cos I always feel really patronized if somebody from medi-
> cine tries to write something.
>
> <div align="right">(Male, 16–18 single gender group [FG14])</div>

> It sounds quite condescending when they say 'blow job' and things
> like that it sounds overtrendy – you need a bit of both so you trust it
> as being sensible. It's got to be proper language but you also need to
> be able to understand it.
>
> <div align="right">(Female, 19–22 mixed gender group [FG8])</div>

Vocabulary, of course, contributes to the all important tone of a message:

> You can make it fun – there are quirky words like 'bonking', like
> sexual swear words.
>
> <div align="right">(Female, 19–22 mixed gender group [FG2])</div>

> A lot of leaflets just nobody reads 'cos it's either patronizing or it's
> just too hard to read – it just depends on your background, culture.
>
> <div align="right">(Male, 16–18 single gender group [FG14])</div>

As this last statement suggests, the difficulty remains of accurately target-
ing the diversity of youth. However, there is evidence here to support
the appropriateness of the 'smutty' tone and language used by Nick Fisher
in his attempt to gain and maintain the attention of his audience.

As far as the promotion of promiscuity is concerned our evidence
suggests that the reader's *pre-existent* sexual practice has a considerable
bearing on the reading of sexual messages, as can be seen in these typical
responses to an ad featuring a couple:

> I've probably got a different view because I've been in a long-term
> relationship but that's quite innocent – they're quite loving. It's not
> like a one night stand – whereas someone else might say 'Oh yeah,
> they've just met.'
>
> <div align="right">(*Davidoff* – Female, 19–22 mixed gender group [FG2])</div>

> If you think about what we've been saying, we've identified so many
> groups of people these adverts are gonna have connotations to – young
> people, one night stands, the men's view, the women's view. So it's
> gonna be very difficult for an ad to encompass all of that.
>
> <div align="right">(Male, 19–22 single gender group [FG15])</div>

In order to attract a reader's attention, then, it is essential that messages

on a sexual topic contain sufficient cues to enable a reading which engages with the sexual practices or orientations of the target audience.

At present, the targeting strategies of HIV campaigns are perceived by young heterosexuals to be failing. This is not just a matter of language and tone:

> Maybe heterosexuals aren't acting on the information they've been given because they think it's a gay disease more than it is for us.
> (Female, 19–22 mixed gender group [FG2])

> I think they like to reinforce the idea of AIDS being a homosexual drug addict sort of thing.
> (Female, 16–18 single gender group [FG13])

Many young people simply ignore HIV awareness messages because such messages are not seen as relevant to their own sexual orientation. Why, when there have been a number of campaigns targeted at heterosexuals,[2] does the idea persist that HIV is a gay disease? One possible answer may be the failure of targeting; another possible answer lies in the fact that continuing widespread coverage of HIV infection in the media focuses on the deaths of gay men from AIDS, coverage which, as the above comments attest, informs the popular imagination.

BELOW THE LINE

Typically, the first and possibly most influential source of information on HIV and AIDS for our sample was not health education campaigns:

> The first thing I ever heard about AIDS was when Rock Hudson died.
> (Female, 19–22 mixed gender group [FG2])

Invariably, information and perceptions were derived from media output which was thought to be non-didactic, including both entertainment and news. In addition, advertisements in health campaigns were often recalled not on the basis of the overt didactic message itself but because of references to them elsewhere in the media:

> The one with the old bloke – 'Geronimo' . . . The Mary Whitehouse Experience – they take the piss out of that on telly.
> (Male, 19–22 single gender group [FG12])

Similarly, many responses to an image of a couple which was associated with the advertising campaign of a pop group arose not from a detailed reading of the image itself but from the editorial coverage of the campaign:

> There was a big hoo-hah 'cos it was two women kissing.
> (*Suede* – Male, 19–22 single gender group [FG15])

By far the most significant and numerous unprompted recalls of an advertisement concerned the recent Benetton campaign.

This campaign clearly stimulated a great deal of discussion among young people. Much of this derived from the fact that the images in the Benetton campaign were documentary depictions of 'real life' situations. The cohort's knowledge of this could only have come from the media controversy that the campaign provoked. Two preliminary conclusions can be drawn from this: those ads that promote a high level of recall are those which become the object of discussion elsewhere in the media; second, depictions in the media of what are perceived as 'strange but true' events are deemed fascinating and worthy of discussion by young people.

Another area of the media's coverage of HIV which young people recall is that which concerns famous people or familiar fictional characters.

> But these days, on the TV and that, the only time you hear about AIDS is on a soap or when a famous person dies.
> (Female, 19–22 single gender group [FG1])

> And I think it only comes up to the surface when you get films like *Philadelphia* just coming out or something happens. Then it dies a death for a little while and then something happens or you find out Freddy Mercury's got AIDS and there's this big thing about it when it's convenient for the media to tell a story I think.
> (Female, 16–18 single gender group [FG13])

These statements indicate an awareness of the media's assorted priorities and routine technique and how these may or may not coincide with broader social imperatives. When these priorities and imperatives do coincide it would appear that recall is enhanced.

> Last year they did that thing on *Eastenders* when they had Mark and he's got HIV, hasn't he? So that's still an ongoing thing. They'll probably bring out the problems as he goes through different stages.
> (Female, 19–22 single gender group [FG1])

Entertainment routinely provokes discussion; recall of media treatment of HIV is therefore further assisted when it is fused with immensely popular fiction. Rather than providing an explicit prescriptive message, one aspect of the successful design of HIV awareness strategies, then, might involve the provision of a simple knowledge of the existence of an issue and its relevance to the target group. A way of achieving this, it seems, is to play down any didactic intent of a message in favour of replacing it in a realm that already provokes recall and discussion.

In order to understand the realm of media which provokes recall and discussion we must return to the concepts of realism and fantasy. Famous people embody fantasy because of their mythical status in contemporary

society; soap opera characters do so because they are fictional characters. At the same time, however, famous people are real people and subject to the same afflictions as every other human; similarly, soap operas and films such as *Philadelphia* are perceived as depicting realistic characters and realistic scenarios. That which was perceived to be 'real' in representations seemed to impart credibility and impact.

> I think it's good in soaps and things 'cos you feel like you know the person.
>
> (Female, 16–18 single gender group [FG9])

> I think that's why the Benetton ad shocks you because you don't think of anyone in your family having HIV and you see the whole family together.
>
> (Female, 16–18 mixed gender group [FG4])

Even though the 'real' is often felt to be mundane, the Benetton ads present a reality which is unsettlingly fantastic and fascinating to our cohort because it represents the 'horrible truth' (female, 16–18 mixed gender group [FG4], see above).

The mixture of horror, 'reality' and controversy, coupled with the absence of a foregrounded didactic message, resonates so closely with the audience's experiences and interests that it provokes and informs discussion.

> You say to someone 'Have you seen that picture?'
>
> (Unprompted response to a Benetton ad. – Female, 16–18 single gender group [FG9])

On its own the media undoubtedly plays a major role in informing young people on sexual matters; however, as we have seen, peer group discussion fulfils a parallel function. The peer group circulates information gained from 'experience' and from hearsay; it also circulates information which it has received from the media:

> The only time we start a conversation is if either there's a programme on telly or someone famous dies or someone comes out and says they're HIV positive.
>
> (Male, 19–22 single gender group [FG12])

As we pointed out earlier, the information of the peer group, especially where 'experience' might be bound up with boastfulness, is not entirely authoritative. Similarly, when information from the media is circulated among the peer group there is a concern about its validity which arises for two reasons. First, the generalized disdain for the media that we have discussed; second, the concern that the media reflect the general uncertainty of the scientific community with regard to HIV matters:

There was an article not very long ago in the *Daily Telegraph* magazine, 'AIDS is a Myth'.

> (Female, 19–22 single gender group [FG1])

Yeah, do you always get AIDS if you're HIV positive?

> (Female, 19–22 mixed gender group [FG8])

In *Top Santé* they found a way of stopping HIV turning into AIDS.

> (Female, 19–22 single gender group [FG1])

Because the peer group is of such central importance to young people, while also often being seen as inauthoritative, HIV awareness strategies not only need to catch the attention of the peer group but need to establish themselves as authoritative within the group's circulation of information. This is the dilemma of design in this area.

CONCLUSION

In this investigation we have sought to determine what factors need to be considered in the design of a successful HIV awareness strategy. But what is it that constitutes 'success' in this instance? Clearly there are instances of accomplished design which succeed in aesthetic terms but, perhaps, fail in other areas:

> I wouldn't go out and buy it . . . I'd buy the picture.
>
> (*Calvin Klein* – Female, 16–18 single gender group [FG13])

In these cases the design of the image has been successful in capturing the attention of its potential target group and has also generated an amount of enjoyment. However, as is made clear, this has not been accompanied by the intended sale to the member of the target group. There is a similar outcome to many HIV awareness strategies where the 'product' in this case is safer sex practice:

> Obviously no one wants to get AIDS but there's countless people still sleeping around, not using protection. I'm sure they don't want to get AIDS – but why are they not using protection? Because there's been a lot of publicity, a lot of hysteria; but I don't think there's been enough constructive publicity. It's probably been more hysteria – AIDS scare stories. But I still don't think people are getting the message – even me. If I was to go to bed with someone, with a girl or whatever, and she was easy about not using a condom, I don't think I'd say 'Well, I'll put a condom on' because I think you look at someone and think you can tell whether they're the sort of person that would have a lot of partners or whatever or HIV which is not good because I don't think you really can tell who's got HIV.
>
> (Male, 19–22 single gender group [FG12])

When my friends started becoming sexually active, and that, we used to say we'd never have unprotected sex, it's really bad – always use a condom. But now I don't think any – I've got a group of about six or seven close friends – there's only one of them who hasn't had unprotected sex. When it comes to the reality of it, it does happen, 'cos if you've been down the pub and had a few jars . . .

<div align="right">(Female, 16–18 single gender group [FG9])</div>

These people are aware of the risk of HIV and are aware of the means by which infection may be avoided, an awareness they have undoubtedly gained from exposure to HIV awareness strategies disseminated through the media. However, their awareness is not necessarily translated into safer sex practice.

The problem that all designers of marketing, advertising or other media strategies and images have to face is that the recall of information does not automatically guarantee further action by the target audience. For the marketers of consumer goods, brand awareness in itself is often considered to be a favourable outcome; in the case of media education about HIV, simple awareness is not sufficient. Persuading the target audience to adopt safer sex practice requires more accurate targeting, a clearer understanding of the reading process and ongoing detailed research into the attitudes, values and experiences of this group.

There is an overwhelming desire for an authoritative and accessible source of information on sexual matters; this is represented in the comments of all the participants in our study. Continually it was felt by young people that gay men were the recipients of the bulk of this type of education. Young heterosexuals' awareness of HIV issues was repeatedly derived from editorial matter rather than from advertising. In many cases, such editorial matter appeared in media output which was specifically targeted; that is to say, it appeared in parts of the media to which young people were already especially attracted.

One of the ways in which the media target highly specific audiences is by recognizing the finely differentiated features of and within a target group's experiences and aspirations and incorporating them within the editorial text. However, it appears that a simple depiction of these alone is insufficient to draw attention; the majority of young people were very much attracted to fantasy-based erotic imagery even while they felt that it compromised the credibility of any accompanying message. Furthermore, they were able to make prescriptions about the erotic imagery that they would wish to see: for young women especially, depictions of nudity were required to include men and women equally.

These findings seem to point to the potential of 'advertorials' in that any one specific medium, by virtue of having an established audience, has already carried out the specifics of credibly targeting its copy. As

noted above, there is no one 'language of youth' in the same way as there is no specific 'medium of youth'; more successful targeting, therefore, could involve adopting the specific language and tone of specific media. In the face of the obvious expense of such flexible targeting, an alternative strategy would seem to be a movement beyond advertising, 'below the line' to promotions and PR.

Members of the 16–22 year age group have a diverse set of informed attitudes which are manifested in their own vocabularies and interests and which are brought to the reading of media output. A failure to engage with these attitudes – however alien they may seem to those who are not members of the group – inevitably reduces the effectivity of the communication strategy. This is the perennial problem of advertisers in their dealings with clients: the latter often finding the campaign that they are financing outside their experience, mystifying and even offensive. Nick Fisher, the experienced 'agony uncle' of *Just 17*, with a market-proven ability to communicate with young people on fraught sexual topics, found himself in just this position in his dealings with Dr Brian Mawhinney.

APPENDIX 1: KEY TO THE FOCUS GROUPS

FG1 Female trainee nurses from the west of England, single gender group

FG2 Trainee nurses from the west of England, mixed gender group

FG3 Female students at sixth form college on the south coast of England, single gender group

FG4 Students at sixth form college on the south coast of England, mixed gender group

FG5 Students at sixth form college in Inner London, mixed gender group

FG6 Male students at sixth form college in Inner London, single gender group

FG7 Female students at sixth form college in Inner London, single gender group

FG8 Students at a university in south London, mixed gender group

FG9 Female students at an independent sixth form college in south London, single gender group (1)

FG10 Female students at an independent sixth form college in south London, single gender group (2)

FG11 Male students at an independent sixth form college in south London, single gender group

FG12 Male football fans, single gender group

FG13 Female students at a sixth form college in north London, single gender group

FG14 Male students at a sixth form college in north London, single gender group

FG15 Male students at a London university, single gender group

FG16 Female students at a London university, single gender group

APPENDIX 2: KEY TO THE PROMPT MATERIAL

Calvin Klein 'Escape' perfume Black and white photograph of woman in white one-piece swimming costume lying on top of a man in white swimming trunks, arms around each other, kissing on a beach.

Davidoff 'Relax' men's fragrance Copy line 'Relax your mind, enjoy your body'; black and white photo of naked man and woman; man's torso is well defined and highly lit; he is sitting with his head against her breast; she is standing with her arm on his shoulder.

Joe Bloggs (two) jeans Copy line 'Everyone snogs in Joe Bloggs'; colour photograph of a teenage couple in aggressive sexual embrace in a nightclub.

Suede (pop group) promotional poster Tinted photo of two people of indeterminate gender, shot from shoulder up, kissing passionately.

Doisneau poster ('documentary' photograph) Copy line 'Le Baiser de l'Hotel de Ville, Paris 1950', Robert Doisneau; black and white photograph of busy Parisian thoroughfare, fully clothed man and woman kissing.

(Not all of the extensive prompt material used in this research is represented in the above study.)

NOTES

1 Marketers are currently attempting to address this problem by means of a monthly updated CD-Rom of qualitative data on youth culture entitled 'Informer' (Benson and Armstrong 1994)

2 See the Health Education Authority report 'Mass Media Activity 1986–1993'.

REFERENCES

Benson, R. and Armstrong, S. (1994) 'These People Know What You Want', *The Face*, July: 56

Hill, J. (1986) *Sex, Class and Realism: British Cinema 1956–1963*, London: British Film Institute

Morgan, D. (1988) *Focus Groups as Qualitative Research*, London and Beverly Hills: Sage

Stewart, D. W. and Shamdasani, P. N. (1990) *Focus Groups: Theory and Practice*, London and Beverly Hills: Sage

Chapter 15

The roots of inequality

Barbara Bender

We legitimize the divisions and inequalities in our own societies by making them the inevitable outcome of inevitable forces. This use of history is part of our dominant ideology, just as alternative 'histories' are often part of an attempt to undermine or demote aspects of contemporary social relations. If we want to understand the roots of social differentiation and social inequality, we will have to look at quite specific prehistoric and historic social configurations and see how it is that in some societies ideology and practice – including, no doubt, past history – was used to create, maintain or subvert sets of social relations that are by no means written into nature or subsistence. I am not suggesting that the level of technology does not impose constraints upon forms of social relations, but it does not explain change or variability. Farming of itself does not create the necessary surplus to underwrite more hierarchized positions; surplus is relative and is initiated by society: 'There are always and everywhere potential surpluses available. What counts is the institutionalised means of bringing them to life' (Parker-Pearson 1984). I want to consider the way in which such 'institutionalization' might occur and social differences and inequalities might be promoted in the context of certain prehistoric gatherer-hunter societies living in south-west Europe towards the end of the Ice Age. It is, at most, a partial analysis concentrating only on a limited aspect of social relations.

Art is part of what Wolf (1984) has called 'insistent signification', part of the ideological imprinting. It is 'the coercion of a fan of potential connotations into a few licensed meanings'; part of a process of institutionalization, not only of what is to be said and thought, but how it is to be said and who is to say it – part, therefore, of an on-going process of negotiation and renegotiation of social relations.

With art, ideology takes material form. In kin-based societies, as Munn (1970) and Weiner (1985) have so elegantly shown, objects are not 'property' in our sense of the word, they are 'inalienable'. Among the Walbiri or the Maori – and surely among late prehistoric gatherer-hunters – objects 'belonged to particular ancestors, were passed down particular

descent lines, held their own stories and were exchanged on various memorable occasions' (Weiner 1985). They are 'inalienable' and related to specific sets of relations, to particular groupings in particular contexts. They 'anchor' and celebrate a 'socio-moral' order in which authority runs from the ancestor to the senior to the junior in an unending process (Munn 1970). The generational ebb and flow may or may not be gender-specific. Among the Walbiri ritual objects anchor an authority that runs from father to son. Women are acknowledged – in myth and ritual – as 'begetters', but their fecundity is socially appropriated by the males (Miller 1987). It is the process of such appropriation that can dimly be perceived among certain societies in the later Upper Palaeolithic of south-west Europe.

While I shall continue to use the term 'art', and to concentrate upon Upper Palaeolithic cave and mobile art, it must be acknowledged that this reflects the reification of 'art' in our own societies, and sets up a false division within the gamut of material culture. Upper Palaeolithic art must be seen as a facet, no more, of ideological and ritual expressiveness. It reiterates and elaborates concepts that permeate every material and non-material aspect of life. At El Juyo in northern Spain we almost catch the ephemeral action: the creation and re-creation of mud 'rosettes', the construction of small pits and hummocks, the precise placement of needles and bone points, the location of a rough stone carving placed so that from one position the human face is visible, from another the feline face (Freeman and Echegaray 1981). Further afield, at Mezhirich on the Central Russian Plain, we see very clearly how house form is another expressive medium: the tents were encased in layer upon layer of mammoth mandible and long bone, carefully arranged in patterned and often mirrored formation. At Gönnersdorf, near Cologne, hut floors were covered with schist plaques with rough female engravings on the undersides. In the Ukraine six different musical instruments made of mammoth bone have been found, and two six-hole flutes from Russia and France again extend the range of expressive media. We only have the durable remains. The faint traces of paint found on some of the figurines hint at other, non-durable, forms (Marshack 1987).

Not only is there material reiteration, but also social action is confirmed, given depth and continuity by re-use and invocation. Material objects show signs of long usage, of touch and wear; the sculptures, engravings and paintings of objects and on cave walls are touched and retouched over and over again, the animal representations are splattered with markings (Marshack 1977, 1987). Within the caves earlier representations are re-incorporated and, no doubt, re-interpreted (cf. Lewis-Williams and Loubser 1986). The actual durable, immoveable fabric of cave and rock-shelter again creates a sense of continuity and makes them part of the process by which the landscape is socialized and 'claimed'

(Layton 1986; Miller 1987). We can be fairly sure that artefact, cave and landscape demarcate a ritual rather than homeland. As Munn (1970) puts it: 'the importance of these sacred countries is not economic in the sense that it does not define the limits over which those who reside may forage ... Rather [it is] a symbol of stability.' Yet this sense of stability and continuity remains an ideological construct, and it masks the process by which social relations are subtly re-evaluated and re-aligned. For example, when an earlier painting is re-incorporated, it both cross-references the past, and takes on new meaning (Layton 1986).

To get a sense of this process of re-evaluation and alignment – and thus of change – we need also to keep in mind the immense timespan within which this cave and mobile art occurs (Conkey 1985; Marshack 1987). Within a 20,000–year span (35,000 to 10,000 BP) the 'domains of discourse' must vary very greatly. For long millennia social relations may have been such that the 'signification' of these material expressions was open to all members of the group, forming part of the process of socialization from birth to death. Objects made of imported shell or fine stones, small sculpted or engraved animals and female figurines, annotated objects, are found in habitation sites right across Europe. Form, distribution and significance changed at different times and places. For example, Marshack (1987) noted that it is only towards the end of the Palaeolithic that there are engravings that have quite specific seasonal connotations. Nevertheless, however varied, this repertoire has in common that it is visible and found in domestic contexts. It is accessible (Hahn, cited in Conkey 1985; Marshack 1987). Personal adornments were often placed in burials, and the lavish endowment of some children's graves (for example, at Sungir in Russia) would also be an expression of communal ritual, since the children can have attained little in their own right. However, there are times, and places, when part of the art and ritual becomes circumscribed, when there is a degree of social closure – by gender, age or status. Access to social knowledge is curtailed and thereby inequalities, however minor, are institutionalized and legitimized.

In the earlier part of the Upper Palaeolithic, entrances to the caves of south-west France and northern Spain were often used as habitations, and entrances, accessible passages and chambers were painted and engraved. Socialization and ritual seem wide open. At some time after 17,000 BP the pattern changes. Certain caves, such as Altamira, Castillo, Lascaux and Pech-Merle, become the foci of regional aggregation and ceremonial activity. In Périgord four of the eighty-six known Magdalenian sites (Laugerie-Basse, La Madeleine, Lumeuil and Rochereil) have 80 per cent of the embellished artefacts (Conkey 1985). In Cantabria two of the eight Early Magdalenian have 60 per cent, and in the Late Magdalenian one has 30 per cent. In the Pyrenees, Isturitz and Mas d'Azil stand out. As the arena of ritual and ceremony, such sites would have been associated

with intense activity. Things would have to be collected together, made and exchanged. There had to be provisioning for feasting as well as for everyday subsistence. In this later Upper Palaeolithic, the number of paintings in the big caves increases enormously, but part of the ritual now moves inwards. The large, accessible chambers, at Lascaux or Altamira, with their great tableaux, may have remained 'open', but small side chambers and passages show a much more intensive retouching of animals and innumerable 'annotations' (Marshack 1987). At Tuc d'Audoubert in the Pyrenees the ceiling of a small chamber has an engraved horse's head, surrounded by eighty-four P signs, made in various styles with various tools, and sometimes renewed. An almost identical configuration is found in the neighbouring cave of Trois Frères (Marshack 1987). Often the paintings and engravings are placed far from the cave entrance (Rouffignac, 2 km from the entrance; Niaux, between 500 m and 2 km; Tuc d'Audoubert and Trois Frères about the same), access is difficult and the space cramped. Exclusivity can take other forms – at El Juyo in Spain the roughly sculpted stone placed near the entrance reads from the outside as a man's head, but from inside the cave it becomes a feline (Freeman and Echegaray 1981).

Who, then, is being excluded? A strong possibility is that these secret places were an arena for the initiation of young males, and the 'capturing' of the animals in the painting was part of the capture of hunting as a male preserve. They become part of the process by which the 'female controlled biological power of reproduction is subsumed by male cultural control over social reproduction' (Miller 1987). There is no reason in nature for the sharp gender divisions found in many gatherer-hunter societies, they have to be created by proscription and taboo, they have to be 'naturalized' through ideology and ritual.

Other aspects of the later Upper Palaeolithic art of this region, both cave and mobile, may substantiate this notion of increased exclusiveness. Although the animal representations have received most of the attention, there are, in reality, many more geometric signs in the caves. These signs are less frequently found on mobile art, they fall into fairly well-defined classes and have tight regional groupings – there is none of the widespread dissemination associated with mobile art (Leroi-Gourhan 1977–8). They increase in number and variety and become more abstract in the later Upper Palaeolithic. They are often used to 'annotate' animal representations (Marshack 1977). Increased abstraction permits increased ambiguity, creates a code that is harder to crack – an individual sign may carry different meanings depending upon the context of use and specific juxtapositions (Munn 1973). There can be a multiplicity of codes that are differentially available to groups within groups. Layton (1986) notes how a North Arnhem Land artist explained that if he were representing the

subject matter in an exclusive male context rather than an open camp, he would use 'geometrics'.

Another interesting feature is that not only are there very high concentrations of decorated pieces at the large sites in Périgord, the Pyrenees and Cantabria, but certain artefacts – spear-thrower, shaft-straightener, harpoon and rod – begin to be highly embellished (Bahn 1982). We seem to be witnessing part of the process by which symbolic representation extends and engulfs the surface of other media, to which access is again limited. Munn (1973: 213) noticed such a development in the male iconography of the Walbiri. Such artefacts have tight distributions; they move in constrained spheres of exchange, available only to socially designated partners.

Social differentiation hinges, in the first instance, on differential access to social knowledge. However, this can be 'converted' into more material control. There is the possibility of exclusive exchange, there are the demands made on people's labour as part of the whole process of ritual, of material creations, of display and feasting. The labour of elder or shaman, young initiate or uninitiated male or female appears, both to us and to the people involved, as a form of communal appropriation. This 'ideology' of communality disguises the way in which the labour is called into being and used by only a limited number of people within the society.

It would seem that the social configuration of areas of south-west France and northern Spain during parts of the Upper Palaeolithic was different from that of contemporary groups, and that the art was part of a process of social negotiation, part of a symbolic 'naturalization' of increased social differentiation. No doubt the seasonal aggregations at the great sites in Périgord, Cantabria and the Pyrenees were made possible by their optimal locations for culling herds or catching salmon, but their ecological setting does not explain the size of aggregation or the intensity of ritual. People came together to celebrate, and they chose locations and seasons that permitted such congregations. No doubt they intensified their subsistence strategies to meet their temporary needs – just as Australian aborigines dug artificial eel runs to permit large ceremonial gatherings (Lourandos 1980). It may even be that the emphasis on reindeer hunting was as much a response to a demand for antlers to make into fine artefacts as a demand for meat (White 1982). No doubt such seasonal aggregations permitted the pooling of much practical information, but it also permitted the control, rather than dissemination, of social knowledge. The ceremony and ritual of the great caves was part of a process of social reproduction which need not have been to the advantage of each and every member of the society.

It is obvious that the developments charted above are still immensely crude. With tighter control of the evidence it may be possible to chart cyclical developments within the different regions. There were perhaps

times when the demands made on labour and resources became too great, and a more egalitarian configuration re-emerged.

Ideological representations are integral to relations of power and control. In some instances these relations make demands on labour and on production, and these demands may, in turn, promote technological developments. The beginnings of inequality do not start with the onset of farming, or with any other ecological input, they lie far back in the varied social configurations and ideologies of gatherer-hunter societies.

REFERENCES

Bahn, P. (1982) 'Inter-site and Inter-regional Links During the Upper Palaeolithic: The Pyrenean Evidence' *Oxford Journal of Archaeology*, 1(3): 247–68

Conkey, M. (1985) 'Ritual Communication, Social Elaboration, and the Variable Trajectories of Paleolithic Material Culture', in T. Price and J. Brown (eds) *Prehistoric Hunters and Gatherers: The Emergence of Cultural Complexity*, New York: Academic Press

Freeman, L. and Echegaray, J. (1981) 'El Juyo: A 14,000-year-old Sanctuary in Northern Spain', *History of Religion*, 21: 1–19

Layton, R. (1986) 'Political and Territorial Structures Among Hunter-gatherers', *Man*, 21: 18–33

Leroi-Gourhan, A. (1977–8) 'Résumé des cours et travaux de l'année scolaire 1977–78', *L'Annuaire du Collège de France*: 523–34

Lewis-Williams, J. and Loubser, J. (1986) 'Deceptive Appearances: A Critique of Southern African Rock Art', in F. Wendorf and A. Close (eds) *Advances in World Archaeology*, New York: Academic Press: 253–89

Lourandos, H. (1980) 'Change or Stability? Hydraulics, Hunter-gatherers and Population in Temperate Australia', *World Archaeology*, 11(3): 245–64

Marshak, A. (1977) 'The Meander as a System', in P. Ucko (ed.) *Form in Indigenous Art*, London: Duckworth: 286–317

—— (1987) 'The Archaeological Evidence for the Emergence of Human Conceptualisation', paper delivered at Santa Fé, April 1987

Miller, D. (1987) *Material Culture and Mass Consumption*, Oxford: Blackwell

Munn, N. (1970) 'The Transformation of Subjects into Objects in Walbiri and Pitjantjatjara Myth', in R. Berndt (ed.) *Australian Aboriginal Anthropology*, Canberra: Australian Institute of Aboriginal Studies: 141–63

—— (1973) *Walbiri Iconography*, Ithaca: Cornell University Press

Parker-Pearson, M. (1984) 'Economic and Ideological Change: Cyclical Growth in the Pre-state Societies of Jutland', in D. Miller and C. Tilley (eds) *Ideology, Power and Prehistory*, Cambridge: Cambridge University Press: 69–92

Weiner, A. (1985) 'Inalienable Wealth', *American Ethnologist*, 12: 210–27

White, R. (1982) 'Rethinking the Middle/Upper Paleolithic Transition', *Current Anthropology*, 23(2): 169–92

Wolf, E. (1984) 'Culture: Panacea or Problem?', *American Antiquity*, 49(2): 393–400

Chapter 16

Art and reproduction
Some aspects of the relations between painters and engravers in London 1760–1850

Gordon J. Fyfe

He had been a sculptor, a painter, an engraver, a stone mason. He left us behind, two lesser men, Otto the stone mason and I, Edmund, the engraver.

(Iris Murdoch, *The Italian Girl*)

The concept of *the artist* – as a person endowed with extraordinary gifts and powers of imagination – is of relatively recent currency; it accommodates an historically specific set of attitudes and meanings. These, it is generally agreed, entail notions of social difference that matured in the late eighteenth century and were unknown to the medieval world. The idea of the artist was linked to decisive changes in the institutional structures which had regulated the production of images in medieval times, namely the dissolution of guild power, the process of state formation and the evolution of art markets. These aspects of change in the conditions of artistic creation are well established in the sociology and social history of art (Antal 1948; Hauser 1962; Martindale 1972; Wolff 1981). The following related features may be identified as correlates of the weakening of the ties that had once bound image-makers to guild craftsmanship – first in northern Italy and later in other western European societies.

(1) The appearance of a cleavage within the visual arts sanctioned by guild authority – that between artists and craftsmen. Thus, by the end of the fourteenth century in Italy: 'doing a panel painting is really a gentleman's job, for you may do anything you want with velvet on your back' (Cennino Cennini, quoted in Holt 1957: 148–9).
(2) The hegemonic role played by painters within a system of production that was increasingly organized through markets, subordinating and marginalizing other image-makers along class and gender lines.
(3) The elaboration of a philosophical system which established the fine arts, painting, sculpture and architecture, as a unified cultural domain (Kristeller, 1951–2). In association with this there was the insti-

tutionalization of the fine arts in the form of academies; for example, the Accademia del Disegno (Florence 1562), the Accademia di S. Luca (Rome 1593), the Académie de Peinture et Sculpture Paris 1648) and the Royal Academy of Arts (London 1768).

(4) The proliferation of academies of art between 1750 and 1800 within the context of three social processes; the extension of state cultural power, the development of manufacturing and the growth of bourgeois art markets.

The analysis presented here concerns a comparatively late phase in the evolution of the fine arts and focuses on one aspect – the situation of reproductive engravers during the late eighteenth century and in the nineteenth century. In France and England these people occupied an ambiguous position within the hierarchy of the fine arts. Early eighteenth-century writings on aesthetics seem to have provided some accommodation for engravers (Kristeller 1951–2), but it is clear that by the end of the century their situation was increasingly precarious. Thus engravers, although eligible for membership of the French Academy, could find their privileges questioned: 'If engravers have to be admitted to the Institute, then locksmiths will have to be admitted as well' (quoted in Adhémar 1964: 231). In London, engravers were at first excluded by the Academy and then admitted as junior members.

During the nineteenth century the status of 'artist' was only reluctantly conferred on those who made their living from engraving. The dominant aesthetic orthodoxies of fine art did not permit the engraver who worked the plate or block personally a publicly acknowledged creative role. At the same time there was a type of engraver, the reproductive engraver, who was able to assert a secondary, but nevertheless publicly recognized claim to be creative. An issue which surfaced from time to time in the politics of art was the problem of the artistic status of reproductive engravers. Were they artists? Were they merely copyists? The Royal Academy of Arts recruited only a handful of engravers, excluded them from the institution's government, denied engraving a place in the curriculum of its Schools and was pre-eminently an academy run by and for painters.

What was the role of reproductive engravers before the development of half-tone photography in the 1880s? They played a key role in supply reproductions of paintings, helping to promote the reputations and the fortunes of painters within a developing fine art market. Reproduction, here, must not be conflated with photographic reproduction. Photography did not usher in the age of reproduction in the fine arts. Photography appeared in a nineteenth-century art world already familiar with the idea of pictorial reproduction in this domain – reproduction through the agency of the handicraft print-maker. The 'effects' of photography were experienced through its impact on the practice and perception of painting

and on established means of graphic reproduction. Thus it was that photography came to be condemned as a 'foe-to-graphic art'!

The 'art' of engraving was largely perceived as a reproductive art, particularly as a means for the reproduction of painted originals. Engraving as a 'language' in which painted originals were 'spoken' after or about, a language which acknowledged (*invenit, pinxit*) that pictorial authority resided elsewhere and that the engraved image had a qualified status as a 'work of art'. From the point of view of the living artist this was a matter of importance for his or her reputation and income. In 1822 the print publisher Hurst and Robinson agreed to pay Thomas Lawrence £3,000 a year for the exclusive right to engrave his paintings (Pye 1845: 243–4). Later in the century Edwin Landseer was getting well over £2,000 and even £3,000 for individual copyrights and was paid over £60,000 for copyrights by Henry Graves. The eighteenth- and nineteenth-century art trade, then, developed partly as a trade in copyrights. Important here is the development of intellectual property with the copyright legislation of 1735 lobbied for by Hogarth. Copyright remained a focus for debate and 'pressure-group' activity through into the nineteenth century, particularly in the context of new methods of reproduction.

A central aspect of the argument presented here concerns the ambiguous artistic status of these craftsmen-artist-engravers. This article explores the roots of the ambiguity and assesses the changing situation of engravers within the relations of production of art. It is argued that the experience of art, insofar as it was gained through encounters with reproductions of paintings, was inextricably bound up with two things. One concerns the tension between the authorship of the painter and the 'translation' of the reproductive engraver. Here, as we shall see, there was an indeterminacy in the relationship between artists and engraver, which sometimes erupted into disagreement and conflict and which could also yield images whose authorial status was ambiguous. The second thing concerns the situation of engravers as a progressively submerged occupational group.

Two principal narrative themes are explored in this case-study. One is the power struggle which took place between painters and engravers over the artistic status of engraving and its proper place within the Academy. Here at the level of professional politics we can see the foundation and consolidation of the Academy as evidence of the growing hegemony of the fine artist within an expanding art market. As we shall see, the concept of the artist received a clear affirmation when the Academy refused to change its policy on engraving in 1812. The second theme concerns the situation of the engraver within the context of the workshop and of technical change. Here is it a matter of the increasing isolation of the labour of reproductive engraving from the intellectual means of production. Throughout the eighteenth and nineteenth centuries the relationship between painters and engravers was nuanced by innovations

in the techniques of reproduction and the organization of labour – innovations which were aimed at perfecting engraving's capacity to report the values of other media. These developments were implicated in the transformation of the engraver's social identity and reputation as an 'artist'.

What is so striking about the period under consideration is that few people, and Blake was one exception, seem to have taken seriously the possibility that engraving might, like painting, be harnessed to 'original' work. T. J. Clark, drawing on Marx's and Engels's observations about Raphael and the structuring of talent, has called for an analysis of creativity which leads to 'a close description, of the class identity of the worker in question, and the ways in which this identity made certain ideological materials available and disguised others, made certain materials workable and others completely intractable, so that they stick out like sore thumbs, unassimilated' (Clark 1974: 562). The case of nineteenth-century engraving begs for such an analysis. There were, to be sure, artists who invested in print-making the same kind of creative energy that others reserved for painting. But until the last part of the nineteenth century they did so against the odds.

THE LANGUAGE OF ENGRAVING

Both the printing of 'literary' texts and 'pictorial' texts were linked to changes in the relationship between text and the concept of creativity. These changes were linked to 'cultural choices' which cannot be taken as necessary effects of printing technology (Ginzburg 1980: 16). In the case of printing we have: (a) the fixing of the individuated author's sphere and the genesis of intellectual property; and (b) the sloughing off, from the text, of those attributes (such as voice, gesture and calligraphy) which are not conveyed by the press. Thus the question of the book as a physical object is marginalized in relation to matters that concern the literary text.

Eisenstein (1979) has argued that in accounting for the rise of the artist the preserving role of printing has not been given its due recognition. She suggests that the circulation of printed biographical records secured the enduring reputations of the great masters. Much the same point can be made about reproductive print-making: that the 'exactly repeatable pictorial statement' (Ivins 1953) was of decisive importance in Europe for the dissemination of knowledge about artists' pictorial achievements. However, it must be stressed that, whilst the origins of 'the artist' go back to the fourteenth century, the first printed pictures did not make their appearance in Europe until the fifteenth century. It is thought that by the middle of the century the woodcut and the engraving had become established as elements of pictorial culture.

Early sixteenth-century engravers evolved print-making techniques that

were capable of representing the world as it was evoked by the conventions of painting. The making of a printed image, whether it is a representation of an object in nature or a copy of another image (say, a painting), is not the simple transcription of the visual qualities of the object onto a printing surface. It involves the deployment of one of several possible visual conventions or 'languages' whose qualities are bound up with the chosen or available technique. Under consideration here is a form of print-making that had been subordinated to the achievements of painting, to the problems of representing the distribution of objects within a rational space – chiaroscuro and volume.

The credit for devising a print-making technique that could, in a world without photogravure, substantially express such qualities goes to Marc Antonio (c. 1480–1530). He developed a linear system, 'a kind of shading that represented not the play of light across a surface, and not the series of local textures, but the bosses and hollows made in a surface by what is underneath it' (Ivins 1953: 66) as though a net had been cast over the objects and people represented. Imagine, suggested Evelyn in *Sculptura* (1662), a shadow cast by the sun, through a mesh of threads onto an object such as a bowl or a person's head: 'it is evident, that these Threads, in whatever manner you interpose the said Frame 'twixt the *Bowle* and the *Sun*, that they will perpetually cast their shadows' (Evelyn 1905: 122). Marc Antonio and those who followed him developed a language, a linear scheme or engraved 'syntax' into which works of art and other images could be 'translated'. Such a visual language could be used by a group or school of craftsmen-engravers who did not design independently, but who worked in a particular 'house' style to reproduce the art of others.

In the seventeenth century the European engraving houses of Rubens, Callot and Bosse passed into a manufacturing phase, with workshops capable of organizing and supervising the labour of engraving. The use of a linear scheme in these workshops had profound consequences for the kind of 'knowledge' that could be communicated about works of art. This was more 'an indication of iconography combined with generalized shapes and masses' than an understanding of the 'personal characteristics of the original works of art, their brush strokes and chisel marks' (Ivins 1953: 166). We know from the engraver George Vertue (1684–1756) and from Evelyn that painters did not care to get directly involved in engraving. Where they did so, they usually made it clear that they were doing it for their personal amusement (Gray 1937: 24). In an imaginary conversation of 1736 the painter states that 'though a Painter, I have formerly pleasured my self at Times with the Practice of those two Arts [Engraving and Etching]'. The painter's partner in conversation, an engraver, has already conceded that the public image of his art is yoked to painting: 'we Engravers are pretty much Painters Copyists' (Atkinson 1736: 1–2).

Engravers may have been copyists, but they appear, by modern aes-

thetic standards to have taken a surprising degree of licence in their 'copying'. In fact they were more likely to argue that they were 'translators' than to concede that they were copyists. In this context connoisseurship might be sensible of an authorship other than that of the painting's 'artist' – that of the painting's reproductive engraver. Meisal (1983) tells us that Dickens drew attention to this sense of pictorial displacement and that he was voicing a widely experienced, though unremarked, feeling. However, engravers talked about it. Along with Dickens, they took the view that the enjoyment of reproductions might flow from their skills in improving on a deficient original.

The author of *Sculptura Historico-Technica* (1770) explains that the engraver may have to correct the rendering of hands and feet 'when he engraves from the Works of Painters or Designers, who were not perfect in this Branch' (Anon 1770: 16). Even 'good Painters' may frequently leave certain matters 'to the Discretion of the Engraver' (*ibid*: 17). Strutt's biographical dictionary of engravers (1785) reflects on the accusation that engravers 'deserve not the name of artists' and are nothing more than copyists: 'What the poet has to do with respect to the idiom of the language, the engraver has also to perform in his translation, for so it may be called, of the original picture upon the copper' (Strutt 1785: 5). This argument was a major plank in the engravers' case against the Royal Academy and was sustained well into the photographic age – at least until the turn of the century. Questioned before the Royal Commission (1863) which was inquiring into the affairs of the Academy, the engraver George Doo opined that 'photography is incapable of correcting the faults of a picture, bad drawing, want of keeping, etc., but copies all the *vicious* with the *good*' (PP, 1863, 3205, xxvii q. 2358).

Engraving, then, was the site of an aesthetic tension between artists and craftsmen. The effects of reproduction threatened to break through, challenge and even obscure the pictorial intentions of the artist, a possibility that was always latent in the 'antinomy' of *pinxit* and *sculpsit*. Going on from Ivins, it seems likely that it was through photographic reproduction that the connection between the artist's intention and the qualities of the medium in which they were expressed could first be widely experienced and demonstrated. What the photograph reported were the 'traces of the creative dance of the artist's hand' and the effects of a 'deliberate creative will' (Ivins 1953: 144). However, whilst a knowledge of painting was mediated by the art of the handicraft reproductive engraver, that 'creative will' was exposed to the vagaries of another 'authorship' and another 'language'.

These aesthetic problems bore the inscription not only of technical innovation (by 1859 there were said to be 156 different reproductive techniques) but also of the struggle for cultural capital. The aesthetics of nineteenth-century reproduction (which were not culturally neutral) were

structured in relation to new methods – lithography, wood-engraving, electro-typing, photography, etc. Technical change was linked to aspects of cultural stratification – to what Bernstein (1975) and Dimaggio (1982) call differentiating rituals. New techniques were developed and appropriated in the context of a 'terracing' of taste which was partly determined by the weight of middle-class demand for access to the fine arts; the middle class 'battle to raise standards, to emulate the class above and differentiate themselves from the class below' (Ryder and Silver 1970: 68).

ENGRAVERS AND THE ROYAL ACADEMY OF ARTS

This section sketches the institutional conditions which allowed engravers to voice their situation and campaign for 'reform' of an Academy which preferred to consign them to the margins of Art.

The Academy was established in 1768 following a petition to George III from twenty-two artists. There were to be forty Royal Academicians who were to be 'artists by profession at the time of their admission, that is to say, *Painters, Sculptors* or *Architects . . .*'. Two other classes of membership were created beyond that of Royal Academician (RA). There was the class of twenty Associate Royal Academicians (ARA) and the class of six Associate Engravers. Associates were excluded from participation in the Academy's government, as were Associate Engravers. This was underlined in 1813 when two engravers tried, unsuccessfully, to get sight of the Academy's minute books and were reminded 'that the government of the Academy exclusively belongs to the Academicians' (RA, Council Minutes, vol. 5, p. 18, 2 February 1813). Moreover, *qua* engraver, a person could not become a full RA.

Engravers experienced the foundation of the Academy as a humiliation. The sources of their humiliation were in the development of a fine art politics from which they were progressively excluded and in the endorsement of a concept of creativity that eluded them altogether. The politics of the Academy's development and the situation of engravers were determined in relation to three aspects of cultural production: a residual craft tradition, patronage and the extension of bourgeois cultural and commercial interests within the domain of art. It is clear that eighteenth-century art institutions were, by comparison with the nineteenth century, aesthetically heterogeneous and that the divide between the arts and the crafts was still in the process of being institutionally secured. The ambiguity of the engraver's identity speaks for a situation that was experienced as being in flux.

The key to the Academy's power is the way in which patronage, rooted in an agrarian capitalism, was imbricated with a developing bourgeois art market. Through the 1750s and 1760s the politics of art translated the

tensions and accommodations between those artists relatively close to the court and aristocratic patronage and those, not least engravers, who were more dependent on the market. Important here is the ideological weight of the bourgeoisie as a public with an antagonistic relationship to the ascriptive privileges of aristocratic culture. In the case of the fine arts, print-making was central to the emergence of an art world, which was an arena of public cultural exchange, debate and scholarship – one yielding the intellectual authority of its own professional practitioners: fine artists. Nonetheless, the impact of patronage and attempts by wealthy connoisseurship and the monarchy to extend their influence over developing metropolitan art institutions were features of art politics in the eighteenth and early nineteenth centuries. This was something that sometimes threatened to fissure the professional art world in that patronage might find common cause with a particular faction. After all, it was precisely this configuration of patronage and market that had enabled the RA to establish itself as an exclusive and dominant artistic body.

The hierarchical and oligarchical character of the Academy with its tendency towards closed orders of artistic practices bore the hallmark of an estate system of stratification, like that found in other occupational groupings such as medicine. These features were linked, as with other professions, to the hegemonic principles of landed privilege and the gentleman. It was precisely this association with aristocratic cultural power, along with the whiff of Old Corruption, that provided the terms of a radical bourgeois attack on the Academy in the 1830s.

Crucial here is the transformation of cultural politics within the context of parliamentary reform, a pressure for 'reform' that was brought to bear on the Academy (which bourgeois radicals perceived both as a bastion of aristocratic and artistic privilege and as an obstacle to the pursuit of industry's artistic needs). A Select Committee was set up in 1835 to inquire into such matters and opened up questions of Academicians' accountability, their privileges, matters of art education, the affairs of the National Gallery and the claims of the engravers. Its *Report* described the situation of engravers as 'extraordinary' (PP, 1836, 568, xi, Select Committee on Arts and Manufacturers, *Report*, pp. viii-ix). Parliamentary interest in the situation of engravers was renewed in 1844 with the *Report* of the Select Committee on the Art Unions: 'the interests of engraving ought to be considered; the alliance ought to be on a fair basis. She is not to be sacrificed to the interests of her elder sisters' (PP, 1845, vii, Select Committee on Art Unions, *Report*, p. xxxv).

What is important is the way in which the state endorsed the artistic claims of engravers (partly in relation to the moralizing influence of a mass produced art) and accommodated a perception of engravers as victims of aristocratic privilege and Academic despotism.

The engravers' claim was (Landseer 1807; Pye 1845) that engraving

was an intellectual activity – a form of translation. As such, engravers demanded not equality, but a due and honourable recognition of what to their way of thinking was a creative vocation. The Academy resisted them on three grounds. First, there was the argument that questions concerning the Academy's constitution must ultimately be determined by the monarch. Second, the financial dependence of the Academy on its annual Exhibition meant that there was a particular 'necessity for bringing forward *original* artists, who alone are capable of supplying sufficient novelty and interest to excite public attention'. Third, there were reasons of 'a more abstract and immutable nature':

> That all the Fine Arts have claims to admiration & encouragement, & honorable distinction, it would be superfluous to urge ... but, that these claims are not all equal has never been denied, & the relative pre-eminence of the Arts has ever been estimated accordingly as they more or less abound in those intellectual qualities of Invention and Composition, which Painting, Sculpture and Architecture so eminently possess, but of which Engraving is wholly devoid; its greatest praise consisting in translating with as little loss as possible the beauties of these original Arts of Design.
>
> (RA, Council Minutes, vol. 4, p. 396, 30 December 1812)

So to admit engravers on equal terms would not be commensurate with 'the dignity of the Royal Academy' and the nature of art.

What exactly is it, then, that was being denied to engravers? Crucial here is the vocabulary of originality and the seventeenth- and eighteenth-century semantic shifts which interiorized creation, establishing the artist as a creator, the possessive individualism of one who has the attributes of creativity. As Shils (1981) argues, 'originality' was once 'a reminder of the ineluctable dominion of the past over the present' – original sin, the burden of a scribal culture that must seek out the authentic in the confusion of past sources. But now originality refers to one who makes a cultural difference, one who can be put forward in the Exhibition as 'supplying sufficient novelty and interest to excite public attention'. In such an exhibition there is a pressure to establish the inferiority of copies which are separated from the origins of creativity but which, nonetheless, register the aura of the original pictures after which they speak.

ENGRAVERS: CRAFTSMEN OR FACTORYMEN?

The Academy secured the promise of a professional identity for painters and sanctioned the aesthetic subordination of engravers. The situation of engravers was not, however, merely the effect of Academic labelling. If the Academy emphasized the concept of an 'original' artist and projected painters (along with sculptors and architects) as professionals, then it is

clear that engravers were heading in an altogether different trajectory. What the politics of the Academy effected was the endorsement of a process of class structuration within cultural production. There were three aspects to this. First there were the professional painters whose artistic reputations were extended through print-making. Second, there was the technical and entrepreneurial leadership, partly recruited from among engravers (e.g. the Boydells and the Heaths). Here we find engravers turning themselves into art directors, employing and directing others on the increasingly routine labour of engraving. Third, there was the proliferation of a class of depressed wage-earners, skilled and semi-skilled workers who were confined by the detailed labour of what was art-manufacturing. As one guide to print collecting put it in 1844: 'The print is, in truth, not a work of individual art, but a manufacture' (Anon 1844: 163).

The story of nineteenth-century engraving is the familiar one of a skilled trade 'threatened on every side by technological innovation and by the inrush of unskilled or juvenile labour' (Thompson 1968: 269). Copper-plate engraving in the late eighteenth and early nineteenth centuries made increasing use of semi-skilled labour. The use of the so-called 'tone' processes (stipple, dot and mezzotint techniques) was associated with the fragmentation of production into separate detailed tasks and the genesis of a house style to which the creative energies of assistants were harnessed. Assistants specialized in engraving parts of the plate or were confined to specific stages of its production such as laying a mezzotint ground or punching holes for dotted prints. Apprentices and journeymen could be forced into a dependence on their masters so that 'after labouring in their masters' studios for years, they were wholly incapable of carrying a plate through its various stages to completion; although skilled in the translation of "backgrounds" unapproachable in their "skies" or unrivalled in their "draperies" ' (*Men of the Time*, 3rd edn, 1856: 644).

The key to this is the distinctive form of the relationship of engraving to the interests of a burgeoning art capital. *Pace* Marx of the first volume of *Capital*, nineteenth-century engraving developed as a system of manufacturing based on handicraft skill. The integration of photographic methods into a means of mechanical production was not realized until the 1890s. It was the invention of dustgrain photogravure by Klic in 1875 and his collaboration with Samuel Fawcett, a calico engraver, which secured the development of rotary engraving in the 1890s with mechanical reproduction capable of 700 impressions an hour (Lilien 1957: 16–19). The first steps towards photographic reproduction had, of course, been taken much earlier. Niepce had researched the possibility of incorporating light-sensitive chemicals into handicraft reproduction in the 1820s; wood-engraving was using photographic methods of transfer by the 1840s; and

in the second half of the century photogravure was turning engravers into finishing workers.

It is in this context that handicraft reproductive print-making experienced the erosion of its independent craftsmanship. The aesthetics of reproductive craftsmanship seemed threatened by sweating and by photographic methods whose aesthetic values did not automatically declare themselves. The engravers' sense of decline was determined not only in relation to the art-politics of the Academy but also in relation to their encounters with the 'middle-men' of the print trade and the process of capital accumulation. Here it is important to stress the distinctive role of handicraft within the labour process. In the reproductive print trade, as elsewhere, skilled craftsmanship retained a relative autonomy as the foundation of manufacture and constituted an obstacle to the process of capital accumulation. The relationship between art-craftsmanship and capital was a chronic source of misunderstanding, dishonesty and tension. The interests of independent engravers collided with those of capital, generating in various modes a sense of collective self-help which was partly fuelled by outrage at the Academy.

In concluding this section it is necessary to point to the structuring of cultural identity, not one-sidedly through the terms of capital accumulation but also in terms of the 'language' of engraving. Engravers fought back, on the terrain of aesthetics, to defend their weakening position. Increasingly they did so within the terms of a photographic language, but their achievements could be those of considerable virtuosity. An Impressionist brush stroke? By the 1880s there were engravers who could supply one.

CONCLUSION

The case of nineteenth-century reproductive print-making is of interest for at least two reasons. First, the conflict between painters and engravers can be seen as one aspect of the process whereby the notion of creativity as an effect of a unitary intelligence gained cultural supremacy. What was at stake was the dissemination of the idea of the artist as expressing the free-play of a coherent creative will, one to which pictorial means and materials were subordinated. Such a notion of the artist-as-creator is central to the discourse of contemporary art history (Pollock 1980), but for much of the last century the means of fine art reproduction were the site of an aesthetic tension which threatened the complete pictorial authority of artists. During their heyday craftsmen-engravers were agents in extending the reputations of fine artists. However, the 'hand' of the engraver was an obstacle to the unqualified extension of what Bourdieu (1980) has called the charismatic ideology: 'the ideology of creation which makes the author the first and last source of the value of his work'.

Second, the exploitation of the market for fine art prints was associated with the separation of engravers from the intellectual means of production. The process of capital accumulation within cultural production endorsed and accentuated the difference between the artist and the craftsman that had been ushered in by the Renaissance. What is important is that the consumption of fine art prints increasingly presupposed a division between mental and manual labour that was internal to pictorial production.

In assessing the role of nineteenth-century reproductive art it is important to realize that the aesthetic of the original print has achieved an importance in the fine art market only in recent times. The contemporary notion of the original print is intimately and ideologically associated with the social construction of authorship as it relates to the pictorial 'text'. The 'originality' of an original print is predicated on (1) the print's categorical difference from a reproduction, (2) its independent status as a work of art and (3) the assigning of a complete pictorial authority to the 'artist'. The hyperbole of the contemporary art market tends to freeze our thinking about image-making, naturalizing the distinction between reproductions and originals. It is not possible to pursue the matter here, but there are ideological aspects to the original/reproduction dichotomy insofar as it fails to accommodate the range of print-making practices, past or present. It is as well to remember, too, as the possibilities of laser holography are anticipated, that the social history of art reproduction is not yet complete.

REFERENCES

Adhémar, J. (1964) *Graphic Art of the Eighteenth Century*

Anon (1770) *Sculptura Historico-Technica: or, the History and Art of Engraving*, 4th edn

Anon [Maberly, J.] (1844) *The Print Collector: and Introduction to the Knowledge Necessary for Forming a Collection of Ancient Prints*

Antal, F. (1948) *Florentine Painting and its Social Background*, London: Routledge & Kegan Paul

Atkinson, T. (1736) *A Conference Between a Painter and an Engraver*

Bernstein, B. (1975) 'Ritual in Education', *Class, Codes and Control*, London: Routledge & Kegan Paul

Bourdieu, P. (1980) 'The Production of Belief: Contribution to an Economy of Symbolic Goods', *Media, Culture and Society*, 2(3): 261–93

Clark, T. J. (1974) 'The Conditions of Artistic Creation', *The Times Literary Supplement*, 24 May

Dimaggio, P. (1982) 'Cultural Entrepreneurship in Nineteenth-century Boston', *Media, Culture and Society*, 4(1 & 4)

Eisenstein, E. (1979) *The Printing Press as an Agent of Change*, Cambridge: Cambridge University Press

Evelyn, J. (1905) *Sculptura: or, the History and Art of Chalcography* (first published 1662)

Ginzburg, C. (1980) 'Morelli, Freud and Sherlock Holmes: Clues and Scientific Method', *History Workshop*, 9

Gray, B. (1937) *The English Print*

Hauser, A. (1962) *The Social History of Art*, 4 vols, London: Routledge & Kegan Paul

Holt, E. G. (1957) *A Documentary History of Art*, vol. 1, *The Middle Ages and the Renaissance*, New York: Doubleday

Ivins, W. M. (1953) *Prints and Visual Communication*, London: Routledge & Kegan Paul

Kristeller, P. O. (1951–2) 'The Modern System of the Arts: A Study in the History of Aesthetics', *Journal of the History of Ideas*, 12: 496–527 and 13: 17–46

Landseer, J. (1807) *Lectures on the Art of Engraving*

Lilien, O. M. (1957) *History of Industrial Gravure Printing Up to 1900*

Martindale, A. (1972) *The Rise of the Artist*, London: Thames & Hudson

Meisel, M. (1983) *Realizations*, Princeton: Princeton University Press

Pollock, G. (1980) 'Artists, Mythologies and Media: Genius, Madness and Art History', *Screen*, 21(3): 52–96

Pye, J. (1845) *Patronage of British Art*

Ryder, J. and Silver, H. (1970) *Modern English Society*, 1st edn, London: Methuen

Shils, E. (1981) *Tradition*, London: Faber & Faber

Strutt, J. (1785) *A Biographical Dictionary: Containing an Historical Account of All the Engravers*

Thompson, E. P. (1968) *The Making of the English Working Class*, Harmondsworth: Penguin Books

Wolff, J. (1981) *The Social Production of Art*, London: Macmillan

Chapter 17

Design, femininity and modernism
Interpreting the work of Susie Cooper

Cheryl Buckley

During the 1930s, as Susie Cooper established and developed her pottery company, her roles as manufacturer and designer were interpreted in two quite distinct ways by contemporary commentators and critics. Each group prioritized and identified different qualities: one stressed the 'essential femininity' of her work, whilst the other emphasized its 'progressive modernity'. One put her in a separate 'feminine' category, the other aligned her with a group of mainly male modernist pottery designers. The source of the first explanation of Cooper's work and increasing success was from within the pottery industry – from its foremost trade journal, the *Pottery Gazette and Glass Trade Review*, whereas the modernist analysis came in the writings of a number of increasingly influential critics, some of whom worked in Stoke-on-Trent or were associated with pottery. Foremost amongst these was Gordon Forsyth who discussed her work in his important survey book *20th Century Ceramics* and in numerous articles, as well as Harry Trethowan, Vice-President of the China and Glass Retailers' Association and DIA (Design and Industries Association) member who wrote articles on pottery including an influential one in *The Studio* in 1932. Other important writers, based outside Stoke-on-Trent, included Nikolaus Pevsner who described Cooper's use of lithographs in his seminal work *An Enquiry into Industrial Arts in England*. It is the aim of this paper to examine and account for these conflicting interpretations of her role as a pottery manufacturer and of the designs that she produced.

Susie Cooper, more than any other woman pottery designer of the 1930s, was assured of a position in the history of modern design in Britain when her work was noticed and described by these influential modernist critics and writers from the mid-1930s onwards. However, the contradictory 'feminine' explanation of her work, which slightly pre-dated the modernist one, was patriarchal in origin and involved 'reading' her designs in terms of her sex. This began shortly after the founding of her company in 1929. Indeed in the first part of the 1930s, the dominant method of analysing Susie Cooper's work had little to do with modernism, but

rather more to do with gender. This was especially so for the reporters of the *Pottery Gazette and Glass Trade Review* who, as I will demonstrate, discerned in Susie Cooper's designs a 'feminine' style. A form of biological essentialism provided the first theory, then, for Susie Cooper's astonishing success. The considerable skills which she acquired at art school, as a trainee designer at A. E. Gray and in her own company were put aside in favour of this biologically-reductionist argument.

This particular analysis, which was in effect shaped by the concerns of patriarchy to keep women as a separate category, was challenged in the latter part of the 1930s by a modernist one. However, both interpretations isolated Cooper from the social and economic context of production and consumption in the inter-war period, thereby undervaluing her achievement.

SUSIE COOPER: DESIGNER AND MANUFACTURER

Like most of the women who became designers in the north Staffordshire pottery industry between the wars, Susan Vera Cooper was born (1902), educated and trained in the Potteries and she had the advantages of a middle-class upbringing. Also like many of her contemporaries she was trained at Burslem School of Art which was the premier art school in the area. It was headed by Gordon Forsyth, pottery designer, educator and writer who was established, since his appointment in the Potteries in 1920, as one of the main spokespersons on industrial pottery design.

Cooper's first job in the industry was in 1922 with A. E. Gray, a manufacturer who prioritized design and whose company became well known for highly stylized, hand-painted patterns in bright colours which related to the fashionable 'moderne' and Art Deco styles. For Gray she designed colourful abstract and/or floral patterns to be painted free-hand by the paintresses. However, in 1929, aged twenty-seven, Cooper left Gray's to set up her own company. In April 1930, the *Pottery Gazette and Glass Trade Review* reported that 'she set her mind, that she should have freedom of opportunity to evolve such new style of design as she feels to be based upon the right lines' (*PG & GTR*, April 1930: 593). She was dissatisfied with designing decoration in isolation from shape, and wanted to develop both aspects of pottery design together – an unusual approach in an industry which rigidly divided the design of pottery shape from the design of pottery pattern. However, it should be borne in mind that there were clear precedents for this within the different, but connected, strands of design theory and practice at the time. For example, within the Arts and Crafts-inspired Art Potteries such as Pilkington's Royal Lancastrian Pottery (where Gordon Forsyth had designed) form and decoration were considered integral: within the emerging studio pottery movement potters such as Bernard Leach,

William Staite Murray and Katherine Pleydell-Bouverie, although working with different emphases, insisted on an inter-dependent relationship between shape and surface decoration; and perhaps most significantly for this discussion of Cooper, within modernist design, which by the late 1920s was beginning to be discussed in avant-garde circles in Britain, there was a belief that form and decoration should be considered as one.

In the same article, in a manner which becomes typical of the trade press, a startled report noted:

> it is only rarely . . . that one comes across an instance of a pottery artist – and particularly a lady – who has the confidence and courage to attempt to carve out a career by laying down a special plant and staff on what must be admitted to be something suggestive of a commercial scale.
>
> (*PG & GTR*, April 1930: 593)

The surprise that a woman would dare to attempt a full-scale pottery manufacturing operation is clearly evident in this quotation. The patronizing emphasis on 'lady', 'career' and 'commercial' enabled the writer to highlight the apparent contradiction between the three words.

From the outset, however, the Susie Cooper Pottery made its mark. It was noted by the trade for modern design: a reporter from the *Pottery Gazette and Glass Trade Review* wrote in 1931, 'Miss Susie Cooper . . . is a gifted, creative artist of the modern school of thought, one who reveals in her work a lively imagination combined with a unique capacity to achieve the maximum degree of effectiveness in pottery decoration by recourse to the simplest modes of expression' (*PG & GTR*, June 1931: 817).

Reporting on the considerable interest which was generated by her designs at the 1931 British Industries Fair, the *Pottery Gazette and Glass Trade Review* described the 'fresh impulse' and 'cleverness of execution', but their reporter was still perplexed: 'By some quality which is difficult to analyse, Miss Susie Cooper's work confounds her critics – and makes them her customers' (*ibid.*: 819). However, her early promise was consolidated in 1932 when John Lewis placed a big order for the 'Polka Dot' pattern to be produced in blue, green and orange. Noting her success at the 1932 British Industries Fair, the *Pottery Gazette and Glass Trade Review* wrote:

> The difference between Miss Cooper's creations and those which are turned out in bulk for the use of the masses is that they are designed with the object of striking a single and definite note; moreover, that note is intended to be different from the ordinary note sounded in pottery decorations.
>
> (*PG & GTR*, August 1935: 975)

Cooper's Kestrel and Curlew designs (manufactured by Harry Wood of Wood and Sons) had streamlined outlines reminiscent of bird forms which clearly related to the smooth, undecorated forms found in modernist-inspired architecture and design of the 1930s in which form was emphasized in preference to applied decoration (Plates 17.1–3) Both Kestrel and Curlew were organic rather than rectilinear, and in this they were formally related to one of the major strands of avant-garde art practice in 1930s Britain – that inspired by Surrealism and the artists and sculptors associated with the Abstraction-Creation group. The work of these artists was not rigidly geometric; instead it was more curvilinear but still frequently abstract.

At the same time. Scandinavian pottery design was being widely admired and regularly illustrated in the pottery trade journals and art journals of this period. Designers such as Wilhelm Kage who worked for the Swedish pottery Gustavsberg provided inspiration for the more formally adventurous companies such as Josiah Wedgwood and Sons Ltd and Susie Cooper.

To a certain extent, the Scandinavian response to modernism was more organic than rectilinear, and made effective use of indigenous or traditional materials. As someone interested in contemporary art and design, it is inconceivable that Susie Cooper would have been unaware of this strand of modernist design practice, and new modernist tendencies in fine art. However, Susie Cooper was also influenced by the most austere strand of modernism which originated in Germany and France, and which was vigorously promoted by Gordon Forsyth, Nikolaus Pevsner and Herbert Read. Particularly important for these theorists was the integration of form and decoration, and it was to facilitate such integration in her own designs that she was keen to take up Woods' offer of space in his factory. Certainly her shape designs of the 1930s demonstrated a commitment to modernity and a knowledge of modernism which was unrivalled. She was undoubtedly innovative and shapes such as Kestrel and Curlew prefigured, in a formal sense, the interest in an 'organic' aesthetic which emerged in the USA and Italy in the late 1940s and 1950s.

In manufacturing terms, the Susie Cooper Pottery was a small to medium scale unit whose production was closely tied to the design abilities of its owner. In turn, any new designs were introduced with the paintresses' skills in mind, and as a consequence new decorating developments were accommodated with relative ease within the flexible factory organisation. Between seventy and one hundred people worked for her company in the late 1930s including free-hand paintresses, lithographers, aerographers, biscuit-workers and kiln-loaders, and there was a small printing shop. Even though the enterprise was begun in what the *Pottery Gazette and Glass Trade Review* described as an 'unpropitious period', it made 'steady progress from the start' (*PG & GTR* June 1931: 817).

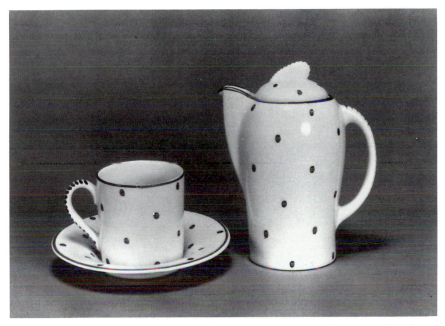

Plate 17.1 'Kestrel' shape hot water jug and cover, cup and saucer with blue 'polka dot' decoration, designed by Susie Cooper for the Susie Cooper Pottery, c. 1934. Copyright A. Eatwell

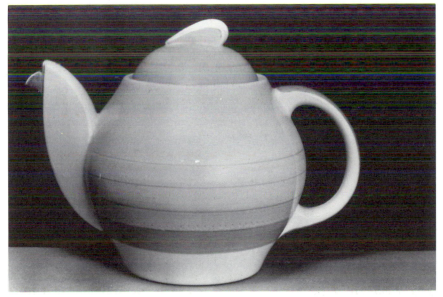

Plate 17.2 'Kestrel' shape teapot with shaded grey and blue/green solid banding, designed by Susie Cooper for the Susie Cooper Pottery, c. 1933. Copyright A. Eatwell

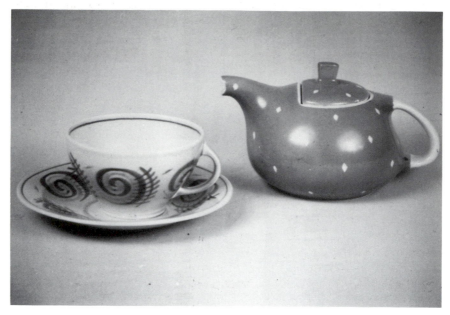

Plate 17.3 'Curlew' shape teapot with green diamond aerographed decoration, designed by Susie Cooper for the Susie Cooper Pottery, c.1933. Copyright A. Eatwell

Within the framework of the British pottery industry in the 1930s, Cooper's company was an undoubted success, although a puzzle to the trade press. A writer in 1931 advised the pottery trade 'to steel yourself against them if you will, but they persist in attracting' (*PG & GTR*, June 1931: 819). The trade press recognized that she was aiming for a distinctive and, to some extent, an artistic and style-conscious market:

> the designs of this artist are, perhaps, not intended to appeal to the surging multitude, but rather to the relative few – those to whom tradition counts for much less than originality and the desire to explore the possibilities of new fields and methods.
>
> (*PG & GTR*, February 1934: 225)

Moreover, the trade press believed that 'she has found, if not actually created, a market for her productions' (*PG & GTR*, April 1934: 467–8).

Marketing and retailing were high priorities for Cooper, and in these areas she demonstrated considerable skills and innovation. Her designs were retailed in shops such as Peter Jones, Selfridges, John Lewis, Waring and Gillow. In order to appeal to the discerning buyer, she acquired a new London outlet at Audrey House, Holborn in the middle of the pottery buying quarter. The *Pottery Gazette and Glass Trade Review* recommended that timid buyers should

take note of the reaction of the average passer-by to this unique collection of pottery ... We did that ourselves ... and must confess that we were more than a little surprised ... it is remarkable how ready the public is to respond to things which are distinctive, and especially so when the distinctiveness is associated with quality and stands for something that is estimable.

(*PG & GTR*, August 1935: 975)

As well as opening a new showroom, she advertised regularly in the pottery trade journals, and she exhibited at the annual British Industries Fairs (Plate 17.4) and most of the major exhibitions in the 1930s including the Dorland Hall exhibition of 1933 and the British Art in Industry exhibition at the Royal Academy of 1935.

One of her main marketing successes, which is indicative of her commitment to modernism, was to identify the demand for smaller sets of pottery rather than the enormous dinner sets of the preceding decades. She believed that not only designs, but also the composition of sets, was due for revision and overhaul: 'the drastic changes that have come over the domestic life of many people warrant the provision of smaller and better balanced services' (*PG & GTR*, August 1935: 975). To this end, Cooper

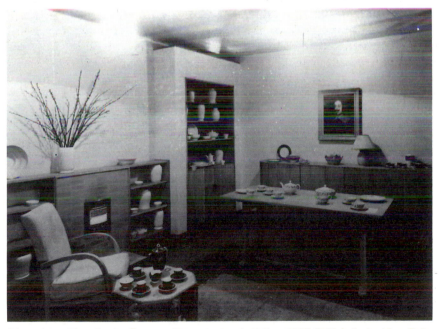

Plate 17.4 The Susie Cooper Pottery stand at the 1938 British Industries Fair. Copyright, Trustees of the Wedgwood Museum, Barlaston, Staffordshire.

introduced new combinations of ware such as a fifteen-piece dinner set, a breakfast-in-bed set and an early morning set. These sets were intended for informal use and catered for the smaller middle-class family instead of the much larger and more extended Edwardian family (Buckley 1991).

DESIGN AND FEMININITY: COOPER AS 'ESSENTIALLY FEMININE'

By the early to mid-1930s the characteristics of Susie Cooper's practice as a designer and manufacturer were clearly established. She was progressive and imaginative in responding to the new ideas which were developing in design theory and practice, and in pottery manufacturing and marketing. Yet in their search to account for her success, the reporters of the major trade journal were ill at ease in writing about her. They stressed her 'difference' to other manufacturers, and they discerned in Cooper's designs a 'feminine' style. In their reporting of the various trade fairs where she had exhibited, they made much of this, claiming: 'Miss Cooper is a lady who designs from the standpoint of the lady' (*PG & GTR*, October 1932: 1249). In this article the writer stressed the importance of the female consumer to the pottery industry and emphasized Susie Cooper's special insight into this market as a woman designer: 'what matters very definitely in regard to pottery sales is what the ladies think' (*ibid.*: 125). There was also grudging acceptance in other articles that 'the woman's point of view . . . counts for a good deal – in domestic pottery designs at all events' (*PG & GTR*, August 1935: 975). In most discussions of the domestic market for pottery, the pottery trade press articulated the consumer as 'she', and, significantly, the main spokesperson for the pottery consumer was the local Conservative MP Ida Copeland, whose husband Ronald was a pottery manufacturer and RSA member. Ida Copeland's views were well known in the pottery trade press which also covered her lectures and talks to professional bodies and her parliamentary speeches. In explicitly linking Cooper, the designer and manufacturer, to women pottery consumers, the trade press was re-affirming her gender and her place in the domestic 'feminine' sphere, and neutralizing her anomalous intrusion into the 'masculine' sphere of pottery manufacturing and management.

To the trade press, it was Cooper's designs as well as her role which were 'feminine'. For example it noted the subtle colour ranges, delicate, light decoration and shapes which were undoubtedly modern and practical, but also understated and stylish. Significantly, the work of contemporaries such as Keith Murray and Eric Ravilious who worked at Josiah Wedgwood and Sons Ltd was also 'feminine' in these terms (as was much modernist design in Britain in the 1930s), although their work was never described as such. Murray's design work at Wedgwood was directly com-

parable to contemporary Wedgwood designers Millie Taplin and Star Wedgwood, and even the machine-turned tablewares which he designed which are so often presented as exemplary modernist designs were in subtle, delicately coloured moonstone glazes.

Indeed, the crucial point here is that although Susie Cooper challenged the dominant stereotype by working as a business woman, independent designer and manufacturer, her role and products were analysed within a framework of conventional gender attributes which linked her to the biologically-determined 'feminine', a category shared, theoretically, with all other women, but not with male designers such as Keith Murray whose work was in fact similar to hers. Clearly Susie Cooper had more in common with Murray because they were both designing in a similar context: for the pottery industry in north Staffordshire (governed as it was by particular economic and technical considerations); for a similar cultivated, middle-class market ('with taste, but not a lot of money'); advertising in the same journals and at similar price levels.

How can we account then for this 'feminine' label? To begin with, we need to utilize theoretical tools which can facilitate our understanding of terms like 'feminine' because it is significant that this particular analysis from the 1930s is gender-based and has origins in the sexual division of labour within the pottery industry which defined jobs, including design, on the basis of sex. Design in the pottery industry was split between the design of shapes and the design of decoration with the former dominated by men and the latter by women. Both jobs were thought to require distinctive and different skills which corresponded to definitions of 'masculine' and 'feminine' categories. It is possible to argue that within the essentially patriarchal structure of the pottery industry between 1919 and 1940, women took on certain jobs not because they were biologically predisposed to them, but because these were the ones that were available as skilled work. These skills were then learned in the same way by women as by men, if such work had constituted skilled men's work.

Not only was the design of pottery decoration thought to require intrinsic 'feminine' skills such as a facility for detail, decorativeness and patience, and the design of shape, intrinsic masculine skills, it was also the case that the design of pottery shapes was probably the most important job in the pottery factory because a successful product shape formed the basis for a profitable business. In contrast, a range of decorations could be added to a viable shape and these could be adapted according to market changes. It was no accident, then, that within the sexual division in design in the pottery factory, the job of designing shape with its central role in the economic success or failure of a pottery business should be controlled by men. At this point, men assume the highest status in pottery design due to the combination of patriarchal and capitalist interests.

CONFLICT AND CONTRADICTION: CHANGING ROLES FOR WOMEN, 1919–1940

Sexual divisions were found throughout all work organization in the pottery industry, not just in design, although these were not rigidly fixed but were based on subtly changing perceptions of 'masculine' and 'feminine' skills throughout the period 1919–1940. As a writer in the *Pottery Gazette and Glass Trade Review* put it in 1919: 'There are certain classes of work in the industries to which women are more adapted than the stronger sex' (*PG & GTR*, May 1919: 478). Women workers predominated in the decorating stages of the production process because they were thought to have intrinsic, biologically-determined abilities for this work – dexterity, patience and a facility for decoration:

> the woman worker is also very skilful with the jolly, the nimbleness and delicacy of touch being remarkable, whilst the processes of moulding the spouts, handles, and other ornamental parts is certainly one for the light feminine hand ... Also, transfer work is woman's work where the gentle touch is necessary.
>
> (*ibid.*: 478)

In contrast men predominated in the forming stages of production, again due to biology: they were apparently physically stronger, more competent with heavy machinery and unperturbed by dirt. Overlying this sexual division was the demarcation of jobs based on craft which distinguished skilled from unskilled work. Men monopolized most skilled jobs and controlled access to these through the apprenticeship system. The net result of these labour divisions in general terms was a hierarchical industrial structure with skilled men at the top and unskilled women at the bottom.

As Cynthia Cockburn has argued, definitions of skill are not unproblematic. Her writings are particularly helpful in terms of problematizing the definitions of skill especially within the context of gender and the sexual division of labour. As she points out, 'skill is partly a political phenomenon' (Cockburn 1985: 66). According to Cockburn, power resides with those who have defined skill, whether it be craft or technological skill. Although Cockburn argues that 'among the haves and have-nots of technological competence, women and men are unevenly represented' (*ibid.*: 7), this could equally well be applied to craft skill. She makes the point that the technological 'competence that men as a sex possess and women as a sex lack is an extension of the physical domination of women by men' (*ibid.*).

In the pottery industry, men and their unions had traditionally controlled definitions of craft skill and access to most craft jobs, and as the industry was increasingly technologized, they tried to dominate and con-

trol the new processes. However the period 1919 to 1940 was one of redefinition in relation to skill, and for particular reasons that were linked to conflicting patriarchal and capitalist interests, women held onto traditional craft skills such as decorating, whilst at the same time they developed new technological skills in forming and decorating ware. Their position in relation to definitions of skill changed during this period. As makers of ware, they were deployed to use new technological processes such as casting, and jiggers and jolleys. As decorators they utilized craft skills (previously recognized as such by male-dominated trade unions) to hand-paint wares, but they also worked in a period of technological development in decorating which saw the introduction of high-quality lithographs. The 1930s can be seen as the high point in the deployment of craft skills in hand decorating, but significantly it also saw a woman designer, Susie Cooper, pioneer the introduction and development of new decorating technology through the use of lithographs. Undoubtedly her power and status as a pottery manufacturer and designer were directly attributable to the fact that she deployed and controlled technological as well as craft skills in the 1930s.

Generally, though, women's skill was recognized by male workers only in work clearly differentiated on the basis of gender: in the decorating sections, for example. Other jobs taken on by women were conceded reluctantly by men or because they were declared 'unskilled'. These latter jobs were designated 'female' within a patriarchal and heirarchical employment structure which protected and esteemed craft work done by men. At the top of the pay and status ladder were the skilled male craftworkers who had served long apprenticeships; these were the master-potters, art directors, throwers, engravers and oven-men.

In the twentieth-century pottery industry women's position within the sexual division of labour underwent change. To some extent this was related to the entry of large numbers of women workers into the industry just prior to and at the end of the First World War. Whereas in 1861 women made up 31 per cent of the potteries workforce, in 1911 women made up 51 per cent, in 1921 57 per cent, and in 1931 just over 50 per cent. Nationwide by 1935, there were 37,635 women pottery workers as opposed to 30,902 men (the total for Stoke-on-Trent was 56,185) representing 55 per cent of the workforce. These large numbers of women provoked a theoretical debate within the trade press and within government about women's place in the pottery industry. This originated in the nineteenth century, but was intensified and exacerbated by women's penetration of the industry during the war. In the post-war euphoria, their contribution was recognized; the *Pottery Gazette and Glass Trade Review* asserted in 1919: 'The part which womanhood has taken during the war in our various industries is remarkable, and there seems no limit

to the class of work in which the gentler sex engage' (*PG & GTR*, May 1919: 478). However, a few years later in April 1924, an unemployment level of 13 per cent induced men pottery workers to demand 'that a clear dividing line shall be drawn between what is considered to be the work of a man and that of a woman' (*PG & GTR* April 1924: 683).

The industry's sexual division of labour, in effect the material basis of patriarchy, aimed to differentiate jobs on the basis of sex. However, these divisions represented an ideal patriarchal position and although they were useful in controlling opinion about the appropriateness of women's access to certain types of work, they were systematically undermined between 1919 and 1940 by women eager for new areas of work and by manufacturers keen to employ cheaper labour. The 1921 and 1931 censuses provide some useful information about the relationship of the sexes to different areas of work during the period of this study. Although the correlation of these is not completely straightforward because of changes in the classifications of work, the figures overall indicate that the needs of capitalism for cheap labour were prioritized over the patriarchal desire to keep women in a separate sphere.

These census figures also confirm that women maintained their dominance in the decorating shops; in fact the number of women increased between 1921 and 1931, and they also far outnumbered men. It is also possible to see that women increased their numbers in the potting shops as makers of ware (most likely as jigger and jolley operators and as casters) from 7,556 to 8,690 at the expense of men whose numbers reduced by about 300. Although this increase may not seem very substantial, it has to be viewed in the context of increased unemployment in the late 1920s and early 1930s. Women doubled their numbers as dippers and glazers; and significantly for this discussion about Susie Cooper they also increased their number as managers and employers, and as foremen and overlookers from 100 in 1921 to 183 in 1931.

Most importantly these figures demonstrate that the sexual division of labour in the pottery industry was changing. It began to change in a significant way in the period 1880 to 1919; but the continuation of these changes was clearly discernible between 1919 and 1939. More women worked in sectors of the pottery industry previously described as 'men's'; more women had access to semi-skilled work; and there were more women in positions of power and influence. The material and ideological basis of patriarchy was being redefined by a combination of women's efforts, economics, labour relations and new practices brought about during the First World War.

Inevitably conflict and contradiction accompanied this change. Even though the art schools had been reorganized and modernized under Gordon Forsyth, it was still the case that as late as the 1930s the Potteries' art schools taught women to decorate and design surface patterns, whilst

men learned to form ware and design shapes. In a key educational policy document drawn up for the industry, the second report by the National Council of the Pottery Industry of 1920 entitled *Appropriate Education of Persons Occupied or Interested in the Pottery Industry*, it is evident that the educational and training needs of boys were given higher priority than those of girls. In a questionnaire to manufacturers, the report writers made certain assumptions about the educational needs of girls which were clearly informed by the industry's patriarchal practices. Whereas a separate question asks about the most suitable way for a boy of good education to enter the industry, for girls there is just one general question which asks about possible openings for the well-educated boy or girl of sixteen. Significantly many manufacturers did not differentiate on the basis of gender in reply to this question – indeed they replied only in relation to boys. When they did differentiate, it was most often by declaring that there were no openings for girls in manufacturing except as decorators. Articulated in the report, then, were manufacturers' expectations for boys and girls, and typically these conformed to the sexual division of labour evident in the industry.

This was reinforced in the *Pottery Gazette and Glass Trade Review's* account of this. Again reiterating the experiences and needs of boys:

> One view put forward was that the boy might enter the industry with a view to being trained as an under-manager. He should pass through the various departments . . . from sliphouse to the 'road'. . . . He should get an insight into making, throwing, and turning, casting, pressing . . . ultimately he might be put in charge of the department. . . . He must acquire a knowledge of and the knack of managing men. . . . Alternatively he might begin work under the art director or designer and, with certain supplementary education in an art school, obtain a responsible position on the decorative side.
>
> <div align="right">(PG & GTR, October 1929: 1354)</div>

This paragraph was the only section which referred directly to pottery workers and characteristically it was clearly gendered as masculine. The emphasis on the masculine gender both in the report and in the article in the *Pottery Gazette and Glass Trade Review* is particularly revealing in that during a period when women were taking on more skilled work and in effect undermining the sexual division of labour by working as managers, supervisors and increasingly as designers, these changes were being ignored by the industry's main trade journal and by educational policy-makers. This demonstrates that the realities of women's work in the pottery industry were denied at a time when they had changed most.

This was also evident in Forsyth's newly organized Junior Art department at Burslem School of Art. This had been the cornerstone of his education system, and of the students, who were nearing completion of

their course in May 1927, there were eighteen girl decorators, eight boy designers and decorators, and the rest, who were boys, comprised two engravers, two printers, two signwriters, three mould-makers and modellers, one tile draughtsman and two throwers. Inevitably girls continued to choose to specialize in aspects of pottery production which approximated to the gender divisions of the industry, and boys chose those jobs considered appropriate for men such as throwing, mould-making, modelling, printing and engraving. Clearly the ideologies underpinning the industry's gender divisions were being reinforced in its art schools at a time when the industry was itself changing (*PG & GTR*, May 1927: 816).

It was in this particular context then that the 'feminine' analysis of Susie Cooper's work emerged in the pottery trade press. It was an interpretation which marked an urgent desire to categorise and account for her work and her increasing success within a conventional framework of gender difference. It resulted from a partriarchal desire to locate and fix women on the basis of a biological reading of sex difference. However it also represents an attempt to stall the overwhelming tide of change.

RE-DEFINITIONS: COOPER AND 1930S MODERNIST DISCOURSE

This 'feminine' interpretation, which was mainly the invention of the industry and its trade journals, was superseded by a modernist analysis which emphasized the modernity, functionalism and progressive quality of her work. By the late 1920s and early 1930s debates about design in the pottery industry were increasingly informed by modernism. Arguably the qualities associated with modernism were the product of patriarchal and capitalist concerns: rationalist, technological, progressive, innovative and cultural (i.e. the antithesis of nature and biology). It was articulated, not as a style, but as a concrete set of procedures which were logical and ordered. Increasingly, modernism became synonymous with the 'masculine' as opposed to the 'feminine': it was abstract rather than decorative and representational, and it was rational rather than emotional. Its spokespersons, almost all men, were vociferous in their attacks on superficial decoration, and this had particular implications for those women who worked mainly as designers of decoration in the 1930s pottery industry.

Modernist writers on 1930s pottery design such as Gordon Forsyth, Harry Trethowan, Herbert Read, Nikolaus Pevsner, John Adams and Reginald Haggar highlighted what they considered to be a struggle to establish a modern twentieth-century style in British pottery manufacture in the 1930s. Their views were expounded in trade journals such as the *Pottery Gazette and Glass Trade Review*, in art periodicals such as the *Studio* and the *Journal of the Royal Society of Arts* and in key texts

such as Forsyth's *20th Century Ceramics*, Read's *Art and Industry* and Pevsner's *An Enquiry into Industrial Arts in England*. Common to all these writers was the belief that the contemporary pottery designer should represent in clay, 'form... characteristic of the twentieth century' (Trethowan 1932: 184).

Pevsner was particularly critical of the pottery industry. He criticized most new shapes as being 'thoughtless in design, and hardly meant to be lasting in value' (Pevsner 1937: 81). He was also severe in his views about lithographic design for pottery decoration, which he described as 'the worst obstacle to any thorough artistic improvements in the ceramics industry' (*ibid.:* 80). Pevsner recognized that lithographs had other potential than merely as a device for copying existing decoration and pattern. His model for good design in industry was Germany which he had recently left, particularly the products of the Bauhaus:

> The Bauhaus pots and cups may be less perfect than some of Josiah Wedgwood's, but they express one quality which Wedgwood of necessity could not bestow upon his objects – the spirit of the twentieth century.

(*ibid.*: 83)

Pevsner's main criticism of the products of the British pottery industry, and this also applied to a fairly progressive company such as Josiah Wedgwood and Co Ltd, was that they were not truly modern – they did not express the zeigeist. When manufacturers and designers such as Keith Murray at Wedgwood and Susie Cooper in her own company did produce modern products which expressed this he was quick to extol their virtues, and illustrate and promote their work.

Significantly Pevsner was also dismissive of those examples of design which appeared modern, but which in his view betrayed a superficial understanding of modernism or which he believed to be 'deviant' of true modernism. In these categories were French Art Deco and the 'Moderne' style which became increasingly influential and popular in Britain after 1925. Art Deco was, in Pevsner's view, the antithesis of modernism, in that it was stylistically eclectic, based on out-moded craft methods of production and elitist. Some designers such as Clarice Cliff fell foul of those modernist critics who believed that her 'Bizarre' wares were merely superficially modern and revealed a lack of understanding about the true nature of modernism.

In the course of their writings, modernists such as Pevsner and Forsyth encouraged, persuaded and eventually celebrated designers and manufacturers whose products met the criteria of modernism. As a result of the activities of these writers, a distinctive type of modernist theory of pottery design developed in 1930s Britain. This focused on the formally and technically innovative; it emphasized the rationalization and standardiz-

ation of product ranges and the collaborations between industry and designers; it promoted the idea of modernity (of designs and products for modern life); and it stressed the importance of defining standards of 'good' and 'bad' design.

Few manufacturers took on the plea for modernism more whole-heartedly than Susie Cooper. As I have shown, she manufactured and designed in a modern idiom (both pottery shapes and decoration at the Susie Cooper Pottery) and she took part in debates about contemporary design at the Potteries branch of the Society of Industrial Artists. Susie Cooper was a favourite of the modernist writers: Gordon Forsyth illus-trated a 'Kestrel' shape teapot and a dinner service by her in *20th Century Ceramics*, and Pevsner wrote that 'apart from hers [Susie Cooper's] and a couple of others, I have not seen any acceptable lithographs' (Pevsner 1937: 80). In his important article 'Modern British Pottery Design', Harry Trethowan called for:

> the individual artist . . . who is a partner of this living tradition within the industry. One who eventually becomes steeped in the processes of manufacture and is then capable of expressing himself in clay that in form and fashion shall be characteristic of the twentieth century.
>
> (Trethowan 1932: 184)

Typically he illustrated a Susie Cooper 'Kestrel' shape teaset with hand-painted dots, lozenges and faded bands. However, Susie Cooper's experi-ences with this powerful modernist lobby were atypical, as most women pottery designers did not have the same freedom in design as her.

For writers such as Pevsner and Forsyth, anxious to establish the viability and credibility of modernism, Susie Cooper was one of the few examples whom they could cite in support of their arguments. In their analysis, they placed her alongside Keith Murray and Eric Ravilious in order to highlight some shared, specifically modernist features. Much was made of the technical innovation of lithographs which had previously been described as 'feminine' such as 'Iris'. Emphasis was placed on the simplicity of her shapes and patterns – the formal agenda shifted from delicate and subtle to simple, rational and modern. Here again, the Kes-trel shapes were cited as exemplary modernist designs; elegant, modern and functional. Attention was drawn to her enthusiasm for mass-pro-duction and for promoting a particular modernist version of 'good' design.

As with the 'feminine' analysis, these modernist methods led to an emphasis on certain qualities over others, in this case the formal, technical and innovatory aspects of pottery design at the expense of the social, economic and cultural. Little was said in these accounts of Cooper's role, products or market outside the modernist framework. But due to the attention of this small but powerful group of writers who were responsible for the vigorous promotion of modernism in Britain in the 1930s, Susie

Cooper has a high profile. Her work was praised and reviewed as pioneering examples of the very latest in design, and as a result of this group's approval, her company and career were given a boost.

In my view, Susie Cooper is an important designer worthy of the historian's attentions not simply due to her commitment to modernism, but due to her ability to chart a reasonably successful route through the complex system of manufacture, marketing and consumption in 1930s Britain. She is an example of how pottery producers could be profitable in an unstable economy due to successful design, the use of new technologies, skills and selling techniques. To focus on Cooper either in the context of some 'essential femininity' or as a 'pioneer modernist' underplays her true role as a woman pottery designer. However it is important to show that women designers such as Cooper were gendered subjects working within the patriarchal context of the British pottery industry. Gender was central to Susie Cooper's role in the industry. Her initial access to design as a designer of decoration, rather than shape, reminds us of the effectiveness of labour divisions based on gender which preserved the most prestigious jobs for men in design as well as in other aspects of production.

In conclusion, Susie Cooper is an example of the way that women did challenge and break down traditional gender stereotypes in their roles as designers between 1919 and 1940, and although some of her success is attributable to the support of modernist writers of the 1930s, by owning and managing her own business, by clearly stamping her products with her own name and by controlling her own career, she occupied a powerful position as a pottery manufacturer and designer in Britain in the 1930s.

REFERENCES

Buckley, C. (1991) *Women Designers in the North Staffordshire Pottery Industry, 1914 to 1940*, PhD thesis, University of East Anglia and Buckley, C. (1990) *Potters and Paintresses: Women Designers in the Pottery Industry, 1870–1955*, London: The Women's Press

Cockburn, C. (1985) *Machinery of Dominance: Women, Men and Technical Know-how*, London: Pluto Press

Forsyth, G. (1936) *20th Century Ceramics*, London: The Studio

Pevsner, N. (1937) *An Enquiry into Industrial Arts in England*, Cambridge: Cambridge University Press

Read, H. (1935) *Art and Industry*, London: Faber & Faber

Trethowan, H. (1932) 'Modern British Pottery Design', *The Studio*, 106: 181–8

(Mis)representations of society?

Problems in the relationship between architectural aesthetics and social meanings

Jos Boys

Space and representation are currently hot subjects in discussions of Post-modernism/ity/ization. Whilst there are many difficulties in defining this new state (if it is new at all), there seems general agreement over certain resonant cultural shifts. Harvey (1989: 7) quotes Eagleton:

> There is, perhaps, a degree of consensus that the typical post-modernist artefact is playful, self-ironizing and even schizoid; and that it reacts to the austere autonomy of high modernism by impudently embracing the language of commerce and the commodity. Its stance towards cultural tradition is one of irreverent pastiche, and its contrived depth-lessness undermines all metaphysical solemnities, sometimes by a brutal aesthetic of squalor and shock.
>
> (Eagleton 1987)

Architecture and urban design are, of course, heavily implicated in all of this. Buildings and cities are seen to have literally changed shape and appearance from earlier modernist or pre-modernist versions. Architecture becomes 'bricolage, pastiche, allegory and . . . hyperspace' (Hebdige 1988: 95). Here, 'reality is said to be continuously overtaken by its images and to be ruled by indeterminacy' (Rose 1991: 4). Representation becomes a simulacrum – a deceptive substitute – of itself. Architectural and urban spaces become depthless, unmappable, producing 'the strange new feelings of an absence of inside and outside, the bewilderment and loss of spatial orientation, . . . the messiness of an environment in which things and people no longer find their "place" ' (Jameson 1991: 117–8).

In such writings, architecture may be initially implicated as a cultural form which is changing via the struggles of its designers against the problems of modernism. The dominant role of space and representation in current debates, however, is to be offered up as evidence for something else, as a reflection of broader shifts in (post-industrial) society's modes of production and consumption. The proliferation of interchangeable, multivalent and depthless signs perceived to be literally 'on the surface' of post-modern buildings and cities and architectural and urban enclos-

ures of spectacle, and 'unseizable' volumes (Jameson 1991: 43) then come to illustrate post-modern society itself.

Here it will be argued that this is to profoundly misjudge the relationship of architectural form to economic, social and cultural processes. Architecture is not just a reflection of society; we should not confuse its use metaphorically in language with its instrumental and associative qualities as lived experience. The framing of architecture as an expression of society was, in fact, painfully and self-consciously constructed by cultural intellectuals from about the 1830s. The way in which this particular relationship was formulated has certainly had enormous impact on both modern and post-modern forms of architectural representation and space, but it is not an adequate explanation for these changes. The many uses of architectural form and space in post-modern thought as an unproblematic (or at least untheorized) visual and experiental expression of broader societal change merely perpetuates deep theoretical assumptions carried on from the nineteenth century. These continue to disorient the theoretical debates. Initially an argument about architecture, the processes of unravelling begun here may have considerable ramifications on conceptualizations of the post-modern more generally. There are six elements to this argument:

(1) The interpretation of any cultural artefact as a visual and/or spatial representation of shifts in society/culture/economic structures obscures more than it reveals. The underlying logic of such a relationship is as follows: a social concept is interpreted as being expressed by/reflected in/ analogous to/simultaneously occurring in particular forms of visual representation and/or spatial manipulation, because both have the same associative qualities. Rational is paired with rectilinear, chaotic with fragmentary. The appropriateness of specific sets of socio-spatial concepts as descriptions of society and/or architecture is then justified by juxaposition with other adjectival chains, placed as binary opposites. Table 18.1 illustrates this (very simplistically). In relationship to the modern/post-modern categories, the conceptual framework itself results in being able to argue that post-modernism is 'good', that it is bad, and even that it is 'good' and 'bad' simultaneously depending on the relative values given to, for example, rational and irrational or universal and multivalent (Harvey 1989: 303, 350–1). However, if such a framework is not taken as a model for attempting to explain what is actually happening but instead is understood as a structure of ideas through which a specific view of society is articulated as obvious and unproblematic, then we have new and interesting questions to ask. Why have ideas been constructed and maintained in this form? Whose interests does such a view meet? What are the processes by which particular interpretations come to dominance in different periods and places? What are the processes by which alternative interpretations are silenced? What is the relationship between this struc-

Table 18.1 Justificatory concepts for architectural form in England 1830–1990

	oppositional		adaptive			oppositional
(Neo-Classicism) -1830	Gothic Revival 1830–60	Arts and Crafts 1860–1910	Rational Vernacular 1910–45	Modern 1945–68	Post-Modern 1968–	
(immanent)	transcendent					immanent
(secular)	godly					anarchic
(reason)	emotion	natural	objective	functional		irrationality
(immoral)	moral	emotion	rationality	rationality		amoral
(ostentation)	honesty					irony
(purposeless)	purposeful					playful
(precedent)	precedent	vernacular	vernacular	essence		surface
(illegible)	text	scene	scene	structure		text
(plain)	decorated	simple	simple	minimal		decorated
(cold)	hot	warm	warm	cool		hot
(false)	true					contradictory
(rectilinear)	sublime	picturesque		rectilinear		fragmented
(symmetry)	asymmetry			symmetry		dynamic
(disordered)	ordered					random
(meaningless)	determining					indeterminate
(asocial)	zeitgeist					zeit who?
(town)	country			town		edge
(foreign)	national			international		local/global

Notes: Terms in brackets indicate 'negative' concepts
See also Hassan (1985: 123–4) reprinted in Harvey (1989)

ture of ideas, and the political, economic and social processes by which cities and buildings get made in particular forms rather than others?

(2) It is here proposed that the process of self-consciously constructing architecture as a reflection of society was part of nineteenth-century struggles by cultural intellectuals in general, and architects in particular, to legitimize their role in cultural production by increasingly articulating a particular (middle-class) understanding of both culture and professionalism (Perkin, 1989). In this essay an outline will be given of how such a formulation came to be the 'commonsense' of much architectural thought, through a brief study of the development of architecture as a profession in England from the 1830s.

(3) Following Rose (1993) this formulation of architecture as a reflection of society is seen as an example of 'masculinist rationality':

> Masculinist rationality is a form of knowledge which assumes a knower who believes he can separate himself from his body, emotions, values, past and so on, so that he and his thought are autonomous, context-free and objective . . . the assumption of an objectivity untainted by any particular social position allows this kind of rationality to claim itself as universal.
>
> (Rose 1993: 6–7)

Through the process of associating social and spatial abstractions, the subject-architect or subject-critic can appear to make a comprehensive, exhaustive and objective diagnosis of a design, through the act of 'reason' which is therefore 'true' (whilst other analyses are seen as irrational and/ or superficial). Crucially, this gaze has come to perceive the object-building as a mirror to itself: as a transparent, knowable and objective reflection 'of what it really is' (that is, how the gaze 'knows it', but where the act of looking makes itself invisible, so that the object-building appears to be revealing its 'true' self). This, it turns out, can only be read 'truthfully' through the gaze of masculine rationality, with the (mainly) feminine or working-class Other (whether producers, consumers or critics) also thereby contained within the conceptual limits of irrationality/false consciousness/triviality/enervation.

Architects' and other cultural intellectuals' own positioning in relationship to the artefact and the specifity of their locations is thus obscured. The tendency to ultimately privilege culture and representation over politics and action and the placing of representation over other types of analysis (two mechanisms which Bourdieu (1989) analyses as part of a specific 'distancing gaze') become invisible as a problem. Challenges from the Other insisting that issues of difference and inequality be made central, continue to be defused and absorbed (Massey 1993: 61).

(4) Because of the dominance of the assumption that architecture reflects society there is little critical study of alternative interpretations

engaged in by different classes and social groupings: that is not just differences in 'reading' representations or in responding to them, but also in unravelling the variety of beliefs as to where social meanings lie, how these are framed by class, gender, race, etc., and how they relate to the processes by which buildings and cities are made.

(5) It will also be argued that this linkage of culture and society through representation is not only conceptually flawed as an explanation of social and architectural processes, but is also internally contradictory. It is tauto-logical (a fragmented post-modern building is evidence of a fragmented post-modern society, is evidence of a fragmented post-modern building...) and so operates as a self-contained and totalizing system from which there is no conceptual escape. In addition, representation is, by its very nature, partial and contested because it generates meaning through association. Associative meanings cannot be universally appli-cable, nor even fixable, precisely because they are endlessly formed and re-formed through struggles over intention and reception which take place in both space and time. Attempts to make a particular, associative conceptual chain which have even some degree of acceptable generality over time are doomed to failure. Both these problems have been struggled with by the critics addressed in this essay (as well as by others); it will be argued that these internal contradictions have a key role in explaining changes in both architectural ideology and cultural theory, but have been dealt with in only a partial, and unsatisfactory, manner.

(6) Such an understanding offers up new possibilities for radical forms of practice, different from current movements in architecture. What effects would a deliberate decentring of architectural representation (= an expression of society), as the dominant logic of theoretical and design discourses, have? What conceptual framework could replace it which would enable the making of cultural artefacts to be engaged directly with political, economic and social processes (as well as struggles over social meanings) rather than with abstract and 'objective' representations of society?

This essay is not arguing that current accounts of post-modernism/ity/ ization are wrong or not useful. It is proposing that the mechanisms by which architecture (and maybe other cultural artefacts such as sculpture, painting, film) and society are linked remain seriously undertheorized. Critics and building producers, whilst appearing to incorporate an acknowledgement of difference in contemporary debates, continue to assume the superiority of the subject and to perpetuate the myths of masculinist rationality by allowing the multitude of existences-in-space so richly analysed as socio-economic processes to be reduced to formal abstractions (as spatio-visual representations of society) when discussing architecture and urban design. Space is here emptied of its occupation

and representation of its conflicts and positionings. And architecture remains in crisis and its potentialities unrealized.

This essay is in three sections. The first will describe how the concept of a direct analogy between architectural form and society was itself historically and self-consciously constructed by the cultural avant-gardes of the early nineteenth-century, and shows how this grew out of struggles for legitimacy over cultural production. It will then briefly trace how that process developed through into modernism in England and propose that the inherent contradictions in this particular framing of architectural knowledge helps to explain both changes in architectural form and the delegitimization of modern architecture which was part of the more general crisis of modernism and of welfare-state professionalism in developed countries through the 1960s and 70s.

The second section will examine the use of architecture as an expression of society in post-modern theories within this historical and critical context. It will illustrate how little some post-modern theorists have challenged assumptions about the relationship between architecture and society and tentatively propose some ways forward. The last section will then look again to architectural practices. It will speculate on the effects of disengaging aesthetic and spatial form from social representation and of re-introducing social processes as the core of design activity, as a form of protest at continuing avoidances in post-modern debates over socio-economic and cultural inequalities and the politics of difference.

MAKING ARCHITECTURE 'REPRESENT' SOCIETY

For much of the history of Western architecture the vocabulary of building elements (such as columns and pediments) and the methods of their combination (proportion, ratios, 'figures') have been codified by tradition and precedent – what Campbell (1987: 148) calls 'techniques in conformity with long established principles'. The continued use of both major Western architectural languages, Gothic and Classical, right through to the nineteenth-century was justified via the assumed certainties of texts handed down from Classical civilization and from the Bible. For the history of Western architecture up to about 1750, attempts to inscribe architecture with social meanings *built on*, or played with existing vocabularies of elements and the rules for their combination precisely because these reinforced a patron's claim to supreme authority – that is an authority legitimized by religious faith and the Ancients. Innovation, then, was restricted on the one hand to variations in the manipulations of parts (what we now tend to see as more 'pure' or more 'mannerist' versions), and on the other to different interpretations of the rules of combination – that is, for example, in preferring certain numbers or geometric relationships to others.

Of course, whilst the bodies of design and building knowledge were codified – both in the sequence of architectural treatises following the first-century Roman Vitruvius and in the building lore of the mediaeval building guilds – they were also malleable, that is, they were adaptable to individual and group preferences, open to other influences (particularly from the East) and highly susceptible to fashion and changing interpretations. There are now some excellent studies of the commissioning, designing and making of buildings in different historical periods which show all too clearly the competitive struggles between wealthy and powerful patrons supporting particular versions of Gothic or Classical forms through making associative links to their own cultural, religious and political values (Ackerman 1966; Goldthwaite 1980; Samurez Smith 1990).

However, as some historians have shown (particularly in relation to France) the logic behind these architectural vocabularies began to break down in late seventeenth- and early eighteenth-century Europe as the certainties which had justified them were increasingly undermined (Rykwert, 1980; Vidler 1986). Colonialist expansions were throwing up an increasingly broad range of architectural precedents. Architectural archaeology was replacing the concept of ahistorical precedent with ideas of historical development and progress and philosophers were increasingly concerned with incorporating human action into explanations of how the world worked. These shifting patterns led to a 'new' problem – how to judge the value of any particular architectural language over others. The belief in an ahistorical externally justified precedent had in fact enabled individual architects and patrons to select widely from the available vocabularies to meet their own particular needs. Both the massive expansion in possible examples and the critical theories which tried to order these examples by historical evolution exposed the process of architectural selection as a problem which had to be explicitly addressed.

Simultaneously the whole process of land development and building design and construction was changing. The aristocratic amateurs and artisan builders of the seventeenth- and eighteenth-centuries were increasingly being replaced by a new professional class (not yet sure of its various roles or disciplinary boundaries) and by the increasingly rationalized, mass-production methods of new building contractors (Clarke 1992; Forty 1979; Kostof 1986).

Many authors have argued that the publications of A. W. N. Pugin (*Contrasts* in 1836 and *True Principles of Pointed or Christian Architecture* in 1841) exemplified this changing perspective. Pugin insisted on a direct relationship between architectural form and the society in which it was made. As Macleod writes:

> few of the propositions of Pugin are new, but their collation and remarkable presentation made an ineradicable impact on the architec-

tural scene. Pugin extracted, from Southey, Cobbett, and almost certainly Carlyle, the principles of social criticism which were current, and used them as a basis for contemporary architecture. What he produced out of this extrapolation was a distinctly new proposition: that the artistic merit of the artifacts of society was dependent on the spiritual, moral and temporal well-being of that society.

<div align="right">(Macleod 1971: 10–11)</div>

In so doing, Pugin shifted associative social meaning from its contingent relationship to externally justified pre-existent architectural forms and made it *central*. The new (and essential) design task was to find an architectural language which could be justified through the authenticity of its reflection of 'true' social meanings. Architecture could then be judged good/beautiful when it could authentically express a good/beautiful society.

Through the nineteenth century cultural intellectuals increasingly agreed that architecture should reflect society, but engaged in major struggles (not surprisingly) over which were relevant social aspects to represent and which were the most appropriate design vocabularies for expressing them. Different authors and architects made associations by reference to the 'truth' of some or all of the following: specific types of building practice, particular construction techniques and particular societal structures and values. Possible vocabularies ranged from variations on the Gothic in the earlier parts of the century to freer mixes of Gothic, Classical and other elements by the 1860s, and to Arts and Crafts, Queen Anne and Free styles at the turn of the century. Paradoxically it was the search for one authentic architectural language which itself produced Victorian eclecticism and variety (Morduant-Cook 1987).

The bundle of concepts around which these were consolidated into architectural 'commonsense' and taken forward into a more 'unified' modernism, were structural rationality, honesty to materials and a form which truthfully expressed content. Whilst there were radical movements throughout the Victorian period concerned with challenging the processes by which buildings were produced (Swenarton 1989), the majority of self-consciously radical architects were not able to successfully challenge existing labour processes and instead focused on symbolizing that challenge aesthetically through architectural representation rather than through changed practices.

What we have here, then, from the 1830s in England, are new and radical social groupings struggling to delineate particular social and cultural beliefs which 'made sense' as part of an attitude to their cultural, class and professional positions. Following Perkin:

> While all classes try to justify themselves by their own concept of distributive justice, the professional class can only exist by persuading

the rest of society to accept a distributive justice which recognises and rewards expert training based on selection by merit and long arduous training. Professional people, rightly or wrongly, see themselves as above the main economic battle, at once privileged observers and benevolent neutrals since, whichever side wins, they believe their services will still be necessary and properly rewarded.

<div align="right">(Perkin 1989: 116–17)</div>

The struggle for legitimacy over artistic skills by designers against either amateurs or builders was thus presented by the radical designers and makers as a conceptual division between 'true' and 'false' association, that is, between the work of themselves on the one hand (justified most eloquently and convincingly in the 1860s and 70s by William Morris as the work of ethically motivated producers combining making and designing who used honest and simple building methods to delineate a morally superior way of life) and everybody else on the other.

By the early years of the twentieth-century the justification of particular architectural forms as a true reflection of society had began to smoothly interlock with concepts of public sector professionalism. It 'made sense' because specific forms of building and urban design were justified by a 'true' relationship to the social values of a newly forming welfare state; were framed as both separate and ethically superior to the free market and the cash nexus (that is, to the context within which architecture was actually produced); and required specific expert aesthetic knowledge which was offered up as simultaneously socially and ethically appropriate, rationally objective and both progressive (the best) and the (unproblematic and obvious) *norm*.

In the brief-lived period of high modernism in England (say 1945–68) new oppositional concepts (which had been argued out intellectually, via European modernist theories, through the inter-war period) came to dominance among radical architects, who tended to be concentrated in this period in the public sector. The act of association itself was now perceived to be false; architecture was to be truly *transparent*; to express itself as it really was through the language of building itself (that is structural elements and materials). The continuing tendency to a radical vernacular in Britain (places like Hampstead Garden Suburb, London and the huge inter-war cottage estates such as Wythenshawe, Manchester) was increasingly undermined both because it was perceived to be associational with a romanticized English past and because it did not 'express' industrialized progressive society. Instead, binary oppositions framing society as divided into (false) appearance and (true) essence, surface and depth, superstructure and base, were literally translated into architectural form as decoration (trivial, superficial, false, feminine) and structure/form (essential, honest, true, masculine). This is masculinist rationality at its

clearest: a cultural elite literally attempting to represent society in built form as transparent and totally knowable – exposing architecture's (society's) structural essence and disposing of its decorative weaknesses. They were, of course, essentially well-meaning but completely blind to the specificity of their own discourses which were taken to be obvious, rational and universal: blind also to (and often dismissive of) the interpretations of others. Thus did modern architects justify a specific version of spatial and visual representation and perceive it as a design solution to economic and social problems, particularly in housing.

Of course, such a formulation contained the seeds of its own destruction. First, there was basic popular resistance to accepting the specific associational references of a professional and cultural intelligentsia. Whilst the structure of thought perceiving architecture (and other cultural artefacts) as a reflection of social values did have popular resonance metaphorically *in language*, the assumed values of design intention bore little connection to their popular transformations on reception. Modern and progressive rationality, reflected architecturally in much post-war public sector housing through use of the repetitive grid, was 'renamed' an imprisoning conformity – Alcatraz (Boys 1984, 1989). Second, these associational references clearly weren't nearly enough to articulate the complexity of different lived experiences. Yet the consolidation of a professional aesthetic built on producer intentions and associations as both obvious and true meant that these alternative interpretations literally could not be heard. By the 1970s popular opinion, whatever its political stance, was challenging these silencings and frustrations. Third, the architectural establishment, in attempting to stand above the cash nexus, had developed a body of knowledge which centred on offering 'representational' solutions to economic, social and political inequalities and conflicts. With the rise of Thatcherism in the 1980s, the Right was able to undermine not only this form of architectural expertise but also public sector professionalism in general by merely reversing certain associational connections. 'Tower block' shifted smoothly from utopia to dystopia (without anyone needing to bother analysing the messy complexities of actual housing production and consumption processes in Britain), the Left was delegitimated and the architectural profession itself now silenced as the Other (in opposition to 'public commonsense') and finally without any obvious representational truths on which to rely.

POST-MODERN ARCHITECTURE AND SOCIETY

It was the architectural critic Charles Jencks (1977) who popularized the application of the term 'post-modern' to architecture, which was, in turn, brought back into wider cultural analysis. His book *The Language of Postmodern Architecture* was responding to precisely this crisis of modernism,

particularly in America. Jencks's insight was to criticize previous interpretations of the modern movement as falsely unified and progressive, and devoid of the linear development its historians claimed (Banham 1960; Jencks 1977; Pevsner 1945). He argued instead that architecture was and should be plural and diverse. He proposed that architectural representation was 'double-coded', that is, it could operate on two levels at once, providing associational meanings at both popular and intellectual levels. To Jencks, however, these meanings were unproblematically 'knowable' to the producer and/or critic and, as described above, need merely to be 'read off' buildings. The great number of books and articles which have followed are thus merely an extensive cataloguing of these diverse meanings, as interpreted by Jencks himself.

The architectural historian Kenneth Frampton (who has also been key to current debates) remains even more firmly in the modernist tradition. His interest is in whether specific architectural movements can be deemed progressive or regressive by the extent to which they express the 'progressive trajectory of the Enlightenment towards modernization' (Frampton 1983: 18). However, he also admits that in the contemporary period modernization per se can no longer be seen as automatically liberatory. Frampton is severely critical of post-modernism as mere 'surface' which in disguising the harsh realities of universal capitalist production processes is 'merely feeding the media-society with gratuitous, quiestistic images rather than proffering, as they claim, a creative rappel à l'ordre after the supposed bankruptcy of the liberative modern project' (*ibid.*: 19). But neither can the simple expression of production ('high-tech') any longer have critical resonance. He therefore proposes an 'arrière-garde' which distances itself equally 'from the Enlightenment myth of progress and from a reactionary, unrealistic impulse to return to the architectonic forms of the preindustrial past' (*ibid.*: 20).

Frampton names this positioning Critical Regionalism. The crucial tightrope he proposes, achieving a balance between 'false' progress and 'false' nostalgia, is obtained by evoking spatial and visual representational meanings which offer a critical perception of reality:

> It is clear that Critical Regionalism depends on maintaining a high level of critical self-consciousness. . . . In contradistinction to Critical Regionalism, the primary vehicle of Popularism is the communicative or instrumental sign. Such a sign seeks to evoke not a critical perception of reality, but rather the sublimation of a desire for direct experience through the provision of information. Its tactical aim is to attain, as economically as possible, a preconceived level of gratification in behaviouristic terms. In this respect, the strong affinity of Popularism for the rhetorical techniques and imagery of advertising is hardly accidental. Unless one guards against such a convergence, one will confuse

the resistant capacity of a critical practice with the demagogic tendencies of Populism.

<div align="right">(Frampton 1983: 21)</div>

How, then, does one actually differentiate between a building which is a mere gratificatory visual and spatial representation and one that is critical of contemporary society? Frampton gives the example of Jorn Utzon's Bagsvaerd Church which he interprets as combining in creative tension the expression of the rationality of universal civilization with the arationality of spirituality, regionally affirmed. This expression is achieved through the juxaposition within the building of two chains of associative concepts which are conventionally oppositional: external/rectilinear/modular/universal/functional/secular and internal/curved/specific/unique/spiritual/religious. We have met these associative chains before as well as their assumed relation to society as representational expressions of abstract social values. The only adaptation from classic masculinist rationality is that here the architecture is progressive because it sets neither side of the binary relationship as superior but offers them instead in creative tension. This adaptation of the superior/inferior logic of binary oppositions to what seems to be perceived as a kind of 'equality in oppositional difference' is, in fact, common in many contemporary writings. The abstract categorization, the primacy of associative representations of society, the pattern of Same and Other and of their linkage through oppositional characteristics remain intact, as does the assumed validity of the critic's interpretation. I will examine the reasons for, and consequences of, such an adaptation later. For now only a couple of comments need to be made. First, as Rose argues, 'another tactic of critique is suggested by the notion of other fields of knowledge beyond A/not A' (1993: 85). Second, such a minor alteration in masculinist rationality's structure of thought seems a very limited response indeed to the challenge of its criticism by many of its Others.

Frederic Jameson (1991) is painfully aware of the problems of seeing architecture (and other cultural artefacts) as a reflection of society merely because they happen in the same time and place: and of realizing that representation in things can be read simultaneously as both a 'true' expression of society and a disguise of that society. Rather than seeing these as internal problems to his structure of thought, though, Jameson externalizes them as a new problem in society: in fact he offers them up as *evidence* of post-modernity. Here representational reflection becomes a thing in and of itself, which is no longer linked in some deep way with 'true' society. Purist critical representation, then, becomes no longer possible but must always incorporate true and false components.

Jameson argues that changes in both representation and space can still be offered as evidence of shifts in social and economic structures, because

they can be shown to exhibit the same underlying logic (the cultural logic of late capitalism). He says that the post-modern commodification of culture itself has anyway removed any possibility of the critical (oppositional) distance between culture and economic organization that Frampton, for example, still wants to find. Instead, because culture has become the central 'stamping ground' of capitalist activity,

> what happened to culture may well be one of the more important clues for tracking the postmodern: an immense dilation of its sphere (the sphere of commodities), an immense and historical acculturation of the Real, (. . . a prodigious exhilaration with the new order of things, a commodity rush, our 'representations' of things tending to arouse an enthusiasm and a mood swing not necessarily inspired by the things themselves) . . . modernism was still minimally and tendentially the critique of the commodity and the effort to make it transcend itself. Postmodernism is the consumption of sheer commodification as process.
>
> (Jameson 1991: x)

Architecture and urban design are the most visible places where these changes have occurred because much contemporary work literally mirrors, through its glass façades, the repudiation of 'depth models' of society (that is, models that differentiate between essence and appearance, latent and manifest, authenticity and inauthenticity, signifier and signified). These are replaced 'for the most part by a conception of practices, discourse and textual play [where] depth is replaced by surface, or by multiple surfaces (what is often called intertextuality is in that sense no longer a matter of depth)' (*ibid*.: 12)

Jameson examines two architectural examples to indicate how this depthlessness is made through spatial and visual representation. One is the Westin Bonaventura hotel in Los Angeles, the other Frank Gehry's own house in Santa Monica. He argues that the Bonaventura deliberately makes a complete world, separated off from the existing city by mirror glass and obscure entrances. The spectacle of escalators and elevators as elements of movement (a substitute for body movement itself) adds to the sheer 'hyperspace' of the central atrium in 'finally transcending the capacities of the individual human body to locate itself' (*ibid*.: 44). This new space

> can itself stand as the symbol and analogon of that even sharper dilemma which is the incapacity of our minds, at least at present, to map the great global multinational and decentered communication network in which we find ourselves caught as individual subjects.
>
> (*ibid*.: 44)

Such a space, then, can be simultaneously read as a 'true' reflection of

the new spatial and informational logics of late capitalist society and as a deliberate distortion to 'divert us from that reality or to disguise its contradictions and resolve them in the guise of various formal mystifications' (*ibid.*: 49). Like Frampton, Jameson is here admitting that the relationship between architecture and society can no longer be theorized through the binary opposition of 'true' (reflection) or 'false' (disguise) association.

To counter this, Jameson proposes the concept of cognitive mapping. He argues that our current problem is not that the vast and complex ensemble of society's structures under late capitalism are unknowable but that they have become unrepresentable, neutralized by both our social and spatial confusion. Instead:

> an aesthetic of cognitive mapping – a pedagogical political culture which seeks to endow the individual subject with some new heightened sense of its place in a global system – will necessarily have to respect this now enormously complex representational dialectic and invent radically new forms in order to do it justice. This is not, then, clearly, a call for a return to some older kind of machinery, some older and more transparent national space, or some more traditional and reassuring perspective or mimetic enclave: the new political art (if it is possible at all) will have to hold to the truth of postmodernism, that is to say, its fundamental object – the world space of multinational capital – at the same time as which it achieves a breakthrough to some as yet unimaginable new mode of representing this last . . .
>
> (Jameson 1991: 54)

Like Frampton, Jameson's 'solution' is within the constraints of masculinist rationality; that is, merely to hold in tension what were conventionally dichotomous: representations of late capitalist society as (unavoidably) surface/disguise/commodity and as deep structure/truth/capitalist logic. He forgoes, however, Frampton's balancing act between these poles and instead hangs on to a 'depth model' of capitalism as something truly knowable, which can be authentically described in architectural representation but for which we do not yet have a language.

Jameson uses Frank Gehry's house to illustrate these possible new representations of a post-modern world. The building is a conventional clapboard house which has been 'wrapped' by a loose, asymmetrical and potentially unfinished skin of mainly corrugated metal and glass. Jameson's concluding interpretation is as follows:

> The problem, then, which the Gehry houses tries to think is the relationship between that abstract knowledge and conviction or belief about the superstate and the existential daily life of people in their traditional rooms and tract houses. There must be a relationship

between these two realms or dimensions of reality, or else we are altogether within science fiction without realising it. But the nature of that relationship eludes the mind. The building then tries to think through this spatial problem in spatial terms. What would be the mark or sign, the index, of a successful resolution for this cognitive but also spatial problem? It could be detected, one would think, in the quality of the new intermediary space itself – the new living space produced by the interaction of the other poles. If that space is meaningful, if you can live in it, if it is somehow comfortable but in a new way, one that opens up historically new and original ways of living – and generates, so to speak, a new Utopian spatial language, a new kind of sentence, a new kind of syntax, radically new words beyond our own grammar – then, one would think, the dilemma, the aporia, has been solved, if only at the level of space itself.

(Jameson 1991: 128–9)

The criticism here is not that Jameson's interpretation of Gehry's house is partial or subjective (although to a non-architectural or cultural intelligentsia it must look decidedly idiosyncratic) but that it routinely accepts metaphorical linkages between specific manipulations of form (fragmentation, dynamic asymmetry, junk materials) and abstract socio-spatial qualities (unmappable, exhilerating, transient); and that it simplistically juxtaposes these with their binary opposites (tract house = stable, rectilinear, plain material = knowable, domestic, permanent). It is no surprise that Gehry, in interview, extends these associative chains by incorporating the female (his wife) with the original/traditional/conventional as the selector of this 'cute little house' which is then explicitly set 'in tension' with the masculine – himself, the potentially uncontrollable creative force behind the new 'unfinished and rough' enclosure (*ibid*.: 108–9). Jameson then assumes that these quite particular (and essentially nineteenth-century) linkages are obvious and rational enough to not need justifying and that they enable him to believe he is saying something profound and generalizable rather than esoteric and specific about contemporary socio-spatial experiences. As with Frampton, all that we are ultimately offered as radical architectural practice is a simple literal juxtaposition in building form of the metaphorical representations of some very conventional oppositions; oppositions straitjacketed by 'dominant subject positions (which) see difference only in relation to themselves' (Rose 1993: 137).

It is as if the challenges to masculinist rationality have hit where it hurts most – in its claims to understand the deep structure of society objectively and authentically. The response is almost childish and perhaps indicates why architectural and urban design have become so predominant in contemporary debates. First the problem is externalized. It is

society which must no longer have a deep structure but be constructed solely on the surface. Since the logic conventionally made deep structure both knowable and 'true' precisely by its binary opposition to and superiority over 'mere' surface, then surface itself must continue to be unknowable, or at least irrelevant to 'real' analysis. So a new logic must be invented. Here, the continuing assumption that descriptions of space and representation can *stand for* descriptions of society via specific associative concepts and binary oppositions, allows masculinist rationality to again 'reveal' its analyses of society, not as underlying and authentic deep structures (disguised by surface appearance) but as surface representations (which, in turn, 'reveal' the shallow depthlessness of post-modern life). What was 'false' has become all too true precisely in its 'falseness'. Partiality is also admitted, not as the partiality of subject position, but as a new partial, rather than a 1:1 match between representation in the architectural product and societal changes.

Then that frightening chain of surface/irrationality/femininity must be embraced in all its awful unknowability (Baudrillard 1983), or maintained in uneasy tension with structure/rationality/masculinity through some semblance of distance (Frampton 1983) or stirred together into new simultaneously rational and irrational chains which reflect the new and truly knowable (and also simultaneously rational and irrational) *deep* structure of post-modernism/ity/isation (Jameson 1991)

It is instructive, in this context, to look briefly at the underlying structures of thought of right-wing critics and populist critics such as the Prince of Wales. In fact, Roger Scruton (1979) uses the same underlying logic as Frampton and Jameson: the result is different only because his society is/should be ordered, stable, transparent and totally knowable and therefore demands an architectural representation which expresses this most appropriately. To Scruton 'criticism involves a search for the "correct" or "balanced" perception, the perception in which ambiguities are resolved and harmonies established, allowing [a] kind of persuasive visual satisfaction' (1979: 119). Unlike some of his colleagues on the Right, this does not require a restriction of associative vocabularies merely to their formal constituents (that is the language of building elements and their modes of combination dealt with in isolation); this is important precisely because architecture does reflect society through the representational meanings it makes. Scruton gives the example of Borromini's Oratory in Rome:

> The Oratory was designed to house one of the most vital institutions of the late Counter-Reformation, and to give expression to its remarkable combination of self-confidence and spiritual humility. . . . The bold rhythmical façade sweeps its arms outward to the street, but its clear cut forms are of modest brick, finely laid. Its angles and corners are

banded with the meeting of innumerable mouldings, combined with consummate elegance; and yet these forms are retiring and softened, seeming to accommodate themselves to the movements of passers-by. It is important to see in these forms the balance of competing claims, of wordly competence and spiritual grace.

(Scruton 1979: 120)

This example mirrors the simple binary juxtapositions of Frampton on Utzon and Jameson on Gehry: it is only the adjectives that differ. Architectural representation is seen to combine two, potentially oppositional aspects (bold/sweeping/powerful and modest/unassuming/elegant) which in turn express the assumed pairing of these social values (self-confident/definite and spiritual/contemplative) in the Counter-Reformation. As with the others, we are given a tautological and closed system, where an abstract reading of the society gives justification to an abstract visual reading of the architecture and vice versa.

To Scruton, spatial and visual representation in architecture is morally significant because it is the predominant means by which we place the Self and gain self-realization about the world. As with Jameson, alienation is the condition of confusion:

Every man (sic) has a need to see the world around him in terms of the wider demands of his rational nature; if he cannot do so he must stand towards it in an alienated relation, a relation based on the sense that the public order resists the meanings with which his own activity seeks to fill it.... While he may identify in this world the individual aims of individual people, he can find no trace of anything larger than their sum.

(Scruton 1979: 249)

Since, for Scruton, the aim of architecture in reflecting society must be to express an essentially knowable non-conflictual world of public order, unity, coherence and self-realization, good architecture is that which can be reasonably argued to be formally and coherently ordered, both visually and spatially. As I have suggested elsewhere (Boys 1988), the Prince of Wales offers precisely this metaphorical blurring between his desire for an ordered, truly knowable society and its expression in the 'knowable' orders of classical architecture and the vernacular; and on a case by case basis, in the reasoned arguments (that is, those that emphasize order and 'stable' social meanings) of some contemporary architects. Here the binary opposition is not with progressive/rational modernity/ism but with alienating/rationalist modernity/ism. The gap between Jameson and Scruton, then, lies not in any differences concerning how architecture is assumed to work but in the abstract concepts they use to describe what

society is/should be like and what is wrong with it. It is to this problem of how architecture works that I will now turn.

TOWARDS A NEW ARCHITECTURE?

In *The Condition of Postmodernity* David Harvey aims to examine how our experiences of space and time actually interlock with shifts in production and consumption; that is, 'the challenge to put some overall interpretative frame . . . that will bridge the gap between cultural change and the dynamics of political economy' (1989: 211). However, despite an acknowledgement (via Bourdieu and Lefebvre) that cultural intellectuals are themselves positioned in these processes, Harvey goes on to treat the texts of architects as unproblematic and to assume that architecture operates predominately at the level of representation and image-making. In the chapter specifically on architecture and urban design, he can only describe a range of contemporary responses from within the architectural avant-garde, summed up as 'fiction, fragmentation, collage and eclectisim' (*ibid*.: 98). Similarly, he merely maps the binary oppositions and their simplistic consequences for architectural practice.

The crucial point, here, of course, is that whilst authors such as Harvey conceptualize urban development and change as a *process* to be analysed as the spatial result of complex political, economic and social power relationships, architectural space and representation remain literally visualized as a *product*, structured around a partial and closed system of metaphor which both artificially splits design off from these wider processes of urban development and prevents other possibilities from being imagined. Rose (1993) has noted this conceptual division in geography where studies of *space* (territory/access and control/movement flows/differentiation/urban) are predominantly undertaken in a rationalist frame, and studies of *place* (experience/feelings/holistic/domestic) within humanism. Here it is proposed that simply to problematize the assumed link between architectural representation and society is one technique by which the theories and practices of building and urban design can be incorporated back, both into broader political, economic and social processes and into the complexity of use and experience that occupation of the material landscape entails for different groupings in society.

Suppose, then, we substitute Bourdieu's concept of 'habitus' (1989: 69–75) for 'representation' at the core of a potentially radical architectural practice and theory (see Garnham and Williams, chapter 4). Instead of abstract descriptions of society represented through the object as formal manipulations of space and surface, we have actual and potential languages of engagement with objects/spaces which are simultaneously symbolic and instrumental; languages which have intimate relationships with the interpreter's 'place' within socio-economic and cultural power

relations. This could enable a way of engaging with the struggles for position around aesthetic and spatial practices which simultaneously analyses inequalities in access to and control over both territories and meanings.

In terms of a critical practice of design, the associative adjective chains 'describing' society on which architectural representation has been predominantly based must be opened up: first, to an awareness of our own partiality; second, to the effects of engaging with the great multitude of everyday social associations and their various 'positionings' rather than through the reductivist abstractions of A/not A; and third, to making a commitment in theory and practice to involvement in the economic and social beyond representation. As Giancarlo De Carlo writes:

> it means the acceptance of confrontation, or in other words risking the very cultural structures (experiences, values, codes) of those who set off the process; since what will come out of it in terms of new information and criticism is unforeseeable and certainly new and cannot be fed into old models without risking making a farce of the whole process by falling back into mirroring the values of the power structures.
>
> In fact, those who are excluded from the use of power – and therefore from what is officially recognised as culture, art, architecture – are not larvae awaiting a metamorphosis which will permit them to benefit from legitimate values of the power structure. They are bearers of new values which exist potentially and are already manifested sporadically in the margins which are not controlled by institutional power.
>
> (De Carlo 1991: 213)

Think, then, for example, of an office design where the 'commonsense' hierarchies (whose commonsense?) of spatial and representational order between boss and secretary are mutated and transformed (not merely reversed) into a new language, justifiable and valuable only to the degree of its resonance in relation to the category 'secretary', to the lived experiences of office workers and to radical understandings about what her place might be. How different this is to a building like Lloyds in London which has been popularly and critically articulated as precisely a reflection of post-modern society (literally a representational icon) and yet, as I have argued elsewhere (Boys 1986), maintains very conventional sociospatial categorizations of its various workers. Think of new building types that bring together activities that have previously been invisible, marginalized or kept apart, which incorporate both instrumental and associative resonances into three-dimensional space; buildings which do not merely attempt to express popular, client or user 'commonsense', but attempt to shift it, to construct 'believable' alternatives. This then becomes not just a matter merely of struggles over associational references and meaning-making but simultaneously of access and control, locational effects, spatial

and resource allocations, spatial relationships and of differential uses and experiences by class, gender, race, age, etc.

For critical cultural theory, such an approach means refusing to interpret architecture or urban design only as a representational product but, following Miller, to understand that 'culture ... is always a process and is never reducible to either its object or its subject form. For this reason, evaluation should always be of a dynamic relationship, never of mere things' (1987: 11). Meaning-making in objects and spaces is just as much a struggle over cultural and socio-economic resources as access to, and control over, land and building development processes and both take place within dominant, if shifting, patterns of power attempting to legitimate their own 'making sense' of the world. Until the rich complexity of the social meanings we attach to the material landscape are no longer 'contained' by cultural intellectuals and by architects within the associative abstractions of visual and spatial representation, we, and the environments in which we live, will remain ultimately impoverished.

REFERENCES

Ackerman, J. (1966) *Palladio*, Harmondsworth: Penguin

Banham, P. R. (1960) *Theory and Design in the First Machine Age*, London: Architectural Press

Baudrillard, J. (1981) *For a Critique of the Political Economy of the Sign*, St Louis: Telos Press

—— (1983) 'The Ecstasy of Communication', in H. Foster (ed.) *The Anti-aesthetic*, Seattle: Bay Press: 126–34

—— (1988) *America*, London and New York: Verso

Bird, J. *et al.* (eds) (1993) *Mapping the Futures: Local Cultures, Global Change*, London: Routledge

Bourdieu, P. (1989) *Distinction: A Social Critique of the Judgment of Taste*, London: Routledge

Boys, J. (1984) 'Women and Public Space', in Matrix (eds) *Making Space: Women and the Man-made Environment*, London: Pluto

—— (1986) 'Grown Men's Games: A Critique of the Lloyds Building', *Architects' Journal*, 22 October

—— (1988) 'Skyline Styles', *Marxism Today*, December

—— (1989) 'From Alcatraz to the O.K. Corral: Images of Class and Gender and their Effects on Post-war British Housing Design', in J. Attfield and P. Kirkham (eds) *A View from the Interior: Feminism, Women and Design*, London: Women's Press

—— (forthcoming) *Constructions of Society: Images of Class, Family and Community and their Effects on Housing Design, 1830–1990*, PhD thesis, University of Reading

Campbell, C. (1987) *The Romantic Ethic and the Spirit of Modern Consumerism*, Oxford: Blackwell

Clarke, L. (1992) *Building Capitalism*, London: Routledge

Davis, M. (1990) *City of Quartz*, London: Verso

De Carlo, G. (1991) 'Architecture's Public', reprinted in B. Zucchi (1991) *Giancarlo DeCarlo*, London: Butterworth

Eagleton, T. (1987) 'Awakening from Modernity', *Times Literary Supplement*, 20 February

Featherstone, M. (1991) *Consumer Culture and Postmodernism*, London: Sage

Forty, A. (1979) 'Problems in the History of the Profession: Architecture in Britain in the Nineteenth and Early Twentieth Centuries', lecture given to the Institute of Historical Research, London

Frampton, K. (1983) 'Towards a Critical Regionalism: Six Points for an Architecture of Resistance', in H. Foster (ed.) *The Anti-aesthetic: Essays on Post-modern Culture*, Seattle: Bay Press: 16–30

Goldthwaite, R. (1980) *The Building of Renaissance Florence*, Baltimore and London: Johns Hopkins University Press

Habermas, J. (1983) 'Modernity: An Incomplete Project', in H. Foster (ed.) *The Anti-aesthetic: Essays on Post-modern Culture*, Seattle: Bay Press: 3–15

Hanfling, O. (ed.) (1992) *Philosophical Aesthetics*, Oxford and Cambridge: Blackwell and Open University Press

Harvey, D. (1989) *The Condition of Postmodernity*, Oxford: Blackwell

Hassan, I. (1985) 'The Culture of Postmodernism', *Theory, Culture and Society*, 2: 119–32

Healey, P. and Nabarro, R. (1990) *Land and Property Development in a Changing Context*, Aldershot: Gower

Hebdige, D. (1988) *Hiding in the Light: On Images and Things*, London: Routledge

Jameson, F. (1991) *Postmodernism: Or the Cultural Logic of Late Capitalism*, London: Verso

Jencks, C. (1977) *The Language of Post-modern Architecture*, London: Academy

Keith, M. and Pile, S. (eds) (1993) *Place and the Politics of Identity*, London: Routledge

Kostof, S. (ed.) (1986) *The Architect*, Oxford: Oxford University Press

Larson, M. S. (1993) *Behind the Postmodern Facade: Architectural Change in Late Twentieth Century America*, Berkeley: University of California Press

Lawrence, E. (1982) 'Just Plain Common Sense: The Roots of Racism', in Centre for Contemporary Cultural Studies (eds) *The Empire Strikes Back*, London: Hutchinson: 47–94

Macleod, R. (1971) *Style and Society: Architectural Ideology in Britain: 1835–1914*, London: RIBA Publications

Massey, D. (1993) 'Power Geometries and a Progressive Sense of Place', in J. Bird *et al.* (eds) *Mapping the Futures*, London: Routledge: 59–69

Miller, D. (1987) *Material Culture and Mass Consumption*, Oxford: Blackwell

Morduant-Cook, J. (1987) *The Dilemma of Style*, London: Murray

Perkin, H. (1989) *The Rise of Professional Society: England Since 1880*, London: Routledge

Pevsner, N. (1945) *An Outline of European Architecture*, Harmondsworth: Penguin

Putnam, T. and Newton, C. (eds) (1990) *Household Choices*, London: Futures

Rose, G. (1993) *Feminism and Geography: The Limits of Geographical Knowledge*, Cambridge: Polity Press

Rose, M. (1991) *The Post-modern and the Post-industrial*, Cambridge: Cambridge University Press

Rykwert, J. (1980) *The First Moderns*, Cambridge, MA: MIT Press

Samurez Smith, C. (1990) *The Building of Castle Howard*, London: Faber

Scruton, R. (1979) *The Aesthetics of Architecture*, London: Methuen

Soja, E. (1989) *Postmodern Geographies: The Reassertion of Space in Critical Social Theory*, London: Verso

Swenarton, M. (1989) *Artisans and Architects: The Ruskinian Tradition in Architectural Thought*, London: Macmillan
Vidler, A. (1986) *The Writing of the Wall*, Princeton: Princeton University Press
Watkin, D. (1977) *Morality and Architecture*, Oxford: Clarendon Press
Zukin, S. (1991) *Landscapes of Power: From Detroit to Disney World*, Berkeley: University of California Press

Index

NB, the index does not include entries listed in the table of contents, nor listings in the bibliographies.